THE ILLUSTRATED HISTORY
OF THE
CAMERA

THE ILLUSTRATED HISTORY OF THE CAMERA

FROM 1839 TO THE PRESENT

by
MICHEL AUER

translated and adapted
by D. B. TUBBS

NEW YORK GRAPHIC SOCIETY · BOSTON

International Standard Book Number: 0-8212-0683-4
Library of Congress Catalog Card Number: 75-9102

First published in Switzerland by Edita S.A., Lausanne
First published in the USA in 1975 by New York Graphic Society

New York Graphic Society books are published by Little, Brown and Company.
Published simultaneously in Canada by Little, Brown and Company (Canada) Limited.

Printed and bound in Switzerland

CONTENTS

INTRODUCTION

Niépce and Daguerre, Fox Talbot and Bayard, the fathers of photography, were all striving after one result—to fix a transient image in permanent and portable form. And to a greater or lesser degree, everything that has been done since, whether it be in the development of lenses, films or shutters, is simply an extension of their discoveries.

People have always wanted to capture a moment, and what better way to recall time than with a picture of a view, or the features of some friend or lover! At first, of course, this was done by art, in portable form the ubiquitous sketch pad, in more ponderous form the flattering portrait in oils. But these methods were for the few, demanding as they did either a rare skill to be satisfactory, or a heavy outlay of money.

How then to cater for the many? It was this need that inspired the pioneers to harness science to art to produce a quick, simple and cheap method of automatic art, or painting with light—photography. The earliest cameras were simple wooden boxes, with a lens at one end, and a light-sensitive plate at the other. Little or no other auxiliaries, and the quality of the image depended more on the preparation of the plate, the length of time it was exposed, and the skill of the developer, than on any technical aid mounted on the camera itself.

Cameras have gone through, and are going through, a process of increasing technical development. A glance at the pages of this book will show the fascinating range of knobs, levers, bezels, and buttons displayed by most photographic machines, but at the same time, behind all this, the mainstream of development, true to the basic ideas of the pioneers, has swung full circle to produce the simplest, most compact form of picture-taking apparatus. Probably among the best-selling types of cameras today are those with least complications, such as the Instamatic range. Everything, once again, depends on the quality of the light-sensitive material, and the way the image is developed and fixed.

Lenses, shutters, aperture controls, range-finders, light-meters, and all the complications are only aids to utilize to the maximum the capabilities and capacities of the film or plate. Research has been directed towards improving the sensitivity of the image–registering material, be it film, the practically universal medium today, or plate. It should be firmly borne in mind that, without this progress, the best lens in an automated camera would be next to useless.

The fascination of the camera, though, lies for very few in the details of development and the progress of film resolution. Primarily, the photographic camera is a readily portable machine, whose controls, and the precision with which they work, give an additional pleasure quite apart from the function they aid. Of course, the criteria of any camera is the end result, the picture it can make, and for this reason the simple box-camera, the early Kodaks, and the automatic press button miniatures and Instamatics of today, have a vast appeal—in Eastman's words: "You press the button, and we do the rest". But these cameras do lack the important factor of individual skill and choice of means. This is by no means to denigrate their achievement, but all the same, it is almost the difference between driving and being driven. What photographer, in looking through these pages, will not be fascinated by the host of gadgets and special-purpose equipment designed throughout the history of the camera? The parallel between cars and cameras might be taken further. We all know that the modern automobile is a highly-efficient transportation system, but with rare and expensive exceptions, it is damnably dull to drive. The older cars, from the vintage age, were more specialised, more individual, more temperamental, and infinitely more rewarding to drive. Why? Because a high degree of skill was needed to get the best out of them. And this is true of the camera. Man's innate love of gadgetry will out, and the results can be seen in these pages.

Studio cameras, were once resplendent in polished mahogany and gleaming brass, while the later models are beautiful pieces of industrial design in matt surfaces and clean outlines. Bellows cameras have an appeal all of their own, with their smooth-sliding lens stan-

dards and flexibility of operation. The soft clunk of the mirror in a well-made single-lens reflex, the intricate links and gearing in the twin lens, all are fascinating in their operation and the thought that went into their design. This list could be extended practically indefinitely, but even the quickest of glances through the pages that follow will show what engineering talents, what thought, and what infinite variety there is in camera design!

Then there are the hidden parts. The thought and the perfection of technique that has gone into the means of excluding light from the interior—the shutter—is a fascinating subject all of its own. From the simple curtain or plug over the lens, to the variable focal-plane shutter, all have had their partisans and their uses. Some very nice devices came relatively early; look for instance at the variable speed shutters on pages 149 and 164 and marvel at their ingenuity.

Aperture control too: Niépce's iris, which sprang up Minerva-like at the very dawn of the camera's history, and is still the most popular form in use today. Waterhouse stops, sliding-blade, variable-slit focal-plane shutter blinds—once again the list is as endless as the needs they were developed to serve.

Lenses and light, the basic twins of the camera! Just look through these pages and see the variety of lenses worn, from the simple telescope to the enormous variety supplied for a 35 mm systems camera, such as the Nikon. Range-finders, light-meters, lens hoods, tripods, monorail systems ... there is no end to the multiplicity of forms and uses of these auxiliaries, and we can only hope to give a representative sample.

We should point out here that this book does not set out to be a catalogue of every make and model of camera ever produced; to be that would demand vastly more space than we dispose of here. Inevitably, and this is true of all books on the subject, there will be gaps, partly due to the fact that there exist few museums or major collections of cameras and partly to the fact that cameras are small and perishable objects, easily lost or destroyed. Nevertheless, our hope is that in setting out this representative collection, we may lead to fresh discoveries, and to further conservation.

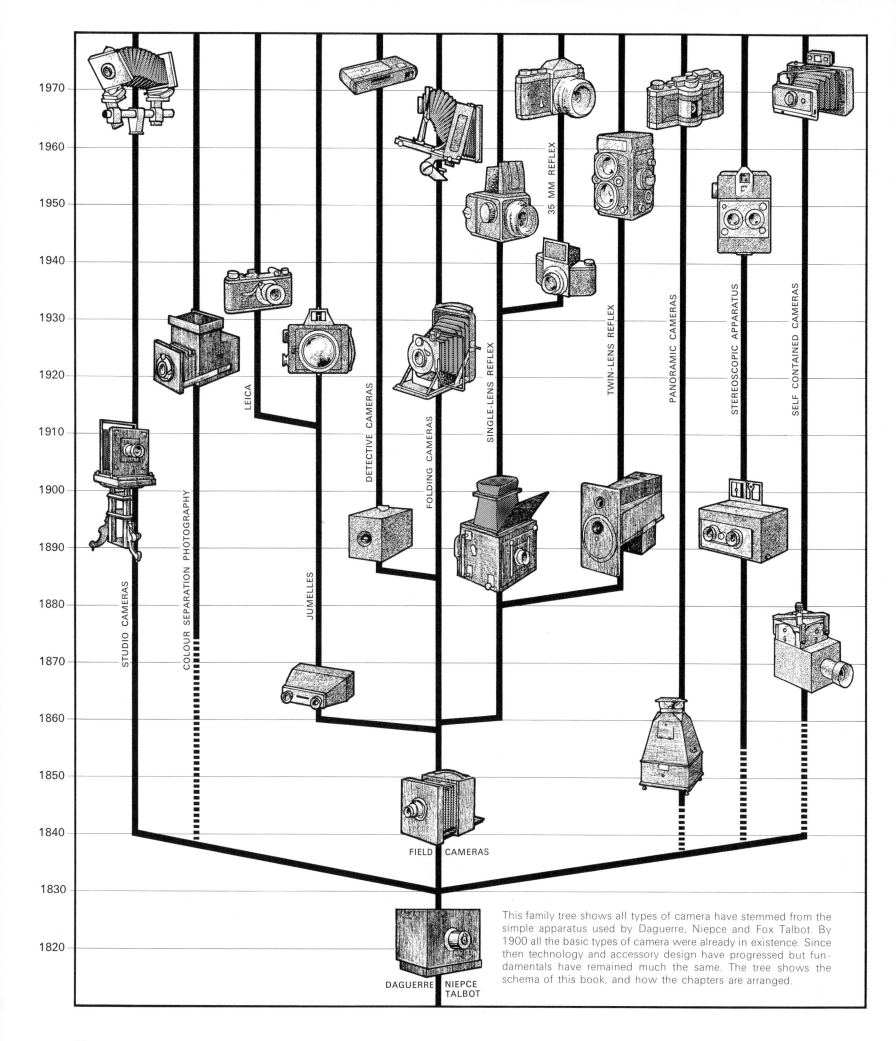

1970
1960
1950
1940
1930
1920
1910
1900
1890
1880
1870
1860
1850
1840
1830
1820

STUDIO CAMERAS

COLOUR SEPARATION PHOTOGRAPHY

LEICA

JUMELLES

DETECTIVE CAMERAS

FOLDING CAMERAS

SINGLE-LENS REFLEX

35 MM REFLEX

TWIN-LENS REFLEX

PANORAMIC CAMERAS

STEREOSCOPIC APPARATUS

SELF CONTAINED CAMERAS

FIELD CAMERAS

DAGUERRE NIEPCE
TALBOT

This family tree shows all types of camera have stemmed from the simple apparatus used by Daguerre, Niepce and Fox Talbot. By 1900 all the basic types of camera were already in existence. Since then technology and accessory design have progressed but fundamentals have remained much the same. The tree shows the schema of this book, and how the chapters are arranged.

GLOSSARY

A

Achromatic: Applied to a lens means that it has been substantially corrected for chromatic aberration, so that its focal length does not depend upon the colour of the light coming through it. This may be done by combining elements made from two kinds of glass having different refractive powers, e.g., a biconvex crown-glass element with a concave flint glass cemented to it. This is known as a Single Landscape Lens or Wollaston's Meniscus.

Actinometer: Exposure meter, often built like a pocket-watch, containing sensitised paper. A sample is exposed and allowed to darken until it matches a standard tint. The time required for this provides an exposure-factor. Also called a tint meter. See also *Exposure meter.*

Adapter: Accessory permitting the use of plate or film of format other than that for which the camera was designed.

Albada viewfinder: Type of optical eye-level finder invented by Van Albada through which the object is seen natural size with, superimposed on it, a frame corresponding to the image to be formed in the camera. Also Brilliant version.

Anastigmat: Lens corrected for *Astigmatism.* Production of anastigmatic lenses was made possible by the discovery in 1888 of new types of crown and flint glass by Abbe and Schott, of Jena. The first anastigmat was the Ross Concentric, patented in the same year but not marketed until 1892.

Antinous Release: Trade name of shutter release introduced by W. Watson & Sons, London. A steel wire plunger runs inside a flexible casing. The latter is screwed to the camera body in such a way that when the operator presses the button the wire emerges at the other end and releases the shutter. In this way the camera need not be touched.

Aperture: *See also Diaphragm:* Opening, controlled by the *Diaphragm,* by which light passes through a lens. The size of aperture is described by its *f number,* found by dividing the diameter of the aperture into the focal length of the lens. For example a lens of 25 mm effective diameter and 50 mm focal length is described as 'working at f/2'. Equally one may say 'the stop is f/2' or 'the exposure should be such and such at f/2'. The effect of stopping down a lens (using a smaller diaphragm) is to reduce the *area,* of the lens in use. The amount of light passing, and hence the exposure, is proportional to the *square* of the f number. For example, in stopping down from f/4 to f/8 the exposure will be proportional to the squares of 4 (=16) and 8 (=64), i.e. 4 times as long. To find the stop requiring double the exposure of f/4 it would be necessary to multiply the f number by the square root of 2, i.e., 1.414, the answer being (in round figures) f/5.6. To spare photographers this sort of calculation lens mounts are usually engraved with a series of f/numbers, e.g.,

f/1.4, f/2, f/2.8, f/4, f/5.6, f/8, f/11, f/16, f/22, f/32 in which each f/number requires twice the exposure of the one before: for example, 1/200 sec at f/8, equals 1/100 at f/11, or 1/50 at f/16 in similar light.
The effect of 'stopping down' (using a smaller diaphragm), is to improve definition—sharpness—and increase the *depth of field.*

Aplanat: One of the names given to the Rapid Rectilinear type of lens.

Aplanatic: Lens corrected for chromatic and spherical aberration; in practice this meant that reasonably sharp definition would be given at full aperture.

Astigmatism: in a lens means an inability to bring vertical and horizontal lines near the edges of the field into sharp focus at the same time.

B

Back focus: Effectively the distance between the rear component of a lens and the focal plane.

Barrel shutter: see *Cylindrical.*

Baseboard: The board or, in folding cameras, the flap which carries the rails or slide for the lens-carrier. The flap may open beyond 90° to permit use of wide-angle lens.

Bayonet fixing: Lens mount in which an ordinary screw mounting is replaced by one having an interrupted thread.

Body of a camera: the principal housing to which other components—lens, bellows, dark slides, shutter etc., are attached.

Brilliant viewfinder: Waist-level finder taking the form of a (sometimes folding) box, the front of which is a short-focus lens. The image from this is reflected upwards via a 45° mirror and viewed through a positive lens masked to correspond with the image being received by the camera. The picture is seen right way up but transposed from right to left. *Ground-glass finders* are of similar construction but the image is seen on a miniature ground-glass screen.

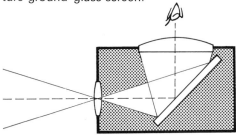

Bulb Release: Early form of shutter release. Pressure on a rubber bulb compressed the air in a rubber pipe. The pipe fitted over a cylinder in which was a piston which triggered the shutter, or inflated a little rubber teat which pressed a catch as it swelled.

C

Camera lucida: Optical instrument by which the image of a landscape, etc., projected on paper in daylight may be traced by a draughtsman. A desire to fix such images led W. H. Fox Talbot to invent first Photogenic Drawing, then the photographic negative.

Camera obscura (See page 175).

Carte de visite: During the 1860s the Parisian photographer Disderi started a craze for small photographs of celebrities which people collected like autographs; they were usually 2¼×3½in albumen prints mounted on slightly larger cards. Personal photographs were prepared in the same way and sometimes treated as visiting-cards.

Cylindrical or **Barrel shutter:** Used on the first Kodak, it comprised a horizontal cylinder pierced with a transverse hole, uncovered as the cylinder rotated.

D

Dark slide: Plate-holder by means of which sensitised material may be introduced into the camera, exposed and removed for development. A light-proof wooden or metal 'pull-out' or slide forming the front of the plate-holder protects the plate except during exposure. Early daguerreotype dark slides used double doors opening forward instead of a pull-out. Dark slides of the wet-collodion period may be recognized by the presence of wire or metal corners designed to hold the plate proud of its supporting frame, and there is sometimes a drainage channel below for collecting surplus solution; they often exhibit staining by chemicals. Dark slides may be single or double to hold two plates; they may be of block form or of book form, hinged for

easy loading. Pull-outs on large cameras are articulated so as to lie flat on top of the camera during exposure, or may be composed of wooden laminae glued to a canvas base, like a roll-top desk. During the waxed-paper period special backs and lightweight holders or envelopes of black card were used. In certain Detective, jumelle and changing-box cameras plates were held in *sheaths*, metal backing-plates having two or three of their edges folded to retain the plate.

Delay action: Mechanism by which shutter is timed for release after a certain interval, enabling the operator to appear in the picture; another advantage is the elimination of camera movement.

Depth of field: Range of distances over which all objects will be rendered with acceptable sharpness. The depth is small when close objects are being photographed but may be increased by stopping down. Focusing mounts often incorporate a depth-of-field scale. On either side of the index line f/numbers are engraved; so, with the camera focused on, say, 10 ft it is easy to read off distances between which sharp pictures can be obtained for any given stop.

Detective: Early name for inconspicuous or camouflaged camera.

Diaphragm: Obstruction placed before, behind or within a lens to cut off marginal rays while allowing central rays to pass. *Rotating* or *Wheel* stops were holes of different sizes pierced in a disc of metal pivoted alongside the lens mount so that any stop could be brought into use by turning the disc (p. 42). Being permanently attached they were more convenient than loose *washers* or separate Waterhouse stops (see *Waterhouse*). A sliding plate pierced with stops was sometimes used instead of a disc, especially on cheap box cameras. In modern cameras an iris diaphragm is used, which

contracts in much the same way as the iris of an eye. The effect is seen on page 28.

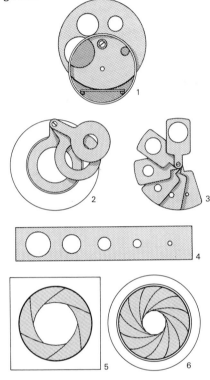

1. Wheel stops. — 2. Washer stops. (N.B. Simple washer stops had no side-arm. They were just metal washers inserted between two tubes or between lens elements which had to be unscrewed.) — 3. Waterhouse stops. — 4. Sliding stops. — 5. Iris diaphragm (Niépce). — 6. Modern iris diaphragm.

Diaphragm or **Central shutter**: The lens is closed by thin overlapping metal blades which open away from the centre. Introduced about 1882. Early models (e.g. Bausch & Lomb, Newman & Guardia) were timed by pneumatic brake; later ones, e.g. Compur, by clockwork escapement. Speed limited to about 1/500 sec.

Direct vision optical viewfinder: For non-reflex cameras used at eye-level. A metal tunnel has a rectangular negative lens at the front masked to the shape of the negative, with a positive eye-piece behind. A brilliant reduced picture is presented, right way up and right way round. Folding versions had hinged lenses and no tunnel; and sometimes the eye-piece was replaced by a simple metal sight. In a *Sports* or *Wire-frame* finder, a wire rectangle of the same shape as the negative is mounted above the lens and a peep-hole for the eye in the plane of the plate or film. The view is seen framed by the wire, with the advantage that objects outside are visible too, making it easier to 'pan' (swing the camera) when photographing high-speed action shots.

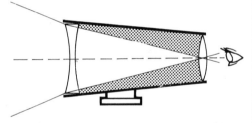

Double-bladed shutter: Variety of in-and-out shutter employing two forked blades, one each side of the lens. Their distance apart could be regulated, controlling the size of the orifice exposed.

E

Emulsion: Photographically the term includes the light-sensitive salts and the viscous medium in which they are carried, such as gelatin, collodion or albumen.

Exposure meters: From the die-hard days when 'Anyone who can't guess his exposures correctly doesn't deserve a camera' to the present era of sophisticated Through-the-Lens-Metering many aids to guesswork have been proposed.

Tables claiming to predict the light-value for every day in the year, any time of day and any weather have appeared in many guises, one of the most convenient being the dial calculator familiar to generations of British amateurs featured in Messrs Burroughs, Wellcome's photographers' diary. *Actinometers*, though laborious enjoyed quite a vogue, and so did Extinction meters based in principle on a strip of progressively tinted glass, a reading being taken at the point on the scale at which the object (or in some models a symbol or number) could just be described. An example of this was Lobel's *Filmographe* (1920). In 1930 J. T. Rhamstine in America invented his Electrophot employing a photo-electric cell powered by a battery, and this was followed in 1932 by the Weston 617 meter using a selenium light-sensitive cell. The first camera made with built-in selenium exposure meter was probably the Zeiss Contaflex of 1935. Modern built-in meters giving automatic control of the diaphragm or shutter speed depend upon cadmium disulphide (CdS) or silicon blue cells of greater sensitivity, usually powered by a mercury battery.

Extension: Distance separating the optical centre of a lens from the sensitised material. Degree of extension depends on: (a) focal length of lens; (b) distance of object being photographed. For objects at infinity it is equal to focal length. If, by contrast, the image on the negative is to be same size as the object, the distance of the latter from the optical centre will be equal to the focal length, and the *extension* will be twice that length.

Extension, double, triple: Supplementary bellows movement enabling camera to photograph very close objects or to be used with long-focus lens.

Eyelid shutter: Hemispherical bellows made in two pieces and opening like the upper and lower lids of a human eye. Found principally on large studio camera.

Field Camera: Portable folding camera designed for use on photographic expeditions 'in the field', i.e. away from a studio. Screen focusing, tripod essential.

Film-pack: Glass plates were heavy and breakable. Users of plate cameras therefore welcomed the invention of film-pack. A stack of cut film interleaved with black paper was suitably packaged for insertion in a dark slide, the black papers protruding as tabs. The slide was placed in the camera and the tab numbered 0 pulled out and discarded. No. 1 film now faced the lens ready for exposure when the pull-out of the dark slide was removed. After exposing No. 1 the photographer pulled No. 1 paper tab which, being attached to the top edge of the film, drew it down and up again behind the pack facing the rear. This paper too was discarded. Exposed films were easily removed in the dark room, so there was no need to wait until all had been used.

Film-pack adaptor: Supplementary back allowing the use of film-pack in plate or rollfilm cameras.

Flap shutter: In simplest form a plate pivoted on the optical axis, (p. 34). Others swung upwards uncovering the lens or opened like double doors (p. 51). *Internal flap* shutters: operating inside the camera body and pivoted like the mirror in a reflex.

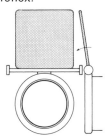

Focal length: The focal length of a lens is the distance between the optical centre of the lens and the image plane (i.e., plate or film) when focused on infinity. Modern lenses are regarded as normal (as opposed to *telephoto* or *wide-angle*) when their focal length equals the diagonal measurement of the format they are to cover. In 1880 they reckoned focal length as twice the longest side of the plate; so in her 15×12 in camera Julia Margaret Cameron used a 30 in lens.

Focal plane: Plane in which the *image* is formed; position of plate or film at time of exposure.

Focal-plane shutter: Situated immediately in front of the sensitised plate or film comprising a fabric or metal blind pierced with a slit through which light passes as it travels in front of the plate. Exposure time may be controlled by varying the spring tension, the width of slit, or both. Popularised during the 1890s by Sigrist and Anschütz for Nature and press photography; now universal on reflex cameras. Later designs employed two blinds, the distance between which could be varied, permitting speeds of 1/2000 sec; Guido Sigrist in whose Jumelle the bellows travelled with the slit (see p. 133) claimed a nominal 1/10000 sec. On modern automatic cameras shutter speed is sometimes controlled electronically according to the light as measured by a cell, the emulsion in use and the aperture selected.

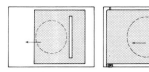

Fresnel lens: Method of increasing the brightness of the viewing screen on reflex cameras. Thin sheet of transparent plastic with concentric serrations having the characteristics of a lens. It may be imagined as a domed lens which has been cut with concentric circles like a target, then pressed flat.

Front cell: The front element in a compound lens.

Ground-glass screen: Sheet of glass with matted surface, placed in the plane to be occupied by the sensitised plate. When the image on the screen is 'sharp' the camera is correctly focused. A black cloth shading the camera and the photographer's head makes the image easier to see.

Half-frame: Popular name for camera taking 18×24 mm negatives on perforated 35 mm film to distinguish it from 'standard 35 mm', the picture size of which is 24×36 mm. Strictly speaking the latter should be called 'double 35 mm' as the frame size in motion-picture cameras, original users of 35 mm film, is 18×24 mm.

Hand, Hand-and-Stand camera: The term 'Hand camera' was coined at a time when gelatin silver bromide emulsions had made 'instantaneous' exposures possible and tripods for small cameras unnecessary. *Hand-and-stand* cameras were designed to operate, preferably, on a stand, with ground-glass screen, or freehand, using an optical view-finder and a focusing scale.

Hood, focusing: folding leather or metal light-shield for the focusing screen on reflex cameras, making the image easier to see. Sometimes fitted with a magnifying glass.

Hyperfocal distance: When a lens is focused on infinity the nearest object rendered with sufficient sharpness is situated at the h.d. If the lens be then focused on the h.d. it will give sharp definition from half that distance to infinity.

Image: The pattern of light and shade formed by a lens on the focusing screen or sensitised material.

Iris diaphragm: See *Diaphragm.*

Iris diaphragm shutter: Shutter in which the action of the laminae could be pre-set so that their opening controlled the lens aperture.

Jumelle: French word for Binoculars; applied to many cameras of vaguely opera-glass shape.

Lens elements: Photographic lenses are usually made up from several elements the shape, size and material of which give them their optical qualities.

They are usually ground to a spherical contour, more rarely aspherical owing to difficulty of manufacture.

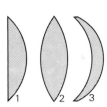

Lenses thicker in the middle than at the edge are Positive, or Convergent; if thicker at the edge than in the middle, Negative, or Divergent. Basic forms are (from left to right): Plano-Convex; Biconvex or Double Convex; Concavo-Convex or Converging Meniscus; Plano-Concave; Biconcave or Double Concave; Negative Concavo-Convex or Divergent Meniscus.

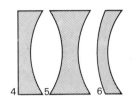

Spherical Aberration. A simple lens is unable to refract rays falling on marginal and central portions of the lens to the same point; it will not focus sharply, but improvement may be had by stopping down, that is, using only the middle of the lens.

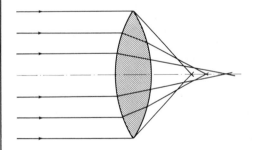

- - - Red
——— Yellow
-·-·- Blue

Chromatic Aberration. White light is composed of all the colours in the spectrum. A simple lens refracts blue light more strongly than colours of longer wavelength. This Aberration may be corrected, as Dollond discovered in 1758 by cementing together elements composed of two kinds of glass, e.g., a Crown glass positive to a Flint glass negative.

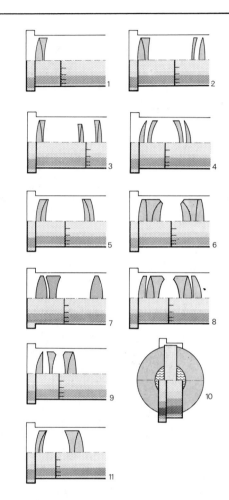

1. Single corrected 'non-distorting' f/10 (achromatic) landscape lens. — 2. Petzval portrait lens 1840. — 3. Dallmeyer Triplet 1861. — 4. Ross Homocentric, a 4-element lens arrived at by dividing the negative element into two to give a symmetrical lens. — 5. Rapid Rectilinear 1869. Either half of the doublet could be used as a long-focus landscape lens. — 6. Goerz Dagor 1904 derived from 1892 Doppel Anastigmat, created by adding an element of the new Jena glass to each achromatic doublets of a Rapid Rectilinear lens, making six in all. — 7. Cooke Triplet. In 1893, H. Dennis Taylor showed that it was possible to achromatise the system as a whole by using only three glasses widely separated by air spaces. The Cooke Triplet sired a huge family of fast lenses. — 8. Zeiss Planar 1896. An early anastigmat designed by Dr Rudolph in which extra Jena glasses were added to a R.R. lens, making six elements in all. — 9. Zeiss Tessar. Designed by Rudolph in 1902, the Tessar remained for 40 years the most popular high-grade lens, working at apertures up to f/3.5. — 10. Sutton's Panoramic Water Lens, 1859. This fluid-filled lens covered a field of 120° at f/12, but as it was not corrected for field-curvature, it had to be used with a curved plate. — 11. Thomas Ross 80° wide-angle doublet.

Lens hood: Hood or shroud placed round the lens to keep out oblique rays, thus avoiding unwanted reflections from internal metal and glass surfaces.

Lens panel (or Lens board): Plain wood or metal panel pierced with a hole for the mount into which the lens is fixed.

Light-meters: are now commonly built into the camera. Early examples (Zeiss Contax and TLR Contaflex) employed a Selenium cell. Cadmium disulphide cells (CdS) requiring a separate battery are now widely used; a few sophisticated systems employ Silicon Blue cells of greater sensitivity still, or LED (Light-emitting diodes).

Meniscus: From the Greek word for crescent moon: a lens convex on one side, concave on the other. If thicker in the middle it is a positive or converging m., if thicker at the edges, a divergent or negative m.

Metering, through the lens (TTL): Exposure calculations are simplified in modern SLR (single lens reflex) cameras by photo-electric measurement of light entering through the lens. Three main systems are used: Stopped down metering, Full-aperture metering (also called Open Aperture), and Automatic. In the first type a button is pressed and the light is measured with the lens stopped down to a pre-set aperture. A needle visible in the view-finder is then adjusted centrally in a +/− gate by the user altering either the stop or the shutter speed setting. In Open Aperture systems all the light entering the camera is measured and the user sees two needles, one connected with the diaphragm, the other with the

shutter. By matching these needles he chooses the right exposure.
Automatic systems are of two kinds: aperture-priority, in which the camera chooses the correct shutter-speed for the aperture selected, and shutter-priority, in which the lens is adjusted automatically to the chosen shutter speed. Over-riding manual control is usually provided.

Mirror, correcting: Two of these were used on the camera built by Giroux for Daguerre: one was placed at angle of 45° in front of the lens to correct left/right inversion of the object, the other, also at 45°, behind the ground-glass screen so that the image appeared right way up.

Monorail: Camera in which the base-board is replaced by a simple bar on which the front and back standards slide for focusing and to which they are attached by universal joints, affording all necessary movements.

Movements: Cameras with ground-glass focusing screens are often equipped with rising, sliding and tilting front, and a back which can be tilted or 'swung', the latter being movement about a vertical axis. These movements give control of perspective and enable nearby and distant objects to be brought into sharp focus.

Multiplying camera: Multi-lens camera for simultaneous exposures.

Object: Rather confusingly this is the name given in optics to what many would call the 'subject', i.e., the scene or pattern being photographed.

Panoramic head: Calibrated support with spirit-level, on which camera may be aimed to take two or more adjacent views of an extended landscape, or on which it can turn.

Parallax error: Is present when the field of view given by the viewfinder is different from that recorded by the lens. All cameras are subject to it except those e.g. single-lens reflex and screen focusing cameras in which viewing and taking are done through the same lens. It is troublesome in taking close-ups. In the Voigtländer Superb twinlens reflex (1933) the difficulty was overcome by tilting the viewing assembly inside the camera as the focusing-knob was turned so that viewing lens and taking lens always looked at the same point.

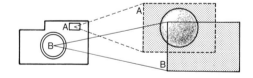

Pentaprism or Roof prism: Prism, pentagonal in side-elevation, used in conjunction with a mirror in modern eye-level reflex cameras. The image in the viewfinder is seen right way up and right way round (see diagram).

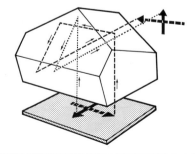

Periscopic lens: Early doublet composed of two convergent menisci arranged symmetrically about a stop. It would work satisfactorily at f/11.

Photograph albums: Family photograph albums, like *cartes de visite* enjoyed a great vogue during the 1860s, occupying a place of honour in the parlour. Bindings were often elaborate and sometimes included a musical-box. Miniature albums for Ambrotype portraits were popular in America where that process was widely used.

Pull-out: Lightproof wood or metal panel, protecting the photographic plate while it is in a dark slide. Before making an exposure, the pull-out is withdrawn: it is, of course, replaced before removing the dark slide from the camera.

Rack and Pinion: A gear wheel (pinion) meshing with a toothed rod. Rotary motion of the wheel causes longitudinal motion of the rack. Basis of many focusing systems.

Range-finder: Optical device for measuring distances. Essentially the requirement is to measure the angle of the hypotenuse in a right-angled triangle: one side of the right-angle is known, being the base of the range-finder. The other is unknown, being the distance of the camera from the object. If therefore we can measure the angle which the third side (hypotenuse) makes with the object, the distance will be known.
The most common type of range-finder comprises two elements. One, situated at the extreme left of the instrument, is a mirror inclined at 45° to the lens axis. It is fixed and semi-transparent. The other pivots about a vertical axis, and is situated to the right, the distance between

the two constituting the base of the range-finder. The second element may take the form of a mirror or a prism. As the user looks through the eye-piece he sees the object through the semi-transparent mirror; at the same time his eye perceives upon this mirror a second outline of the object, transmitted by the pivoting mirror. When these two images blend the deviation of the mobile mirror must represent one-half the angle of the hypotenuse. This angle known, the distance can be read and the lens focused accordingly. Originally sold as an accessory range-finders are now usually built in and coupled to the lens mount so that turning the latter simultaneously operates the range-finder and focuses the lens.

Rapid Rectilinear lens: also known by such names as Aplanat and Euryscope, Rapid Symmetrical and R.R. A variant of the Periscopic, but with achromatic instead of plain menisci. A good R.R. would work at f/8 and cover a plate the longer dimension of which was two-thirds the focal length.

Repeating Back: Fitting for back of camera allowing several small photos to

be taken on one plate, or adapting a large camera to accept small plates.

Reversing Back: Back in which screen and dark slides may be inserted to give either horizontal (landscape) or vertical (portrait) format.

Revolving Back: Same effect (choice of landscape or vertical format) as *Reversing back* but without need for removal.

Roller-blind or **Mousetrap shutter:** Sold at first (from about 1855) as an accessory for placing in front of the lens. A box contains an opaque fabric blind pierced with a slit. The shutter is usually cocked by pulling a cord, which winds a spring which causes the slit to move across the lens, at a speed determined by the tension of the spring. Unfortunately, simple blind shutters are not *'self-capping'*. They uncover the lens while they are being cocked, so that a lens cap must

be used. Double blinds arranged to overlap overcame this drawback. *Time* exposures are made by pressing the release twice, at the beginning and end of the desired interval. When set to Bulb or Short Time the shutter remains open so long as the release is pressed.

Roller-slide, Roll-holder: Warnerke, and later Eastman-Walker roller-slides contained rolled film and fitted to a plate camera in the same way as a dark slide. Rollfilm adapters for daylight-loading film were used in the same way.

Roof prism: see *Pentaprism.*

Rotary stops: See *Diaphragm.*

S

Shutter: Device for regulating the time of exposure. In early days when exposures were long a simple lens cap, pivoted plate or black cloth was all that was needed. With the advent of gelatin silver bromide processes c. 1873, more sophisticated shutters became necessary. Many systems were tried, of which the following are typical: (a) Drop shutters comprising a plate pierced with a hole falling by gravity in front of the lens. (b) *Rotary:* Disc or sector pierced with a hole rotated in front of lens, its speed of rotation regulating the exposure, speed being governed by a spring or (in early examples) rubber band. (c) *Horizontal:*

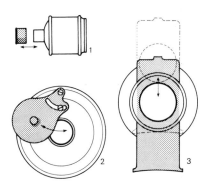

1. Lens cap or 'pillbox'. — 2. Swinging plate. — 3. Blade or guillotine shutter.

Similar to (a) but blade moves sideways or 'in and out'. Spring tension sometimes adjustable.

SLR = Single Lens Reflex: Reflex camera in which the same lens is used for viewing and taking. A TLR (Twin Lens Reflex) is a two-storey camera with separate viewing and taking lenses.

Soft-focus lens: Desirable for 'flattering' portraits, being imperfectly corrected for spherical aberration. In modern examples the degree of softness can be controlled by diaphragm.

Solar Enlarger: Apparatus for making enlarged or reduced copy of negative or print by the light of the sun. The camera had three elements. The back, containing the material to be reproduced in front of a ground glass diffuser screen, was placed facing the sun; the central body contained the lens, a front element held the sensitised paper or plate.

Split image: see *Range-finder.*

Sports finder: Wire-frame view-finder

Spring Back: Introduced about 1900, now usual on technical cameras. The screen frame is mounted on springs so that after focusing a dark slide may be introduced and held in place by the frame.

Stanhope lens: Miniature magnifying-glass placed over microscopic transparencies concealed in jewelry, souvenirs, etc.

Stereoscope: Binocular viewer for stereoscopic prints or transparencies. For the three-dimensional impression to be correct the stereoscope must have the same separation and focal length as the taking camera.

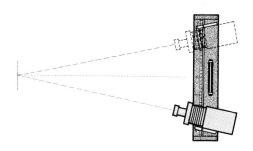

Stereoscopic camera: Camera having two lenses side by side separated by approximately the same distance as a pair of human eyes. Two pictures are taken which, when viewed simultaneously in a stereoscope give an impression of solidity.

Stop: see *Diaphragm.* 'Stopping down' means using a smaller diaphragm for increased sharpness and *depth of field.*

Supplementary lens, or **portrait attachment:** Extra (positive) lens applied to the lens of a camera having fixed or limited extension to increase the focal length and adapt it for close work.

Support: Backing on which sensitised material is carried. The first support was paper, used by W. H. Fox Talbot for photogenic drawings (1835-1839), and his Calotype process discovered in 1840. Glass was not successfully used until 1847 when Abel Niépce de Saint-Victor,

a nephew of Nicéphore Niépce, described a method of coating it with an albumen emulsion. In 1851 Gustave Le Gray introduced waxed paper negatives and Scott Archer used glass for his wet-plate process. During the 1850s the Revd J. B. Reade suggested gutta percha as a base for a strippable emulsion and Alexander Parkes used collodion for the same purpose. In 1886 George Eastman returned to a paper base for a stripping film developed for the Eastman-Walker roller slide and the original Kodak which followed two years later. Less complicated has been the fine-grain paper coated with gelatine emulsion brought out for the E-W roller slide in 1885 which was oiled to increase its transparency. Collodion and hardened gelatine supports were tried, but the most important development since glass negatives was the introduction of celluloid (nitro-cellulose) in 1/100 in. sheets at the suggestion of John Carbutt, an English photographer resident in America. The date was 1888, after which cut film, film-packs and roll-film began to supersede the heavy and vulnerable glass negative. Safety film, made from non-inflammable cellulose acetate appeared about 1930 and is now universal.

Synchronised shutters: Are those arranged to fire a flash bulb or electronic flash, making allowance for the aperture in use.

Tailboard Camera: Modern term for a practical idea originating in the wet-plate period. Folding camera in which back and bellows push forward against the front standard and a hinged baseboard lifts up like the tailboard of a truck, protecting the focusing-screen.

Telephoto lens: Lens in which the focal length exceeds the back focus, that is, a relatively short lens producing a magnified image. Popularised by Dallmeyer in 1891. 'Catadioptric' or Mirror telephoto lenses borrow techniques from the reflecting telescope, employing concave mirrors to increase the focal length; suggested by B. Schmidt in 1931.

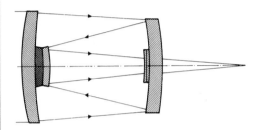

Tintype. Also known as *Ferrotype*. 'While-you-wait' photographs on black japanned tin, being negatives seen as positive against the dark ground. Originally wet collodion, later dry.

Tripod bush: Threaded hole in camera body into which tripod is screwed. The larger thread adopted by Continental manufacturers following the International Congress of 1889 was not standardised in the English-speaking countries. Today ¼ in Whitworth is almost universal.

Washer stops: See *Diaphragm*.

Waterhouse stops Diaphragms invented by Col. Waterhouse, consisting of thin plates of metal, each pierced with a hole of different diameter, placed in a slot in the lens mount so that the centre of the hole coincided with the axis of the lens. See *Diaphragm*.

Wheel stops See *Diaphragm*.

Whole-plate: Plate 21×16 cm (8½× 6½ in) as used by Daguerre which became a standard measurement. In sub-dividing into half-plate and quarter-plate adjustments were made to preserve good proportions.

Wide angle: Lens covering a wide field of view because of shorter focal length than 'normal', i.e., less than the diagonal of the format for which it is designed. Wide angle lenses cover a field of about 90°; semi wide-angle, one of 65°-70°. An extra-wide angle or extreme angle lens covers 160° or even more.

Z

Zoom lens: Lens in which the focal length, and hence the field of view, may be varied between limits. Perhaps the first zoom lens for still cameras was the 36-82 mm f/2.8 Voigtländer-Zoomar for 35 mm work introduced in 1959. As the name implies, the focal length was continuously variable between 36 mm (wide angle) and 82 mm (telephoto).

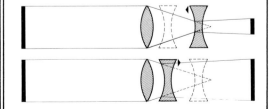

OBTAINING AN IMAGE: BRIEF NOTES ON THE EARLY PHOTOGRAPHIC PROCESSES

Extraordinarily fine and detailed results were obtained, from the very outset, by the pioneers, working often in extremely difficult conditions. The current interest in the history of photography and the influence exerted by the early processes on the development of cameras themselves require the following brief resumé of the various methods used more than a century ago in the unceasing quest for faster and more sensitive materials.

A word of caution however: would-be experimenters are warned that many of the chemicals are highly dangerous or poisonous, or both, and that every precaution should be taken to avoid inhaling toxic vapours from mercury, for example, or potassium cyanide, and to protect the hands and clothing from silver nitrate—a substance rightly called 'lunar caustic'.

1839 THE DAGUERREOTYPE

It was on 19 August 1839 that scientist François Arago announced full details of L.J.M. Daguerre's process at a joint session of the Académie des Sciences and the Académie des Beaux-Arts in Paris. The process was as follows:

1. Prepare the plate. A sheet of copper with fused silver coating (i.e., made in the same way as Sheffield plate) was lightly dusted with pumice and polished by means of a pad moistened with olive oil, then cleaned with a similar pad containing nitric acid. This process was to be repeated until a perfect surface was obtained.

2. Sensitising the plate. This operation was carried out in a darkened room. Iodine crystals were sprinkled inside a box with sliding lid, in which hermetic container the silver plate was placed face downwards. Fumes from the iodine combined with the silver to form a coating of silver iodide sensitive to light. This process was complete when the plate attained a golden yellow colour. The plate was then ready, and had to be used within the hour.

3. Exposure. The Daguerreotype process was at first very slow. It required an exposure of 10 to 15 minutes in bright sunlight, and was therefore not suitable for portraits.

4. Development. This operation was carried out by candlelight. A small bath of mercury in the lower part of the developing chest was heated by spirit lamp to a temperature of 60°C. Vapour from the mercury passed over the plate to be developed, which rested face down-wards at an angle of 45° in a rack in the upper part of the chest. The process of development could be inspected from time to time by sliding a shutter from the yellow glass window in the chest. Development was complete by the time the mercury had cooled to 45°C.

5. Fixing the image. The image was fixed by immersion in a warm solution of common salt (sodium chloride) and then washed thoroughly in hot distilled water.

Comment. The original Daguerreotype process underwent rapid improvements. 'Accelerating substances' including chlorine and bromine were suggested by J.F. Goddard and Antoine Claudet early in 1841, which greatly increased the sensitivity of the plates, and reduced the exposure required to a mere two or three minutes, while the substitution of 'hypo' (sodium thiosulphate) for salt (at Sir John Herschel's suggestion) rendered the plates permanently impervious to light. During 1840 greatly improved lenses were evolved by Chevalier and, more particularly, Prof. J.M. Petzval, the latter's working at apertures up to f/3.8, that is to say some 16 times faster than the original landscape lens used in Daguerre's original camera which worked at about f/16. In 1840, too, Fizeau introduced his gold toning process, which gave a pleasantly warm glow to the plate as well as protecting its surface.

Despite these improvements, however, the surface of any daguerreotype is extremely delicate, and care must be taken never to touch it with the fingers—or wipe it in any way at all, for the damage will be irremediable. Restoring a daguerreotype is a job for the expert, and even for him it is fraught with risk.

1840 THE CALOTYPE

In June 1840, William Henry Fox Talbot, who had published the result of his earlier researches on reading of Daguerre's announcement, described a further important discovery, that of the 'latent image'. It was unnecessary, he found, to wait for the negative image in the camera to 'print out'; an exposure of only a few seconds sufficed to form an image on the sensitised paper, invisible but latent, which could be developed by chemical means, when it would appear 'in all its perfection'. Talbot gave the name Calotype to his process, from the Greek *Kalos*, beautiful, and *Tupos* impression. His process was as follows:

1. Prepare the paper. Good quality writing paper was to be used, made from rags and free from chemical impurities and bleaching agents. The paper must be washed, then thoroughly dried.

2. Sensitising the paper. Working in darkness or by candlelight the paper was to be floated and rocked gently for several minutes in a bath containing a 4 per cent solution of silver nitrate in distilled water. After drying the operation was to be repeated, this time for two minutes in a 7 per cent solution of potassium iodide. These two reagents combined to form a layer of silver iodide on the paper, which was now sensitive to light. It remained only to wash the paper again in distilled water, and to make sure that no stain or specks of chemical was present to mar the surface. If so the operation had to be started afresh with a clean sheet. Finally the paper was brushed over with Talbot's 'exciting liquid', gallo-nitrate of silver (gallic acid, acetic acid and silver nitrate). The paper might then be placed, still damp, in the camera.

3. Exposure. Talbot's early Calotypes were made with an exposure of one to three minutes. Later an exposure of 2 sec. at f/5.6 for landscapes was quoted.

4. Developing the negative. For development the paper was brushed again with gallo-nitrate of silver. Time for development 1 to 3 minutes. The resulting paper negative was fixed with 'hypo' (sodium thiosulphate) or potassium bromide, washed and dried.

5. Printing. Place the paper negative in a printing frame, blank side towards the glass. Take a sheet of silver-chloride paper prepared by floating first on a solution of 2.5 per cent ammonium chloride, then on a 10 per cent solution of silver nitrate. Place the sensitised paper in contact with the negative, emulsion to emulsion. Printing in daylight should take about ten minutes. Fix and wash well.

Comment. The Calotype process introduced the now universal negative/positive system into photography. Owing to the texture of the paper Calotypes have a character all of their own, sometimes suggesting a charcoal drawing. Very successful effects were obtained in landscape, genre, still life and portrait photography.

1847 THE ALBUMEN PROCESS

This process was invented by Abel Niépce de Saint-Victor, nephew of Nicéphore Niépce. It enabled glass negatives

of extreme delicacy to be made, and glass positives for use as lantern slides. The albumen was obtained from the beaten white of eggs.

1. Prepare the plate. Take a glass plate and cover it with a thin film of iodised albumen (beaten egg-white which has been treated with potassium iodide and iodine)—a difficult process requiring centrifugal force to ensure even distribution of the film.

2. Sensitising the plate. The plate is sensitised by immersion in a solution made from water 100 grammes, silver nitrate crystals 6 grammes, acetic acid crystals 12 grammes for 10-60 seconds. Wash and dry away from the light.

3. Expose in the camera.

4. Development. The latent image is developed in a solution of gallic acid (1 gramme per litre of distilled water).

5. Printing. Albumen negatives are printed in exactly the same way as calotypes.

Comment. The albumen process was valuable where clarity of detail was essential, for example in stereoscope slides and certain scientific applications, but despite improvements introduced by Blanquart-Evrard in 1849 it was never widely adopted because the plates were extremely slow. After 1851 albumen plates were superseded by the wet collodion process, although albumen papers continued in almost universal use for several decades.

1850 WET COLLODION PROCESS

Credit for the invention of the wet collodion process goes to an Englishman, Frederick Scott Archer, who described his methods during March 1850 in the *Chemist*. He did not patent his discovery. Collodion is a solution of pyroxyline (gun-cotton) in alcohol and ether, forming a clear viscous liquid. The procedure is as follows:

1. Prepare the plate. Thoroughly clean a glass plate with a mixture of pumice and alcohol.

2. Sensitising the plate. Prepare a bath containing 12 parts by volume of water to 1 part of silver nitrate. Pour over the plate your collodion, previously sensitised with ammonium iodide and ammonium bromide, tilting the plate so that the bromiodised collodion covers the whole surface. Immerse the plate in the silver bath for 4 to 6 minutes. This operation is done in the darkroom, by the light of a candle. The plate should present a uniform surface, creamy white in colour.

3. Exposure. The plate must be exposed while still wet.

4. Development. Develop the plate immediately, while still wet, using either iron sulphate or pyrogallic acid.

5. Fixing. Professional photographers fixed their negatives in a highly toxic solution of potassium cyanide, claiming to be largely immune from ill effects—except when cyanide entered through a cut or scratch. Hypo could be used instead, but very prolonged washing was required.

6. Printing. Obtain contact prints as before, on silver-chloride albumen printing-out paper.

Comment. Once it became known, Archer's wet collodion process was almost universally adopted although almost every photographer had his own pet formulae. Wet plates held sway until about 1880 when dry plates coated with gelatin silver bromide emulsion reached the market commercially. For almost 30 years wet collodion negatives, reproduced by the million, brought photography to the masses, reporting wars, exploring the Alps and Himalayas, filling albums with *cartes de visite* and flattering the great and the notorious.

1881 THE AMBROTYPE

An Ambrotype, alias Melainotype, alias 'collodion positive on glass', is a special application of Archer's wet collodion process, depending on Herschel's observation that a negative viewed by reflection against a dark background is seen as a positive. A wet collodion, fixed with cyanide not hypo, was covered with dark varnish made from bitumen of Judaea either on the back or on the emulsion side (in the latter case being first varnished with gum arabic).

Comment. Ambrotypes, framed like daguerrotypes ('*C'est magnifique mais ce n'est pas Daguerre...*') enjoyed great popularity, especially in the U.S.A. Their disadvantage was that, being positives, they would not yield copies.

1903 AUTOCHROME PROCESS

The first practical system of colour photography was invented by the Lumière brothers, Louis and Auguste, and patented in 1903. The process was launched on the market in 1907, and had to be prepared at the factory, rather than entrusted to amateurs, who lacked the equipment and know-how to prepare the plate. An outline of the process is given below:

1. Prepare the plate. Minute grains of potato starch, about 10 thousands of a millimetre in diameter, were divided by colour into three groups, orange, green and violet. These three were sorted together in equal proportions, so that each of the colours was represented in the same proportion. The grains were then scattered evenly over a glass plate, and pressed on to form a lamination of small transparent discs. Each square inch of the plate should be covered with a fine layer of alternating orange, green and violet 'filters'. The minute gaps between the discs was dusted with charcoal, so that light could only pass through the coloured 'screens'. The density of coverage was about 8000 to 9000 coloured starch discs per square millimetre. Finally, the layer was covered by a thin transparent varnish having the same refractive index as the starch.

2. Sensitising the plate. The glass plate was coated on the same side as the starch with a black and white panchromatic emulsion, gelatin silver bromide. The varnish kept the emulsion from contact with the starch.

3. Exposure. The sensitised plate was placed in the camera with the plain glass towards the lens, and the starch, followed by the varnish and then the panchromatic emulsion, faced towards the rear of the camera. Thus the starch grains acted as colour filters placed in front of the sensitive emulsion. The lens was fitted with a yellow filter.

4. Developing the plate. The plate was developed by the same methods used to obtain a black and white negative. The image obtained contained the complementary colours to those of the subject, that is, if a blue, white and red tricolour flag were photographed, the negative would come out as an orange, black and green flag. The negative had to be reversed, or transformed into a positive, and this was done chemically by a further development, which produced a transparency which had to be either projected or looked at in a viewer. In fact, what happened was that the starch grains remained, their colour unaltered, but the black and white positive allowed light to pass through the colour filters to constitute the coloured image.

Comment. The Autochrome process gave extremely good results, and brought colour photography within the reach of a large public. It soon became popular, and about 1913, the Lumière factories were turning out 6000 plates a day. Production continued until 1932, when Autochrome plates were replaced by a similar method based on rollfilm, Lumicolor.

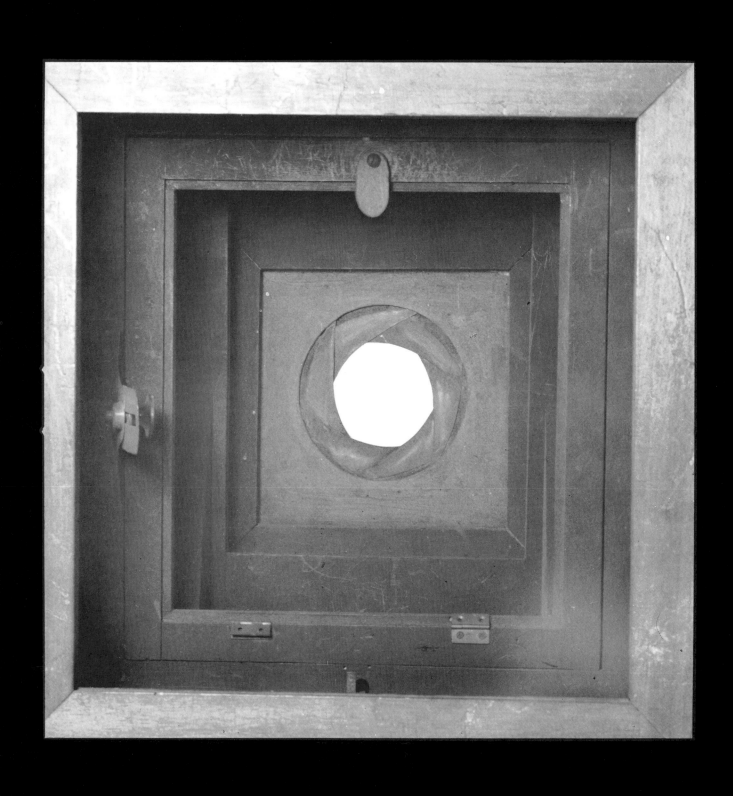

THE INVENTORS

◁ Interior view of the camera illustrated on
page 33. The sensitised plate was mounted on
a board, the hinges of which can be seen in
this photograph. For focusing the portion car-
rying the dark slide was arranged to slide
inside the body. Mention is made of an iris
diaphragm in Thomas Spratt's *History of the
Royal Society*, first published in 1667, in con-
nexion with the inventions of Sir Christopher
Wren, who was Professor of Astronomy at
Oxford from 1660 to 1673. It is also described
in the *Grande Encyclopédie* of Diderot and
d'Alembert (Vol. II, suppl. 1776).

In 1824, when Nicéphore Niépce took his first picture, which from 1839 was to be known by the neologism 'photography', the three elements that were essential parts of his process, camera obscura, light-sensitive plate, and image fixation, had already been the subject of diverse and dispersed researches.

The camera obscura, first of these elements, was known to Aristotle (384-322 BC), to the Arab sage Alhazen (965-1038 AD), and to Leonardo da Vinci (1452-1519). It was used by many artists, amongst them Giovanni Baptista della Porta, and nearer to our own times, by Vermeer, Canaletto and Guardi.

The discovery of the action of light on a sensitive surface perhaps can be traced back to the alchemists of the Middle Ages, but the first known researches are attributed to the German Johann Heinrich Schulze (1687-1744). He mixed together chalk, silver and nitric acid in a bottle, shook it, and noticed that the portion exposed to the light darkened. Giacomo Baptista Beccaria (1716-1781) discovered the action of light on silver chloride. Thomas Wedgwood, of pottery fame, managed to form a fleeting image on a piece of paper, soaked in a solution of silver nitrate, but daylight quickly darkened the surface and made the image disappear. Wedgwood died in 1805 without finding a way to fix his image, and his experiments were unknown to the three pioneers, Niepce, Daguerre and Fox Talbot.

Some twenty years later, Niepce, then aged 59, found the first answer to the problem of reproducing and conserving images by means of apparatus.

The word 'photography' was first used by Charles Wheatstone in a letter dated 1 February 1839 to William Henry Fox Talbot. Sir John Herschel, the celebrated Astronomer, adopted the word in an official report the same year. The two other primary words, negative and positive, were also applied at this time.

Posthumous portrait of Nicéphore Niépce painted by Léonard Berger in 1854, some 21 years after the inventor's death. It was based upon an original bust at Chalon-sur-Saône.

JOSEPH NICÉPHORE NIÉPCE 1765-1833

This Burgundian gentleman was the first man in the world to form and fix a photographic image, in 1822 or 1824. How did he manage to discover what nobody else could?

Niépce was an inspired tinkerer, always on the lookout for new fields to conquer. He invented, with his brother, a machine which employed hot air as a driving force, which he called a 'pyreolophore', he found a method for extracting a colorant from woad to replace the indigo kept out of France by the Napoleonic blockade, and he made himself a draisienne, the ancestor of the bicycle. In 1797, Alois Senefelder invented lithography, a process whereby an image was drawn with a greasy pencil on a water-absorbing stone. Niépce was interested in utilising this discovery in his own area. His son made the designs on the stone, but just when the process was getting underway, the young man was called up to do his military service. Father, who could not draw, cast about to find a way to project and fix a design instead.

In 1816, Niépce used a camera obscura to obtain an image on paper soaked in silver chloride, but it was a negative, and Niépce was seeking to obtain positives. From 1822, he reproduced transparent engravings by pressing them against pewter plates covered with a thin layer of bitumen, thus becoming the inventor of photogravure. At the same time, Niépce took what he called '*points de vue*', the first photographs. He placed one of the pewter plates with its bitumen surface at the back of a camera obscura, which was fitted with a lens. Then he put the camera in front of a window, and left the plate exposed the whole day. At night, the plate was taken out, and a wash in lavender oil revealed the hazy image of the landscape outside the window. Only one of these plates exists today, preserved by Texas University.

After a brief association with Daguerre, Niépce died, unknown and practically ruined, in 1833.

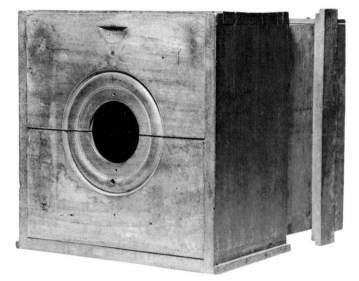

This primitive-looking piece of apparatus is probably the earliest camera known; thanks to a recently discovered letter from Niépce to Chevalier it can be dated to 1826. The lens which is missing, is a described and suits the camera perfectly. It is a biconvex achromatic lens of 80 mm diameter and 300 mm focal length mounted on a sliding panel. The camera measures 30.5 cm by 31.5 cm by 38.5 cm, the format being approximately 16×19 cm.

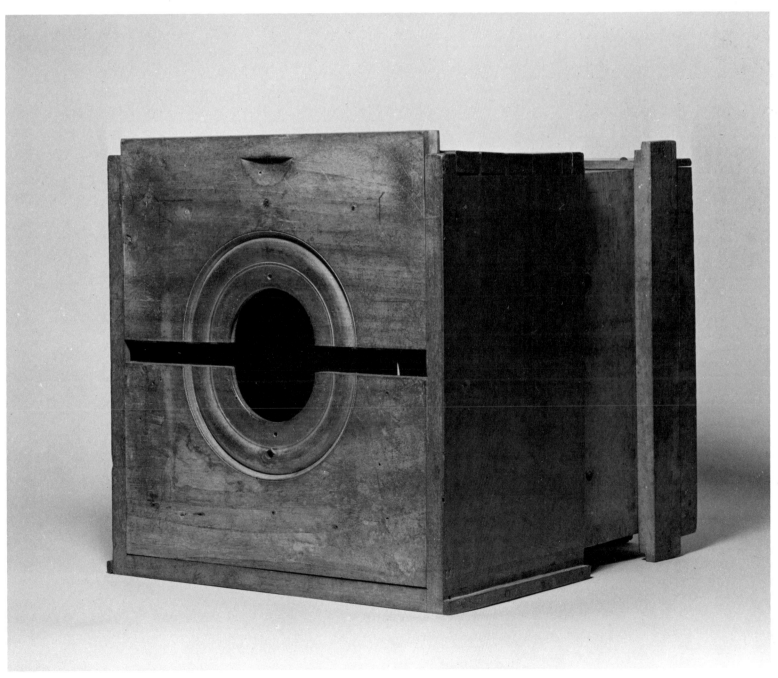

Camera used by Nicéphore Niépce, discoverer ▷
of photography, in his earliest experiments.
The front panel carries an iris diaphragm.

This heliographic view, as Nicéphore Niépce
explained in a letter to his brother Claude, was
photographed from a window in his house at
Gras. Taken upon a pewter plate measuring
approximately 16×20 cm, it is the earliest
'heliograph' extant. When Niepce came to
England in 1827 with a view to patenting his
invention, he presented this picture, the ear-
liest camera photograph, to his friend Francis
Bauer. (Texas University Museum, Austin, Texas)

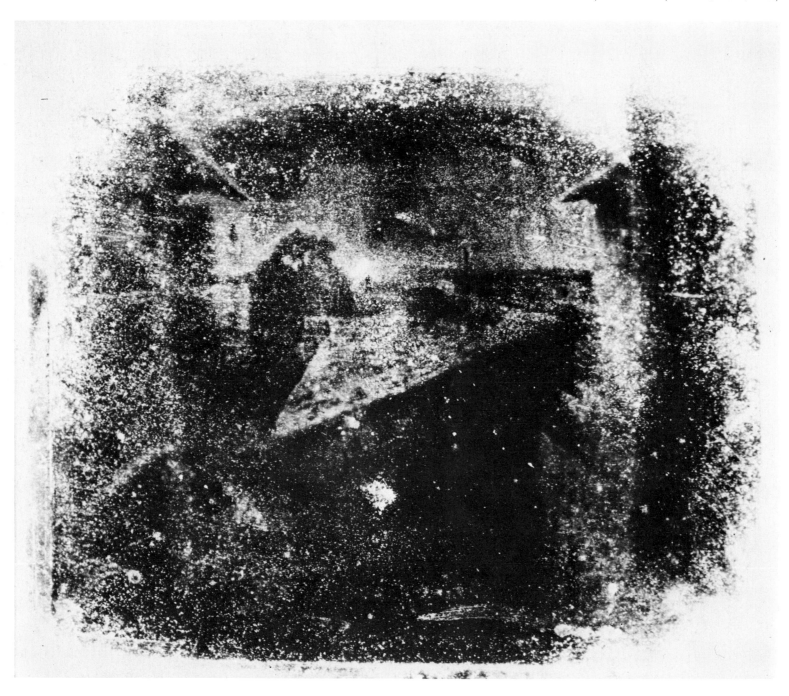

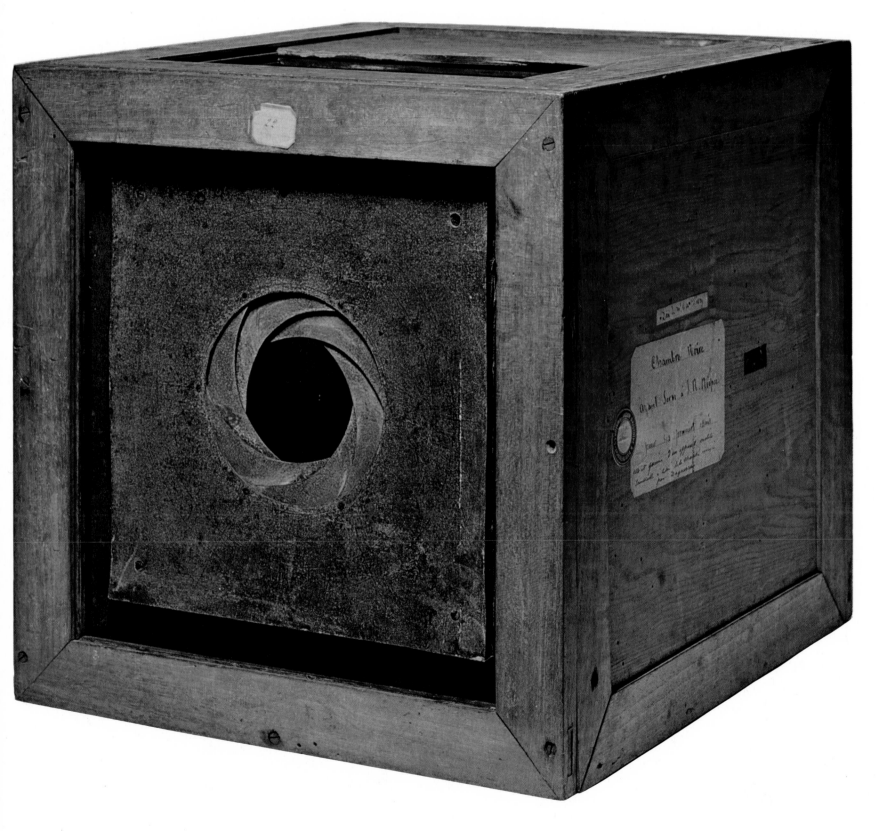

Licence to manufacture cameras was granted to Alphonse Giroux, of Paris, by Daguerre, each instrument bearing a plaque signed by him. The single achromatic lens had a diameter of 85 mm and a focal length of 380 mm (16 inches). It worked at f/17.

The first camera placed on the market by Daguerre was known as the **Daguerreotype.** Within hours of the first public announcement of the process, in course of a lecture to the Académie des Sciences, opticians in Paris were besieged with orders and could hardly keep pace with demand.

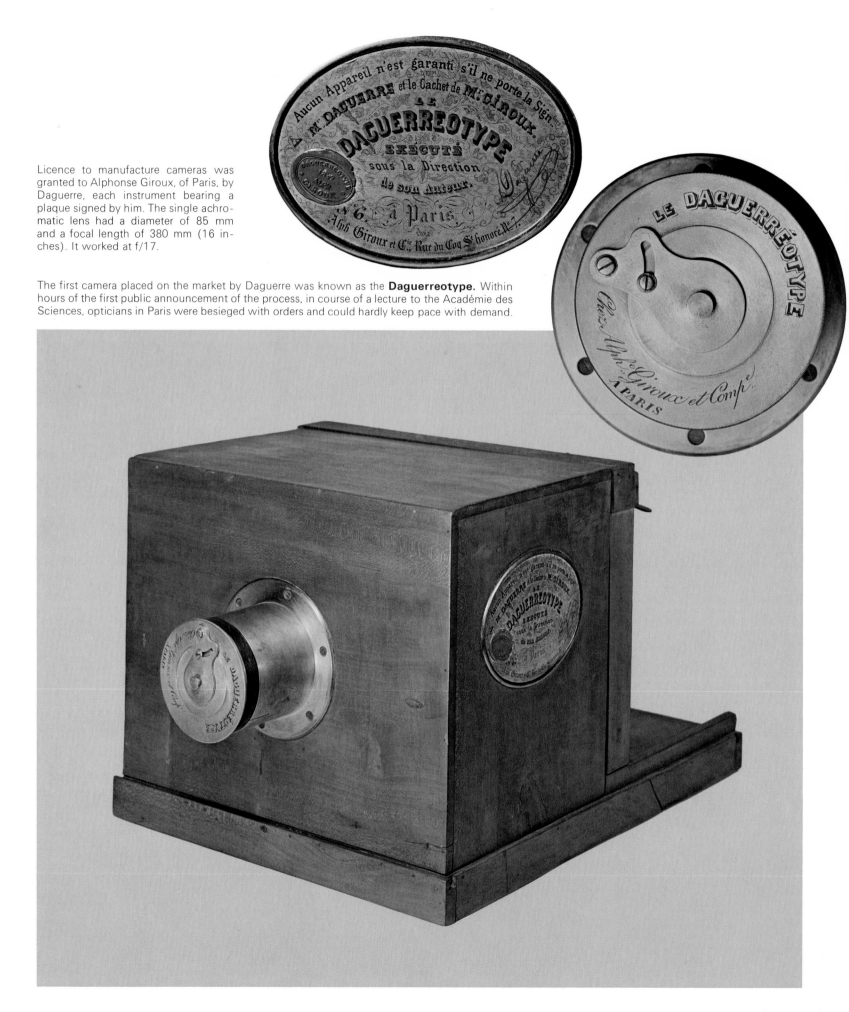

LOUIS JACQUES MANDÉ DAGUERRE 1799-1851

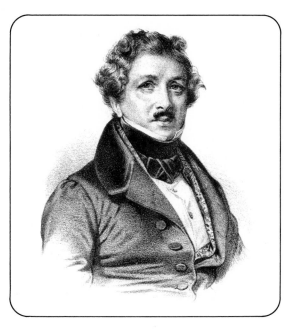

This print, taken from a series of lithographs entitled *La Galerie du Voleur* ('The Rogues' Gallery'), is an early portrait of Louis-Jacques Mandé Daguerre, afterwards famous as inventor of the Daguerréotype process.

Showman, talented painter, both of scenery and of pictures, Daguerre was the inventor of a method for sensitising a metal plate in such a way that it retained a positive image that could be fixed, and which came to be widely known as the Daguerreotype.

A self-taught man of ebullient personality, Daguerre became associated with Niepce, although he was some 22 years younger than his partner. Some few months after Niepce's death, Daguerre managed to obtain a stable positive image, but conscious of the shortcomings in his scientific education, asked the French scientific authority Arago to examine his process. On 7 January 1839, Arago underwrote the discovery: 'Daguerre has discovered some remarkable screens, upon which an optical image leaves a perfect impression, reproducing all the details minutely, in absolute exactitude...'

Once the method was perfected, it had to be turned into money, and this was well within the showman capabilities of Daguerre. Demonstrations given by him at the Paris Conservatoire des Arts et Métiers were followed by such a rush to purchase his apparatus that all the stockists were cleared out. His brochure, explaining the history and the method of his process, went through thirty French editions and was translated into eight languages all in eighteen months. His camera cost 600 Francs in 1839, and weighed over 100 lbs. Many painters interested themselves in it; some saw it as an ideal method of making a preliminary sketch, others abandoned painting for a get-rich-quick career in photography.

All this, of course, redounded to Daguerre's glory. Money flowed in, the fountain of honour played, and he was able to take his profits and set up as a country squire, decorated with the Legion d'Honneur and many honorary diplomas and degrees. In just one year, the Paris sales of daguerreotypes amounted to 500,000 plates. Daguerre died, unlike his erstwhile partner, rich in 1851.

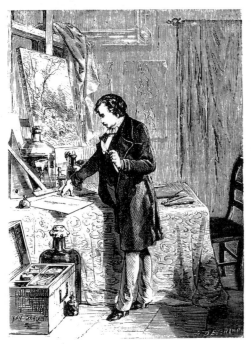

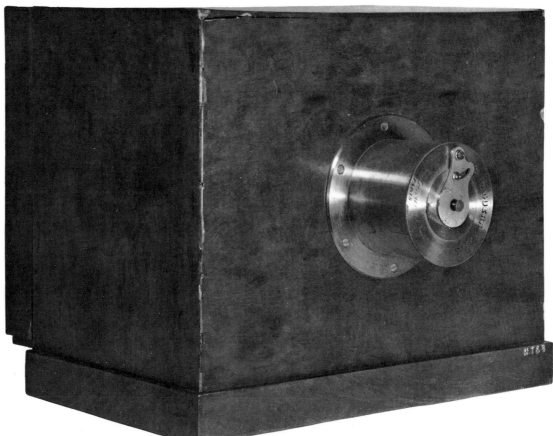

Nicéphore Niépce explains to his partner Daguerre his process for fixing images obtained with the camera obscura. Daguerre's experiments (below) into the properties of silver iodide, which blackens on exposure to light, led him to the discovery of how this phenomenon could be applied to photography. (Prints reproduced from *Les Merveilles de la Science* by Louis Figuier).

Built under the direction of Daguerre himself, this whole-plate (8½×6½ in.) camera closely ressembles those marketed by Giroux at the same period; it differs from them, however, in that the sliding arrangements for focusing are not carried on the baseboard, which has in fact the same dimensions as the camera body, and forms its support. The lens resembles those fitted to the first series of production cameras. The shutter consists of a pivoted plate in front of the lens.

Proof positive. This whole-plate daguerreo-type was presented to Prince Metternich as evidence of his discovery by the inventor, J. L. M. Daguerre. Similar presentations were made to other public figures.

(Société Française de Photographie, Paris)

After fixing and washing the daguerreotype was dried over a spirit ▷
flame, since drops of water would have left a mark. The image was
much improved and rendered permanent by gold toning, a process
suggested by Hippolyte Fizeau in August 1840. Having been fixed
and washed, the silvered copper plate was laid upon this trivet, and,
when perfectly level, soaked in a solution made by dissolving
2 grammes of gold chloride and 3 grammes of hypo in a litre of
water. On being warmed for a few minutes the plate took on a warmer
and stronger tone; it was then washed again and dried.

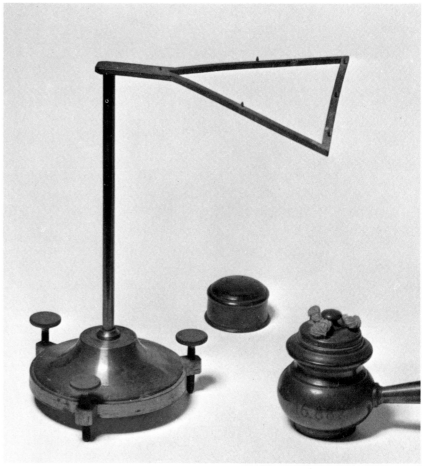

Mercury developing box from Daguerre's laboratory. A spirit-lamp in
the base heated a pottery trough of metallic mercury to a temperature
of about 60°C, the vapour from which was deposited as an amalgam
of silver and mercury on the exposed plates racked at 45 degrees in
the upper compartment. When developed sufficiently the image was
fixed with 'hypo'. (Conservatoire des Arts et Métiers, Paris)

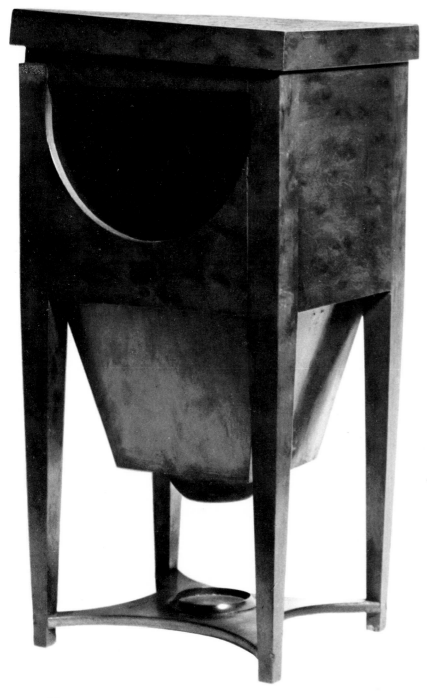

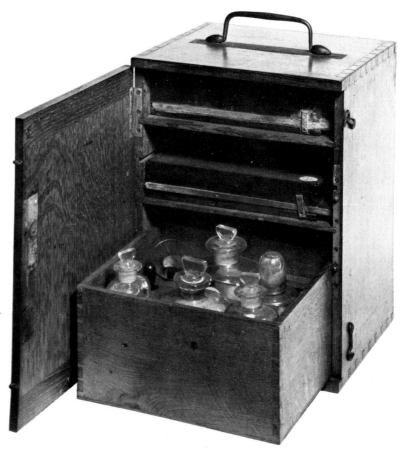

Contained in this chest were materials for polishing silvered
copper plates, sensitising agents such as silver iodide, mercury
for developing and sea salt for fixing.

(Conservatoire des Arts et Métiers, Paris)

38

WILLIAM HENRY FOX TALBOT 1800-1877

Fox Talbot was an English archaeologist, linguist, and chemist of independant means. He was the inventor of the negative-positive process of photography, that is the form used today.

It was in 1833 while sketching Lake Como with the aid of a camera obscura that Fox Talbot was seized with the possibilities of preserving a fleeting image on sensitised paper inserted into the camera. On his return to England, he commenced a course of experiments into the reaction of light on paper he treated in various ways. He first soaked paper in a brine solution, dried it, then bathed it again in a silver nitrate solution. One of the pictures taken by this method still exists, a photograph of the window of Lacock Abbey, his home, taken in 1835. His researches to make his paper more sensitive went on, with a stimulus being given by the news of Daguerre's discovery. In 1839 he described his 'Photogenic Drawing' to the Royal Society. Not long afterwards, he discovered the greater sensitivity of silver bromide paper, then passed on to producing a latent image on silver iodide, an image that could be developed using gallic acid. This process he christened 'Calotype' and patented it in 1841. He used paper waxed to make it transparent for his negative, and the positive was produced by contact, using silver chloride paper. The calotype process was much shorter.

Fox Talbot used his new process to produce the first photographically illustrated book, *The Pencil of Nature*, which was published in 1844. He followed this with *Sun Pictures of Scotland*, published 1845. Although originally less well-defined than daguerreotypes, the soft outlines of the calotypes appealed to the public, and Fox Talbot's portraits and landscapes were extremely popular. He carefully patented all his processes, insisting that a licence should be taken out for commercial use of his inventions. After 1851, however, he made it known that amateurs could make free use of his process. He died in 1877.

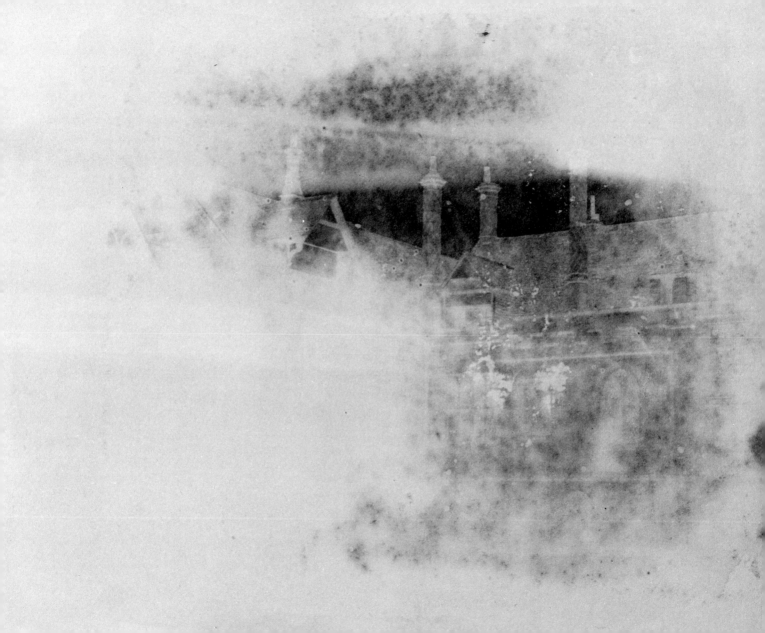

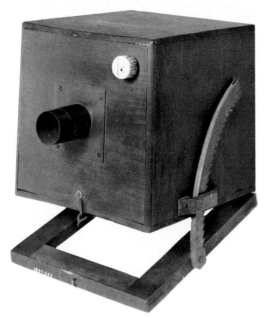

Cameras used by Fox Talbot in his earliest experiments. They were made by the village carpenter, and fitted with telescope or microscope lenses; the front panels are about 3 in square (75 mm). For obvious reasons Mrs Fox Talbot called them 'mousetraps'. The sensitised paper was stuck or pinned at the back of the box. It was with a camera such as this that the above negative was taken.

(Science Museum, London)

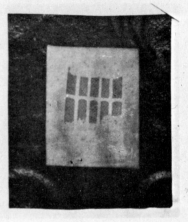

◁ Paper negative (Calotype) by Fox Talbot.

Above: One of the first paper negatives, obtained by Talbot in 1835. The subject is a mullioned window at Lacock Abbey, Wiltshire, Talbot's country house. The hand-written note states that 'when first made, the squares of glass, about 200 in number could be counted with help of a lens'. (Science Museum, London)

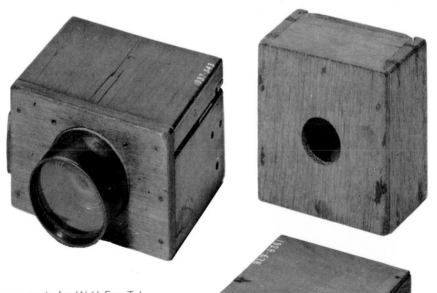

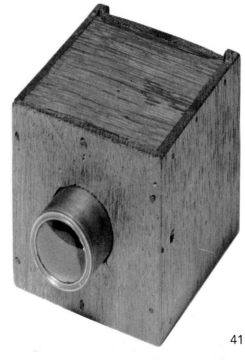

This primitive camera made for W. H. Fox Talbot took photographs approximately 7½ in (14 cm) square. The lens, of some 12 in (300 mm) focal length, moved in a sleeve for focusing. The hole above and to the right of the lens, normally closed with a cork, was used while focusing the image on the sensitised paper. It also allowed the formation of the image to be watched during exposures.

(Science Museum, London)

41

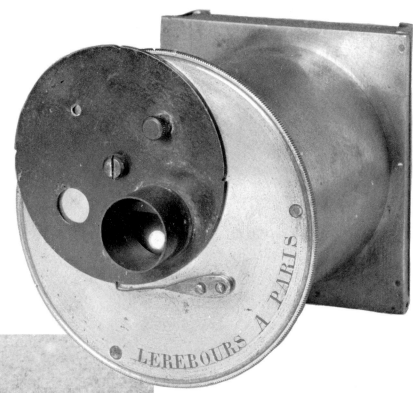

All-metal Gaudin camera made by Lerebours, of Paris about 1841. Talbot used this as a fixed-focus camera for portraiture, where the short exposures made possible by a relatively large aperture were an advantage. When better definition was required it could be stopped down by means of the black rotating disc pierced with holes of different sizes. A lens hood was fitted. The slot through which plate-holders were inserted is clearly visible in this picture. (Science Museum, London)

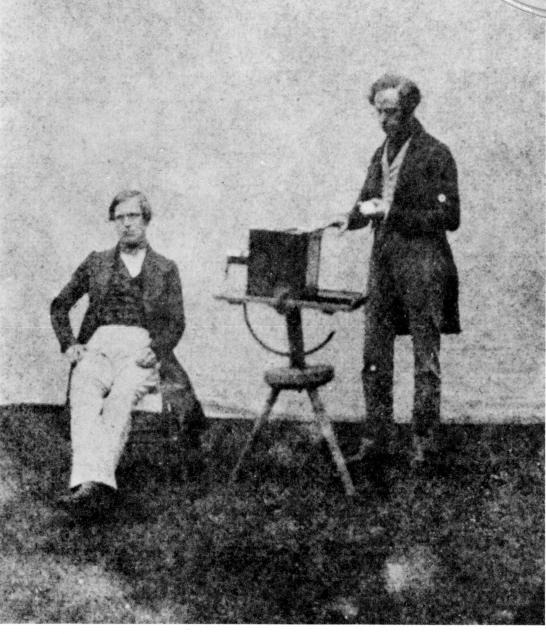

Portrait artist at work. This calotype from the Fox Talbot collection dates from about 1842.
(Science Museum, London)

Now in the Science Museum, London, this Lerebours sliding-box camera of about 1845 was used by Fox Talbot for calotype photography, taking photographs on paper 3½ in by 3¼ in (8 cm×9 cm). The folding wooden hood allowed the ground-glass focusing screen to be used without a black cloth. It was with a camera like this that Antoine Gaudin took the first so-called 'instantaneous' photographs in 1841, showing carriages and horses in motion. The camera had a rotary stop giving three openings, but had neither shutter nor lens-cap; instead a black curtain was hung over the front and briefly raised and lowered.

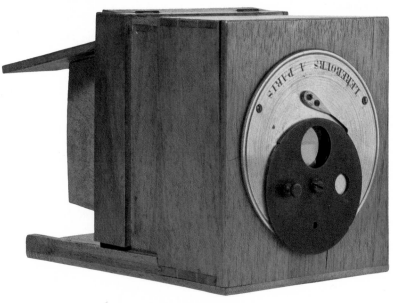

Mahogany sliding-box camera (2½ in×3 in) of French make used by Fox Talbot for taking paper negatives. It is fitted with Charles Chevalier's *Photographe à verres combinés* lens which won the prize in the 1840 competition for the best portrait lens organised by the Société d'Encouragement des Arts. Chevalier (1804-1859) produced an achromatic doublet which was one of the first 'universal' or 'convertible' lenses. It was supplied with two alternative front elements to provide a choice of focal lengths. One was marked *paysages* (landscapes) the other *portraits*; they could also be used together, making with the rear component a triplet lens. Each component was made from crown glass and flint glass elements cemented together to correct chromatic aberration hence the term *verres combinés*. With the landscape combination the focal length was 7½ in (190 mm) and the aperture f/6. The lens is focused by rack and pinion, the camera itself by ground-glass screen.

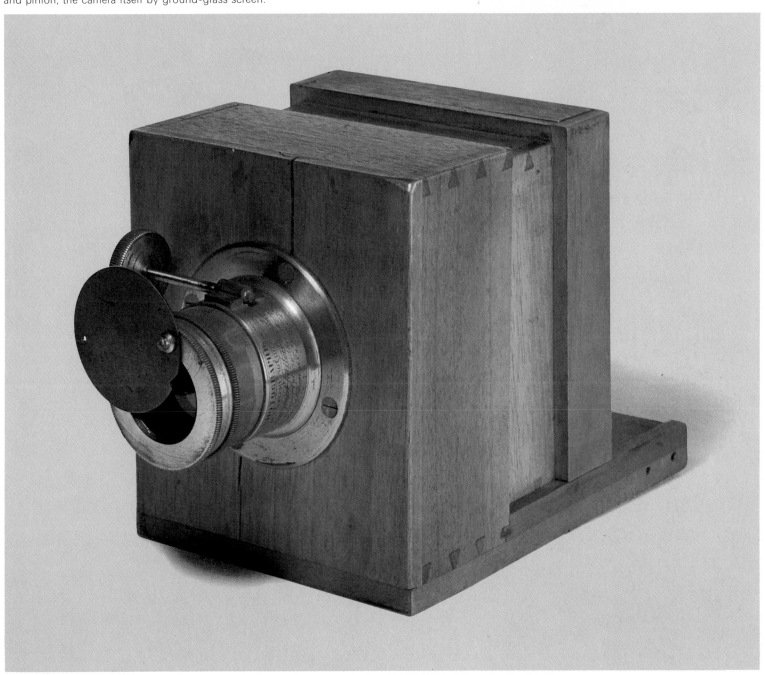

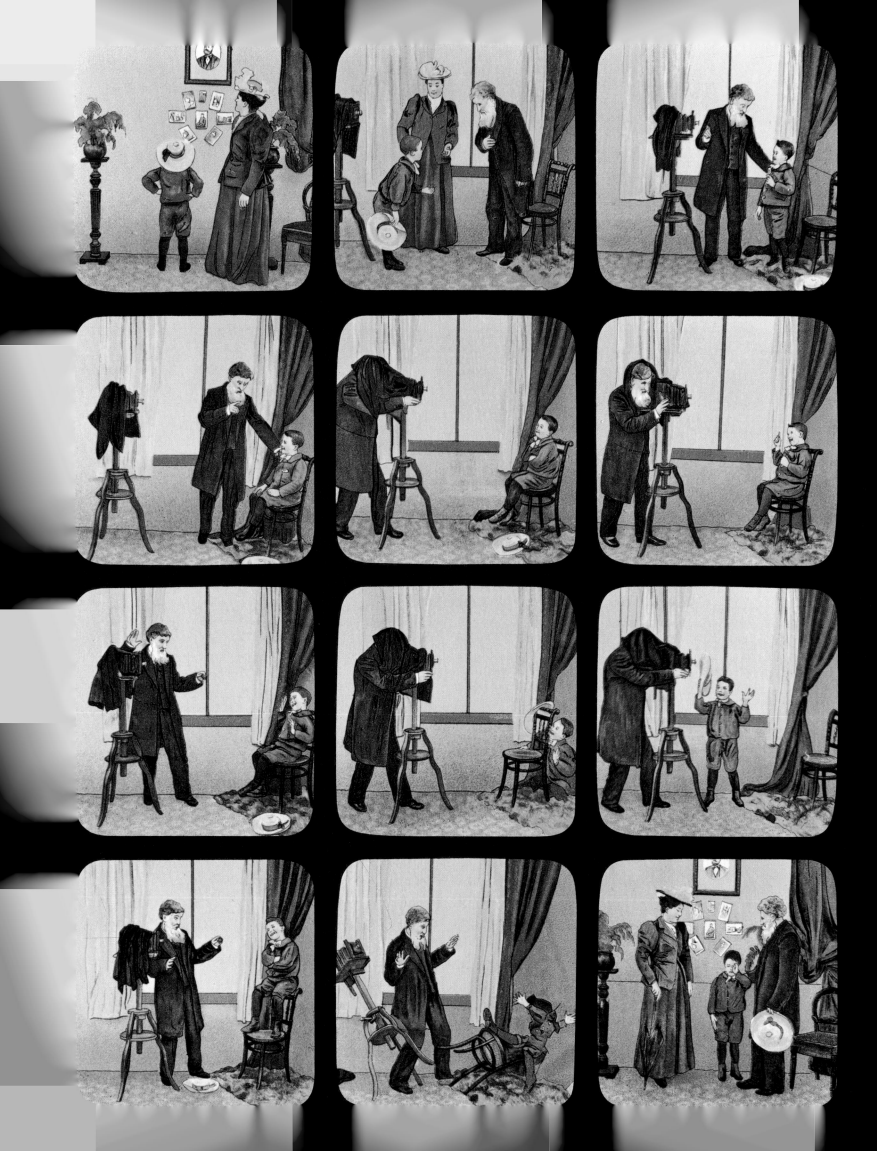

STUDIO CAMERAS

Studio cameras, mainstay of the professional photographer for portraits, still lifes and copying, reached their full flowering—towering might be a better word—during the 1860s and 70s. Grandiose constructions in rosewood, walnut or mahogany, they dealt with any job that came to hand, at the same time impressing customers with the opulence of their surroundings. They had certainly put on weight since 1839, the year in which Daguerre and Fox Talbot gave their discoveries to the world.

The world's first commercial camera caused a rush on Alphonse Giroux's shop in Paris almost before Daguerre had stopped speaking. It set the pattern for the next twenty years. Very simply it comprised one wooden box sliding inside another, open behind for the insertion of focusing screen and plate-holder. The lens at first was an acromatic Wollaston meniscus placed with its convex side facing the plate. Exposures were long because the aperture was about f/14. Two much faster lenses appeared during 1840, competing for a prize offered by the Société d'Encouragement pour l'Industrie Nationale. The winner was Charles Chevalier with his f/6 'photographe à verres combinés'; also competing was the remarkable portrait doublet calculated by Prof. Joseph Max Petzval, a Hungarian mathematician which worked at apertures as large as f/3.5—in other words about twenty times as fast. Petzval granted manufacturing rights to Friedrich Voigtländer, a Viennese optician, who promptly produced not only lenses but a beautiful little all-metal portrait camera (p. 68) of which he sold 600 within two years. Petzval failed to patent his invention in France, where copies of his lens were soon on sale, described as système allemand. By 1851 lenses of 4 inches diameter were being made, to be followed shortly by some of 12 inches. Sliding-box and all-metal cameras were used for both daguerreotype and calotype photography; Fox Talbot owned several of each.

Strangely, neither of these types was chosen by Richard Beard when he opened the first London photographic studio at the Royal Polytechnic Institution, Regent Street in March 1841. His wooden

camera did not have a lens of any sort, but a concave mirror as patented by A. S. Wolcott, of New York (p. 47). Thanks to an ingenious means of reflecting light into his glasshouse studio, tinted blue because blue is the most actinic colour, Beard was able to use short exposures, but the design of the mirror camera limited the size of plate to $1\frac{3}{4} \times 2\frac{1}{4}$ inches.

Ambitiously Daguerre's original camera used $8\frac{1}{2} \times 10\frac{1}{2}$ in plates, whose size became known as 'whole plate', though in practice often only the centre of the dark slide was used, since the exquisite detail and high metallic sheen of a gold-toned daguerreotype encouraged the use of quarter, one-sixth and one-ninth plate images framed as miniatures. Half-plate and even whole-plate daguerreotypes were made, and even one monster, now in the Science Museum, measuring 2 ft 3 in by 2 ft 1 in, but better work in large sizes was possible by Talbot's Calotype process. Hill and Adamson for their portrait work in Scotland used whole-plate and even 10×8 in for their paper negatives between 1843 and 1848, in sliding-box cameras. So long as daguerreotype and calotype held sway there was no need for large studio cameras—daguerreotypes being small and the spread of Calotype being restricted by Fox Talbot's patents. However, when Frederick Scott Archer proclaimed his wet collodion process in 1851 and made it freely available the position changed quickly. With glass negatives generating prints ad lib, and no royalties to pay, portraiture became a growth industry and cameras swelled. Massive instruments were stood on heavy tripods able to withstand heavy use and support glass plates 10×8, 12×10, even 12×15 in. Bellows came in during the Fifties making it simple to provide tilting and swinging backs for adjusting perspective; rising- and cross-front movements although often fitted, were less useful in the studio than out of doors. It was also found convenient to focus from the back, leaving the camera at a set distance from the object. Fronts became massive and well braced to carry the heavy portrait lens. A splendid example of evolution was Prof. Petzval's own camera (p. 60) which although built for testing lenses and too large for studio work, is interesting because it shows bellows extensions working forwards and backwards from a central frame, and a slide which foreshadowed modern monorail

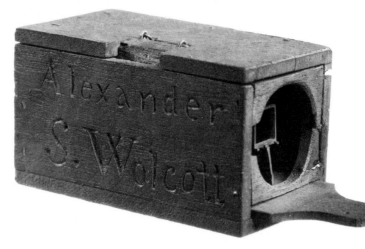

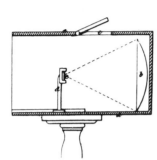

These illustrations show Wolcott's mirror camera, designed in 1840 and used by Richard Beard who opened the world's first photographic studio at the Royal Polytechnic Institution, Regent Street, in 1841. In this system the lens is replaced by a concave mirror, a principle still used in reflecting telescopes. The camera shown, as the document testifies, is the scale model deposited with the Patent application dated 8 May 1840.

(Smithsonian Institution, Washington, D.C.)

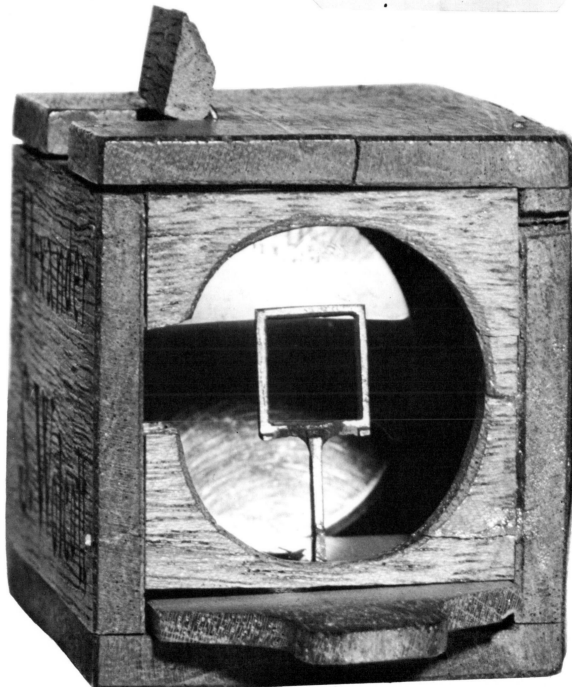

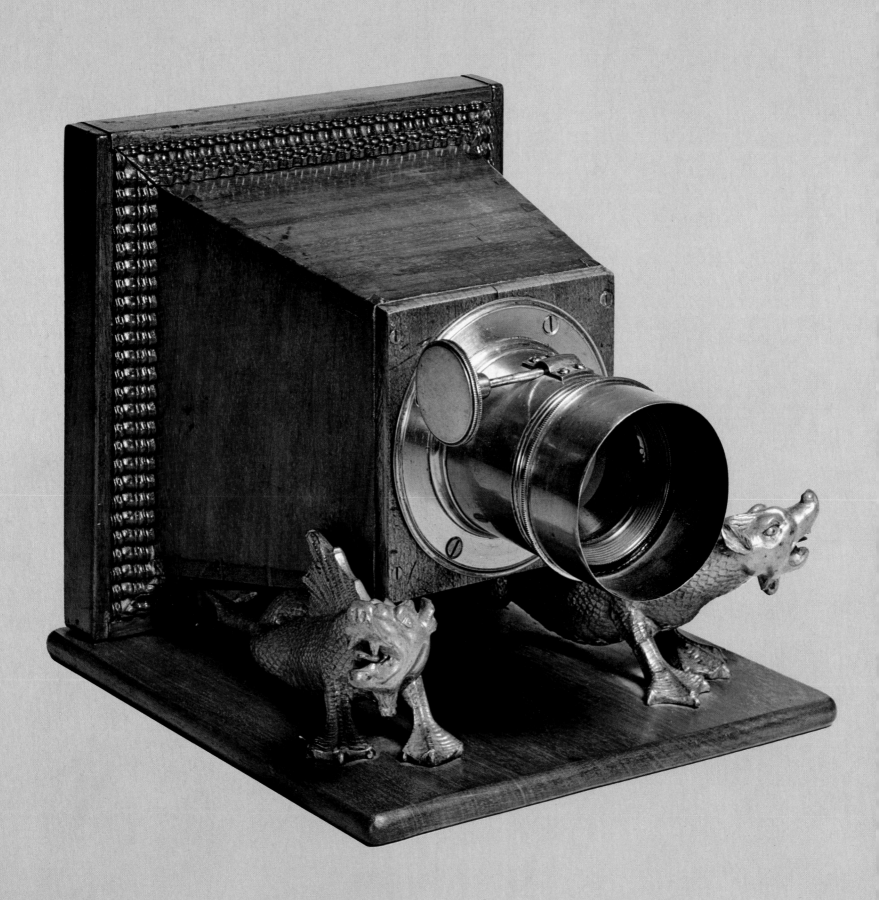

Daguerreotypes were often sumptuously mounted and framed. The picture was seen to best advantage when slightly tilted, preferably facing a dark background.

construction. This was a giant amongst cameras, but large format was essential in the nineteenth century when, for want of electric light, enlargers were not practical. Instead prints were rephotographed in larger or smaller format. Repeating backs were common, so that big cameras would accept small plates. Professional photographers armed themselves with a battery of lenses. Monckhoven, writing in 1879 just as dry plates were succeeding wet collodion, recommended, for those whose glasshouse was long enough, 20 feet (6 metres) at least, a 2¾ in diameter portrait doublet Dallmeyer of 6 in focus for full-length portraits in *carte de visite* (quarter-plate) size, a 3 in of 8 in focus for Cabinet (half-plate) size and a 4 in lens of 12 in focal length for whole-plate. Prosperous studios, he added, might also run to great lenses of 6 in diameter with a focal length of 18 to 24 in focal length for 16×12 in plates. An aplanat (rapid rectilinear) was better in these sizes, he said, than a petzval, having greater depth of field. Mrs Julia Margaret Cameron agreed. The lens for her great close-up portraits was a 30 in Dallmeyer f/6 RR, used in a 12×15 sliding-box camera, by no means a luxurious affair.

Professional portrait studios were dominated by mastodontic apparatus well into the present century, because professionals tend to conservatism and because large pictures are easier to retouch. Massively mounted on stands adjustable for height and range, and consciously handsome, they were often supplemented by smaller stereo cameras, which remained popular from daguerreotype days until the Edwardian period.

Gradually as film secured a foothold in the studios, and electric-lighted enlargers came out 'professional' formats tended to shrink. Big stand cameras were complemented by lighter, handier maids-of-all-work such as half-plate Sandersons. Half-plate and quarter-plate reflexes of 'Soho' type found their way into the studios, first with plates then with filmpack; then the advantages of small format were discovered. Studio cameras have continued to be made, but big formal apparatus has given way to the modern 'technical' camera by, for example, Sinar, whose monorail universally-jointed construction with choice of lenses, backs and bellows provides huge versatility for commercial, architectural, advertising, portraiture and every other sort of photography.

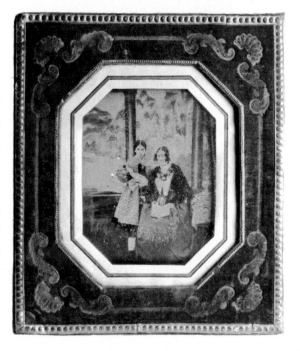

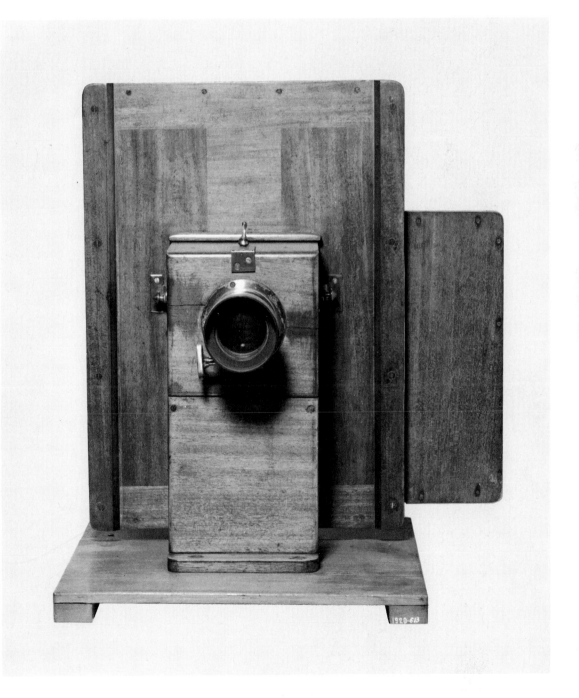

⊲Photographer's advertisement, for Paul Labhart, of Rohrschach. The studio camera on the left is fitted with a Guerry shutter in front of the lens, operated by pneumatic bulb.

Dallmeyer Multiple Portrait Camera (1866). Four 4 in×3 in (10 cm×75 cm) *carte de visite* wet-collodion portraits could be taken on the same plate, since the plate-holder could be moved both vertically and sideways. It appears to have one of J.H. Dallmeyer's patent portrait lenses with a focal length of 5 in (12.6 cm) working at about f/3, and Waterhouse stops. (Science Museum, London)

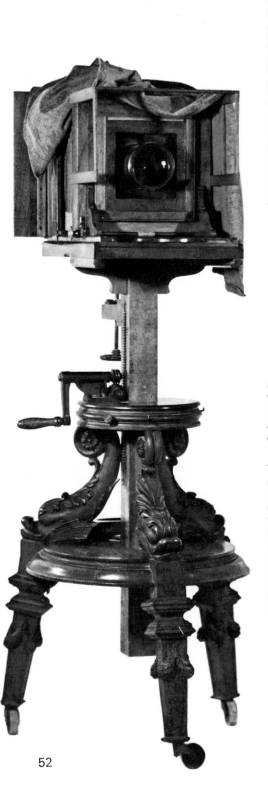

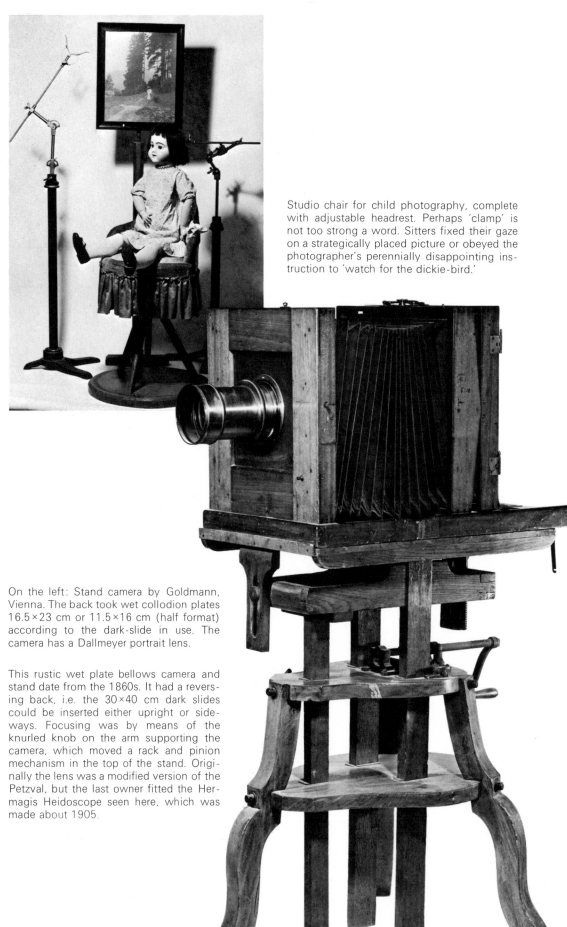

On the left: Stand camera by Goldmann, Vienna. The back took wet collodion plates 16.5×23 cm or 11.5×16 cm (half format) according to the dark-slide in use. The camera has a Dallmeyer portrait lens.

This rustic wet plate bellows camera and stand date from the 1860s. It had a reversing back, i.e. the 30×40 cm dark slides could be inserted either upright or sideways. Focusing was by means of the knurled knob on the arm supporting the camera, which moved a rack and pinion mechanism in the top of the stand. Originally the lens was a modified version of the Petzval, but the last owner fitted the Hermagis Heidoscope seen here, which was made about 1905.

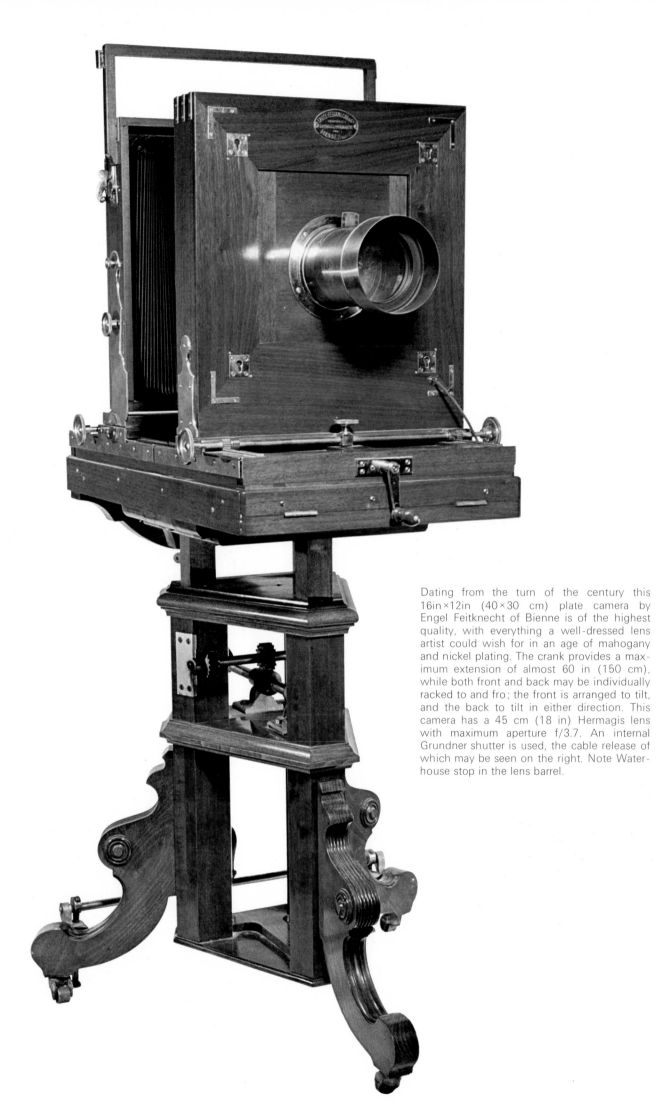

Dating from the turn of the century this 16in×12in (40×30 cm) plate camera by Engel Feitknecht of Bienne is of the highest quality, with everything a well-dressed lens artist could wish for in an age of mahogany and nickel plating. The crank provides a maximum extension of almost 60 in (150 cm), while both front and back may be individually racked to and fro; the front is arranged to tilt, and the back to tilt in either direction. This camera has a 45 cm (18 in) Hermagis lens with maximum aperture f/3.7. An internal Grundner shutter is used, the cable release of which may be seen on the right. Note Waterhouse stop in the lens barrel.

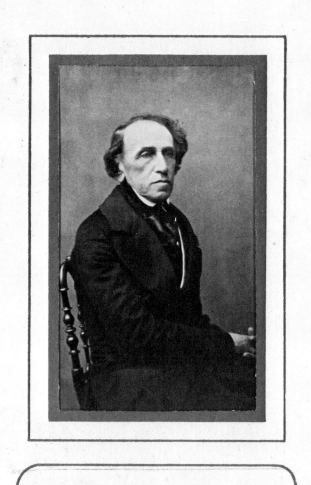
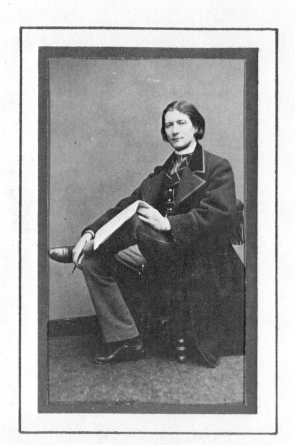

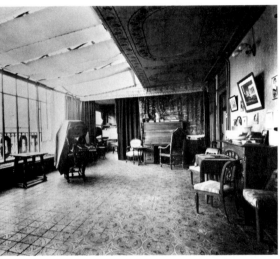

These three contemporary pictures show what a Victorian photographer's studio was like, with abundant side and top lighting and furniture to suit any sitter, from rustic to grandiose. Especially interesting are the 'properties' in the bottom picture, so familiar from a thousand portraits: marble fireplace, back-drop with Ionic columns, tricolore and pennants, candelabra, busts, clocks and occasional tables, not to mention toys to keep children quiet. The huge plate camera, right, and the stereo-camera on its portable stand show two items of equipment in use by this probably provincial photographer. Altogether grander are the fashionable studios above.

◁This page from a photograph album, reproduced in original size, shows Meyerbeer the composer, the playwright Victorien Sardou, Wilhelm Grimm, of Fairy Tales fame, and Victor Regnault, professor of physics and chemistry, head of the Sèvres porcelain factory.

In 1853 Samuel Peck patented what he called 'Union cases' in the United States. By heating a mixture of papier maché, sawdust and shellac and pressing the composition into moulds, ornate and highly decorated wallets, frames and albums could be made. They were much used for daguerreotype and collodion positive portraits. Bottom left: a tortoise-shell wallet.

Collodion-positive portraits, often known as Ambrotypes in the USA. The wet collodion process described in 1851 by Frederick Scott Archer (1813-1857) would produce negatives or positives on glass. So long ago as 1840 Sir William Herschel had observed that an under-exposed glass negative appeared as positive when viewed against a black ground. During the eighteen-fifties many 'collodion positive' portraits were made simply by framing collodion negatives in front of black paper with the result seen (left). 'Ambrotypes' became very popular; providing a cheap substitute for daguerreotypes, which they superseded, although lacking the latters' tonal values. A tintype is a wet-collodion negative taken not on glass but on black-lacquered tin plate.

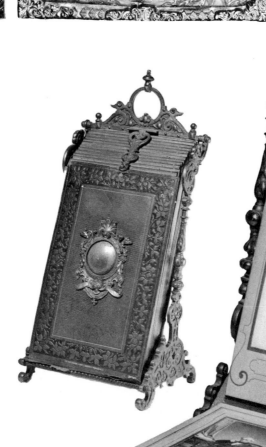

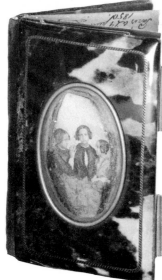

UPWARDS OF FIVE HUNDRED PHOTOGRAPHIC PORTRAITS OF THE MOST CELEBRATED PERSONAGES OF THE AGE. WITH A HAND MAGNIFYING GLASS, EVERY PORTRAIT WILL BE SEEN PERFECT.

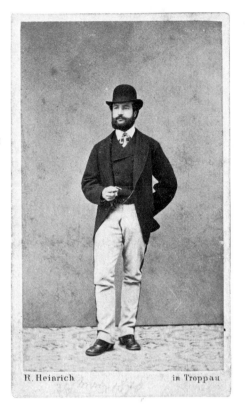

R. Heinrich in Troppau

'Carte de visite' photographs. These enjoyed a great popularity during the Victorian era, and many were formed into collections. Their comparatively modest price brought them within the reach of a large public, and they became a lucrative part of the portrait photographer's work. The subject could be photographed from front and back, and the results printed back to back, as in the example above. Montages, such as the one shown above left, often included some 500 portraits of personalities of the time.

MOSAÏQUE.

Diudieri, Phot. Breveté s.g.d.g.

Jealous painters called it 'the foe to graphic ▷ art'; but photography could be quite useful in supplying cheap models.

Studio photographers built settings for every occasion, with painted back-cloths and plaster 'props'; sitters were expected to enter into the spirit of the thing. You should see the ones that got away...

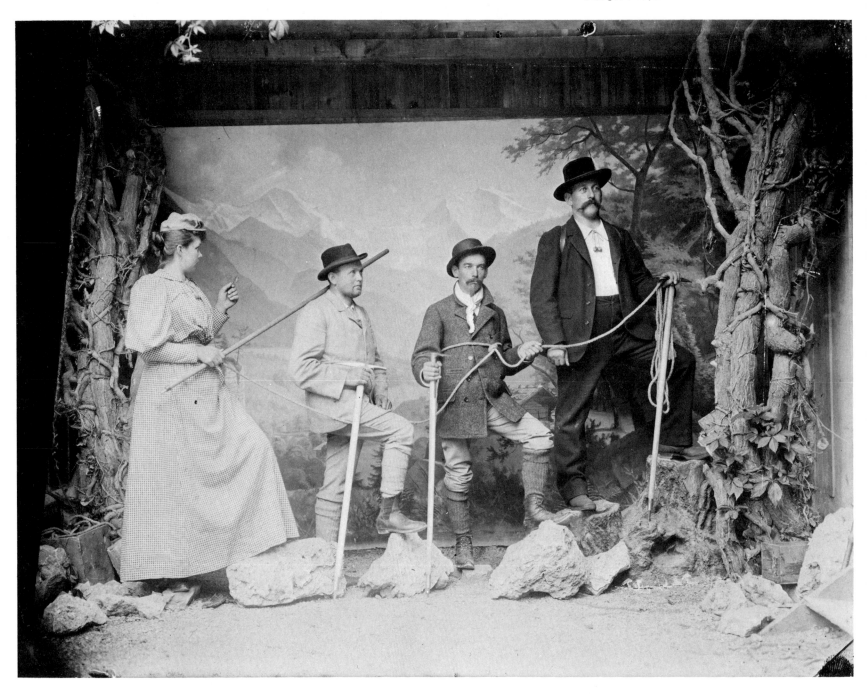

Probably the world's first full-sized monorail camera, this double-extension instrument was built in 1857 to the designs of Prof. Josef Petzval, inventor of the Petzval doublet portrait lens and the first man to design a lens by computation.

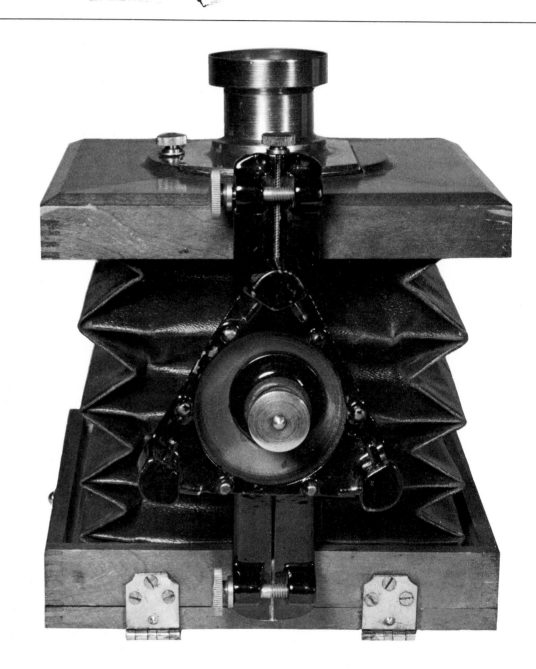

The **American Challenge Swivel Bed Camera** figures in the 1883 catalogue of the Rochester Optical Company and may be described as an early monorail; the tripod had an adjustable head so that the camera could be aimed without moving the position of the legs. A handy camera for travelling, as the front panel could be reversed, bringing the lens inside the body, and the package was only two inches thick. This one is the 5×4 in, with 6-in lens and Waterhouse stops. A handsome article, in polished cherry-wood.

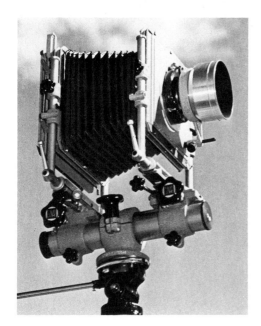

In this **Sinar** monorail chromium and stoved enamel replace Petzval's brass-mounted mahogany; but the principle remains the same.

The **Sinar P** is the most highly-perfected studio apparatus marketed today. The manufacturers have concentrated on eliminating the errors that can creep in the use of swinging and rising movements. With the conventional movements, there is the risk that certain combinations of positions lead to loss of overall focus on the transmitted image (fig. 1) because the distance on the focal plane obviously changes. To correct this, the **Sinar P** makes use of convex segment moving on a concave track, which allows the least possible change in focus when making these movements. (H) shows the ideal focusing position which (fig. 2) changes least in this modification which keeps the distance of the lower third of the screen as constant as possible.

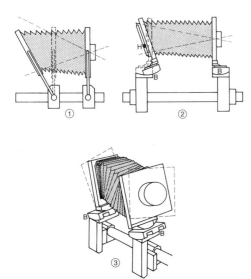

The colour plate following shows how these ▷▷ movements can make an egg round.

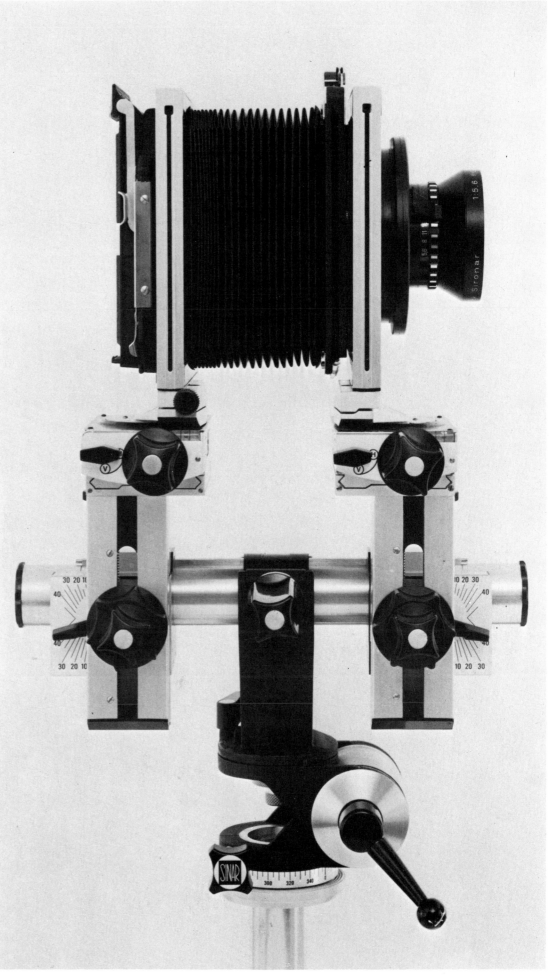

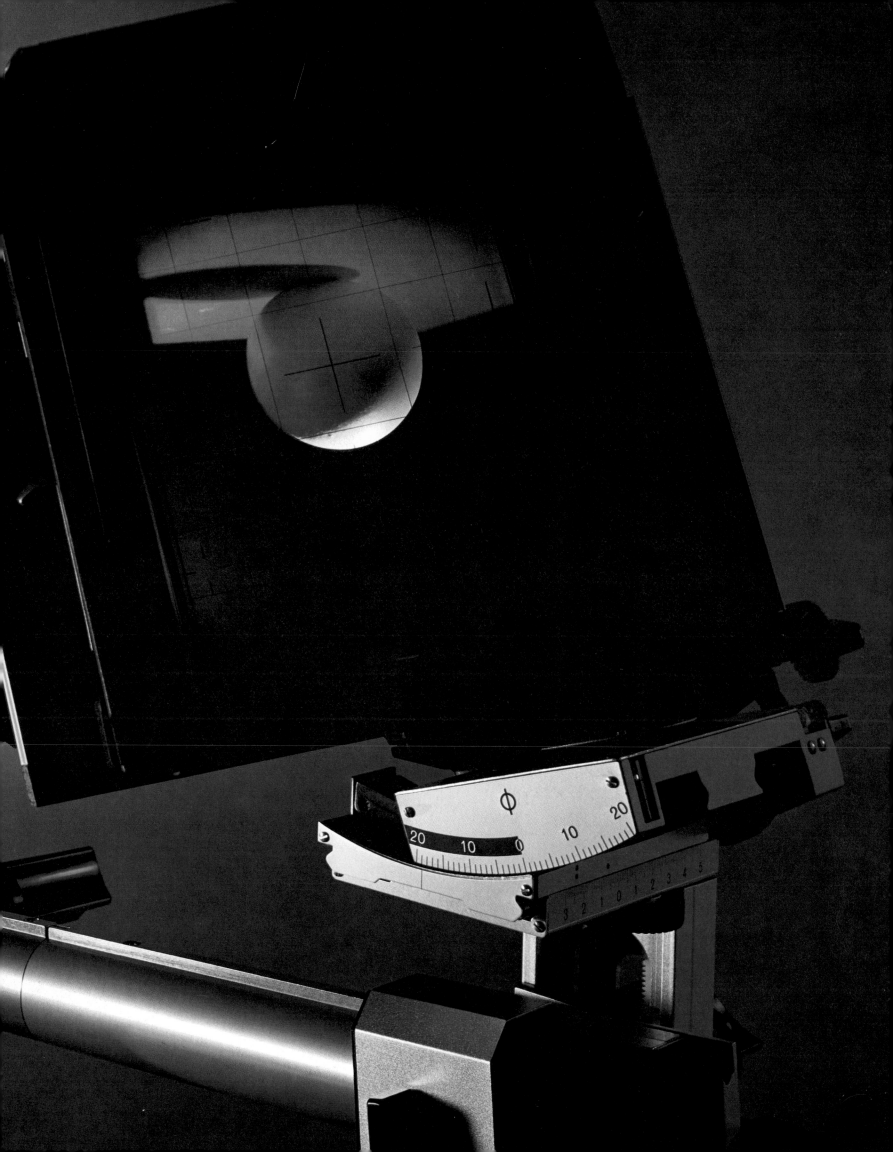

FIELD CAMERAS

The first photographic sorties into the countryside were rightly called "expeditions"! The operator took the field accompanied by one or more helpers to carry his equipment and keep spectators at bay; so "field camera" is the name given to portable stand cameras for outdoor use.

The Giroux sliding box-camera was a little cumbersome, although Daguerre and Talbot both used it for landscape work. The first true landscape outfit, perhaps, was announced by a keen French amateur, Baron Pierre Armand Séguier (1803-1876) in November, 1839. His camera had two sets of bellows, opening forwards and backwards from a central body, the lens was reversible for storage and when folded the camera took its place in a larger box containing all the paraphernalia for sensitizing and developing Daguerreotype plates. A tripod was provided complete with canvas cover to make it into a dark tent. All this may be seen on page 67. The main trouble was instability; in strong winds it was liable to blow away. Improved, one-piece bellows were designed by Humbert de Molard, and rack focusing, introduced by the Paris optician Chevalier in the lens he named *Le photographe à verres combinés* made life much easier. An alternative to leather bellows was devised by Thomas Ottewill, of Islington, early in the wet-plate period (1853), and described by Lewis Carroll (who owned one) in the 'Hiawatha's Photographing' written in 1857:

'From his shoulder Hiawatha
Took the camera of rosewood,
Made of sliding, folding rosewood;
Neatly put it all together,
In its case it lay compactly,
Folded into nearly nothing;
But he opened out the hinges,
Pushed and pulled the joints and hinges,
Till it looked all squares and oblongs,
Like a complicated figure
In the Second Book of Euclid.
This he perched upon a tripod...'

Considering Daguerre's camera too heavy and cumbersome, Baron Séguier drew up plans for the world's first bellows camera in October 1839. The turntable tripod when draped with a cloth became a dark-tent. The chest (2, on right) held everything the Compleat Daguerreotypist required: note the mercury dish and spirit lamp for developing.

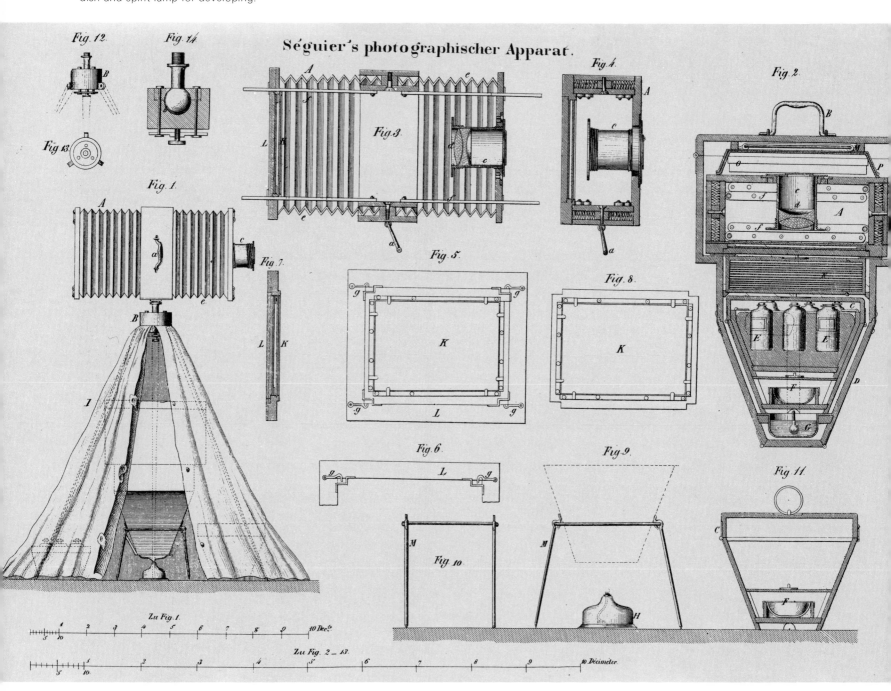

Séguier's photographischer Apparat.

Another folding-camera man was J. Fleury-Hermagis, whose advertisement is on page 71.

The two systems, leather bellows and folding woodwork, alone and in combination, set the pattern for field cameras. Most of them closed by means of a flap or baseboard which, when open, carried slides for the front standard. Designers were about equally divided as to whether the bellows should push forward or backwards for folding. Their dilemma can be judged by comparing the Tourist on page 77 with the camera on top of page 74. To fold the first, one would release the struts holding the baseboard, push the bellows back into the body and lift the front flap. The lens being small it goes into a recess in the baseboard; if larger it would have to be taken off. The camera is now folded flat but its back is constituted, very vulnerably, by the ground-glass screen. Now let us look at the second. To fold this one, the bellows are run forward on their rails until the body touches the lens panel; it now clears a hinge in the base, which is lifted up like the tailboard of a truck, so that it covers the focusing screen. Collectors call this a tailboard camera. The lens stays in place or may be removed for safekeeping, and the screen is protected.

Tailboard cameras suffer less from instability and vibration than those in which bellows and front standard move forward. Designers of the other form gave much thought to clamping the front standard. Vertical tie-rods, introduced by George Hare in 1882, worked well only if rails and baseboard were very substantial; Lancaster braced the front by means of a horizontal tie-rod threaded at both ends. L-braced fronts helped and Shew's wooden struts made a solid, compact job for the ordinary tourist. But photography to many was a serious business, especially those interested in architectural subjects, and for those workers neither struts nor tailboard sufficed. They wanted 'movement'. Not simply a rising lens panel to cut out foreground and bring church towers into the picture, but tilt and swing for more complicated perspective adjustments, as for example when set up in the nave of a church with a font close by on the left and a tall reredos forty feet away. No camera coped better with such problems than Frederick Sanderson's classic design, with its four-strut front, formidable extension and provision for wide-angle lens—virtually all the movements of a modern technical camera. Early field cameras had no need of a shutter. Having composed his picture on the screen, his head under a black cloth, the operator withdrew the screen and inserted a dark slide. He then stopped the lens down to working aperture, and placed a cap over the lens. With the pull-out removed from the dark slide he uncapped the lens, timed his exposure and put the cap back, replacing the pull-out. He might use a bulb and flap shutter, but there was really no need in time-exposure days.

'A most ingenious toy....' but was it ever built?

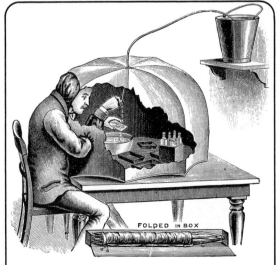

Collodion wet-plate cameras cropped up in the most unlikely places: Roger Fenton covered the Crimean War, David Livingstone took one to Darkest Africa—exploits which make mere mountaineering seem positively tame.

Paraphernalia contained in the tent/laboratory.

The Gentleman's Photo-Brolly, or Amateur Photographer's *Vade Mecum*. Note water supply by bucket and siphon.

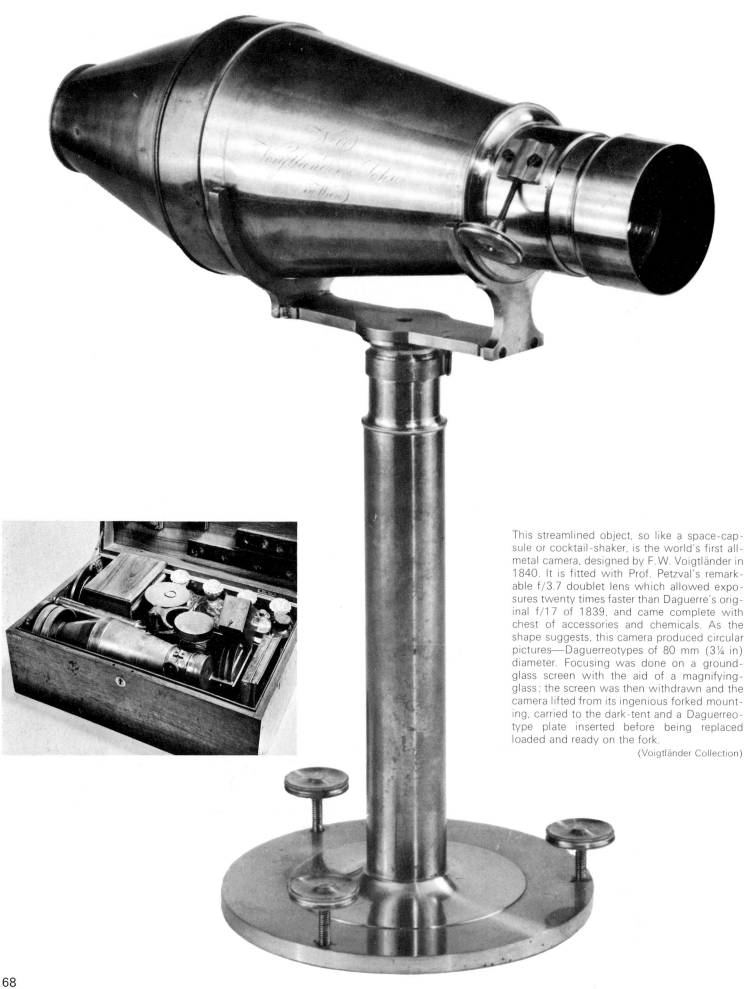

This streamlined object, so like a space-cap-sule or cocktail-shaker, is the world's first all-metal camera, designed by F. W. Voigtländer in 1840. It is fitted with Prof. Petzval's remark-able f/3.7 doublet lens which allowed expo-sures twenty times faster than Daguerre's orig-inal f/17 of 1839, and came complete with chest of accessories and chemicals. As the shape suggests, this camera produced circular pictures—Daguerreotypes of 80 mm (3¼ in) diameter. Focusing was done on a ground-glass screen with the aid of a magnifying-glass; the screen was then withdrawn and the camera lifted from its ingenious forked mount-ing, carried to the dark-tent and a Daguerreo-type plate inserted before being replaced loaded and ready on the fork.

(Voigtländer Collection)

Charles Chevalier, the Paris optician, called this camera his **Grand Photographe**. The body, built of mahogany and satinwood, was made to fold for easy stowage, and focusing was by a single knurled screw, engaging with a rack inside the camera. The doublet lens, which Chevalier named *Le Photographe*, provided a choice of two focal lengths, for landscape work or close-ups: the front element acted as what we should now call a portrait-attachment. Depth of focus could be increased by using a simple stop behind the front lens; a correcting prism was also supplied, so that portraits parted their hair on the proper side. Contrasted wood and brassbound corners make this an extremely handsome piece of equipment. On the left a mercury-vapour developing-chest, and a fitted box for plates.

(Conservatoire des Arts et Métiers, Paris)

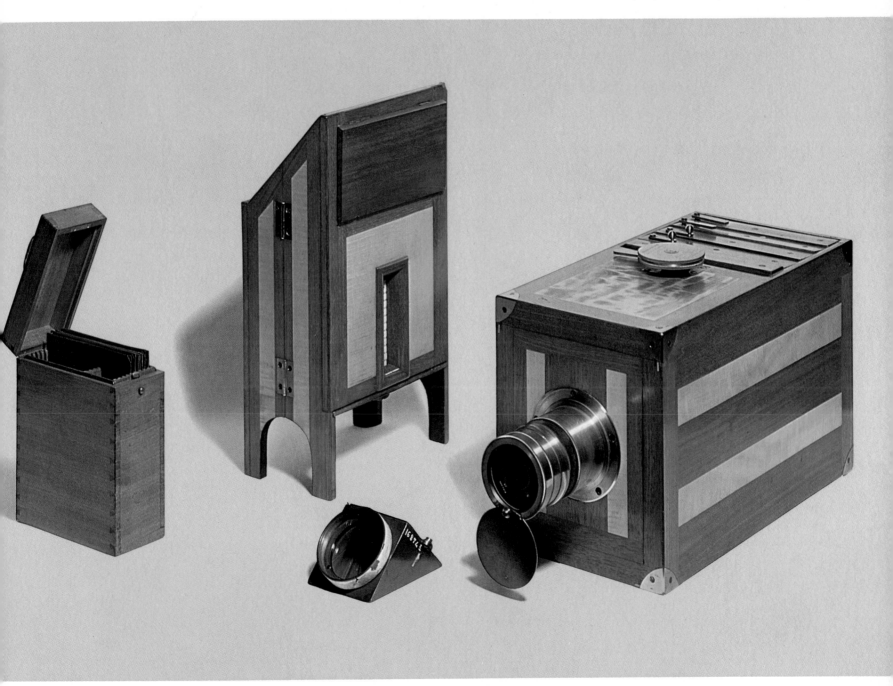

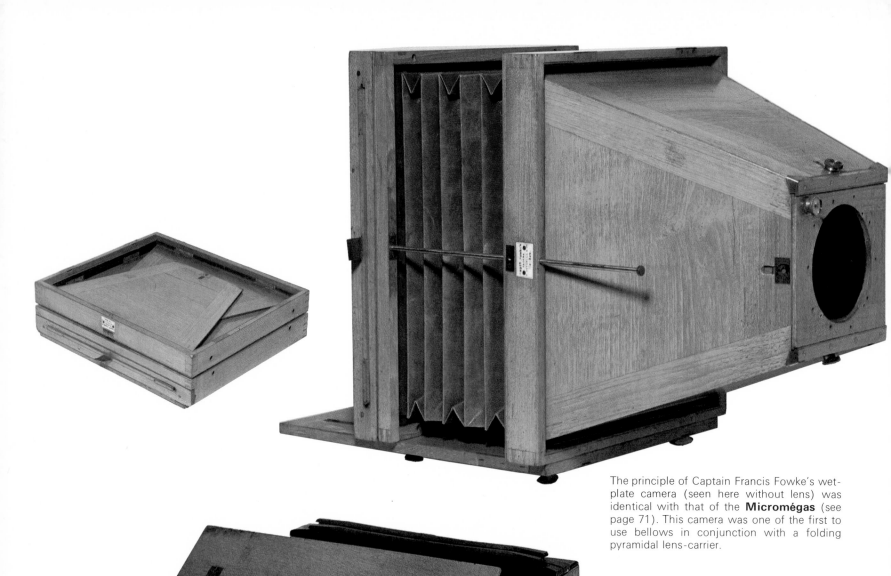

The principle of Captain Francis Fowke's wet-plate camera (seen here without lens) was identical with that of the **Micromégas** (see page 71). This camera was one of the first to use bellows in conjunction with a folding pyramidal lens-carrier.

T. Ottewill & Co. brought out this sliding-box folding camera for 10×8 in wet plates in 1853 specially for use in the field. It was popular for landscape work until superseded by bellows types. With lens panel and focusing screen removed the sides of the two boxes folded inwards, making a package only 21 in×13 in×3 in. The lens panel is arranged to slide vertically and horizontally 'for sky and foreground adjustments', an early use of rising and cross front. The lens fitted is a Shepherd *carte de visite* of later date.

(Science Museum, London)

The advertisement extols the virtues of the Hermagis All-wood
Micromégas 8×10 cm folding/field camera whose specification
included a rising front and wide-angle aplanat in helical focusing
mount, although the camera illustrated has a 120 mm Dubroni.
Accessories included folding alpenstock/tripod and optical wedge
exposure-meter (6). When folded with lens removed the camera
was less than two inches (4 cm) thick. French patent No. 107064,
4 March 1875.

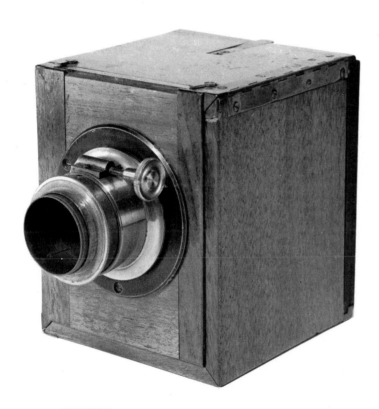

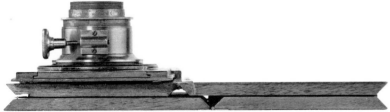

NOUVEL APPAREIL PHOTOGRAPHIQUE ᴮᴿᴱᵛᴱᵀᴱ S. G. D. G. POUR TOURISTES

DE

J. FLEURY-HERMAGIS

OPTICIEN BREVETÉ S. G. D. G.

MÉDAILLÉ A TOUTES LES GRANDES EXPOSITIONS, FOURNISSEUR DES MINISTÈRES DE LA GUERRE
ET DE LA MARINE, DE L'IMPRIMERIE NATIONALE, DE LA PRÉFECTURE, DES ÉCOLES
RÉGIMENTAIRES, DU GÉNIE ET DE TOUS LES PHOTOGRAPHES ET AMATEURS DE MÉRITE

18, Rue Rambuteau, Paris

Adopté par l'élite des Amateurs et des Photographes, par nombre d'Artistes-Peintres,
Membres du **Club Alpin** *et de l'* **Alpin Club**, *par la Mission scientifique*
du **Muséum** *au* **Gabon**, *etc., etc.*

Médaillé à l'**Exposition fluviale** et **maritime de Paris 1875**.

LÉGENDE ET DESCRIPTION

1. Pied-canne à 3 branches fermé, servant au
Touriste de bâton de montagne, avec picot
d'acier, à l'épreuve du rocher.

2. Pomme de ce pied, dont la vis sert à fixer
solidement la chambre sur son pied et à rele-
ver, au besoin, par un fil à plomb, les sta-
tions géodésiques.

3. Chambre tout en bois, ouverte et montée, mais
pouvant s'aplatir, étant fermée, comme le
montre en coupe la figure **8**, grâce à ses plan-
chettes taillées en onglet et articulées à 4 char-
nières d'une seule pièce (équerre parfaite).

4 et 7. Objectif aplanétique à grand angle pour
vues et portraits, monture en nickel inoxy-
dable, à coulant hélicoïdal, permettant la
mise au point à toute distance, et suppri-
mant le soufflet branlant des chambres

ordinaires. La planchette, sur laquelle cet
objectif est monté, est munie d'une vis à
décentrer évitant les déformations dans les
monuments, quand on ne peut s'élever
jusqu'au milieu de leur hauteur. L'obtura-
teur porte avec lui l'étui à diaphragmes.

5. Trou pour introduire la vis de la pomme du
pied quand on veut fixer la chambre dans
l'autre sens et opérer en largeur plutôt qu'en
hauteur.

6. Photomètre à prisme d'HERMAGIS, pour appré-
cier exactement la durée du temps de pose.

8. La chambre, vue en coupe et fermée, moitié
moins épaisse que le seul charriot de la plus
mince Chambre à soufflet.

9. Sac élégant de Touriste, contenant tout l'ap-
pareil.

71

Calotype paper and a contact obtained from it. Printing was done in the open air by direct sunlight. Photographer unknown, about 1850.

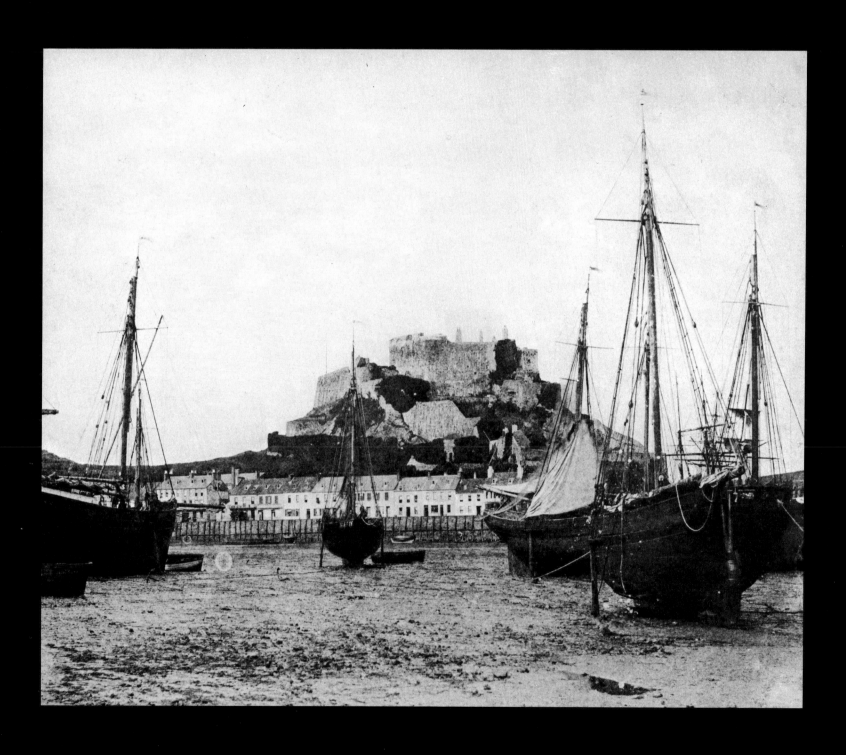

English travelling camera on the sliding-box system, focused by moving the back. It has a meniscus lens by Lerebours, Paris, about 1860. (Science Museum, London)

Jonte's **Photo-Revolver** of 1872. Built on the lines of a 'six-shooter', this was an early example of magazine camera. As on J.B. Dancer's stereo-camera of 1856, plates were changed by means of rods which screwed into the top of the plate-holder, as shown in the sketch. The lens is lacking.

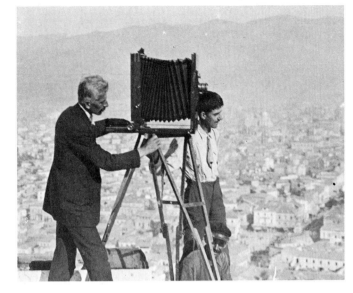

Strong nerves and calm weather were needed for this sort of thing. Fred Boissonnas of Geneva uses a large camera for close-ups of the Acropolis in 1913. He survived, dying aged 89 in 1947. Fine detail demanded big negatives; enlargement was not yet very satisfactory.

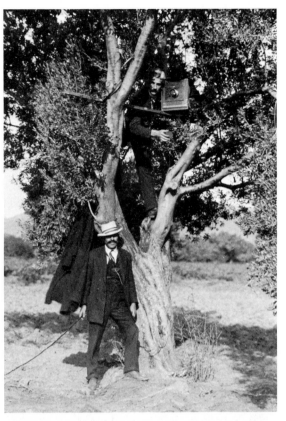

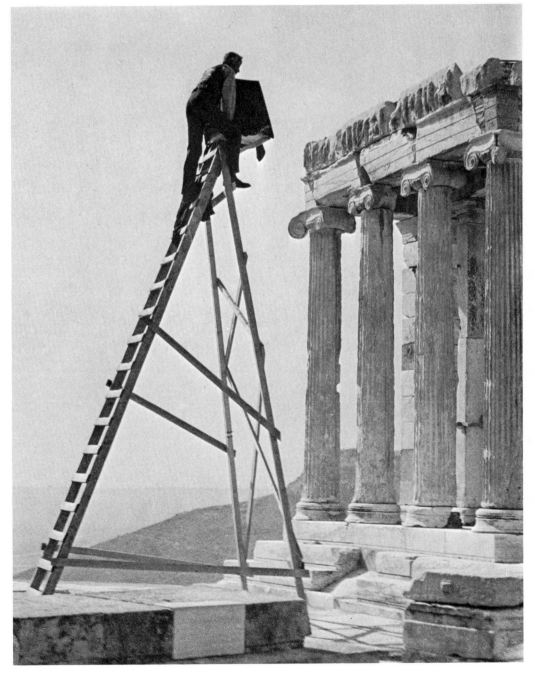

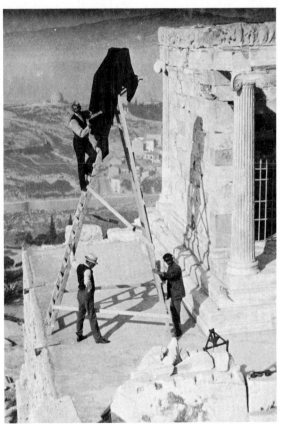

The **Fin de siècle** changing-box camera invented by Aïvas and Chauvet (French Patent No. 220262 of 19 March 1892). The plate-changing arrangements are shown in the sketch. Format 9×12 cm; 150 mm f/8 'rapid rectilinear' lens. Another model of the same name, a 13×18 cm travelling camera by S. Schaeffner, is mentioned in the *Annuaire de la Photographie*, 1898.

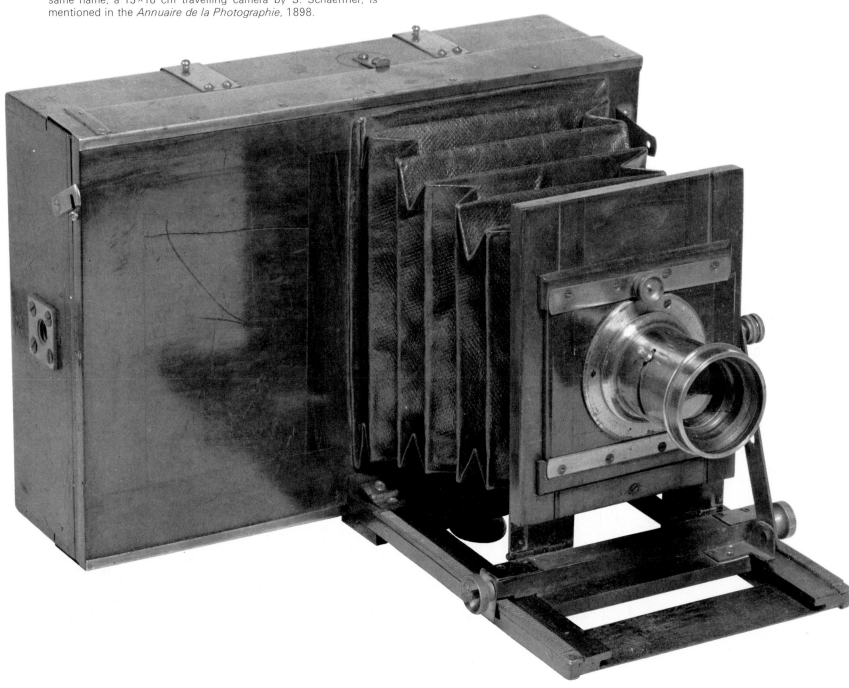

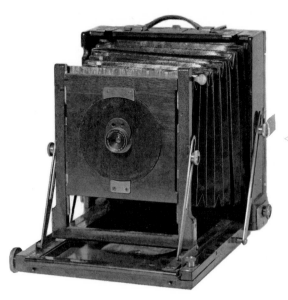

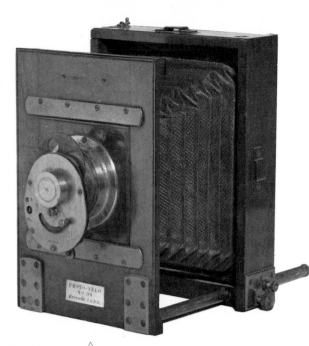

According to *La Nature* for 14 September 1889 the **Express-Nadar** could be had in formats 13×18, 18×24, 24×30 and 30×40 cm; it was beautifully constructed in brass-bound mahogany. Architectural subjects would seem to have been in the designer's mind, for he has provided a rising lens panel and tilting front. The reversing back gives a choice of 'portrait' or 'landscape' format. This model is the 13×18 cm with an 86 mm wide-angle f/18 Zeiss anastigmat and rotating stops.

Le Touriste with drawer magazine by Enjalbert patented in France on 19 February 1880, No. 135186. A spring-loaded knob retained the plate being exposed, allowing the rest to slide with the drawer. As the distance from lens to plate varied, focus had to be adjusted before each exposure.

Designed during the cycling craze of the 1890s when bicycle tours and amateur photography appealed to the same type of person, the **Photo-Vélo** came in three sizes, taking pictures 9×12, 9×18 and 13×18 cm. This model, advertised in *La Nature*, 1892 is the 9 cm×12 cm (quarter plate) with meniscus lens, rotary stops and lens cap. The bellows move by means of a pinion engaging with two rack rods in the baseboard. A lens cap was necessary because the shutter admitted light while it was being cocked, i.e. it was not 'self-capping'.

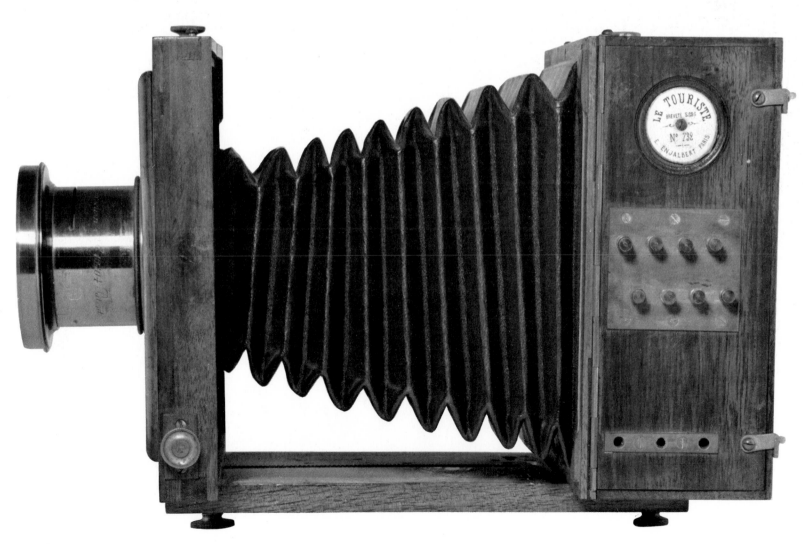

To several generations of British photographers F.H. Sanderson's beautiful brassbound mahogany or teak creations were the archetypal camera, an instrument that would meet any of the demands made upon a stand camera and meet them supremely well. This example has the later form of wood-framed front, unlike earlier models, commencing with the 1895 patent, in which the outer front arms were of brass like the inner pair. These two pairs of arms provided every movement conceivable: rise, fall, tilt and swing. The back also would tilt or swing, while the front would be 'outrigged' to the full extent of its arms, giving extra length in addition to the triple extension provided. This camera is fitted with a Swiss lens, a 6-in Suter. It also has Sanderson's 'tall-body' feature: the back is oblong rather than square, to accommodate the bellows when full rise of front is required. Quite a few Sandersons are still in professional use, although gradually being superseded by modern monorail technical cameras.

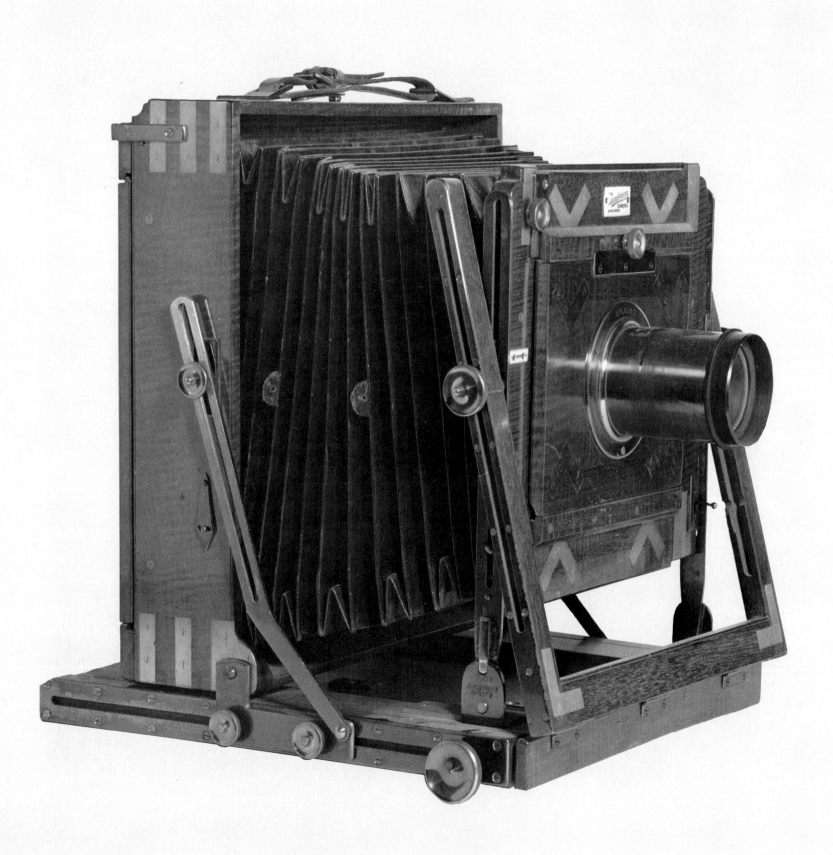

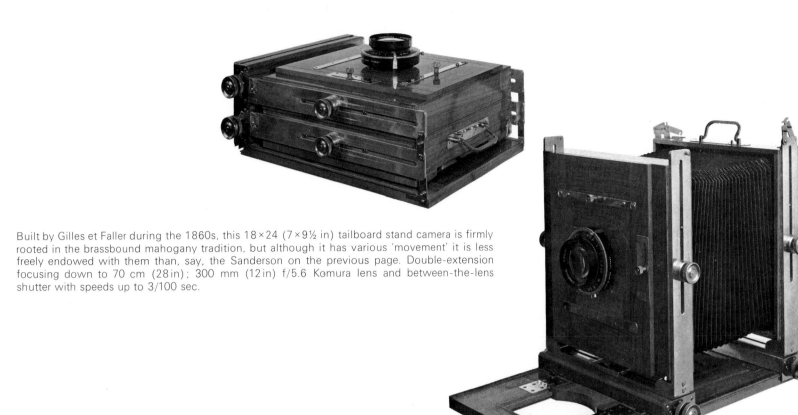

Built by Gilles et Faller during the 1860s, this 18×24 (7×9½ in) tailboard stand camera is firmly rooted in the brassbound mahogany tradition, but although it has various 'movement' it is less freely endowed with them than, say, the Sanderson on the previous page. Double-extension focusing down to 70 cm (28 in); 300 mm (12 in) f/5.6 Komura lens and between-the-lens shutter with speeds up to 3/100 sec.

Built in Chicago for George R. Lawrence in 1900 specially for photographing trains of the Chicago & Alton Railroad, this enormous camera called **The Mammoth** is probably the largest ever made. It measured 20 feet (6 m) when extended, weighed 1,400 pounds (620 kg) and took glass plates 8 ft × 4 ft 6 in (130×240 cm). A crew of 15 men was required to operate it. ▽

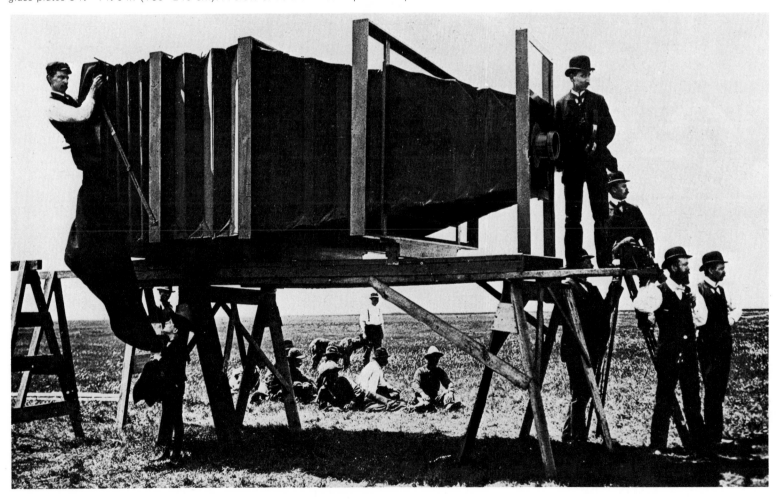

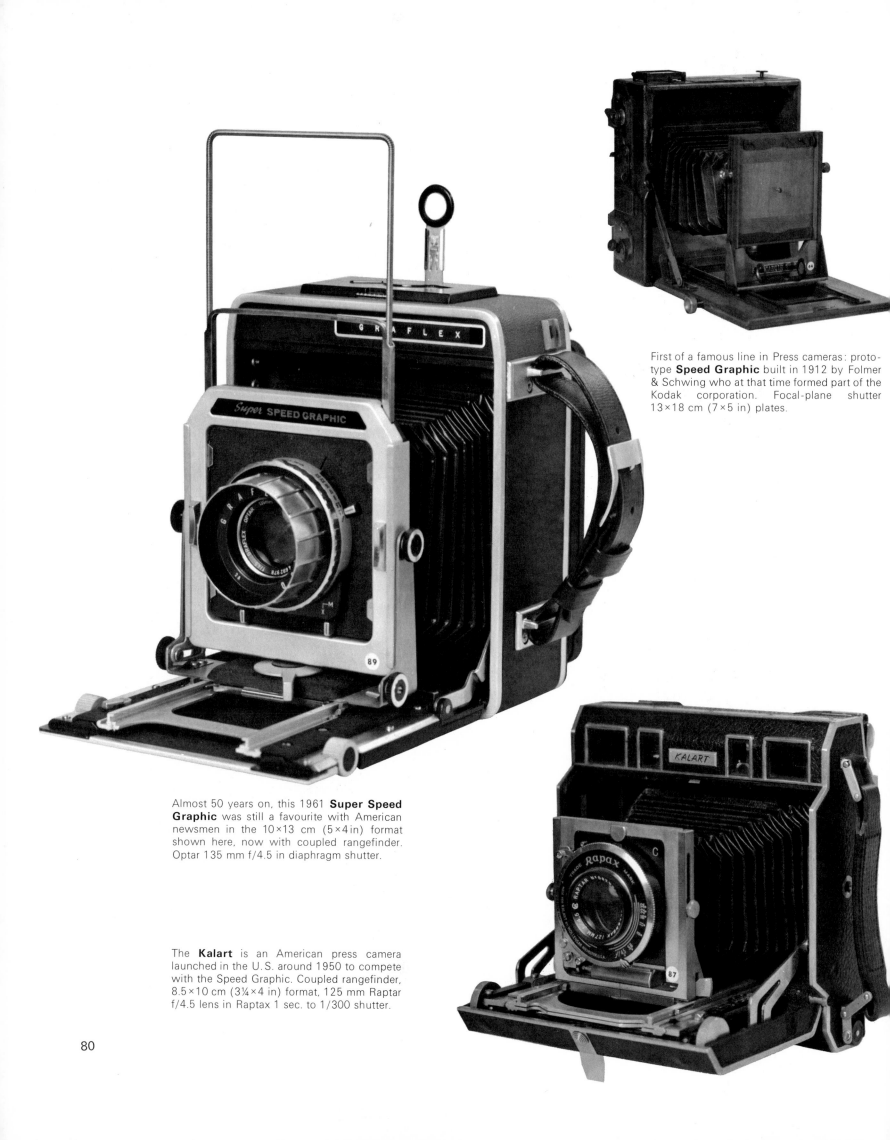

First of a famous line in Press cameras: prototype **Speed Graphic** built in 1912 by Folmer & Schwing who at that time formed part of the Kodak corporation. Focal-plane shutter 13×18 cm (7×5 in) plates.

Almost 50 years on, this 1961 **Super Speed Graphic** was still a favourite with American newsmen in the 10×13 cm (5×4 in) format shown here, now with coupled rangefinder. Optar 135 mm f/4.5 in diaphragm shutter.

The **Kalart** is an American press camera launched in the U.S. around 1950 to compete with the Speed Graphic. Coupled rangefinder, 8.5×10 cm (3¼×4 in) format, 125 mm Raptar f/4.5 lens in Raptax 1 sec. to 1/300 shutter.

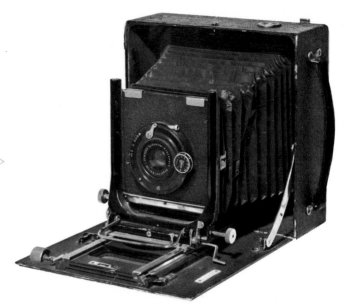

This early **Technika Linhof** 13×18 cm (7×5 in) plate camera can be dated 1912 from the ▷ catalogue of Wachtl, Vienna. Rising and tilting front, revolving back. The baseboard may be lowered when used with wide-angle lenses; the lens here is not the original.

This newcomer to the Linhof range is a **Super Technika V**, combining the advantage of portability with those of a 13×18 cm (7×5 in) monorail technical camera. It is here seen demonstrating most of the possible 'movements': rising and tilting front, forward and backward extensions, revolving, tilting and swing back. These very robust instruments are manufactured by Niklaus Karpf AG, Munich. This one is wearing a 210 mm f/5.5 Symmar in 1 sec. to 1/200 Compur shutter.

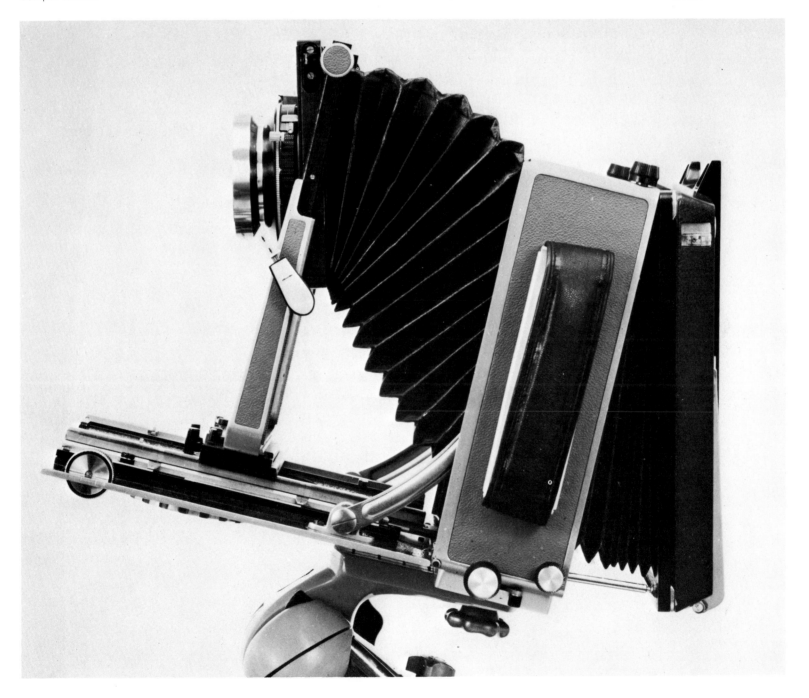

CAMERAS IN DISGUISE

In days when 'camera' to most people meant a sort of dog-kennel on stilts it was easy to deceive. Nothing not actively brassbound and bebellowsed would send bathing-belles into hiding or cause a crowd to collect. When, therefore, during the 1880s gelatine bromide dry plates and the Eastman-Walker roller-slide brought photography out of the lab and into the parlour the trade was ready with discreet apparatus for the photo-fiend: 'detective' cameras aimed at the amateur sleuth—all those eager to identify with Sherlock Holmes, Dr Watson or Arsène Lupin. Two strains quickly emerged, which can be classified (since we have undercover work in mind) as Plain Clothes and Fancy Dress. The former have a chapter to themselves (page 115) and also crop up amongst the Miniatures; the latter have taken many forms, workaday, practical, zany and frivolous.

As we thumb through this present section a spectre begins to take shape. We become obsessed by Photographic Man armèd cap à pie with hidden lenses. Nothing about him is quite what it seems nor, we realise, of a style and cut of which Jeeves would approve—but then the aim is clandestine art, not sartorial perfection or good manners. It should not surprise us if the fellow stares a lady in the face instead of removing his hat, because he yearns for her picture and that bowler has a camera inside. Next time round he may doff his billycock and hold it against his chest, breathing deeply to adjust the angle. Only desperate longing would drive him to remove his topper, screw it to a walking-stick, and peer into the telescopic lining like the personage on page 87. Beneath that waistcoat there may be a heart of gold, but it's even money he is wearing Stirn's patent camera with its lens through one of the buttonholes, and that the outrageous spotted four-in-hand came from High Holborn rather than Burlington Arcade, which would explain the perfidy of those polka dots. The fellow's very belt holds a hidden camera; who knows, perhaps even his braces...

It is doubtful whether serious photography could be had from such toys or from most of the cameras disguised as books, even though Bloch's Photo-Bouquin Stereoscopique of 1904, retaining the appearance of a plain pocket dictionary, did have an achromatic lens made

No well-dressed spy should be without one. The **Photo-Cravate** invented by Edmond Bloch, a Parisian (naturally), made by Charles Dessoudeix in Paris and introduced to the Société Française de Photographie by M. Londe on 5 December 1890. The instrument itself measured 10×80×10 cm and weighed 300 grammes, i.e., about 10½ ounces, and carried six plates rather smaller than a postage stamp (23×23 mm). A pneumatic bulb hidden in the palm of the hand was used to release the everset metal diaphragm shutter. The illustration shows front and back views of the camera; on the left the six plate-holders are plain to see, on the right cravat, lens, bulb release and tube.

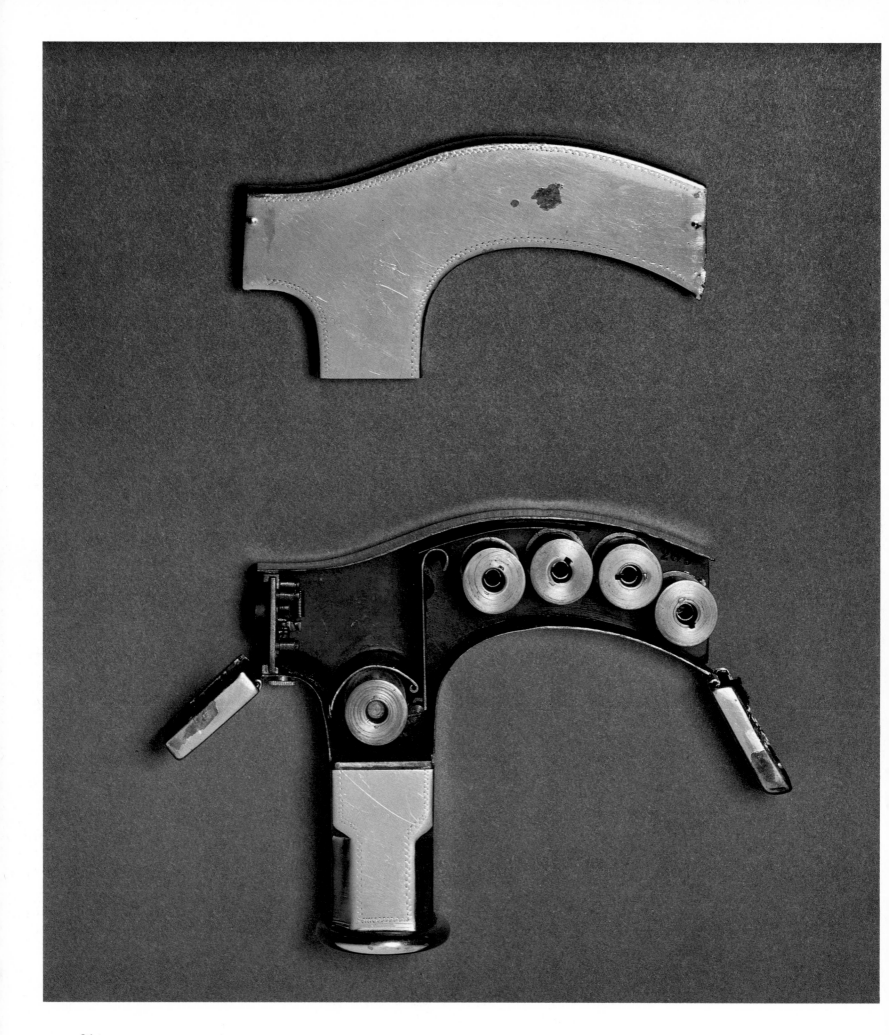

Edwardian walking-sticks were not always what they seemed: there were sword-sticks, tipsy-canes with flask for secret drinkers— even camera-canes for secret snappers.

The **Ben Akiba** photographic cane, invented by Kronke and manufactured by A. Lehmann of Berlin was patented in France on 3 June 1903, No. 322264. A camera in the handle took roll film, with six 16×20 mm exposures on a roll, and there was room for three spare spools.

from new-fangled Jena glass. The fun lay in snapping away unperceived, stealing pictures like the *papparazzi* of today. Probably the best early clandestine cameras were those disguised as binoculars, especially Goerz instruments (p. 96) which had proper optical equipment. Some binoculars even took pictures at right-angles to the apparent field of view.

Most of the time, though, photographers found anonymity an advantage, if not actually on site at least on the way there. An unobtrusive bag like Lancaster's Detective Camera or the similar bag by Kauffer, Paris (p. 88) would pass freely through a crowd even though it might look incongruous on a tripod. This particular apparatus was a 9×12 cm, Continental equivalent of quarter-plate, and hence quite a practical affair. The same could not be said of some fancy-dress cameras, like the Ticka and Lancaster watch cameras, the matchbox on page 107 and the Demon outfit (p. 91) which, the advertiser states, surrounded the explorer H. M. Stanley on his arrival in London. They all took tiny pictures which would hardly have enlarged satisfactorily with the equipment then on the market. This was the bane of miniature negatives until good fine-grain film and developers appeared during the 1930s.

Gun forms were a natural for the camera maker. There can hardly be a more collectable item than the dry-plate repeating rifle/camera with which Messrs Sands & Hunter beguiled the London public in 1885, all resplendent in walnut and brass. Prices were high and sales disappointing—the shape appealed only to shooting men and no sportsman would dream of pointing guns at people. Perhaps the same applied to Enjalbert's Photo-Revolver although not to the Thompson, the Krauss or Darier's delightful folly called a blunderbuss—*escopette*.

Pistols we have, cigarette-lighters we have, telescopes and vanity-cases too. But what of those which await some collector's discovery? A Photographic Tankard must exist, and can we escape the 35 mm Gardeners' Photo-Trowel and a Trani-Cam radio, tape recorder with cassettes for sound and film? Are there no sauce-bottle cameras, no lens-holder Teddy Bears? Best of all would be The Child-Photographer's Friend: a camera and cuckoo-clock combined, its dickie-bird working the shutter.

Cross-sectional view of the **Chapeau photo-graphique,** dream-child of two Viennese mad hatters K.F. Jekeli and J. Horner (Swiss Patent No. 3086 of 24 January 1891). To make an exposure the wearer doffed his hat (since the lens was in the crown), pulled out the rear extension, inserted a plate holder, withdrew the dark slide and set the shutter. The hat was aimed imaginatively from chest level, there being no view-finder. Format depended on one's size in hats: 8.5×10 up to hat- size 56 and 9×12 for the broader brow.

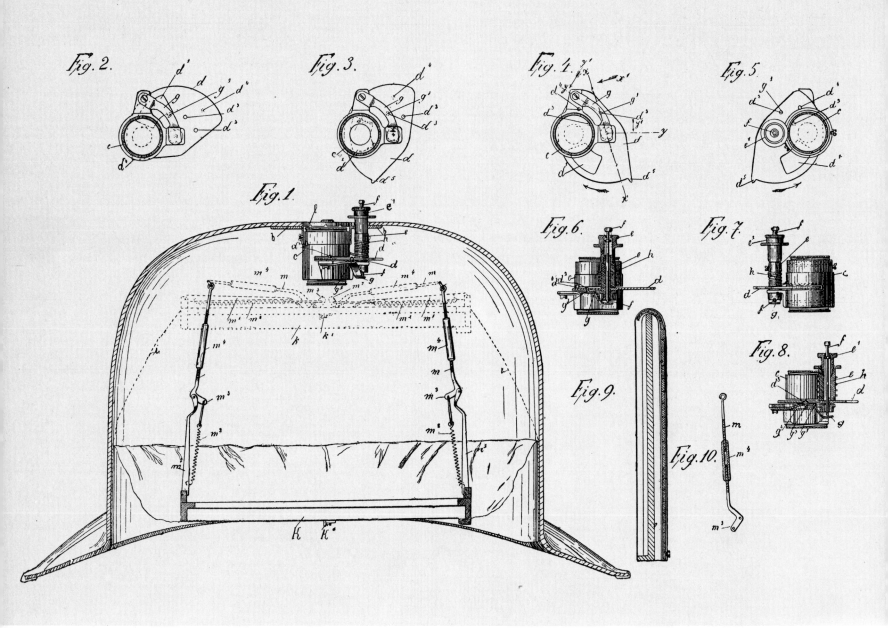

M. J. de Neck should perhaps have invented a candid cravat (pages 82-83); instead he planned this **Photo-Chapeau**, described in Dr J.M. Eder's *Photographie Instantanée*, published in 1888. The hat contained a small camera taking 5×5 cm (2 in) plates and did not have to be taken off; the wearer simply directed his gaze and pulled a string. For plate-changing and shutter setting the camera was let out of the hat.

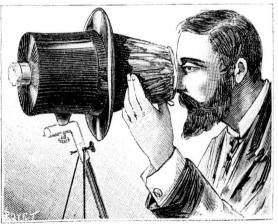

The camera for formal wear.

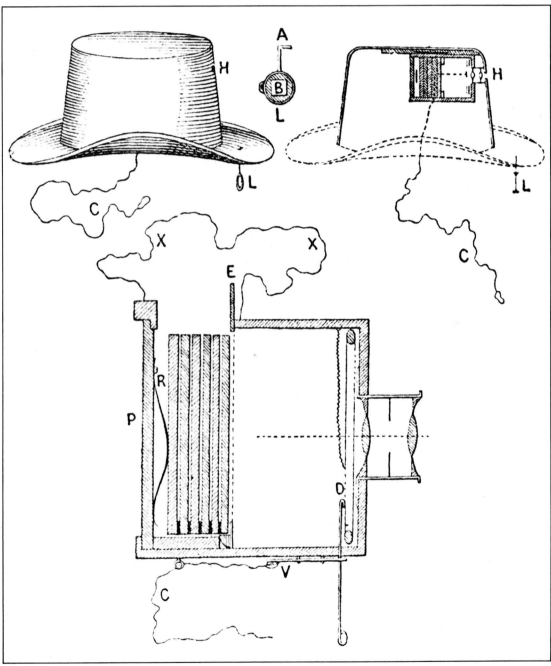

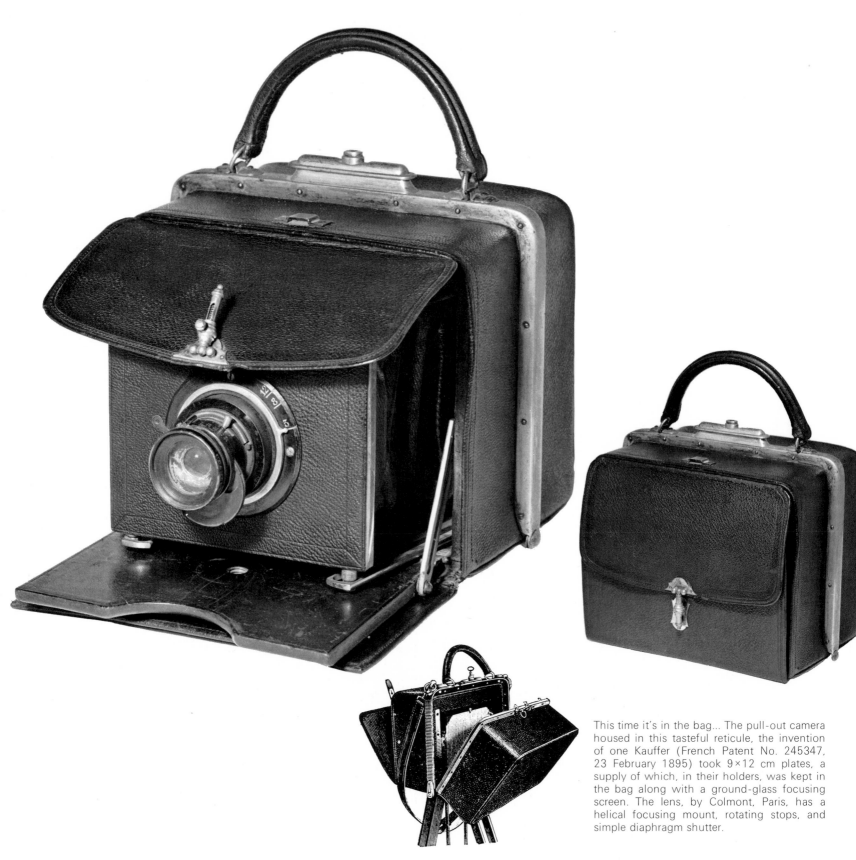

This time it's in the bag... The pull-out camera housed in this tasteful reticule, the invention of one Kauffer (French Patent No. 245347, 23 February 1895) took 9×12 cm plates, a supply of which, in their holders, was kept in the bag along with a ground-glass focusing screen. The lens, by Colmont, Paris, has a helical focusing mount, rotating stops, and simple diaphragm shutter.

Beauty-Case. Besides glamour-goo and looking glass this dangerous item housed an Ansco box-camera (c. 1926), its meniscus lens pointing through one end. The viewfinder is to the right, beside the carrying-handle, and the winding knob is underneath. Simple diaphragm shutter.

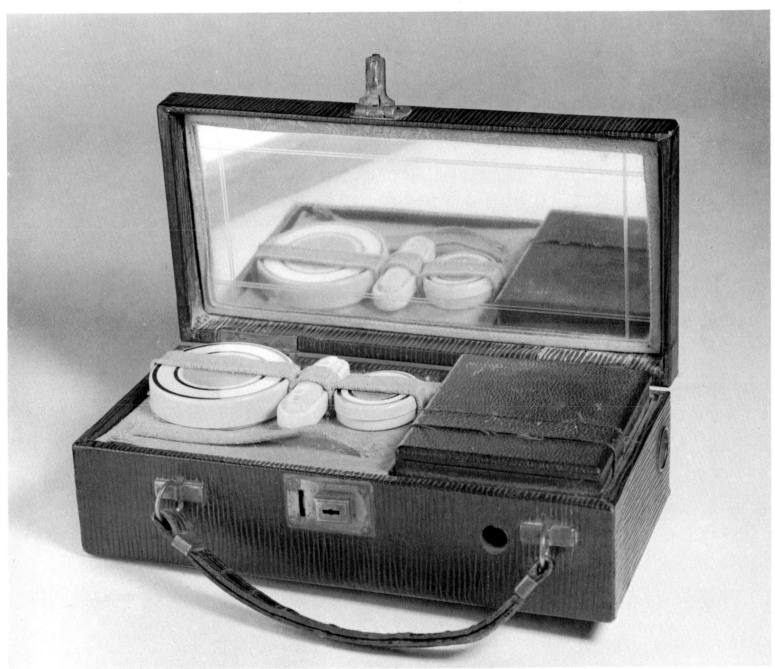

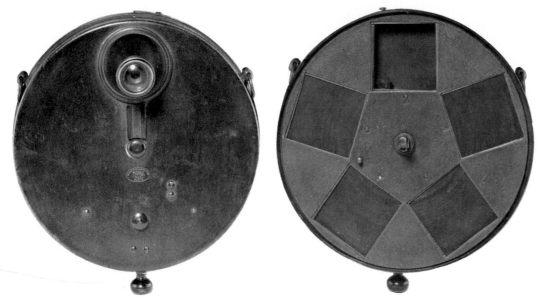

Very much the detective camera, this **Photo-Eclair** was invented and marketed by J. Fetter, Paris, (the patent No. 175615 dating from 1886). Worn inside a waistcoat, its lens disguised as a button, it took plates 38 mm square (say an inch and a half). The left-hand picture shows the jutting 40 mm f/8 rapid rectilinear ('aplanat') lens; on the right an interior view showing stowage for plates.

Stirn's detective camera was a variant of the **Photo-Eclair** by D. Gray of New York, taking six 40 mm (1⅝ inch) round pictures on a single 140 mm (5½ in) circular plate. It was patented in France (No. 177621) on 27 July 1886. The lens is a 40 mm f/10 aplanat, with rotary diaphragm shutter reset by the action of turning the plate.

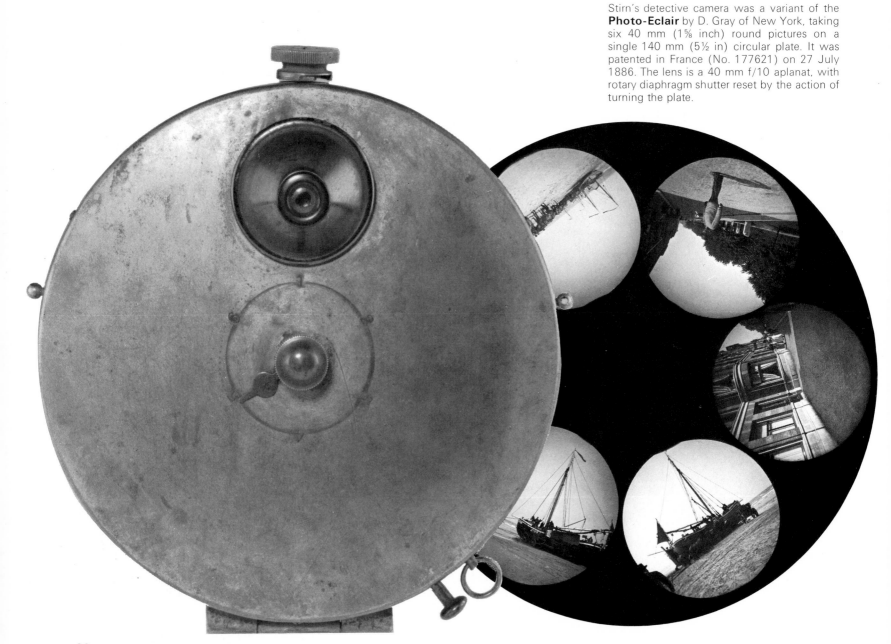

Crudely made of cardboard, the **Quint** was little more than a toy. As its name implies it took five pictures, of 4×5 cm. It has a small-aperture meniscus lens of some 90 mm focal length, with only a lens cap by way of shutter. The **Quint** was made in France, and described in *La Nature* for 7 October 1911.

The diagram above right shows how the plates, which are attached to the lid, are rotated by turning this until the exposed plate is opposite the lens.

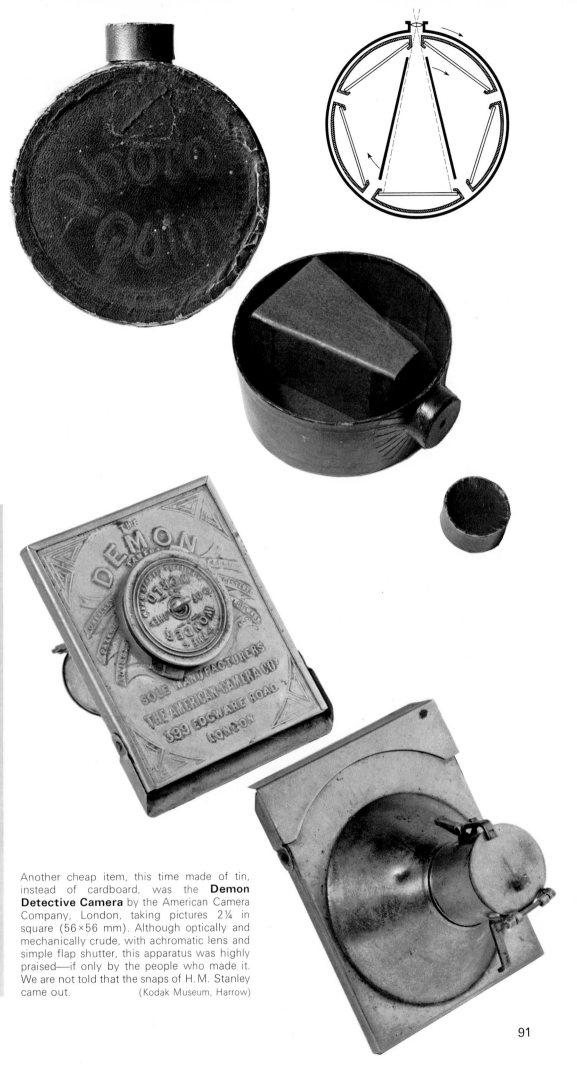

Another cheap item, this time made of tin, instead of cardboard, was the **Demon Detective Camera** by the American Camera Company, London, taking pictures 2¼ in square (56×56 mm). Although optically and mechanically crude, with achromatic lens and simple flap shutter, this apparatus was highly praised—if only by the people who made it. We are not told that the snaps of H. M. Stanley came out. (Kodak Museum, Harrow)

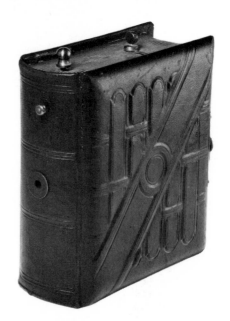

The Book camera (right, and below) carries no information about itself apart from a label stating that a German patent has been applied for; it is probably an example of Schaeffer's **Photo-Album**, 1893. The internal view shows the plate-holder and drop shutter.

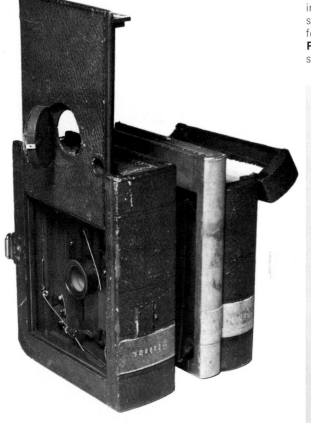

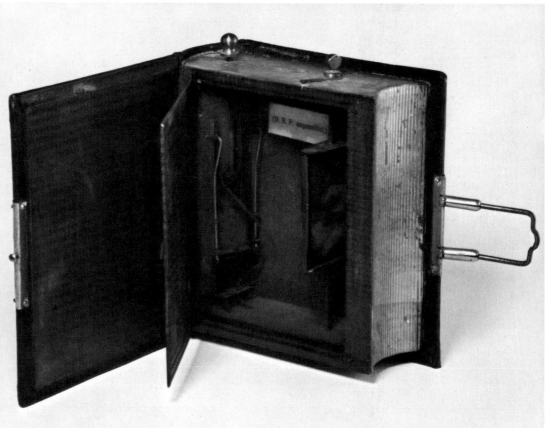

More sophisticated than others of its kind, this camera by the Scovill & Adams Co., New York, designed by Andrew Dobbs (U. S. patent 470783 of 15 March 1892) is a plate camera disguised as a row of books. It has bellows and a 3 in (75 mm) periscopic lens, with variable-speed guillotine shutter set by a cord. (George Eastman House, Rochester, N.Y.)

Plain-clothes cameras took many forms. Here is Dr Krugener's patent **Taschenbuch Camera** (notebook camera) as made by Haake & Albers, Frankfurt a. Main (French patent 188476, 1 February 1888). The apparatus took 24 40×40 mm (1⅝ in) plates, changed by pulling a knob. Rapid rectilinear lens, 60 mm, f/12. Double guillotine shutter.

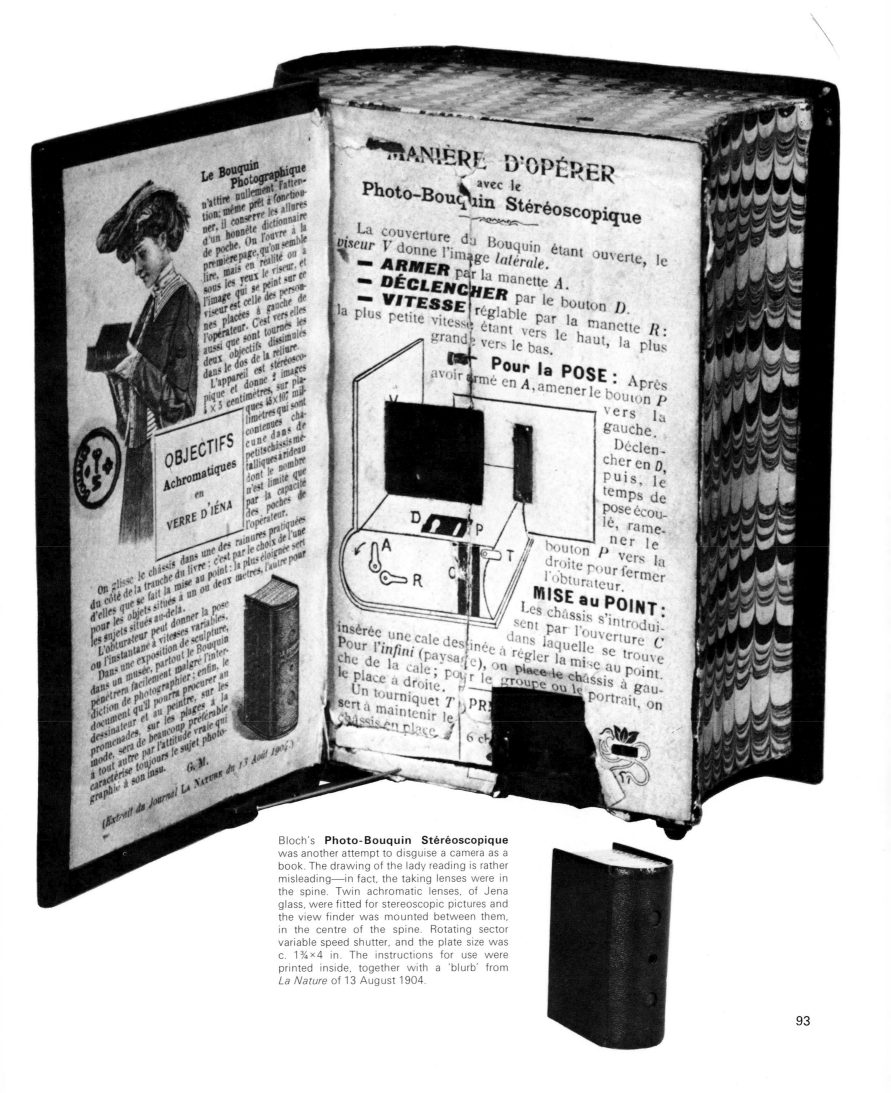

MANIÈRE D'OPÉRER
avec le
Photo-Bouquin Stéréoscopique

La couverture du Bouquin étant ouverte, le *viseur V* donne l'image *latérale*.

- **ARMER** par la manette *A*.
- **DÉCLENCHER** par le bouton *D*.
- **VITESSE** réglable par la manette *R*: la plus petite vitesse étant vers le haut, la plus grande vers le bas.

Pour la POSE: Après avoir armé en *A*, amener le bouton *P* vers la gauche. Déclencher en *D*, puis, le temps de pose écoulé, ramener le bouton *P* vers la droite pour fermer l'obturateur.

MISE au POINT: Les châssis s'introduisent par l'ouverture *C* dans laquelle se trouve insérée une cale destinée à régler la mise au point. Pour l'*infini* (paysage), on place le châssis à gauche de la cale; pour le groupe ou le portrait, on le place à droite.

Un tourniquet *T* sert à maintenir le châssis en place.

Le Bouquin Photographique

n'attire nullement l'attention; même prêt à fonctionner, il conserve les allures d'un honnête dictionnaire de poche. On l'ouvre à la première page, qu'on semble lire, mais en réalité on a sous les yeux le viseur, et l'image qui se peint sur ce viseur est celle des personnes placées à gauche de l'opérateur. C'est vers elles aussi que sont tournés les deux objectifs dissimulés dans le dos de la reliure.

L'appareil est stéréoscopique et donne 2 images sur plaques 45×107 millimètres qui sont contenues chacune dans de petits châssis métalliques à rideau dont le nombre n'est limité que par la capacité des poches de l'opérateur.

4 × 5 centimètres, sur pla-

OBJECTIFS
Achromatiques
en
VERRE D'IÉNA

On glisse le châssis dans une des rainures pratiquées du côté de la tranche du livre: c'est par le choix de l'une d'elles que se fait la mise au point: la plus éloignée sert pour les objets situés au-delà.

L'obturateur peut donner la pose ou l'instantané à vitesses variables.

Dans une exposition de sculpture, dans un musée, partout le Bouquin pénétrera facilement malgré l'interdiction de photographier; enfin, le document qu'il pourra procurer au dessinateur et au peintre, sur les promenades, sur les plages à la mode, sera de beaucoup préférable à tout autre par l'attitude vraie qui caractérise toujours le sujet photographié à son insu.

G.M.

(Extrait du Journal La Nature du 13 Août 1904.)

Bloch's **Photo-Bouquin Stéréoscopique** was another attempt to disguise a camera as a book. The drawing of the lady reading is rather misleading—in fact, the taking lenses were in the spine. Twin achromatic lenses, of Jena glass, were fitted for stereoscopic pictures and the view finder was mounted between them, in the centre of the spine. Rotating sector variable speed shutter, and the plate size was c. 1¾×4 in. The instructions for use were printed inside, together with a 'blurb' from *La Nature* of 13 August 1904.

La Jumelle de Goldschmidt, alias Goldschmidt's Binocular Camera, bore the name of its inventor, who came from Zurich (Swiss patent No. 1241 of 30 July 1889). One tube is a view-finder, the other takes the pictures, on 5×6 cm plates. The lens is an f/6.3 Steinheil 150 mm, with drop shutter.

The upper picture shows the Binocular ready for action; below, the changing muff.

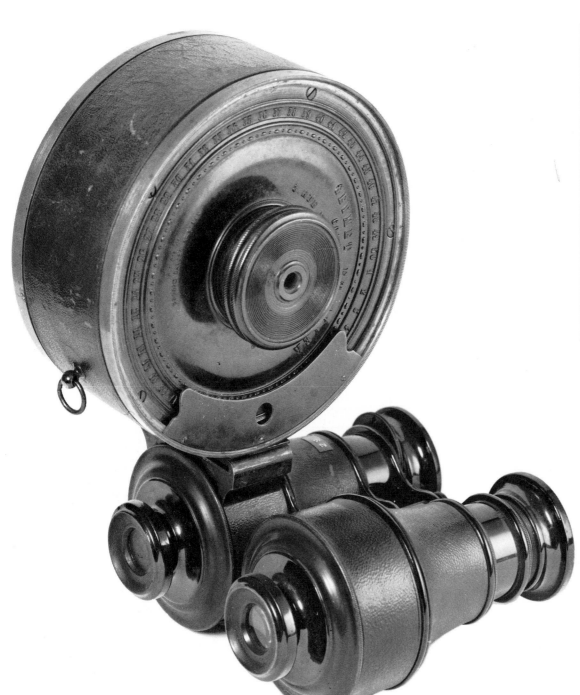

Similar to the Goldschmidt but much earlier was the **Jumelle de Nicour** bearing the name of its inventor, Octave Nicour, and which was manufactured by Geymet & Alker (French patent No. 72873, 10 September 1866). The moveable drum contained 50 collodion dry plates, 40×40 mm. In the left-hand tube was a ground-glass screen with magnifying-glass for fine adjustment; the right-hand tube took the pictures. Plate changing was simple: the camera was turned upside down, allowing the exposed plate to drop into the drum-shaped magazine; the latter was advanced one click, and when the camera was righted again a new plate fell into place. Sold with the camera was an ingenious walking stick which doubled as tripod.

94

Léon Bloch gave the name of **Stéréo-Physiographe** to his invention, (French patent No. 255261, 2 April 1896), taking 45×107 mm plates in magazine holders. The example shown is of considerably later manufacture. The lens fitted is a Zeiss Tessar f/4.5 and diaphragm shutter.

Opera-glass-case camera. Patented in ▷ France by Franck Valery (No. 213401, 12 May 1891), this device was simplicity itself: one opened the case and it was ready to shoot. The size of the plates was 9×12 cm. A drop shutter was mounted in front of the Darlot lens.

Photo-Stereo-Binoculars by C.P. Goerz, of Berlin.
These are real glasses, with a magnification of 2½ to
3½ times; they can also be used as a camera, either
single-lens or stereoscopic. Dating from 1899, the Goerz
P.S.B. used 45×55 mm plates and had a pair of 75 mm
Dagor f/6.8 lenses and drop shutters. Note the optical
direct view-finder.

Moving swiftly and silently compared with ▷
cavalry, cycle troops were highly regarded,
especially by the French General Staff. This
one no doubt is engaged on photographic
reconnaissance.

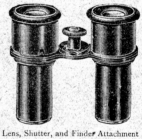

This Léon Bloch **Physiographe** may be com-
pared with plate 125; it is a much later model,
probably made about 1920.

This illustration from *The British Journal
Photographic Almanac* shows Sander's
Patent Photoscope which, like the Goerz
on p. 96, could be used either as spy-glass
or camera, one lens being replaced by a roll-
film carrier. It was covered by German
Patent No. 51648 of 1 June 1889. ▽

This Contessa Nettel **Ergo**, described in the
company's 1924 catalogue, resembled a single
opera-glass. Taking 4.5×6 cm plates, it was
fitted with 55 mm Zeiss Tessar f/4.5 lens and
Compur shutter giving speeds from 1/25 to
1/100 sec. A very similar camera had been
listed by these makers in 1911 under the name
of **Argus**.

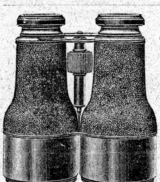
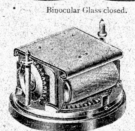

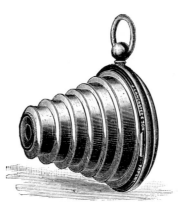

Lancaster's **Patent Watch Camera**, as illustrated in the *British Journal Photographic Almanac* 1888. Disguised as a pocket watch, the camera sprang telescopically open for instant photography when the winder was pressed Plates measured 2 in×1½ in (50×38 mm). During the 1880s and 90s, J. Lancaster & Son, Birmingham were the largest manufacturers of cameras in the world.

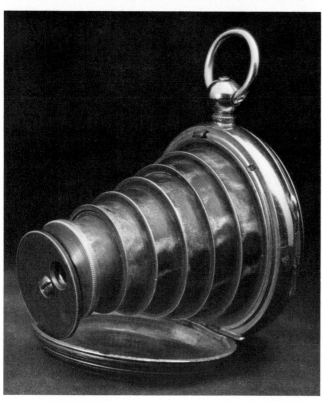

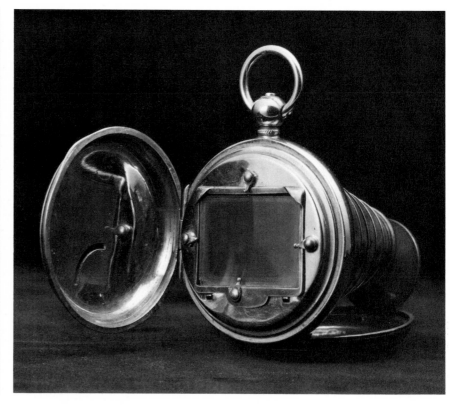

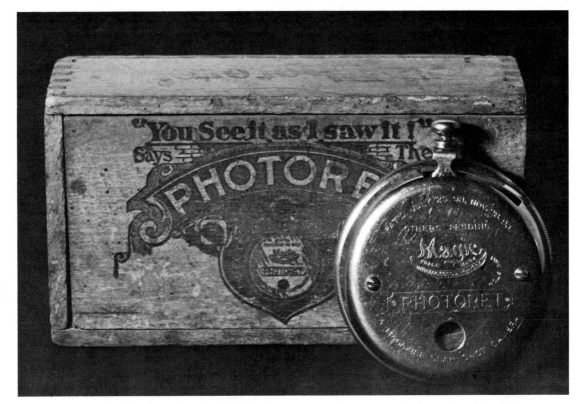

Another watch camera was the **Magic Photoret**, seen here with its original box. It had a simple lens and diaphragm shutter, taking six 12 mm (½in) square pictures on a 45 mm circular plate.

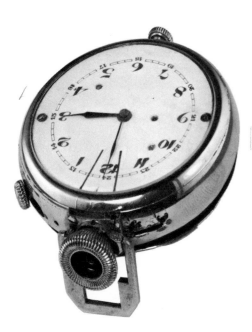

Pocket watch camera by Kurt Steiner and Dr Sebastian Heckelmann (German patent No. 745598, 1939). The lens is in the winder.

Designed in the shape of a pocket watch, although it had neither movement nor dial, the **Ticka Camera**, by Houghton, London dates from 1906 and was described in *La Nature* the following year. The lens was in the winding-knob and a 'brilliant' view-finder was fitted. A **Ticka** took 25 exposures, ⅞ in × ⅝ in on roll-film supplied in cassettes. The prints shown are actual size.

The Steineck A B C wristlet designed by Dr Steineck was merely a curiosity. Described in the *Prisma Almanac* of 1949, it had a 12.5 mm f/2.5 Steineck lens and a variable-speed shutter offering six 3×4 mm exposures on a 25 mm (one-inch) disc of film. Owners made their own discs from cut film using a special tool sold with the camera. The latter weighed 45 g., or just over 1½ ounces.

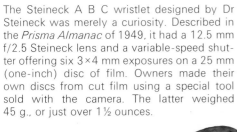

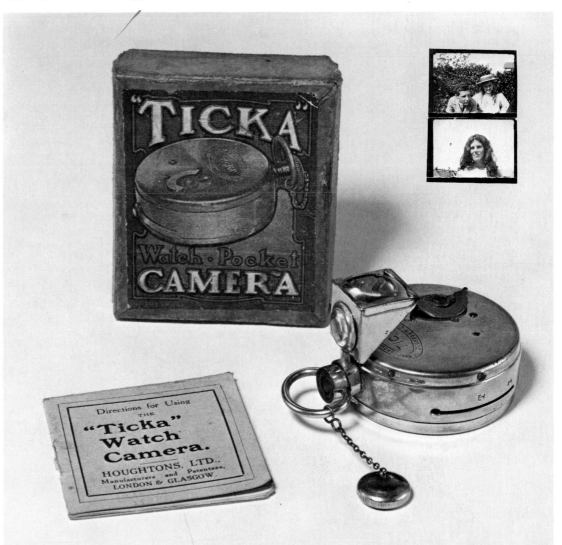

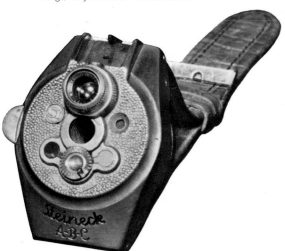

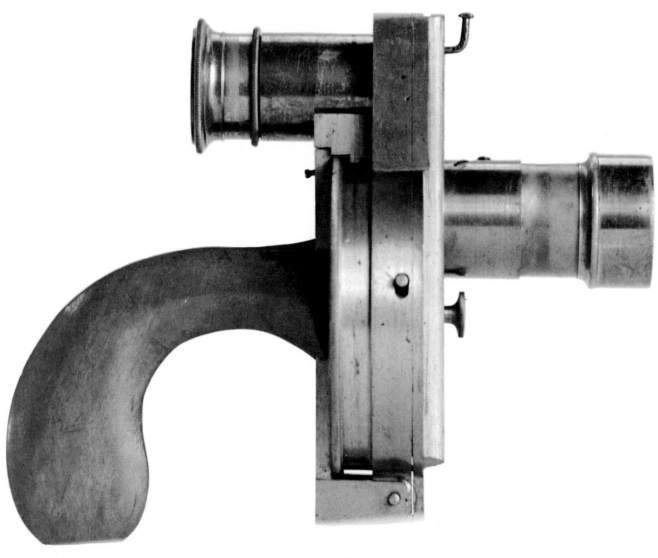

Thompson's **Revolver Camera** was made in
France by A. Briois, of Paris (French patent
No. 52713 of 20 January 1862). This splendid
mid-Victorian novelty took four exposures on
a 3 in plate carried in a drum where the cham-
bers of a real revolver would be. These illustra-
tions clearly show the lens, with circular front
shutter, the drum and the optical view-finder.
(George Eastman House, Rochester, N.Y.)

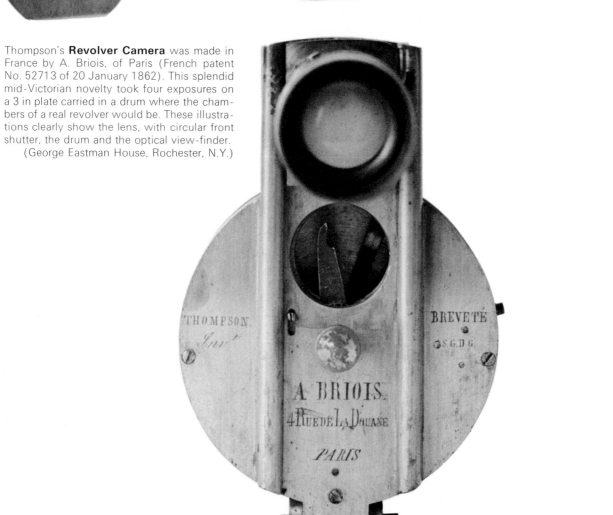

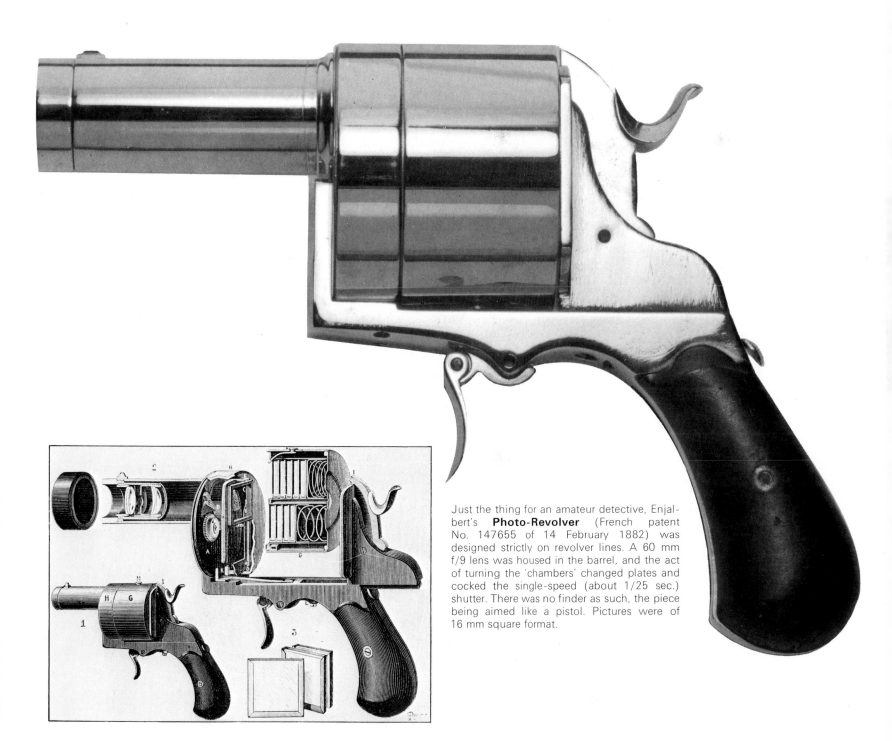

Just the thing for an amateur detective, Enjalbert's **Photo-Revolver** (French patent No. 147655 of 14 February 1882) was designed strictly on revolver lines. A 60 mm f/9 lens was housed in the barrel, and the act of turning the 'chambers' changed plates and cocked the single-speed (about 1/25 sec.) shutter. There was no finder as such, the piece being aimed like a pistol. Pictures were of 16 mm square format.

Known as the Coviland Stewart **Erac** and marketed by the Erac Selling Co., of London, this rather nasty little plastic camera with meniscus lens and single-speed shutter took pictures 18 mm square on special roll-film 20 mm wide. The optimistic producers were granted a British patent on 18 August 1931, in the trough, that is to say, of the Great Depression. (Kodak Museum, Harrow, Middlesex)

Revolver-Cameras enjoyed a long run for their money. This one, the Krauss, which was presented before the Société Française de Photographie on 28 October 1921 is interesting not only for its shape but because it would take either plates or rollfilm: 48 18×35 mm plates or a spool giving 100 exposures. The 40 mm Zeiss Tessar of f/4 aperture and a shutter giving Time, 1/25, 1/50, and 1/100 sec. made it quite versatile for its period. The spur below the body is the trigger; it would be a bold man who brandished such a weapon in public today. The photo is actual size.

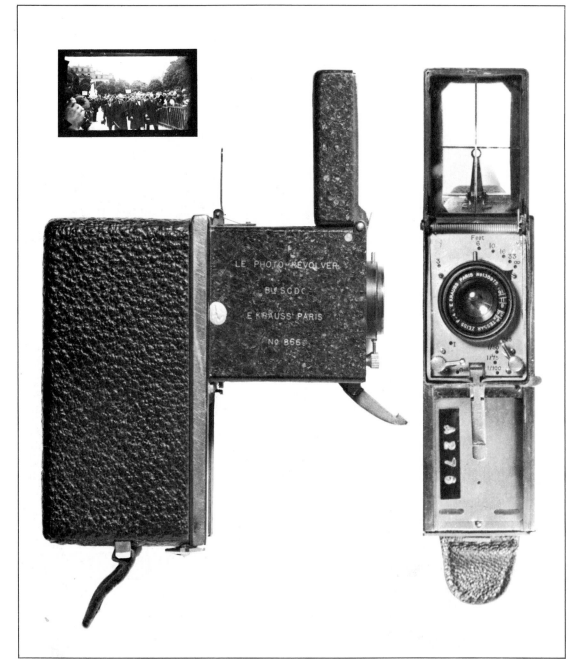

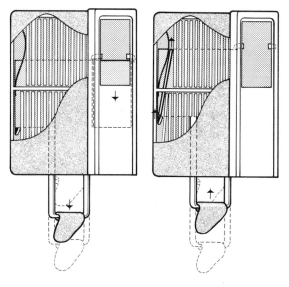

Photographic Gun by Sands & Hunter, Bedford Street, Strand, London. Made in the form of a rifle and dating from 1885 this is an early example of miniature magazine camera, made possible by the dry gelatin plate. The photographer aimed as with a rifle over open sights, the lens and roller-blind shutter being in the barrel. Three brass cylinders could be brought into register. The shortest concealed a ground-glass screen focused by means of a knob under the barrel; the others held unexposed and exposed plates respectively. Once a plate had been exposed by pressing the trigger it was transferred to the 'exposed' cylinder by turning the plate through 120 degrees. The magazine held 28 plates 1½ in in diameter. Either a Ross or a Dallmeyer Rapid Rectilinear lens could be specified.

(Science Museum, London)

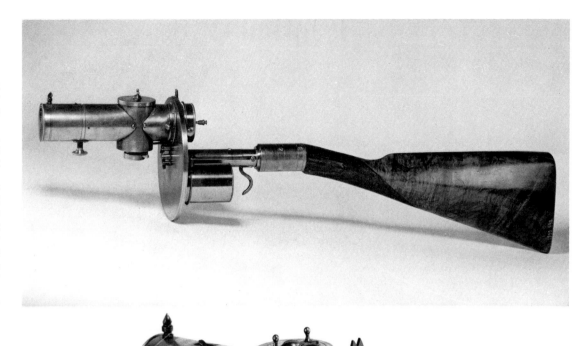

Thornton Pickard was one of the great names in British photographic equipment. When aerial combats became common, during 1915, the company developed this camera gun for the training of observers, taking the body and ring sight of a Lewis light machine-gun, standard armament in the Royal Flying Corps. A normal Lewis-gun cocking-handle was used to set the shutter and wind the film, which gave 16 exposures 4.5×6 cm (1¾ in×2¼ in) on an ordinary 120 film. The 12 in lens worked at f/8 with a between-the-lens schutter. ▽

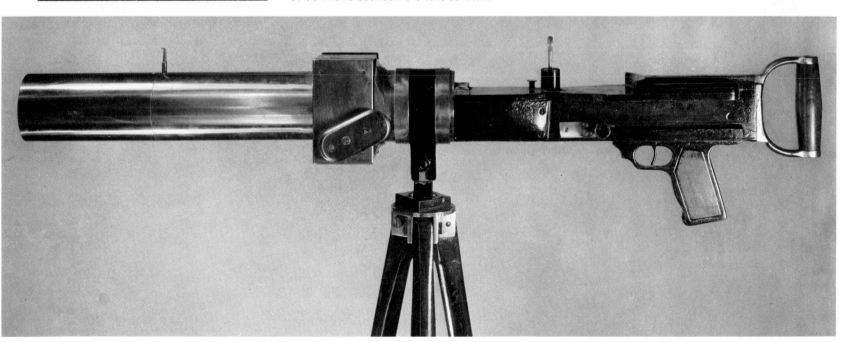

Camera Gun by Romain Talbot, Berlin. Inverted commas because this really neither a camera nor a gun; it is a piece of fairground equipment producing round or 'tintypes' ferrotypes (positives taken by the wet collodion process on thin iron plate coated with dark varnish) for making into brooches or buttons. Although very crudely made, it probably served its purpose, which was to capture the imagination of children—who naturally would rather be 'shot' than face an ordinary camera.

Darier's **Escopette** (musket) was beautifully made, as befits a Swiss product. Albert Darier ▷ patented this weapon on 15 November 1888 for manufacture by his own company, Darier-Gide S.A. of Geneva. It could be aimed like a gun or, for deliberate shooting placed upon a table, when the legs and butt formed a tripod. Thanks to George Eastman's newly-announced roll-film, it took 100 65 mm (2⅝ in) circular pictures without reloading. The lens was a 100 mm f/8 Steinheil rapid rectilinear doublet with washer stops in the lens mount, which, however, had to be unscrewed before they could be changed. The 'eyelid' shutter comprised two hemispheres, one of which pivoted axially.

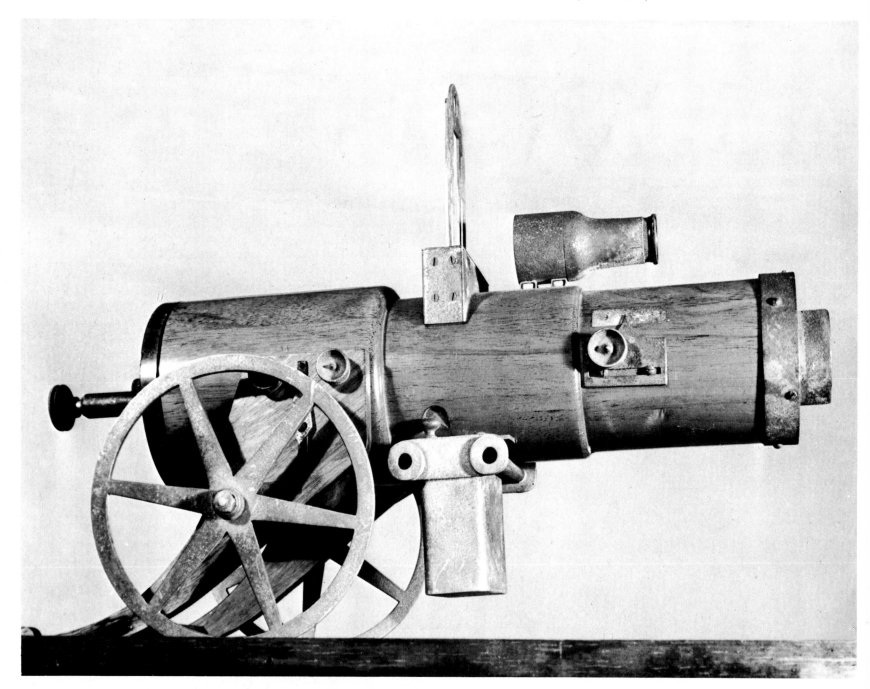

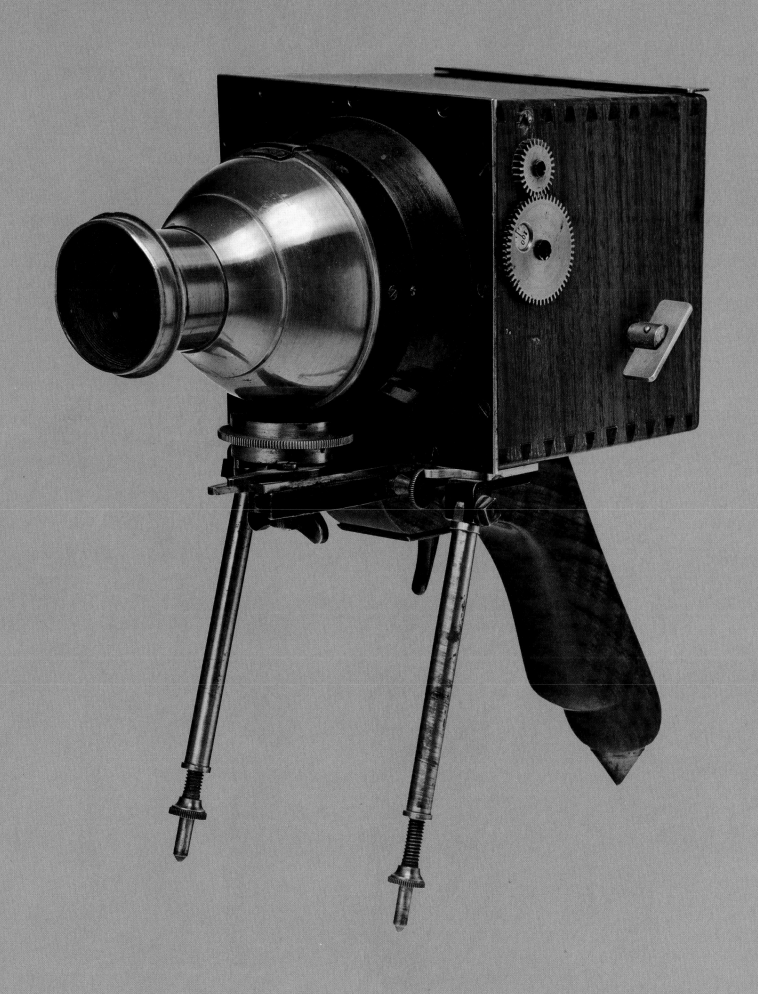

Relatively modern (about 1950) is the **Micro 16** made by the Wittaker Los Angeles, which fits inside a cigarette packet. It has a single-speed shutter, taking 14 mm square pictures on 16 mm ciné film.

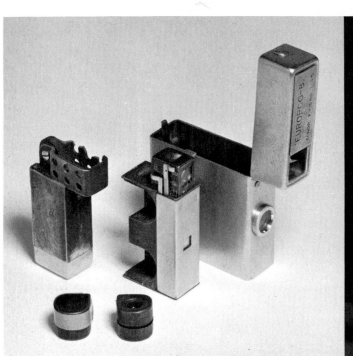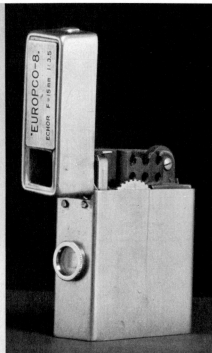

Cigarette-lighter camera: The **Europco-8** figured in the 1954 Asahi catalogue, and sold in the U.S.A. as the **Echo Lighter Camera**. This was indeed a petrol lighter and camera combined, the body being divided to hold reservoir and mechanism, and the cap doubling as view-finder. A 15 mm f/3.5 Echor lens was fitted, taking 16 4×6 exposures on 8 mm ciné film wound from one special cassette to another inside the body. A guillotine shutter gave choice of ¹/₅₀ sec. or Time; the lens could be stopped down to f/11.

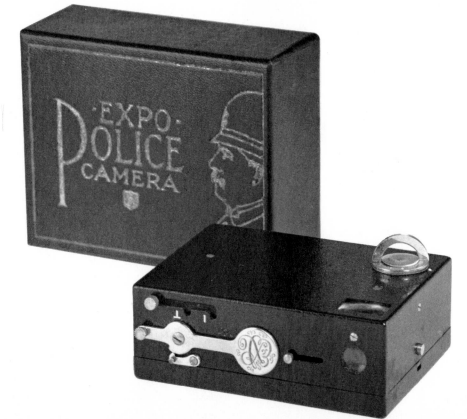

Expo Police Camera made by the Expo Camera Corp., New York (U.S. patent No. 31, January 1911) In name at least the detective's own camera. Obviously usable only in bright light out of doors, it had a simple meniscus lens and B/I roller blind shutter. The magazine gave twelve exposures 12×25 mm (½×1 in.)

106

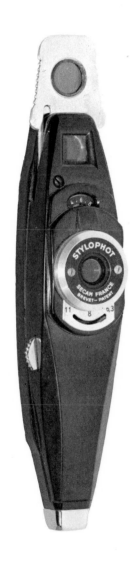

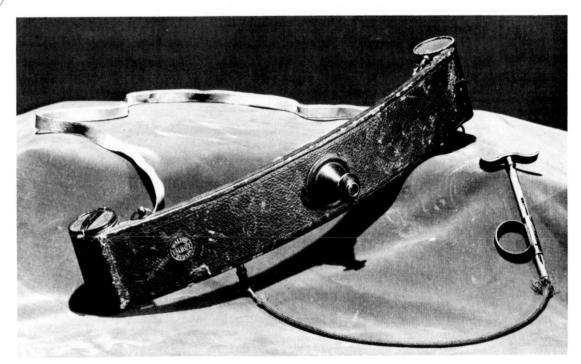

Photographic optimists put their trust in the **Invisible** belt camera, a brain-child of Walter Talbot, of Berlin mentioned in the *B.J. Almanac* 1929. It was worn under the waistcoat like Stirn's **Waistcoat Camera** (page 90) with the lens passed through a button-hole. There was a single-speed shutter controlled by cable release which also cocked it and wound on the film. This example used standard 35 mm ciné stock, darkroom loaded, but other versions of the Invisible had been available, say the advertisements, since 1911.

(Coll. Kodak, Vincennes)

Designed by an engineer named Koftanski and manufactured by Secam, France, the **Stylophot** was carried like a fountain-pen and rather flimsily made. There were three stops, f/6.3, f/8 and f/11, and a single-speed shutter set by pulling the knob on top. Before setting, the finder was obscured by a red disc.

Matchbox Camera. One thousand of these tiny cameras were built in 1943 by Kodak at Rochester, N.Y., for United States intelligence services. They took square pictures on 16 mm ciné film. An f/5 lens of one-inch focal length gave sharp pictures from 4 ft to infinity.

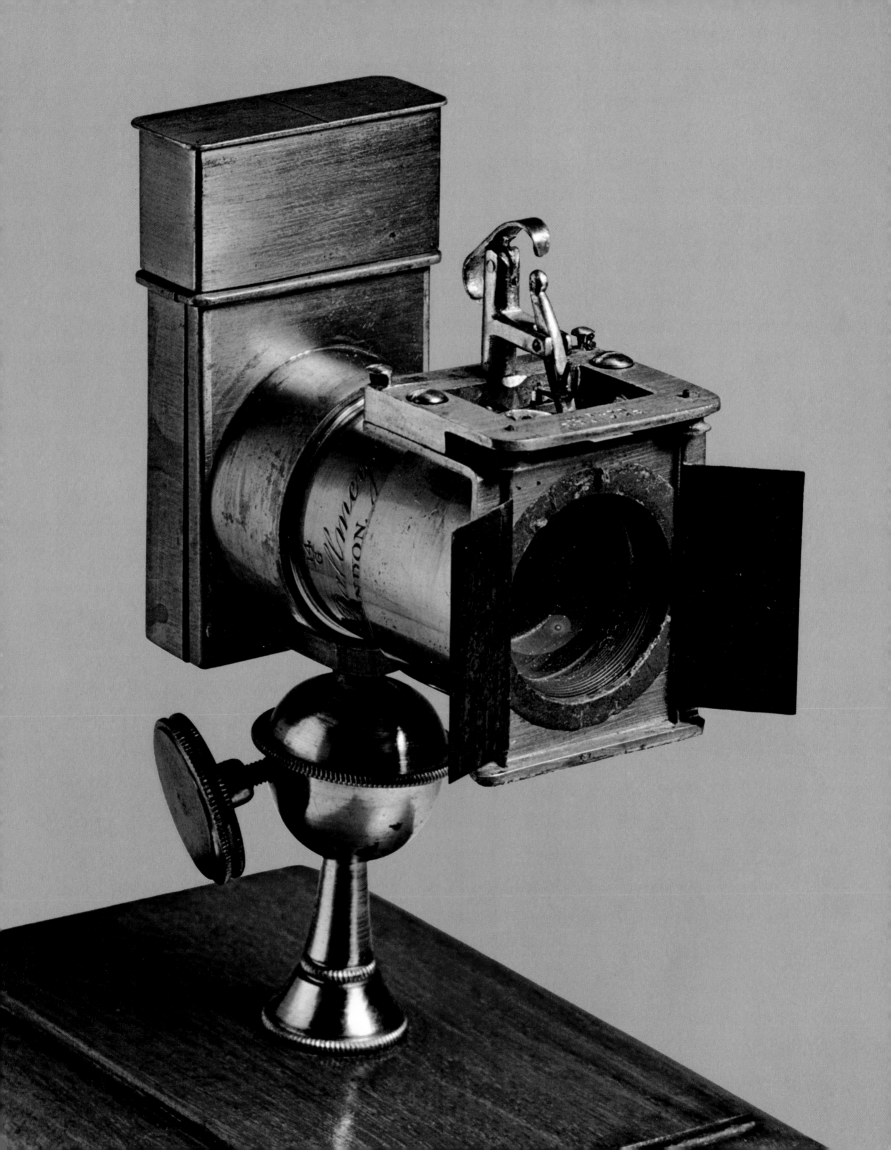

SMALL FORMAT

The earliest known photographic negative was taken by W.H. Fox Talbot in a little camera measuring $3 \times 3 \times 3$ inches (75 mm³). It was small because the lens was a microscope lens. Expediency kept the picture small; but with the coming of special photographic lenses, people took larger plates because, before enlargers, this was the only way to make a reasonably large picture.

Smallness however has charm and utility of its own. Mid-nineteenth century ladies loved lockets and brooches containing a miniature portrait. They also liked photographic jewelry containing transparent microphotographs and a built-in Stanhope lens. Wet-collodion and Ferrotype processes made millions of such things.

Stanhope-lens souvenirs are still manufactured today. So are more practical, even sinister devices. Dr. Steineck's ABC wristlet camera (page 99) (1949) taking pictures 3×4 mm on cut film is said to have served the CIA, and no spy film is complete unless someone uses a Minox (page 111) to copy the secret blueprints.

Brin's Patent Camera, 1891. This little instrument is a combined camera and spy-glass. A metal dark slide carrying a plate of 25 mm diameter (1 in) was inserted in the body and exposed by means of a front shutter. With dark slide removed it could be used as a spy-glass, with eye-piece focusing.

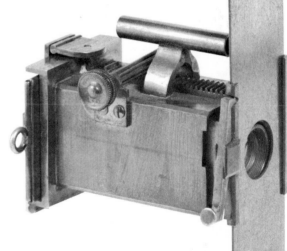

Marion's Miniature Camera 1884. An early all-metal miniature using 4.4 cm (1¾ in) square plates in metal dark slides. The rack and pinion focusing device can be plainly seen, as can the tubular view finder and the gravity shutter, with notches for the trigger lever. When raised the shutter covers the lens and its orifice registers with the finder.

◁With T. Skaife's **Pistolgraph** we are back in the world of wet collodion plates. Skaife patented his miniature brass camera in 1866 (10 June, No. 1373). In using a short-focus lens, wide aperture and small format—a Petzval portrait doublet f/2.2 of 40 mm for 30×40 mm (1⅛×1½ in) plates—he looked forward to the modern miniature camera. He used a central Waterhouse stop and twin-flap front shutter powered by a rubber band giving an exposure of about 1/10 sec. The case acted as stand for the ball-jointed mounting.

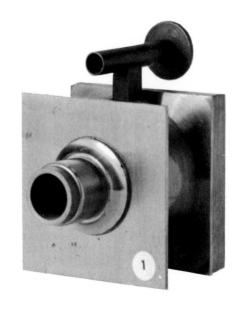

Bertsch's Automatic Camera. Dated by the George Eastman House to 1861 this simple apparatus has an achromatic meniscus lens of fixed focus (hence the name 'automatic') and tubular finder. Circular views less than 2 cm in diameter (1in) were taken on 3.7 cm (1½ in) wet collodion plates.

Kombi box camera by A. C. Kemper, of Chicago (U. S. patent 20 December 1892). An early rollfilm camera taking 25 circular 1 in views on special film. Fixed aperture meniscus lens, diaphragm shutter. Three turns of the knob wound on the film but there was no exposure-counter. With the back removed the **Kombi** could be used as a viewer for negatives or transparencies, hence the name.

The **Franceville**, made by a Paris company of the same name about 1908, is a typical cheap box camera of the period, made of black varnished cardboard, with fixed aperture meniscus lens and guillotine shutter, and sold complete with one dark slide, one 4×4 cm (1½×1½ in) plate and a packet of P.O.P. (printing-out paper). One wonders why anyone should have bought it in preference to the daylight-loading rollfilm Brownie which by this time had been on the market for more than ten years.

The **Presto**, by E. B. Koopman and H. Casler, of New York, and catalogued as 1899 by the Kodak Museum at Harrow. Could be used with 1¼ in square plates or rollfilm of similar width. It has a rotating stop in front of the meniscus lens and a gravity shutter, reset by turning the camera upside down.

Very different in period is the **Minifex** designed by Fritz Kaftanski, Berlin and noted in the *Photofreund-Jahrbuch* 1932. An early sub-miniature, it used rollfilm giving an 18×13 mm format (¾×½ in), and was fitted as standard with a 25 mm f/.5 Trioplan lens and Compur chronometric shutter giving Time, Bulb and speeds from 1 sec. to 1/300 sec. The Compur shutter, which figures often in these pages, was devised by Friedrich Deckel, of Munich, about 1912 as an improvement on his Compound design. Shutter speed was controlled by a clockwork escapement (wound by the lever seen above the lens) with a gear train for the slower speeds. An iris diaphragm formed part of the shutter assembly and front-cell focusing was used (by rotating the lens bezel). As will be seen, the Trioplan could be stopped down to f/8 and focused down to 0.8 metres (3 ft). A 52 mm Astro Tachon lens was also listed, working at an astonishing f/0.95. Note the lens cap on cord attached to the shutter release.

L'Aiglon had nothing in common with the King of Rome except its name. A French 'novelty' or publicity handout, it is dated by Kodak Ltd, Harrow, to about 1934.

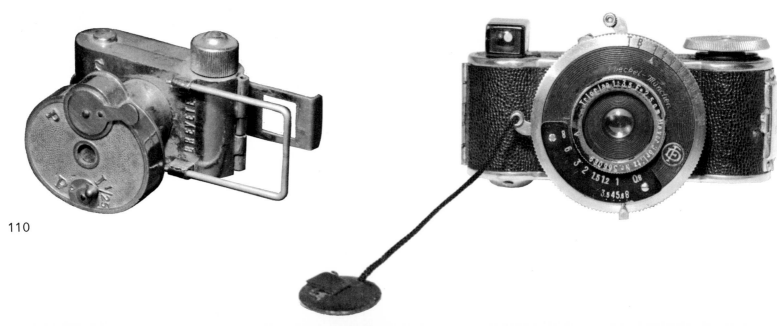

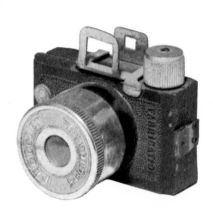

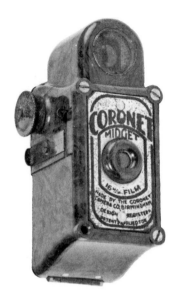

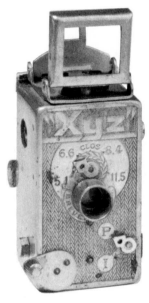

Sold in its native France as **Le Photolet** and catalogued by Pizl of Prague in 1935 as an **Uica**, this tiny pseudo Leica gave 20 exposures 20 mm × 20 mm (¾ × ¾ in) on a special film. Rodenstock 31 mm f/8 meniscus lens, everset shutter.

Another cheap novelty 'given away with a packet of cornflakes' was this **Midget** by the Coronet Camera Co., Birmingham, taking six 13 × 18 mm (½ × ¾ in) pictures on 16-mm film.
(Kodak Museum, Harrow)

A direct frame finder and the tinniest of controls characterise the **XYZ**, from the Etablissements Lancart, Paris, which was on sale in 1935. Bulb and Instantaneous exposures. The lettering is misleading: the lens is a 22 mm Roussel Xyzor, maximum aperture f/7.

Produced in Germany just before the war, this 1939 **Sola** is a sub-miniature taking 13 × 18 mm (½ × ¾ in) pictures on 16-mm ciné film. Schneider Xenon f/2 lens of 25 mm focal length, diaphragm shutter with speeds from 1 sec. to 1/500. Two view finders were fitted, a brilliant and a frame finder for action shots. A system of springs enabled 6 consecutive shots to be taken.

Although tiny, the **Minox** was a practical and effective camera for under-cover use. It was a **Minox** that caused such a furore in 1938 when a reporter photographed Ruth Schneider's electrocution. This beautifully detailed instrument was designed by Walter Zapp and manufactured at the VEF works in Riga, Lithuania from 1937; it gave 50 exposures 8 × 11 mm ($^3/_{16}$ × $^7/_{16}$ in) on special film in reloadable cassettes. No stops were fitted in view of the small format and short focal length of the 15 mm f/3.5 Minostigmat lens, exposure being regulated by the shutter which gave speeds from 1/2 to 1/1000 sec. There was a built-in yellow filter.

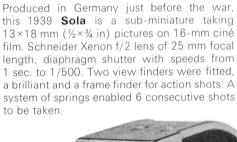

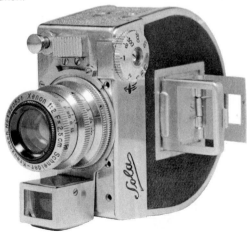

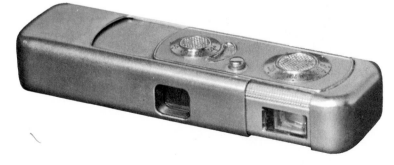

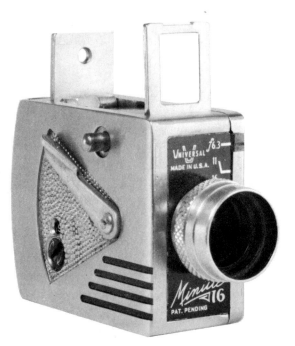

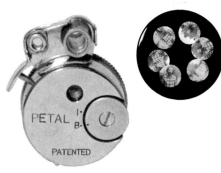

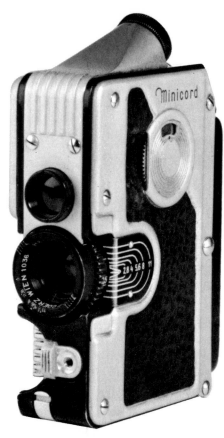

Dressed up as a cine camera, the **Minute 16** was in fact designed for 16-mm cine film. The right-hand lever set the shutter and an adjacent button released the single-speed shutter (1/25 sec.). Made by the Universal Camera Corp., of New York, Chicago and Hollywood, it is listed in the 1950 *Master Buying Guide*.
(Stadtmuseum, Munich)

The **Petal**, from Japan, was unusual in taking six circular pictures on 25 mm film in daylight-loading cassettes. Plain 1/50 sec. shutter, f/5.6 lens.

The **Minicord** by C.P. Goerz, Vienna, was mechanically sophisticated: not merely 'mini' but reflex into the bargain. This precision instrument is described in the *Oestereichische Photographen Zeitung* in 1951. Loaded with special cassettes giving 40 exposures 10×10 mm ($^5/_{16}$×$^5/_{16}$ in) the Minicord used an f/2 Goerz Helgro lens of only 25 mm focal length giving sharp pictures from 40 cm—say 16 in—to infinity. Shutter speeds from 1/10 to 1/400 sec. Note the depth-of-field scale beside the lens.

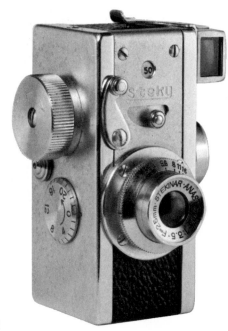

In 1948 the Japanese optical industry was already flexing its muscles. This nicely detailed **Steky** sub-miniature gave 20 exposures, 10×14 mm ($^1/_3$×$^9/_{16}$ in). Three-speed shutter 1/25, 1/50 and 1/100 sec, 25 mm f/3.5 Stekinar.
(Stadtmuseum, Munich)

The **Tessina** twin-lens reflex from Switzerland is one of the smallest cameras built for 35 mm film. It used special cassettes holding 18 14×21 colour exposures or 23 black and white, and contains a spring-driven rapid-fire device for sequence of 5-8 exposures. The **Tessina** is so slim that there is no room for the lens in the normal position; instead the image is turned through 90° by a mirror. The taking lens is a 25 mm f/2.8 Tessinon with central shutter giving 12 sec. to 1/500; it and the viewing lens are protected by a sliding cover, which also locks the shutter.

The **Minox C** which came out in 1969, like earlier Minox models, takes special film in cassettes holding 15 or 36 exposures each 8×11 mm (say 5/16×7/16 in). Transistorised electronically controlled shutter in conjunction with photo-electric cell gives automatic gradation from 10 sec. to 1/1000, or manual selection between 1/15 and 1/1000 sec. The 15 mm f/3.5 lens works at fixed aperture. The camera weights only 4 ounces (114 grammes) loaded and measures less than 5 in (122 mm) when closed.

The **Minolta MG-S** sub-miniature by Minolta differed from its predecessor, the model **MG** in taking larger pictures—12×17 mm (½×⅝ in) instead of 10×14 mm (³/₈×⁵/₁₆ in). The **MG-S,** brought out in 1969, takes 18 exposures on non-perforated film in cassettes. Shutter speeds are automatically adjusted from 1/30 to 1/500 sec. according to the light. A 23 mm f/4 lens is fitted.

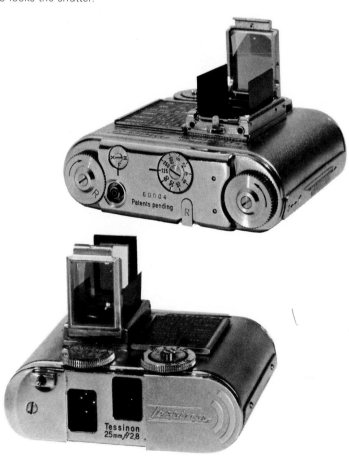

113

114

DETECTIVE CAMERAS

PHOTOGRAPHY—PAST. **PHOTOGRAPHY—PRESENT.**

By the year 1884, when this advertisement appeared, gelatine dry plates had become a valuable export. Not only did they liberate photographers from the cumbersome paraphernalia of the wet collodion process (see the three-man team on the left), but they were ten to twenty times as fast. 'Their introduction', says H. Gernsheim in his *History of Photography*, 'was due entirely to British ingenuity.'

◁The camera may be hanging in mid air and neither the artist nor his model may ever have looked in a view-finder; but the message is plain—'No picnic complete without the little black box'.

After the appearance on the market of relatively rapid dry plates in the 1870s life became simpler. Freed from the trammels of sensitising bath and "dark box" or tent, amateurs in ever increasing numbers took up the pastime, assured that even a tripod was now unnecessary. New "instantaneous" hand cameras came out, costing and weighing far less than the bulky studio and field instruments of the wet-plate era, and it became possible to take pictures by stealth, with apparatus not in the least like a conventional camera. This might take the form of a discreet black box with all mechanism hidden away, or it might be disguised as a handbag or parcel. These "Detectives" as they were called were the first "candid" cameras, and with them many fine semi-action shots were obtained, including Paul Martin's splendid series on London street traders during the early 1890s.

There is also the story of the New York actress who refused to sit to a fashionable photographer for a *carte de visite*. Undismayed, the photographer followed her to the seaside, rented an adjacent bathing-cabin and "snapped" the lady with his Detective as she emerged dripping from her bathe. "I just have to have your picture to put on show", he said. "Shall it be this one or will you give me a sitting?" She sat.

Many single-shot and magazine plate cameras appeared during the 1880s, and many cameras camouflaged as something else. The latter are discussed in the section on "Cameras in Disguise". Undoubtedly, however, it was rollfilm that set the whole world snapping. The man responsible was George Eastman, the year 1888.

About 1875, Eastman, a 20-year-old bank clerk in Rochester, N.Y., became interested in photography so that he could take pictures on vacation. He purchased an outfit and took lessons from a professional, but he disliked the messy manipulations of the wet-collodion process. He enquired about dry plates but found no satisfaction. Then, learning of gelatine silver bromide emulsions, he imported some from England and began coating plates in

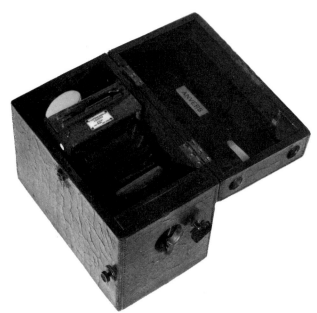

This **Detective** camera by Watson & Sons, Holborn, London, is in *British Journal Photographic Almanac* for 1886. Being light, simple and inconspicuous it appealed to the great mass of amateurs eager to take advantage of the new dry plates. It is in fact a quarter-plate bellows camera housed in a leather-covered box, with space behind for dark slides and ground glass screen. There is a focusing knob on the front panel but the majority of snaps would have been framed in the two 'brilliant' finders in the top, one for horizontal, the other for vertical views.

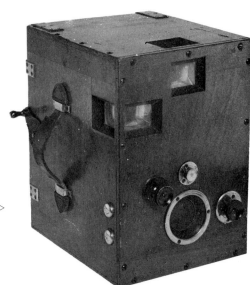

Similar finders are seen on this **Fichter ▷ Excelsior** by Huttig, which has a Steinheil aplanat and takes 12 12×9 cm (4¾×3½ in) plates. R. Huttig founded his camera manufacturing company in Berlin in 1862, moving to Dresden in 1898. In 1909 the firm of R. Huttig & Son was absorbed by Ica.

Facile magazine camera designed by F. Miall and made by J. Fallowfield, ▷ London in 1887. The magazine holds twelve plates, 10.8×8.3 cm (4¼×3¾ in) which pass by their own weight through a slot from an upper compartment to a lower. The raised front panel shows view-finder, release mechanism and rotary sector shutter.

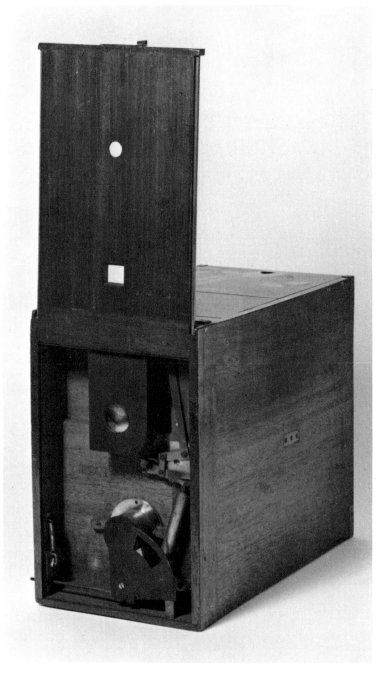

This imposing brassbound mahogany instrument bears the name of its inventor, Nadar—or to give him his full name, Gaspard Felix Tournachon (1820-1910). Pioneer of aerial photography (from balloons), fashionable photographer, friend of painters and musicians, Nadar cut a great figure in nineteenth century Paris. It was in his studio that the first Impressionist exhibition was held, in 1874. Nadar retired from the studio in 1886, leaving the business to his son Paul, who became the Paris agent for the Eastman Kodak company. This camera could be used with plates or with an interchangeable back called a roller slide (seen here) for Eastman Walker rollfilm.

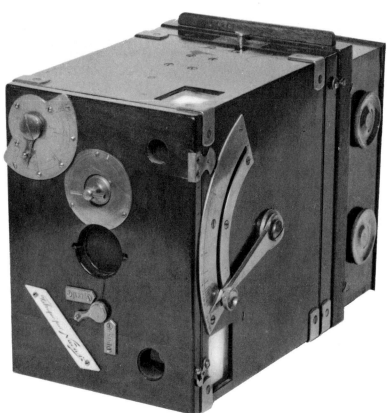

Steinheil's Detectiv Kamera, noted in the *Lexikon für Photograph- und Reproduktionstechnik* for 1888 was a nicely dovetailed bit of walnut cabinet-making. Rotary sector shutter behind the Steinheil achromatic doublet lens, stops for which comprised holes in a plate sliding between the front and rear elements of the lens. Twelve quarter-plates in magazine with leather changing-bag.

Mignon changing-box 'detective' camera. Manufactured from 1889, by Anton Tischler, it was filled with a meniscus lens of f/14, 50 mm, and a front-mounted circular guillotine shutter. It took 4×4 cm (1⅝ in square) plates.

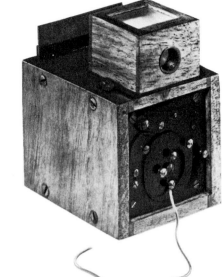

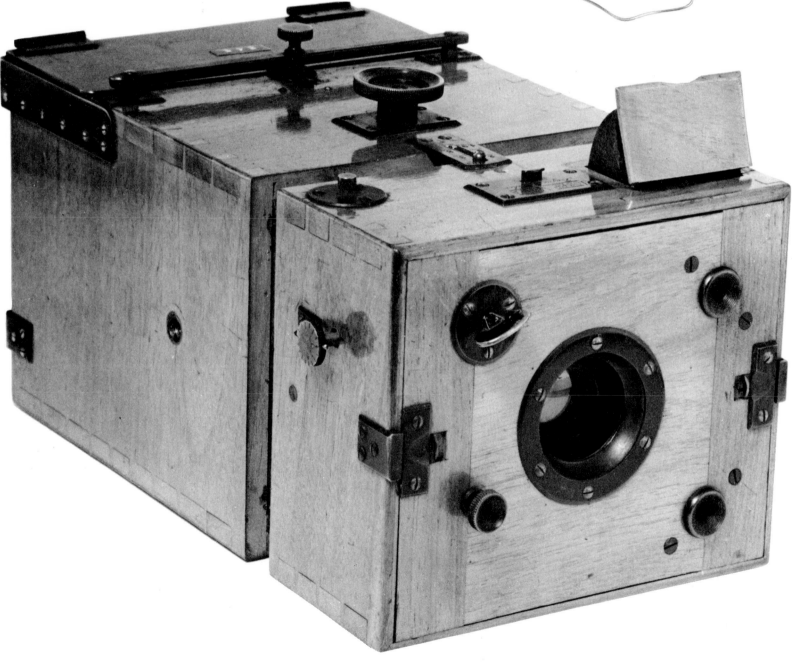

December 1877. A year later, he prepared emulsion of his own. During the day, he worked at the bank, at night he coated plates, one at a time, by hand. To simplify the task, he devised a machine, and had it patented in London. By 1880, Eastman was supplying dry plates commercially to a well-known wholesaler. In 1881, customers complained that his emulsions did not retain their sensitivity. He sailed for England in March and returned shortly having purchased the rights to a new dry-plate emulsion from Messrs Mawson & Swan. Eastman's new plates were faster than before and of better quality. They proved very successful, so in 1883 to meet the demand he was obliged to build a factory.

In 1884, the Eastman Dry Plate & Film Co. revived the idea of paper negatives in rollform, the paper being made transparent after development by immersion in castor oil. When these negatives proved unsatisfactory, Eastman and his company secretary, William H. Walker, revived another idea, that of "stripping" emulsion. A roll of paper was coated with gelatine, then with a layer of harder gelatine carrying the emulsion. After development, the intermediate layer was softened by warm water and the emulsion stripped off for transfer to a glass (after 1889 celluloid) support. The Company then went into cameras, producing Eastman's Detective Camera for rollfilm in 1886, but at 4 pounds this instrument was too heavy and did not sell. Then in 1888 appeared the Kodak, a lightweight box detective camera measuring $3\frac{1}{4} \times 3\frac{1}{2} \times 6\frac{1}{4}$ in, which removed the mystique from photography. Instructions were: "Pull the string; Point the camera; Press the button; Turn the key." When 100 exposures had been made, the camera was returned to the factory with a fee of 10 dollars. It came back reloaded, accompanied by all the owner's successful shots, printed and mounted. "Real" photographers could snip off exposed film in the dark room and process their own.

Soon there followed the famous slogan "You press the button, we do the rest"—a slogan which started a revolution in photography.

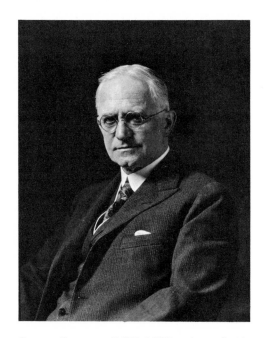

George Eastman (1854-1932) whose fixed-focus rollfilm Kodak introduced in 1888 did for photography what the Model T did for motoring. 'You press the button, we do the rest'.

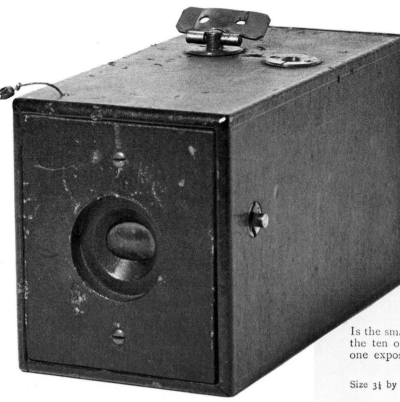

The camera which set the world 'pressing the button'. George Eastman introduced the **Kodak** in August, 1888. The onomatopoeic name was a purely arbitrary combination of letters—like the car name Alvis—chosen because it was memorable. Instructions were simple: 1. Pull the String; 2. Turn the Key; 3. Press the Button. The camera cost 25 dollars (then 5 guineas) and contained a roll of stripping paper film giving 100 circular 2½ in pictures. When all had been exposed the camera was posted to the works with a fee of 10 dollars, which covered frame developing and producing 100 mounted prints (if all had come out), reloading with film and return postage. The camera, which could hardly have been simpler, had one stop (f/9, 67 mm) one speed and fixed focus: the original 'idiot box'. Note the barrel shutter.

This original Kodak advertisement (reproduced actual size) is a reminder that darkroom users were catered for as well as the new legion of 'button pressers'.

A print from the original Kodak, showing the size.

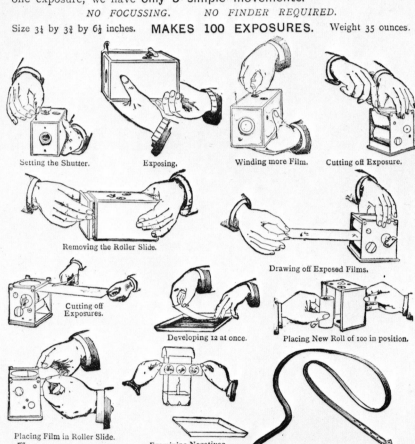

THE KODAK

Is the smallest, lightest, and simplest of all Detective Cameras—for the ten operations necessary with most Cameras of this class to make one exposure, we have **only 3 simple** movements.

NO FOCUSSING. NO FINDER REQUIRED.

Size 3¼ by 3¾ by 6½ inches. **MAKES 100 EXPOSURES.** Weight 35 ounces.

Setting the Shutter. Exposing. Winding more Film. Cutting off Exposure.

Removing the Roller Slide.

Drawing off Exposed Films.

Cutting off Exposures.

Developing 12 at once. Placing New Roll of 100 in position.

Placing Film in Roller Slide.

Examining Negatives (three on one strip).

Complete Kodak. Carrying Case.

FULL INFORMATION FURNISHED BY

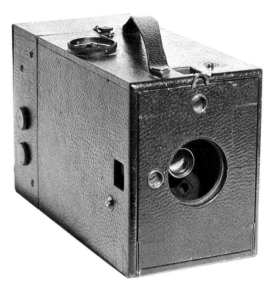

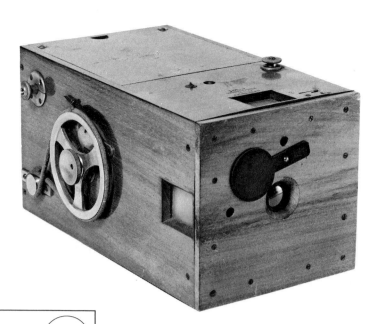

The Kodak Junior No. 4. Taking pictures 5×4in it was normally loaded with spools giving 48 exposures, although 250-exposure films could be had. The camera weighed nearly 5 pounds. The lens was a 6in f/8 rapid rectilinear. It had two reflex viewfinders.

Prisma Detective camera (German patent by O. Freitwirth, No. 52935, 18 February 1890). The camera used rollfilm, to give 44 or 90 6×8 cm (2¼×3¼ in) shots. The diagram left shows the film transport round a triangular-section wooden support, which moved on the film when the cocking and shutter release lever was operated. The prospectus claimed that 60 shots a minute could be taken.

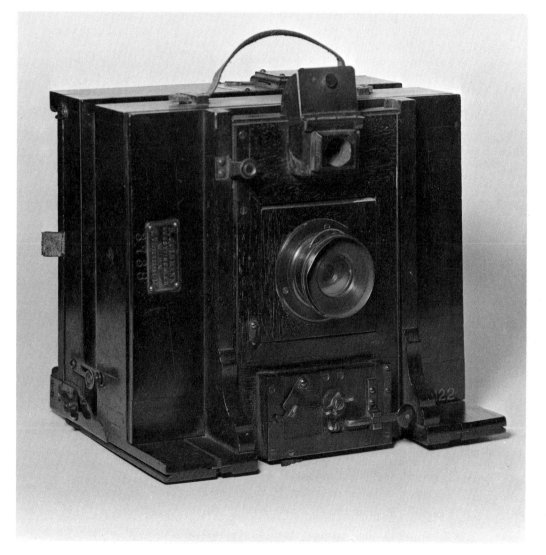

R.A. Goldmann's **Universal Detective Camera**, now in the Museum of Technology, Prague. Made in Vienna about 1890, this instrument taking 18×13 cm plates (7×5in) is more of a 'hand and stand' than a Detective, and is rather more sophisticated, having bellows focusing and a rising front as well as a brilliant viewfinder for snapshot work. This example has a Français rapid rectilinear lens and drop shutter; it was delivered complete with interchangeable wide-angle lens.

(Prague Museum of Technology)

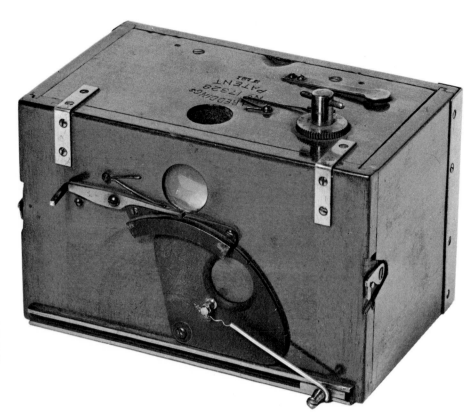

Luzo Detective Camera by Robinson & Sons, London (Redding's patent) dates from 1890. Using quarter-plate Eastman rollfilm (12×9 cm) the brass-mounted mahogany box has aplanat lens with rotary sector shutter.

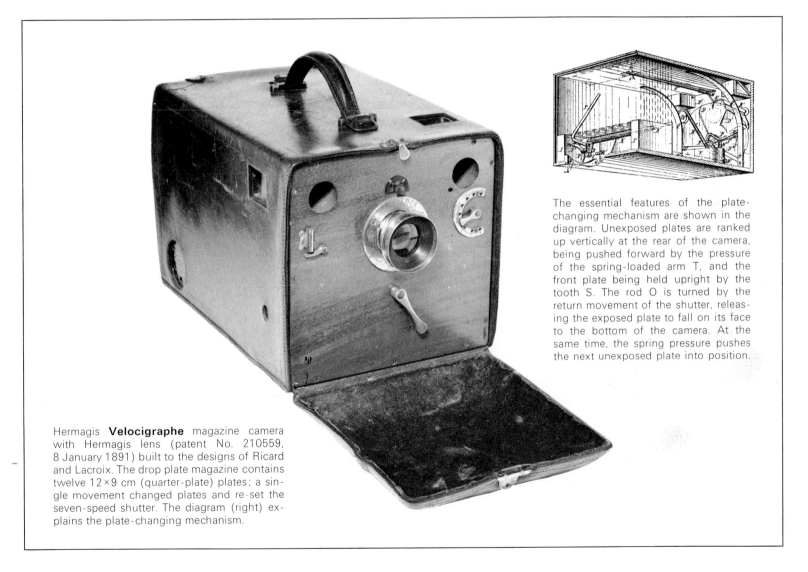

The essential features of the plate-changing mechanism are shown in the diagram. Unexposed plates are ranked up vertically at the rear of the camera, being pushed forward by the pressure of the spring-loaded arm T, and the front plate being held upright by the tooth S. The rod O is turned by the return movement of the shutter, releasing the exposed plate to fall on its face to the bottom of the camera. At the same time, the spring pressure pushes the next unexposed plate into position.

Hermagis **Velocigraphe** magazine camera with Hermagis lens (patent No. 210559, 8 January 1891) built to the designs of Ricard and Lacroix. The drop plate magazine contains twelve 12×9 cm (quarter-plate) plates; a single movement changed plates and re-set the seven-speed shutter. The diagram (right) explains the plate-changing mechanism.

121

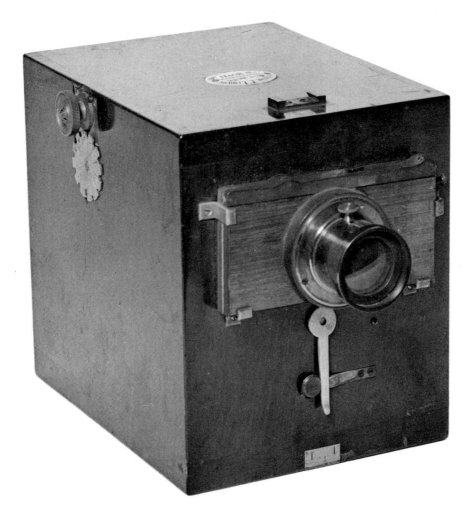

Louis Lumière's **Automatique** (French patent 205106, 21 April 1890), made by F. Jonte, successor to Monti. Rapid rectilinear lens, rotary sector shutter, magazine for twelve quarter-plates as in the Hermagis (p. 121) but with improved magazine mechanism, each plate being carried in a sheath with four trunnion guides.

Le Velocigraphe and **l'Automatique** could produce quite acceptable snapshots provided the action was not brisk. This skating picture is typical of what the amateur might expect.

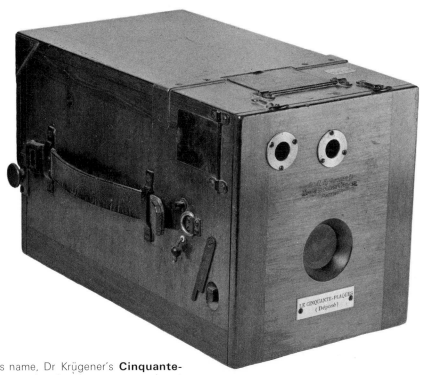

Despite its name, Dr Krügener's **Cinquante-plaques** magazine hand camera used not plates but cut film. The 50 individual pieces were arranged in the folds of a long piece of accordion-pleated black paper, and held in place by tabs. When exposed the film and its pleat were lifted into a sort of magazine in the top of the box. The brilliant finders have hinged metal covers.

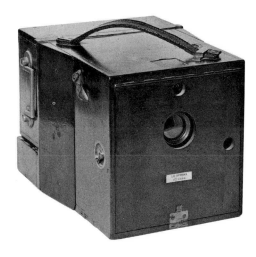

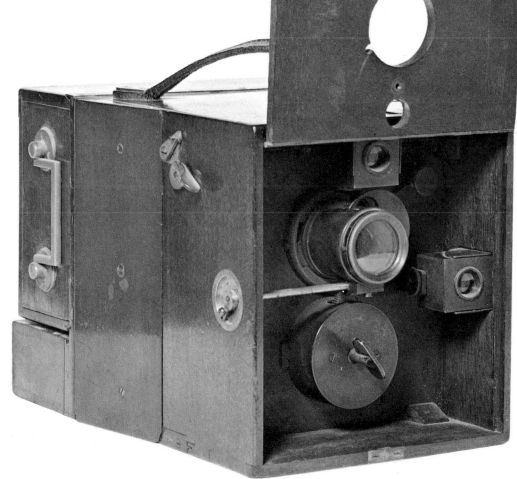

The riddle of this **Sphinx** is answered by the metal drum below the aplanat lens and rotary shutter. The drum houses a spring and clock-work motor which automatically changes the plates and cocks the shutter so that it is possible to make 12 exposures, 9×12 cm (3½×4¾in) inside 30 seconds. Wheel stops. Manufactured by Guilleminot et Cie, Paris, to the designs of Georges Maroniez, patented 25 August 1891, No. 215659.

123

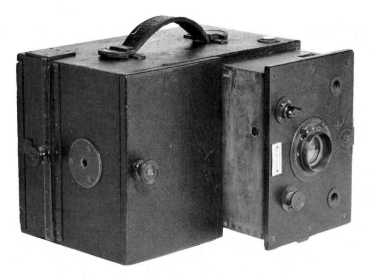

This 1893 instrument by Suter of Basle has a changing-box alongside. Exposed plates dropped to the bottom of the camera. Rotary shutter, Suter aplanat lens.

The changing-box arrangements of this quarter-plate (9×12 cm) **Delta** detective by Krugner of Frankfurt (1892) are clearly seen in the diagram. Under the swivelling brass plate a hole in the lid—with flexible leather light-trap—allows plates to be grasped with the fingers and moved into position. Aplanat lens, shutter set by pulling strings, hence the beads.

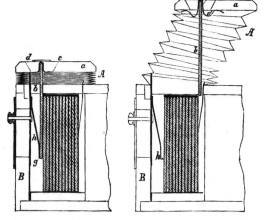

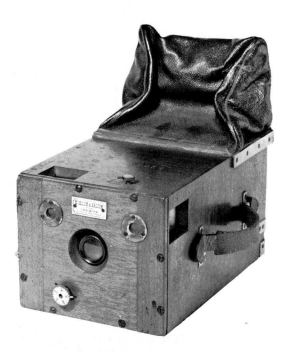

Suter camera with light-proof changing-bag for 9×12 cm (quarter-plate) plates. The shutter was set by pulling a knob and exposures regulated by a button on the front.

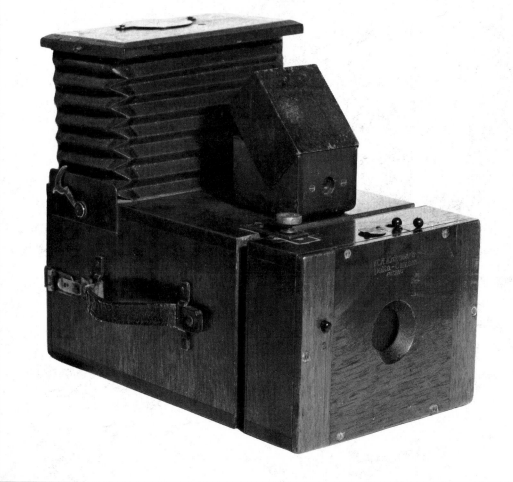

In addition to its two brilliant viewfinders this ▷ camera made in 1893 by Christian Bruns of Munich had a special reflex attachment. The magazine held twelve quarter-plates and the 144 mm lens worked at f/6.3.

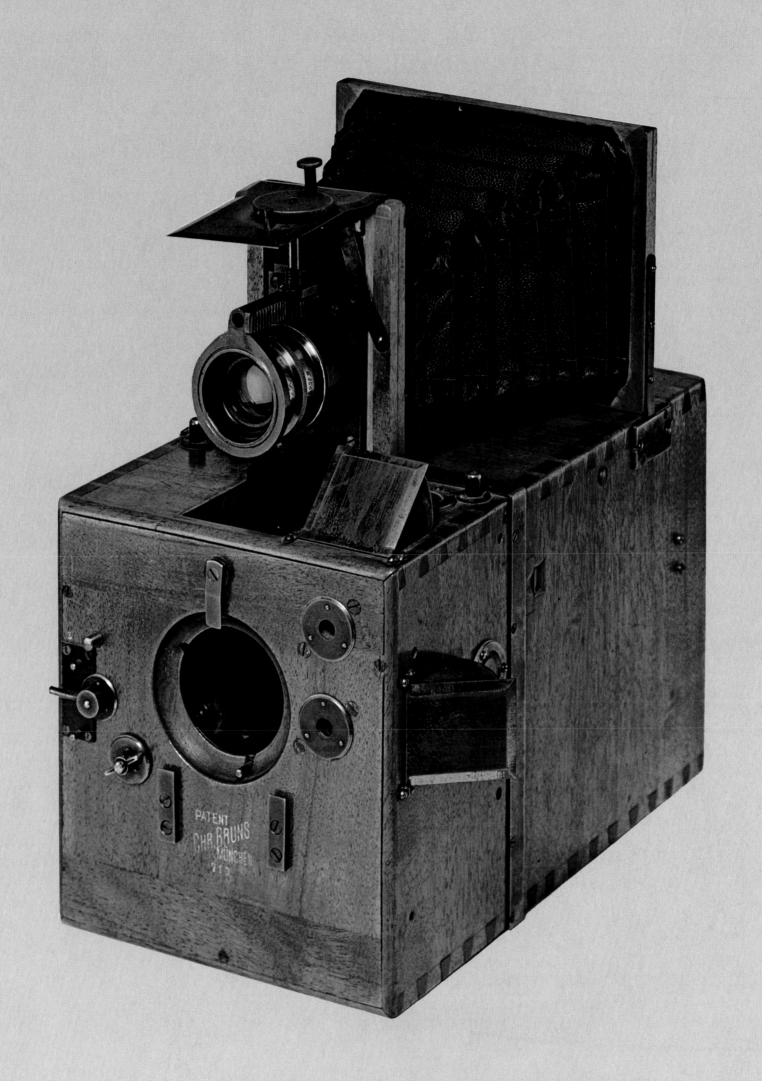

Frena camera by R. and J. Beck, London (1892). The first camera to employ a pack of cut celluloid films and therefore the ancestor of all film-pack cameras. We cannot do better than quote the Science Museum catalogue: 'The makers sold packs of 40 films notched along their edges with an opaque card between to prevent light passing through one film to the next. The pack was loaded into a metal box in the camera which could be swung on a pivot by means of a handle on the side of the camera. To remove an exposed film from the front of the pack the camera is held with the lens pointing upwards and the handle moved half a revolution. Pins within the camera no longer support the exposed film and it falls to the back of the camera with its interleaving card, leaving the next unexposed film in its place. The spirit level on the handle indicates when the film is in a vertical position irrespective of the position of the camera body. Thus if the camera is tilted upwards for architectural shots the handle is rotated until the spirit level indicates that the film is vertical. In this position there will be no distortion i.e. the camera has in effect a tilting back.' Better results could be had than the amateur snap below in which the camera has been canted sideways. The **Frena** had a between-the-lens rotary shutter giving speeds from 1/5 to 1/80 of a second, and was normally fitted with an f/8 rapid rectilinear.

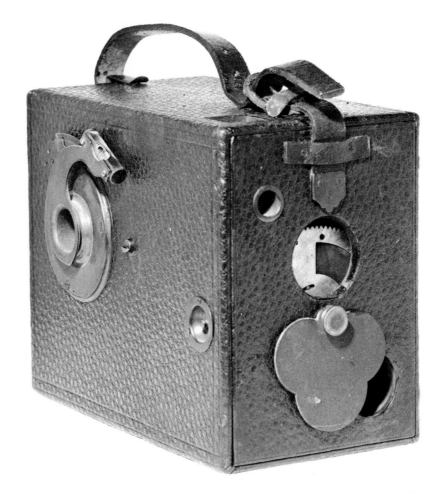

Ernemann's **Edison** 9×12 cm magazine quarter-plate camera was nicely made and fitted with a Zeiss anastigmat, series III No. 3 lens. A single control changed plates and reset the shutter; the viewfinders have metal flaps. This camera is described in the *Lexikon für Photographie und Reproduktionstechnik*, 1894.

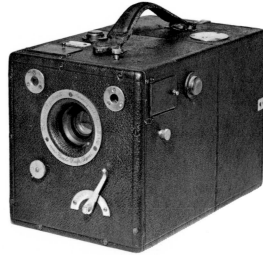

Plate-camera manufacturers became increasingly worried by George Eastman's press-button publicity. This well-made instrument designed by Guitton de Géraudy and noted in the 1895 *Annuaire Général de la Photographie* contains *two* clockwork motors so that 'simply pressing the button releases the shutter, exposes the plate, replaces it by another and simultaneously resets the shutter'. As the plates measured 13×18 cm (5×7 in) the whirring and clicking must have been quite formidable. The lens is a Zeiss anastigmat.

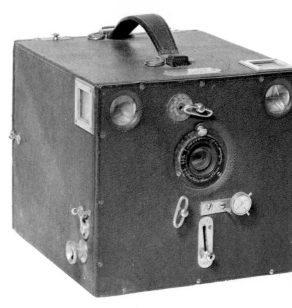

The Kodak **Bull's Eye No. 2**, a box camera of 1895, was the first to employ paper-backed rollfilm. It took 18 exposures, 3½in square. Fixed focus achromatic meniscus, with three stops and revolving disc shutter. Brilliant circular view-finder.

The 1895 **Pocket Kodak** (left) was Kodak's first small daylight-loading box camera, very similar to the 1896 model shown open, and an ancestor of the **Box Brownie** designed by Frank A. Brownell in 1900. Daylight-loading film was soon on sale in photographers' and chemists' shops throughout the world. Instead of being encumbered with plates or posting the entire camera back to the works to be processed and reloaded (see p. 119) amateurs could change spools in daylight. Film enough for 12 exposures 37×50 mm (1½×2 in) was enclosed in a strip of black paper substantially longer than the film and wound into a light-tight spool. Numbers printed in white on the backing-paper could be read through a small red window thus indicating how far to wind on the film. Measuring less than 96×72×57 mm (4×3×2¼in) this Kodak really would fit into a pocket. It was made partly of aluminium.

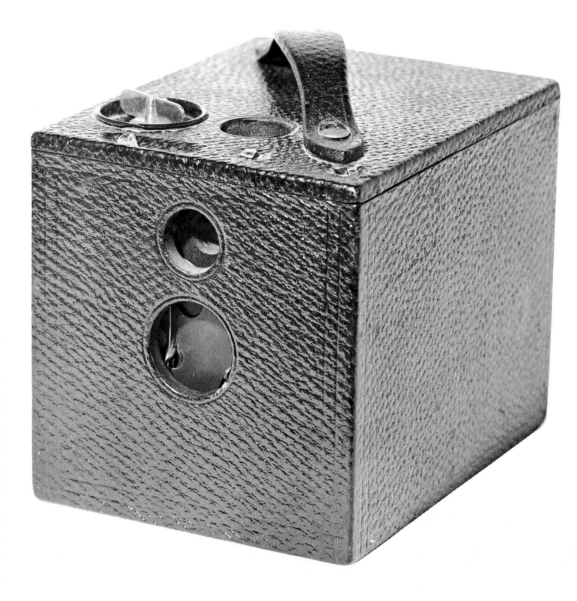

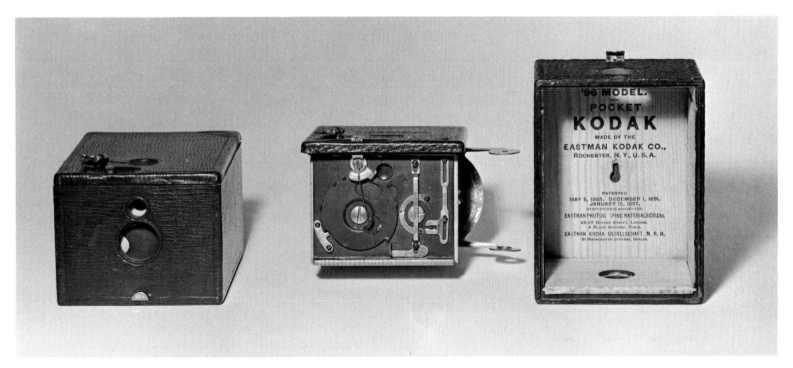

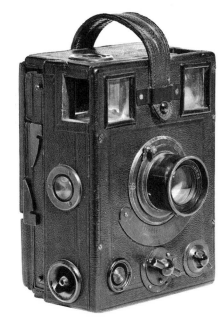

The Cadot **Detective Cyclos** quarter-plate used the same front as that manufacturer's **Vidi** and **Multiplex** Detectives and therefore borrowed their description. In fact it is what collectors call a 'tailboard camera' since the bellows and back telescope behind the front standard and the baseboard is hinged to swing upwards like the tailboard of a van, protecting the ground-glass screen. Here there is a top board as well. Dérogy Orthopériscopique lens in focusing mount; variable-speed shutter; metal dark slides.

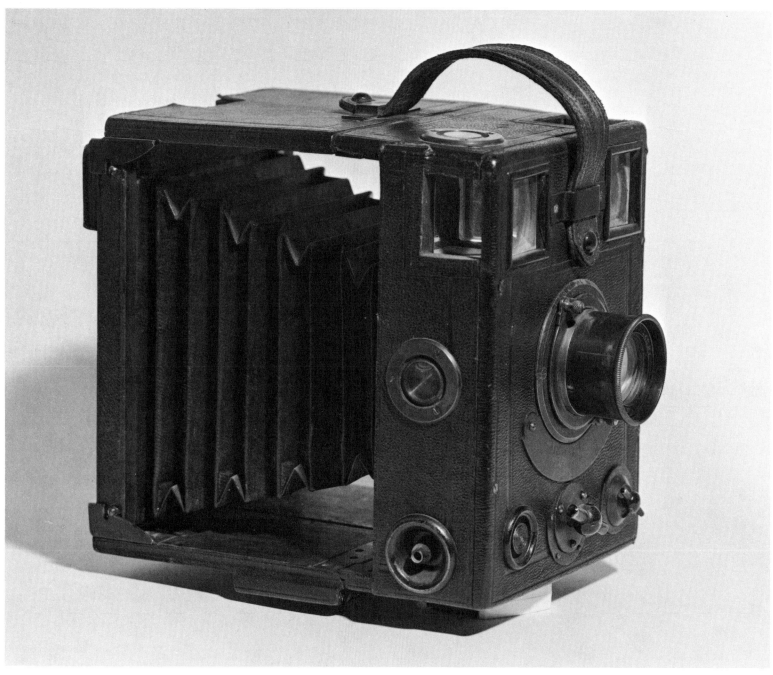

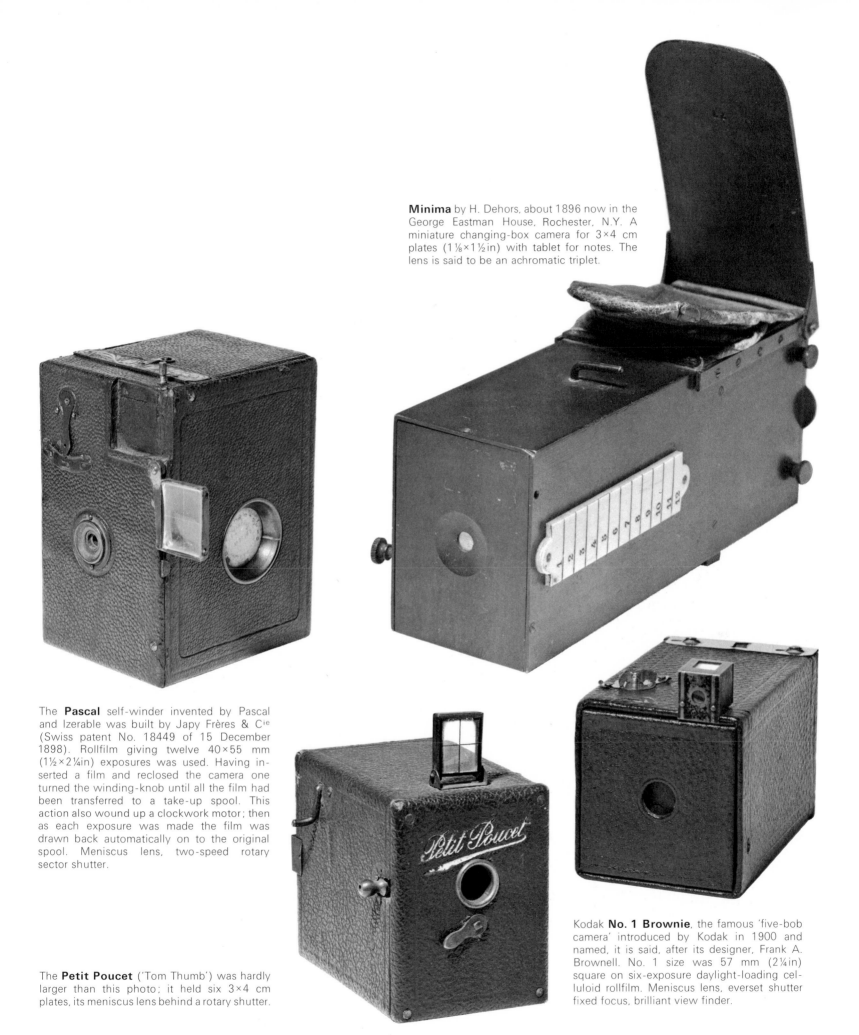

Minima by H. Dehors, about 1896 now in the George Eastman House, Rochester, N.Y. A miniature changing-box camera for 3×4 cm plates (1⅛×1½ in) with tablet for notes. The lens is said to be an achromatic triplet.

The **Pascal** self-winder invented by Pascal and Izerable was built by Japy Frères & Cⁱᵉ (Swiss patent No. 18449 of 15 December 1898). Rollfilm giving twelve 40×55 mm (1½×2¼ in) exposures was used. Having inserted a film and reclosed the camera one turned the winding-knob until all the film had been transferred to a take-up spool. This action also wound up a clockwork motor; then as each exposure was made the film was drawn back automatically on to the original spool. Meniscus lens, two-speed rotary sector shutter.

The **Petit Poucet** ('Tom Thumb') was hardly larger than this photo; it held six 3×4 cm plates, its meniscus lens behind a rotary shutter.

Kodak **No. 1 Brownie**, the famous 'five-bob camera' introduced by Kodak in 1900 and named, it is said, after its designer, Frank A. Brownell. No. 1 size was 57 mm (2¼ in) square on six-exposure daylight-loading celluloid rollfilm. Meniscus lens, everset shutter fixed focus, brilliant view finder.

129

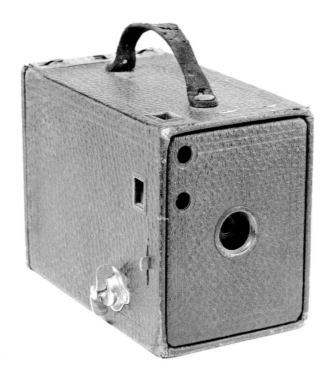

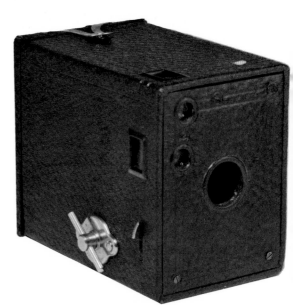

The **Brownie** series ran from 1900 until 1935. Towards the end of the period Kodak moved away from the 'black box' image and offered **Brownies** of several colours. This is a No. 2, taking six exposures on 120 film, 6×9 cm (2¼×3¼ in).

No. 0 Brownie, the original 'Christmas stocking' camera. It took 8 exposures 40×57 mm (1⅝×2½ in) on size 127 VPK (vest pocket Kodak) daylight loading film. Introduced 1914.

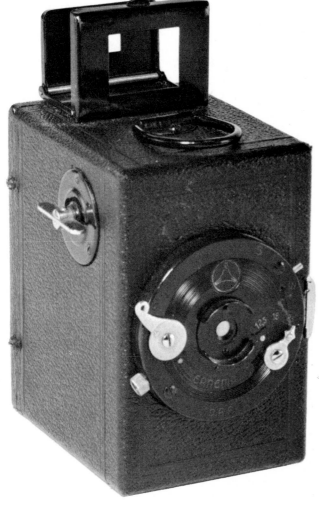

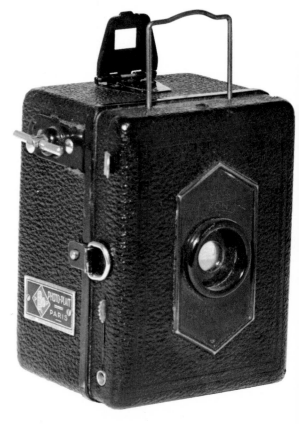

◁A cut above the ordinary box camera, with its folding direct vision finder and f/12.5 lens stopping down to f/18, the **Unette** used special film giving either 12 or 24 exposures 22×33 mm (⅞×1¾ in) and was made by Ernemann A.G., Dresden. It dates from 1924.

Offering better presentation and finish than many of its rivals, the Zeiss Ikon **Baby Box** appeared during the Depression, in 1931. Disappearing frame finder, Goerz Frontar lens and provision for a cable release; rotary shutter, 16 30×40 mm (1⅛×1½ in) exposures on daylight-loading VP rollfilm. The plate refers to a Paris retailer.

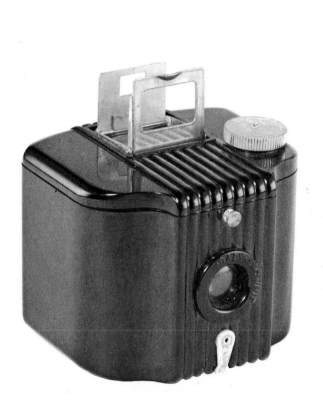

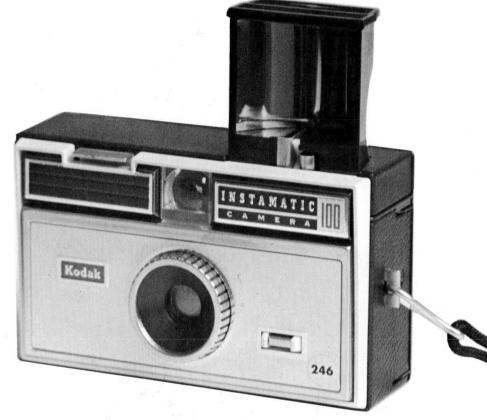

In 1935 the original **Brownies** were withdrawn, their square practical outlines replaced by this Stylist's Dream called **Baby Brownie**. The plastic material was 'galalithe'.

A **Pocket Instamatic 50** cost some five times as much as the 100 but takes the same Size 110 film. Focusing from 1 metre to infinity, 26 mm four-element Ektar f/2.7 with fixed aperture, electronic control of shutter speeds. Length 6 in (147 mm), weight including battery for the meter 8 ounces.

The Kodak **Instamatic 100** appeared in 1963 and reached a wide public. Nothing could be simpler: single-speed shutter, 3-element plastic lens, film supplied in instant-loading cartridges to be sent away for development. Outfit includes 'magicube' flash-bulbs.

131

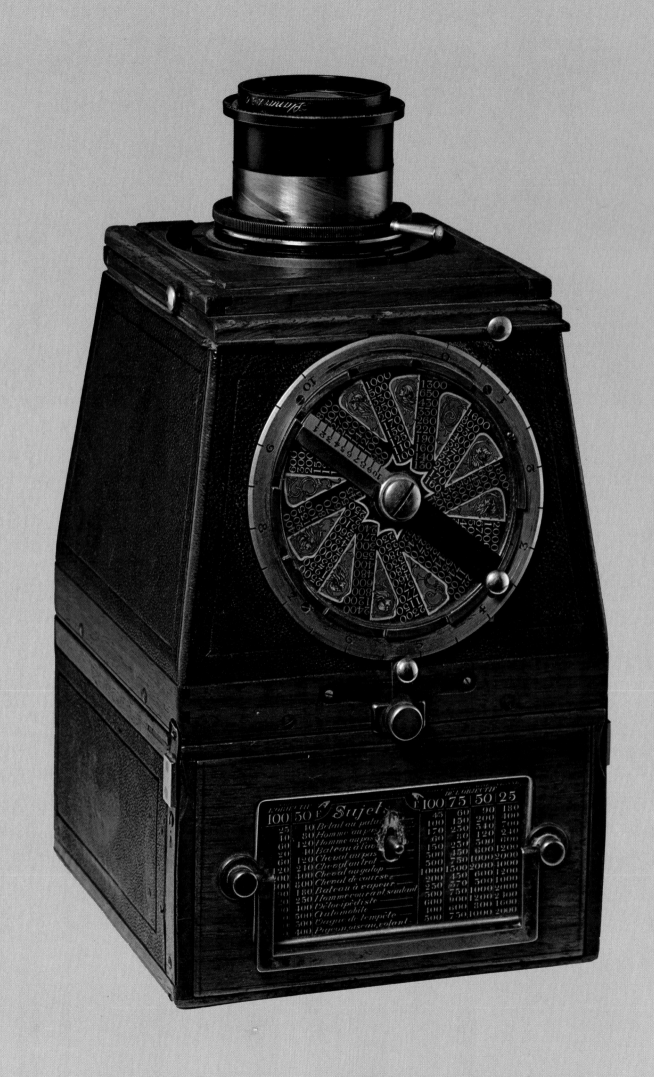

BOX FORM AND JUMELLE

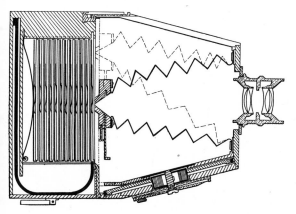

The original **Photo-Jumelle** ('field-glass camera') was designed in 1892 by Jules Carpentier, who built the **Cinématographe** for the Lumière brothers. One lens was used for taking, the other for focusing on a ground-glass screen. The optical industry was more than startled by the fine tolerances required by Carpentier, who demanded plus or minus one-hundredth of a millimetre (less than a 'thou.'). The example shown (Swiss patent No. 181190 17 November 1898) was developed for the Swiss painter Jean Guido Sigriste who wished to study the action of a racehorse. It has a 110 mm Zeiss Planar f/3.5 lens and the then new focal-plane shutter allowing exposures as fast as 1/2500 of a second. This comprised a blind of black cloth with a slit in it working between two rollers, placed immediately in front of the plate, i.e. as nearly as possible in the focal plane of the lens. Exposures could be varied by altering the width of the slit or adjusting the tension of the spring which operated the blind. As the diagram shows, a feature of this design was a conical bellows connecting with the slit in the blind and moving with it, thus excluding all extraneous light. Claims were made for a nominal 1/10000 sec.

The natural form for a camera is the box. So when rapid dry plates came in and later when the newfangled electric light made enlargements practical and cheap, camera designers took another look at the box, drawing inspiration from the pioneers' sliding-box cameras and from the Detective. What more natural then, than an instrument of tapering form like a pair of opera-glasses, the French for which is *jumelle* — "twin" or "binocular"?

The classic *jumelle* and the most expensive today is Carpentier's, made for Guido Sigrist, artist and wildlife photographer. It is seen in section on p. 133, which shows the "non-actinic envelope", a bellows made to travel with the focal-plane shutter and providing, the inventor claimed, exposures as short as 1/10,000 sec. Sigrists are beautifully finished, with much fine engraving; but there were many cheaper forms of jumelle, all slightly incongruous since the lens is situated at the small or "eye-piece" (p. 135) end. Focusing, when provided, could be by sliding box (p. 134) or by means of the lens mount. The design lent itself well to the inclusion of a changing-box (p. 134) or magazine (p. 135). A variant was the somewhat bulkier form made by Decaux and Bellieni (p. 139) which was a sort of non-folding Press camera — a "strut camera without struts", which may be compared with the Ensign Cupid (p. 140) which is clearly a bellows design without bellows.

A logical step from this was the Ermanox, perhaps the most covetable camera of the 1920s, and certainly the instrument that put "candid" photography on the map. Here the place of struts or bellows was taken by a rigid barrel for the enormous f/1.8 Ernostar lens in a focusing mount. Overall size was kept to a strict minimum by the use of plates. This was doubtless important to the candid cameraman; rollfilm would have added considerably to the bulk, and would have given us a form like that of the Zeiss-Ikon Kolibri or Roland (p. 142), a shape seen also in the Nagel (p. 143) and in an entire generation of 35 mm cameras starting with the Leica.

Stebbing's **Paper Rollfilm Camera**. This camera is described in the *Bulletin* of the Société Française de Photographie for 1883. Paper negatives enjoyed a brief revival during the early 1880s before giving way first to stripping gelatine film on paper, then to celluloid film. In 1881 Professor E. Stebbing had experimented in Paris with tanned gelatine film, rather unsuccessfully; he turned now to the rolls of gelatine bromide negative paper now marketed by several concerns including Morgan & Kidd and Warnecke & Co., of London. In the camera shown the paper was held flat during exposure by a spring against a glass plate. An audible click announced when the paper had been wound on and at the same time the paper was punctured at the edge to indicate where it might be cut in the darkroom.

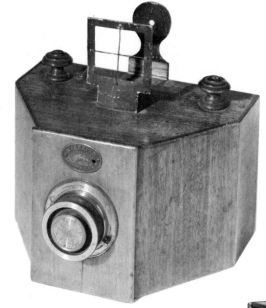

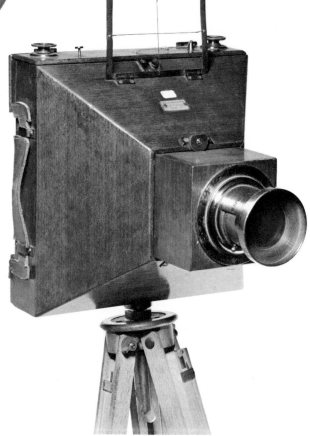

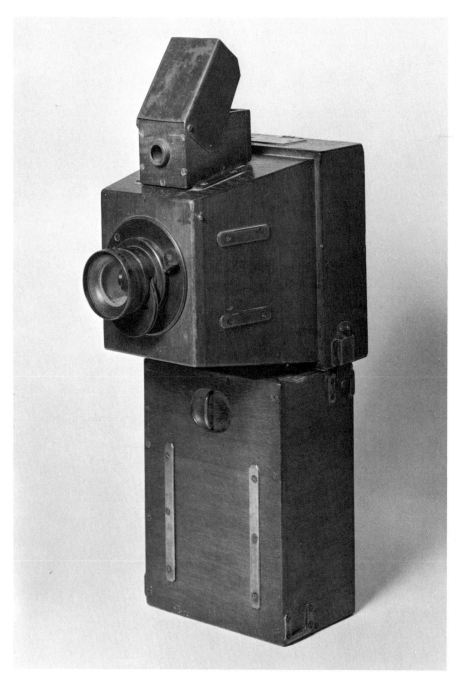

Ottomar Anschütz, whose estates at Leszno in Poland contained a private zoo, was a pioneer of high-speed animal photography. To capture the fleeting moment and thus analyse muscular action, he used a focal-plane shutter (see p. 133) giving speeds up to 1/1000 of a second in a stand camera for use from a hide. The wooden camera here is a prototype dating from 1891, with Goerz lens. From it over the ensuing decade was developed the famous folding bellows Goerz-Anschütz, best known of the early Press cameras (see page 161).

Alphonse Darlot **Rapide** changing-box camera communicated to the Société Française de Photographie on 4 November 1887. Twelve 8×9 cm (3¼×3½ in) plates were held in a rack in the magazine box, in the top of which was a light-tight slit. On turning the camera upside down one plate would fall into position for exposure. Exposed plates were transferred back in the same way. The lens, with wheel stops, is a Darlot rectilinear doublet.

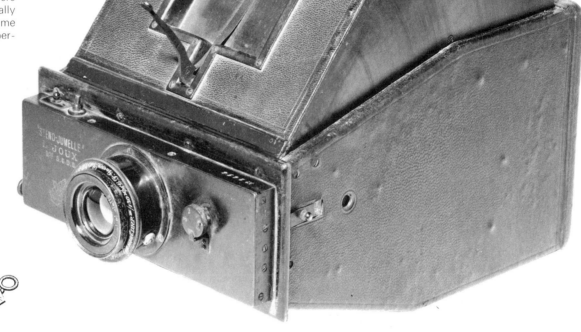

The **Steno-Jumelle** of L.Joux (French patent No. 239019 of 4 June 1894) was a magazine camera with hinged action (left). The five-speed guillotine shutter was in the panel behind the lens, a 130 mm f/8 anastigmat by Goerz. Note the direct-vision optical finder with its lens element behind. The dotted lines show how the 18 exposed plates were stowed. Format 9×12 (3½×4¾ in). Originally applied to twin-lens cameras, the name *Jumelle* came to refer to any camera of tapering 'opera-glass' form.

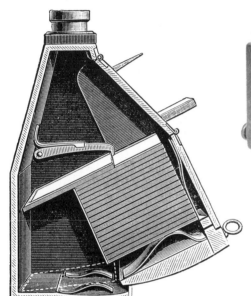

Passe-partout by Eugène Hanau, Paris. Demonstrated to the Société Française de Photographie on 6 December 1889, this 6×6 cm (2½ in square) camera should really be classed as a Detective. It has a between-the-lens rotary sector shutter and carries four plates in the double-sided dark slide.

Jules Carpentier, pioneer of precision cameras (see page 133) made his first binocular **Jumelle** in 1892. This is the 1898 model (Swiss patent 4911, 16 April 1898) seen from the front. The camera lens, a rapid rectilinear, is on the right, with six 4.4×6 cm (1¾×2⅜ in) plates in a changing-box behind. The large lens on the left projects an image on to a screen adjacent to the plate awaiting exposure which may be viewed, when the guillotine shutter is cocked, through a window in the base. The window has red glass to prevent fogging.

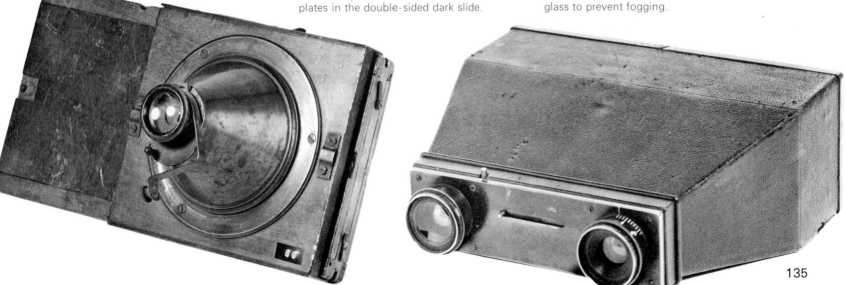

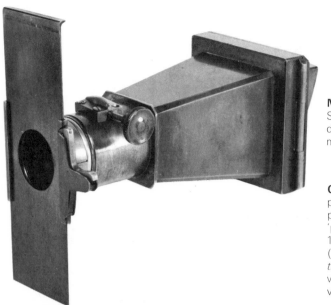

Marion metal camera by Marion, Soho Square. Focusing by racking front element of doublet lens. Drop shutter (sliding element missing in this example).

Chambre Automatique by Bertsch (French patent No. 47755, 29 June 1860), one of the pioneers of photomicrography famous for his 'phosphorescent apparatus of a glow-worm', 1857. He called this simple metal 6×6 cm (2½ in square) wet-collodion camera *automatique* because it was of fixed focus; a lens cap was used instead of shutter. The crude direct-vision finder is obviously a later addition.

Napoléon Conti's **Photosphère** was the ▷ subject of French patent no. 194 324 of 4 November 1888, and was a commercial success. The Compagnie Française de Photographie brought it out in four sizes: 8×9 cm (3¼×3½ in), 9×12 cm (3½×4¾ in), 9×18 cm (3½×7⅛ in) and 13×18 cm (5⅛×7⅛ in). A metal hemispherical (eyelid) shutter gave five speeds and time, but was not self-capping. The Zeiss-Kraus anastigmat lens had to be covered when the shutter was cocked. The camera came either with a metal plate-changing magazine, or a double wooden plate holder. Some models were made in aluminium, while the first version was made of silvered and blackened brass.

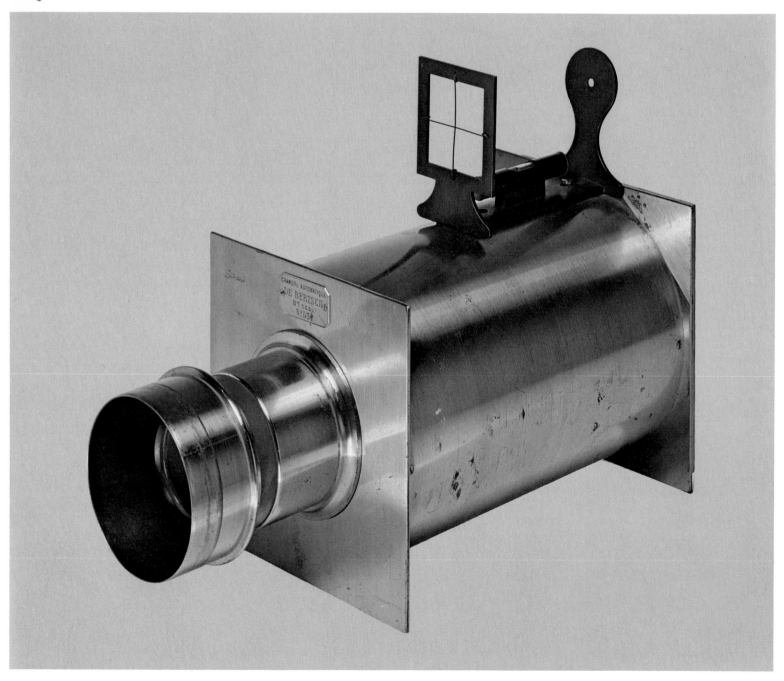

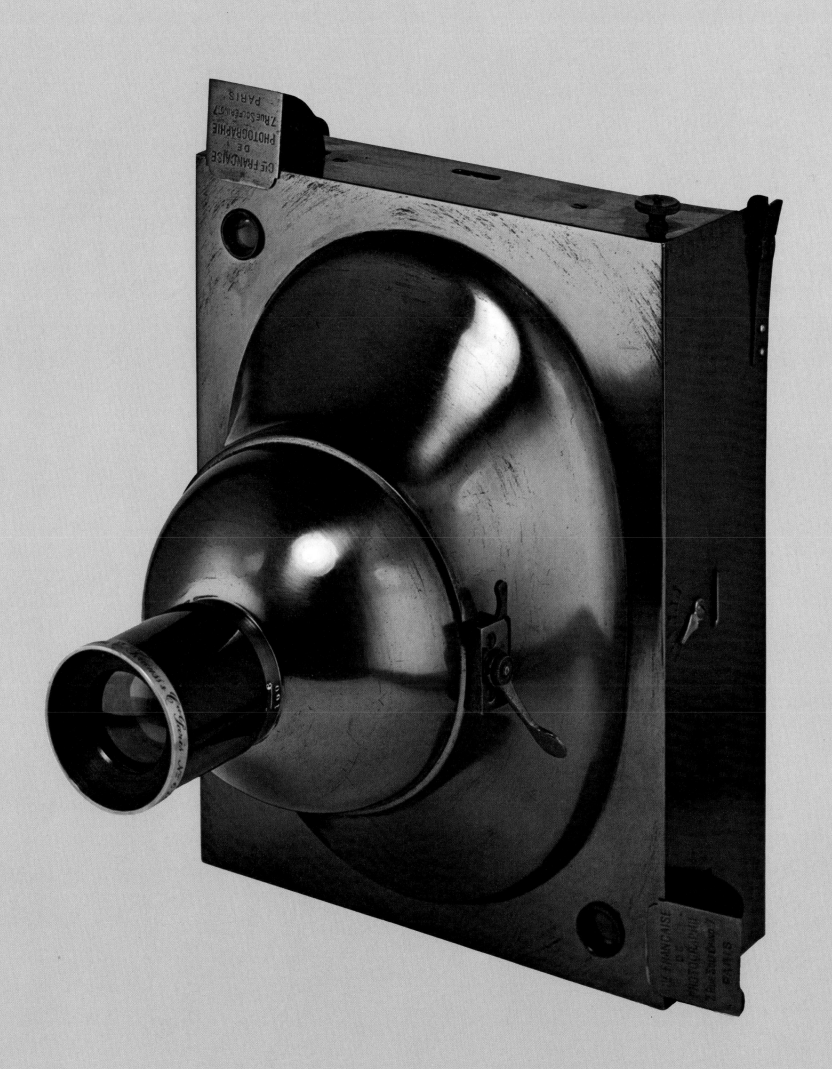

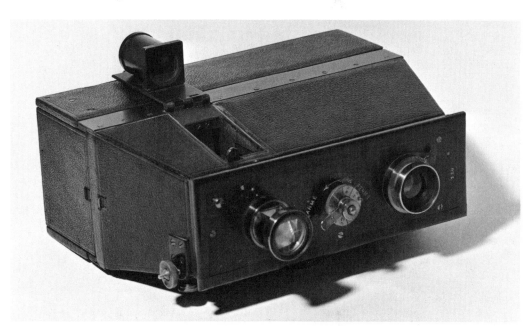

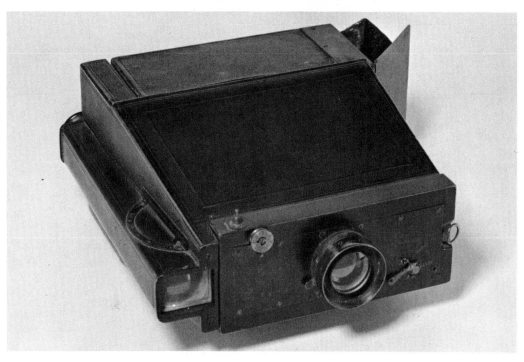

Described in *La Nature* during 1896, Mackenstein's **Jumelle** is interesting as an early twinlens reflex: the left-hand lens here was used for viewing via the folding optical finder, or the latter could be used on its own. The camera lens, right, is a 110 mm f/8 Zeiss-Krauss and the roller blind shutter gives 8 speeds. Eighteen 6×9 cm (2½×3½in) plates were carried in the magazine rack.

Sometimes called the 'poor man's *jumelle*'; the **Piccolo**, from Photo-Opéra, Paris, had in fact only one lens, and that a small meniscus with guillotine shutter. This was one of the few 'opera-glass' cameras to use rollfilm instead of plates. It gave 12 4×5 cm exposures (1⁹/₁₆× 2 in).

Profiting perhaps from publicity for Carpentier's twin-lens camera (page 135) J. Zion of Paris patented the instrument shown (French patent No. 233137 of 30 September 1893) and called it the **Simili-Jumelle.** Twelve 9×12 cm (3½×4¾in) plates were carried in a changing-box back (seen open). The lens is a 150 mm Zeiss-Krauss f/8 anastigmat, with 4-speed roller-blind shutter and focusing mount. Direct vision optical finder of tunnel type.

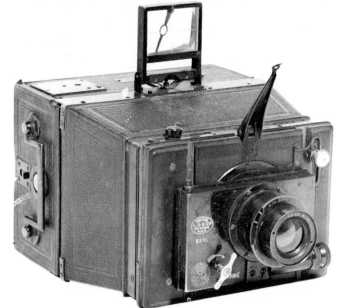

L. Gaumont's **Spido** is mentioned in the *Annuaire Général de la Photographie*, 1898. It has a Hanau changing-box magazine for twelve 9×12 cm quarter-plate plates with automatic spring-loaded changing. The camera has a direct view finder the foresight of which follows the movements of the rising- and cross front. A Decaux pneumatic shutter is fitted giving six speeds regulated by the rate of escape of air from a cylinder. The 130 mm f/8 Zeiss Protar is one of the earliest anastigmats, an unsymmetrical doublet comprising two cemented elements made from glasses developed by Abbe and Schott at Jena in 1888.

During the 1890s it was fashionable for any camera of tapering rectangular shape to be called a 'Jumelle' whether it had two lenses or not. This big hand camera, 9×14 cm (2½×5½ in), the **Jumelle** of H. Bellieni of Nancy has a single Zeiss Protar (as above) in focusing mount. It too has rising and cross fronts, but a pneumatic shutter of circular type with cylinder below the lens. Magazine back, direct finder. ▽

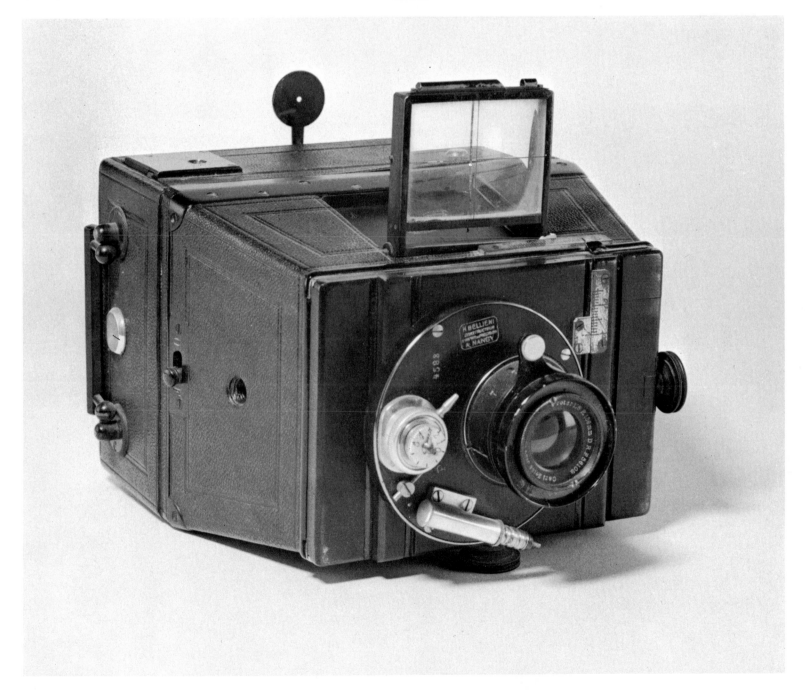

Photo-Ticket No. 2 camera by Louis Turillon of Paris, successor to Darlot, with f/4.5 95 mm lens of Petzval type. Described in *La Nature* during 1905, it took 4×5 cm (1½×2 in) rollfilm and the body was entirely of aluminium. Focal-plane shutter with exposed mechanism.

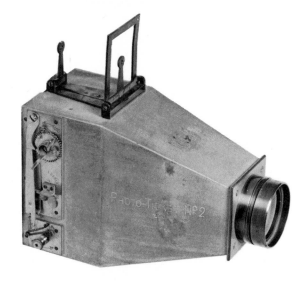

Made from aluminium and called for some reason **Le Marsouin** (the Porpoise) this magazine hand camera by Hanau, Paris, has that manufacturer's patent changing back for eighteen 4.5×8 cm (1⅜×3⅛in) plates. The lens is a 90 mm f/6.8 Goerz anastigmat. Roller-blind shutter for 1/25, 1/50 or 1/80 sec. and Bulb.

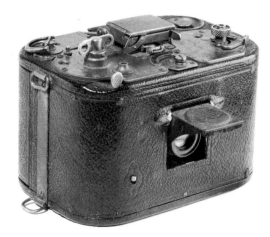

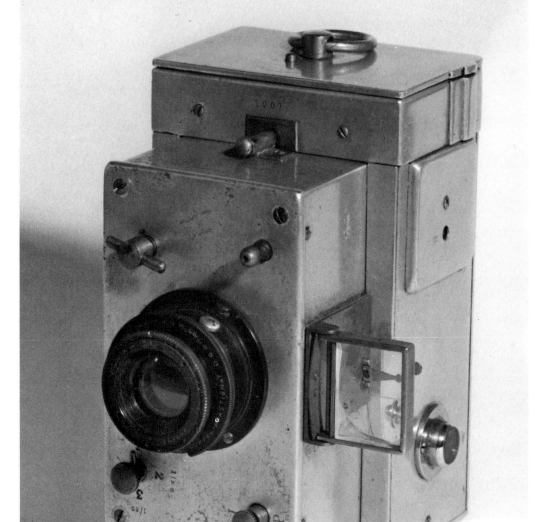

Original patents on the **Graphic No. 0** were taken out by Folmer and Schwing in 1911. Regarded very much as a miniature in its day, this nicely presented leatherbound camera used Vest Pocket Kodak (VPK) size 127 rollfilm to give eight 1½×2½in pictures. A focal plane shutter offered speeds from 1/10 to 1/500 of a second, and the Goerz 69 mm anastigmat worked between f/6.3 and f/32. Note the hinged lens protector and disappearing direct-vision view-finder.

Houghton Ltd, of High Holborn were predecessors of Houghton-Butcher Ltd and eventually Ilford Ltd; they manufactured for Sandersons and probably produced more cameras than any other British maker. This 1922 **Ensign Cupid** taking 120 rollfilm is hardly one of their happiest efforts, a frustrated bellows device made rigidly of metal. However it does have an f/12 meniscus, which was generous for a cheap camera, and a supplementary direct finder for optimists wishing to 'pan'. Price was 17s. 6d.

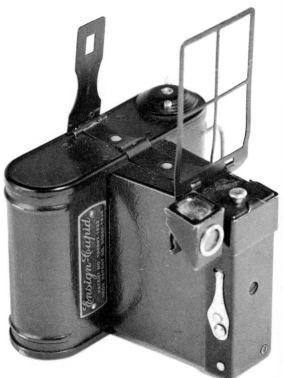

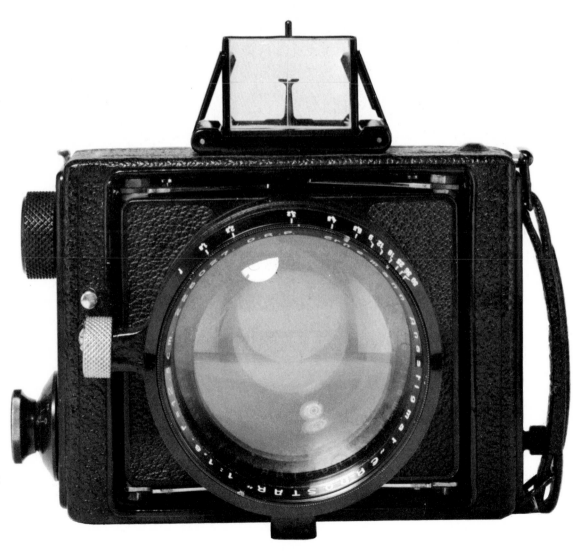

The **Ermanox**, launched by Ernemann-Werke A.G. of Dresden in 1924, must have bated more breath than any camera of its generation. When the summit of most amateurs' ambition was f/4.5 the **Ermanox** flaunted an Ernostar lens of f/1.8, an almost incredible light-gathering faculty for the period. It meant that when bad light limited an f/4.5 to 1/50 of a second, the **Ermanox** owner could use, in theory at least, 1/300. The lens could be stopped down to f/50 by means of its iris diaphragm and the focusing scale read to less than 4 feet, although of course even with the short focal length of 85 mm depth of field was limited. By using fast panchromatic plates the **Ermanox** could take pictures indoors by ordinary room lighting. This first real 'Candid Camera', was wielded by such operators as Erich Salomon (1886-1944) to gather many journalistic scoops. Format was 4.5×6 cm (1¾×2¼in) for either plates or cut film.

This **Ermanox** is a later and bigger model, taking 6×9 cm (2¼×3¼in) plate or film and equipped with an Ernostar of the same aperture, f/1.8, but longer focal length—125 mm. For this reason it had a bellows extension held rigid by struts. This camera, like the foregoing, had a focal-plane shutter speeded from about 1/20 to 1/1000 of a second. It is listed in the *Eder Jahrbuch für Photographie und Reproduktionstechnik*, 1925.

Also dating from 1930 but less obviously modelled on the Leica was the **Kolibri**, a Zeiss-Ikon pocket camera, also taking 16 on VPK film. It had the same Compur shutter but a 50 mm 1/3.5 Tessar lens, and with lens panel pushed in, as here, took up little room in the pocket. This was the first camera to take 16 exposures (3×4 cm) on a standard 8-exposure VP film; slightly vague viewfinder.

The **Roland** by Plasmat GmbH, Berlin represents a size larger, being one of the first (1931) of the 'sixteen on' cameras taking 16 exposures on 120 rollfilms, thus reverting to the original VP plate size 4.5×6 cm (1¾×2⅓in). Compur shutter, pull-out lens mount and very early use of built-in range-finder coupled to the focusing mount. The operation of turning the mount to bring two overlapping images in the viewfinder into register simultaneously focused the lens. The latter is a Kleinbild-Plasmat f/2.7 of 70 mm focal length; Compur shutter with built-in iris diaphragm stopping down to f/22. The calculator on the left is for exposures, showing the depth of field.

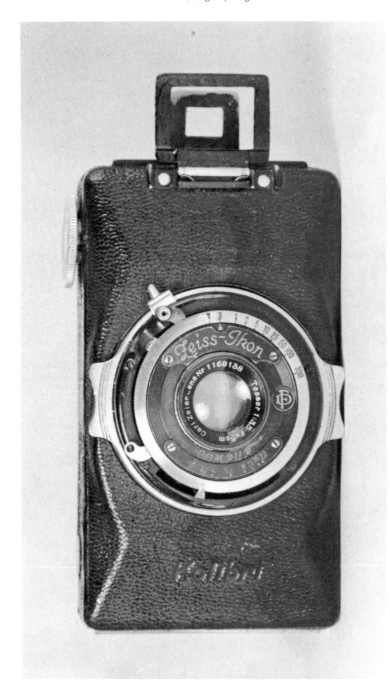

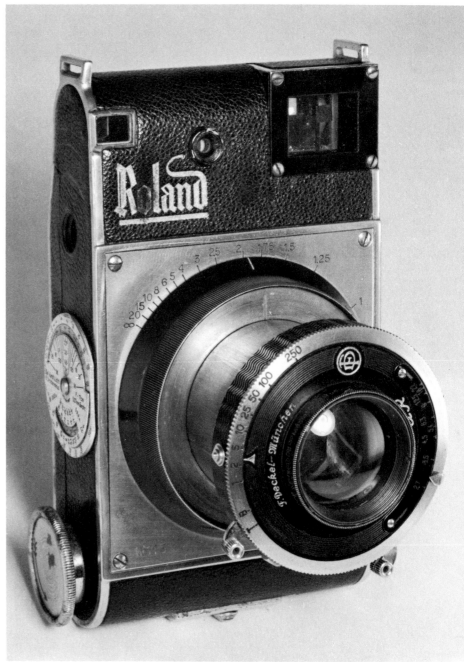

With the **Pupille** by Dr A. Nagel we move a step nearer the modern miniature. As the name suggests this 1930 camera was aimed at the student rather than the professional; people who thought the Leica too grand or too expensive, or mistrusted 35 mm stock. The **Pupille** gave 16 exposures on ordinary VPK 127 rollfilm obtainable anywhere. An f/2 45 mm Xenon by Schneider of Kreuznach, a Compur shutter with slow speeds as well as fast (1 sec to 1/300, T and B) made it a real candid camera.

As time goes on cameras have grown portly. They no longer slip into a pocket but dangle in a drop-front 'ever-ready' case. The Kodak **Medalist I** of 1941 is an example. It is not a miniature although built like one; it took eight 6×9 cm (2¼×3¼in) on the 620 film which was trying to oust 120. The lens is a 100 mm Kodak Ektar with iris diaphragm built into the Supermatic shutter which has speeds from 1 second to 1/400. The focusing knob, right, is geared to the lens mount, which is coupled to a built-in range-finder.

Koni-Omega Rapid. The Koni aspired to popularity as a press camera with photographers hitherto devoted to Leica or Contax. Originally named simply **Omega** and designed by the Simmons Bros, Inc., of New York about 1957 it was taken over by the Japanese Konica concern who produced this version in 1967 (see *Popular Photography* for February of that year). It gave 9 exposures on 120 film in interchangeable backs, i.e., it is a 'system' camera. Built-in light meter, automatic exposure setting, coupled focusing, viewfinder corrected for parallax. Rapid-wind lever (right).

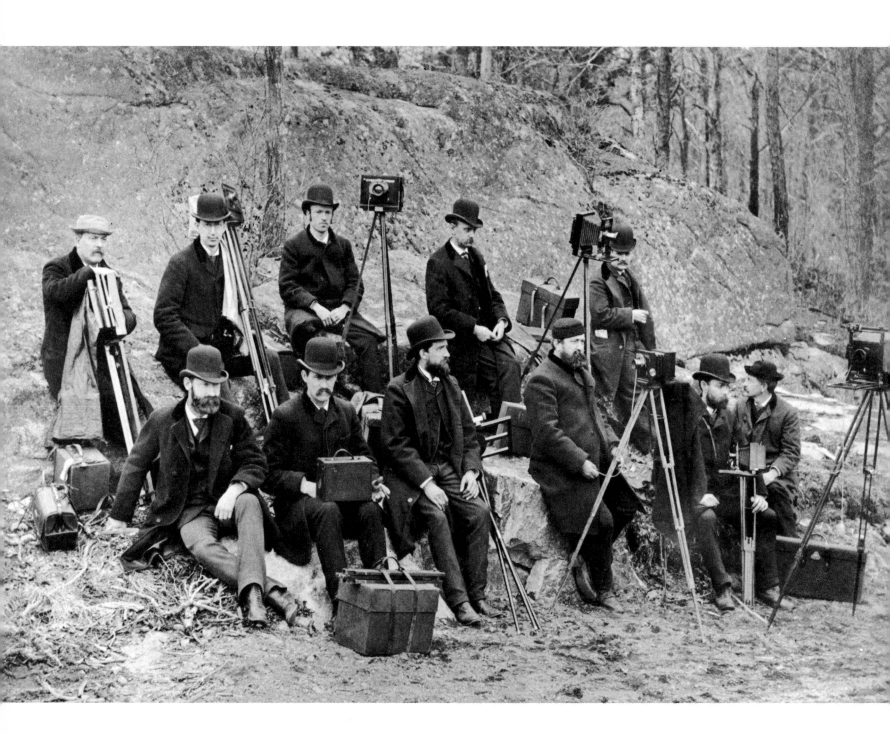

144

BELLOWS CAMERAS

After 1879 when relatively rapid dry plates liberated the photographic world from the tyranny of wet collodion, amateurs took up the pastime in a big way, some seriously, others as "mere buttonpushers". There was an immediate demand for apparatus lighter and less bulky than the classic Field camera. This new public required a camera which could be folded without detaching the lens and which when folded would be reasonably protected from damage. Quarter-plate (or 13×18 cm) became a popular size.

The first type to emerge was the "hand and stand", a bellows camera folding into a box, and equipped with "instantaneous" shutter, brilliant view-finder and focusing-scale. The front of the box let down to form a baseboard on which the lens standard moved, and many were equipped with such refinements as rising and cross fronts and a spirit level, but there remained the problem of dark slides, so that these ostensibly portable cameras normally travelled in a leather case.

True portability came with rollfilm, since rollfilm cameras were self-contained. They attained their classic shape with the Folding Pocket Kodak (page 149), a flat box with rounded ends and front-opening baseboard which superseded an earlier model having a pull-out front (page 161), forerunner of the strut, "lazy-tong" (trellis) and flat-folding designs treated in Part II of this chapter. Strut cameras, known in Germany as *Klapps* were especially popular on the Continent. Pressmen adopted the focal-plane Goerz-Anschütz as their favourite weapon, at first with plate back, later with film-pack adapter, for it must be remembered that film-pack gave a new lease of life to plate cameras, and that plates were long regarded as better than film for serious and permanent work.

Strut cameras, whether fixed-focus or fitted with racking fronts like the Goerz Tenax or with helical focusing lens-mounts, were certainly easier to set up than early baseboard designs, which were sometimes

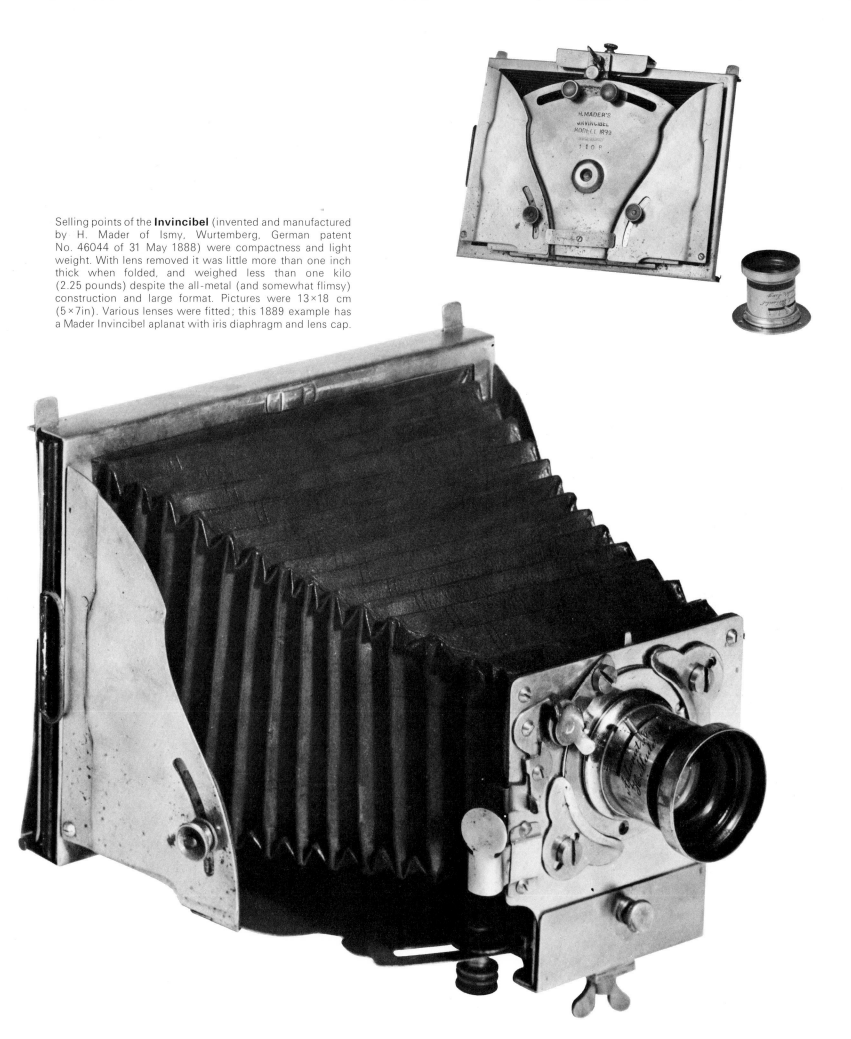

Selling points of the **Invincibel** (invented and manufactured by H. Mader of Ismy, Wurtemberg, German patent No. 46044 of 31 May 1888) were compactness and light weight. With lens removed it was little more than one inch thick when folded, and weighed less than one kilo (2.25 pounds) despite the all-metal (and somewhat flimsy) construction and large format. Pictures were 13×18 cm (5×7in). Various lenses were fitted; this 1889 example has a Mader Invincibel aplanat with iris diaphragm and lens cap.

Cristallos 6×9 (2¼×3¼in) by Jumeau and Jannin (French patent No. 206086 of 3 May 1890. An early French rollfilm camera with external wheel stops. (Kodak Museum, Harrow)

This 9×12 cm quarter-plate folding camera is unsigned. It has an f/8 165 mm lens and variable speed shutter and is equipped with a rising front. A typical 'hand-and-stand' camera of the period.

baffling to the uninitiated. They were also faster, which appealed to sportsmen and to the Press; but the lens being out in the open the camera had to travel in a box or wash-leather purse. The most popular strut camera of all was probably the Vest (waistcoat) Pocket Kodak, introduced in 1912, an instrument not for "photographers" but for the family and the tourist, taking 127 rollfilm for pictures 4×6.5 slightly longer and narrower than the Vest Pocket plate size (4.5×6) which had been popular since 1900.

During the 20s and 30s, quarter-plate, hitherto regarded as the normal size, gave way to 9×12 cm (2¼×3¼ in); then as D & P (developing and printing) firms acquired fixed-focus enlargers making "Magnaprints" and emulsions improved, 120 film was used to give not 8 but 12 or 16 exposures, and even VP film was subdivided under the influence of 35 mm apparatus.

Side by side with cheap folding snapshot cameras were those made for the expert, with lenses of f/4.5, f/3.5, and even f/2.9 in the case of the Dallmeyer Pentac. Great ingenuity was shown in the design of "self-erecting" mechanisms by which the camera sprang open ready for use when a button was pressed, and bellows designs, especially small-format cameras with side-opening baseboard (like the Zeiss-Ikon on page 156) proved admirably rigid. Some were equipped with coupled range-finder and built-in selenium cell.

For a collector folding hand cameras offer an almost bewildering choice: brassbound mahogany and tropical teak, composite construction, all metal, "funnies" in book form (pages 172-173), earlies like the Scenographe (page 160), right down to the automatic Super Kodak (page 171). Fancy finishes alone would make an interesting display: not just fine woods and morocco, but pigskin, hide, Russian leather, lizard-skin, crocodile; lacquered brass, stoved enamel, nickel, silver, even fittings plated in gold.

147

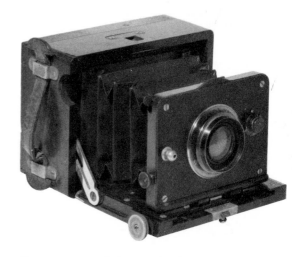

Krügeners Delta Patronen Flach-Kamera
was the full name of this 9×12 cm (roughly
quarter-plate) hand-and-stand camera taking
six on a roll of film and usable also with plates,
for which a separate focusing scale was
employed. Rising front, Delta shutter up to
1/100 sec., 180 mm f/9 Extra-Rapid-Aplanat
with iris diaphragm.

Guyard of Paris, inventor and maker of this
hand-and-stand instrument was very early on
the scene with rollfilm adaptors; he patented a
roller slide on 13 January 1887, French patent
No. 186377. This camera, using either plates
or film (twelve 13×18 cm [5×7 in] exposures
on a spool) has a 290 mm f/16 Balbreck
rectilinear lens and multi-speed between-the-
lens shutter. 'The so-called pocket cameras are
a delusion, a mockery and a snare' complained
a writer in 1882. This continued to be so. The
instrument here would be happier on a tripod
although the finder and distance-scale give it
hand-camera pretensions. However, it has a
roller slide back.

Derogy was well known in French photo-
graphic circles, having produced an interesting
combination lens as far back as 1858. The
Vercak seen here, a folding 6.5×9 cm
(2½×3½in) plate camera with his Ortho-
Periscopique lens is interesting as a very early
example (1897) of plastic construction.

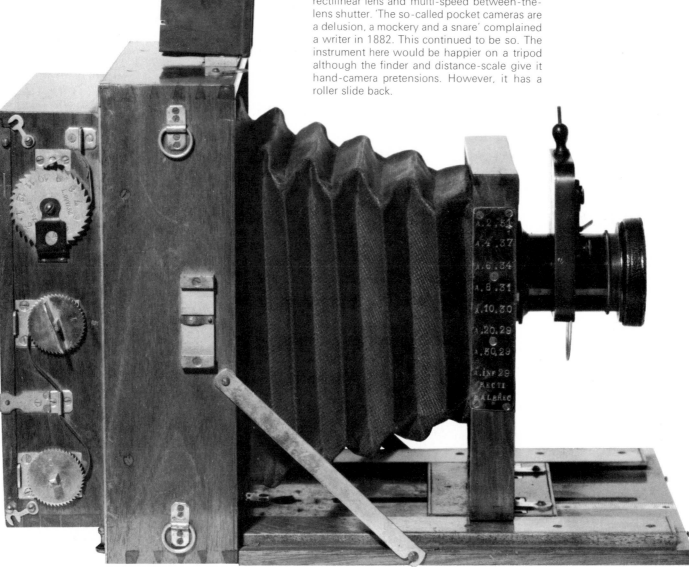

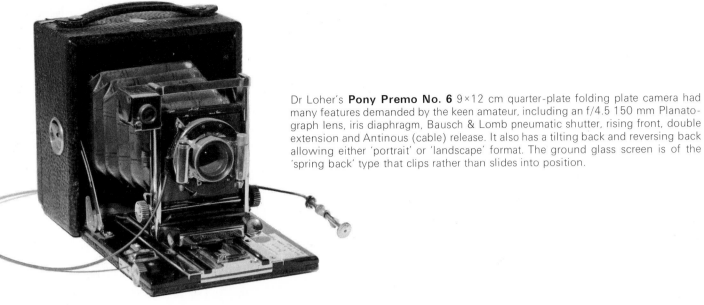

Dr Loher's **Pony Premo No. 6** 9×12 cm quarter-plate folding plate camera had many features demanded by the keen amateur, including an f/4.5 150 mm Planatograph lens, iris diaphragm, Bausch & Lomb pneumatic shutter, rising front, double extension and Antinous (cable) release. It also has a tilting back and reversing back allowing either 'portrait' or 'landscape' format. The ground glass screen is of the 'spring back' type that clips rather than slides into position.

Early hand-and-stand camera from Kodak:▷ **No. 5 Folding Kodak** (1890). No. 5 was the 7×5 in size. One of Eastman's earliest tapered-bellows cameras, folding into a box, and using the Eastman-Walker roll holder. Bausch & Lomb f/8 rapid rectilinear lens, reversible finder, swing back and exposure-counter, pneumatic shutter.

No. 3 Folding Pocket Kodak, 1900, taking 12 exposures on quarter-plate daylight-loading film. Shutter in morocco-covered front standard. The classic form of folding pocket camera has arrived.

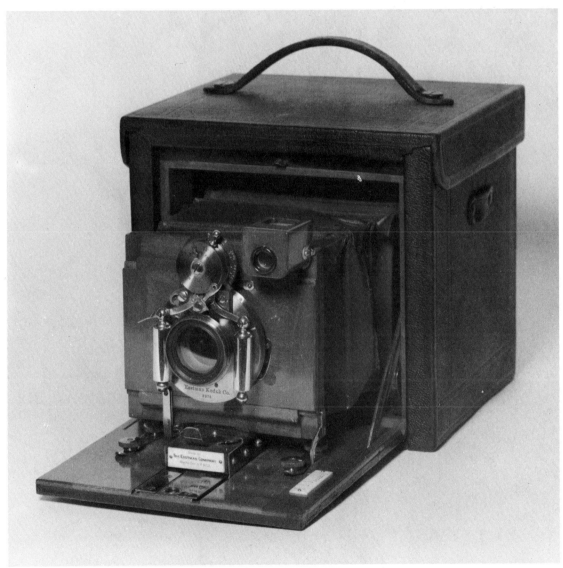

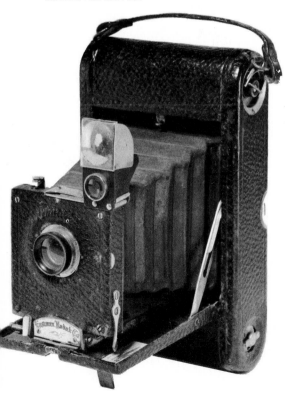

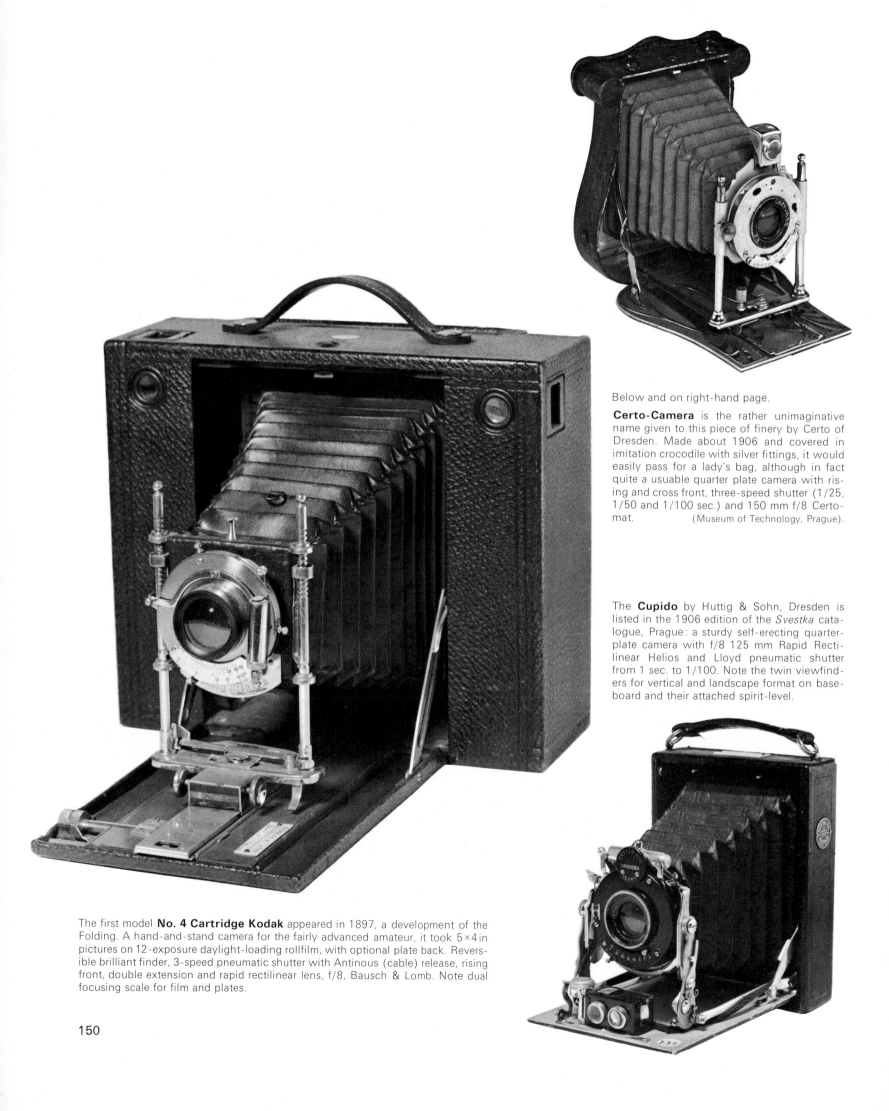

Below and on right-hand page.

Certo-Camera is the rather unimaginative name given to this piece of finery by Certo of Dresden. Made about 1906 and covered in imitation crocodile with silver fittings, it would easily pass for a lady's bag, although in fact quite a usuable quarter plate camera with rising and cross front, three-speed shutter (1/25, 1/50 and 1/100 sec.) and 150 mm f/8 Certomat. (Museum of Technology, Prague).

The **Cupido** by Huttig & Sohn, Dresden is listed in the 1906 edition of the *Svestka* catalogue, Prague: a sturdy self-erecting quarterplate camera with f/8 125 mm Rapid Rectilinear Helios and Lloyd pneumatic shutter from 1 sec. to 1/100. Note the twin viewfinders for vertical and landscape format on baseboard and their attached spirit-level.

The first model **No. 4 Cartridge Kodak** appeared in 1897, a development of the Folding. A hand-and-stand camera for the fairly advanced amateur, it took 5×4 in pictures on 12-exposure daylight-loading rollfilm, with optional plate back. Reversible brilliant finder, 3-speed pneumatic shutter with Antinous (cable) release, rising front, double extension and rapid rectilinear lens, f/8, Bausch & Lomb. Note dual focusing scale for film and plates.

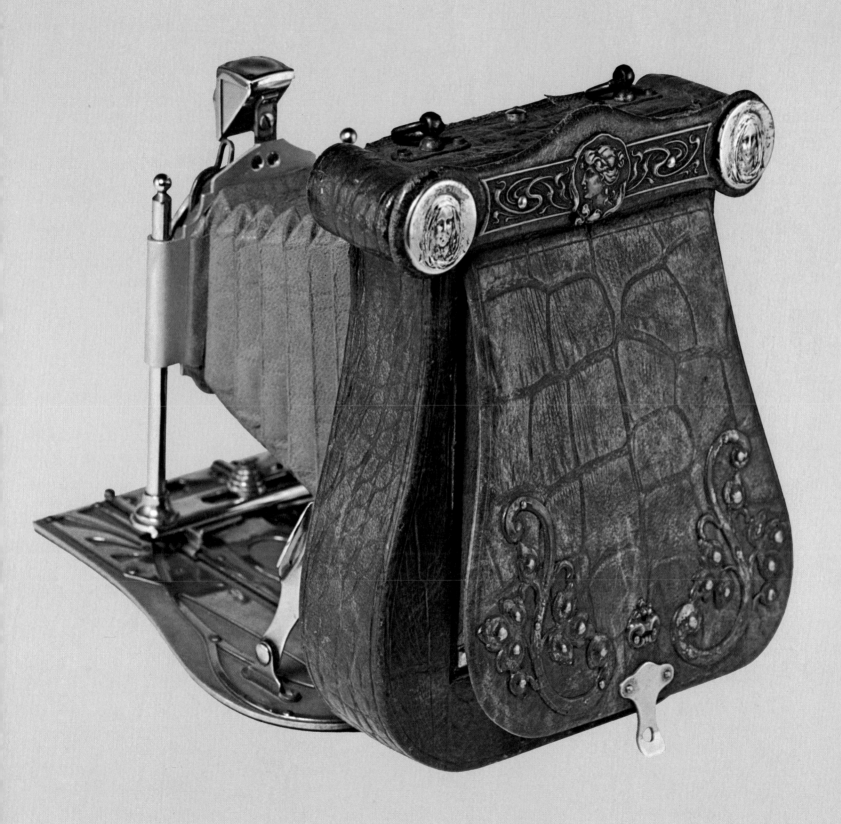

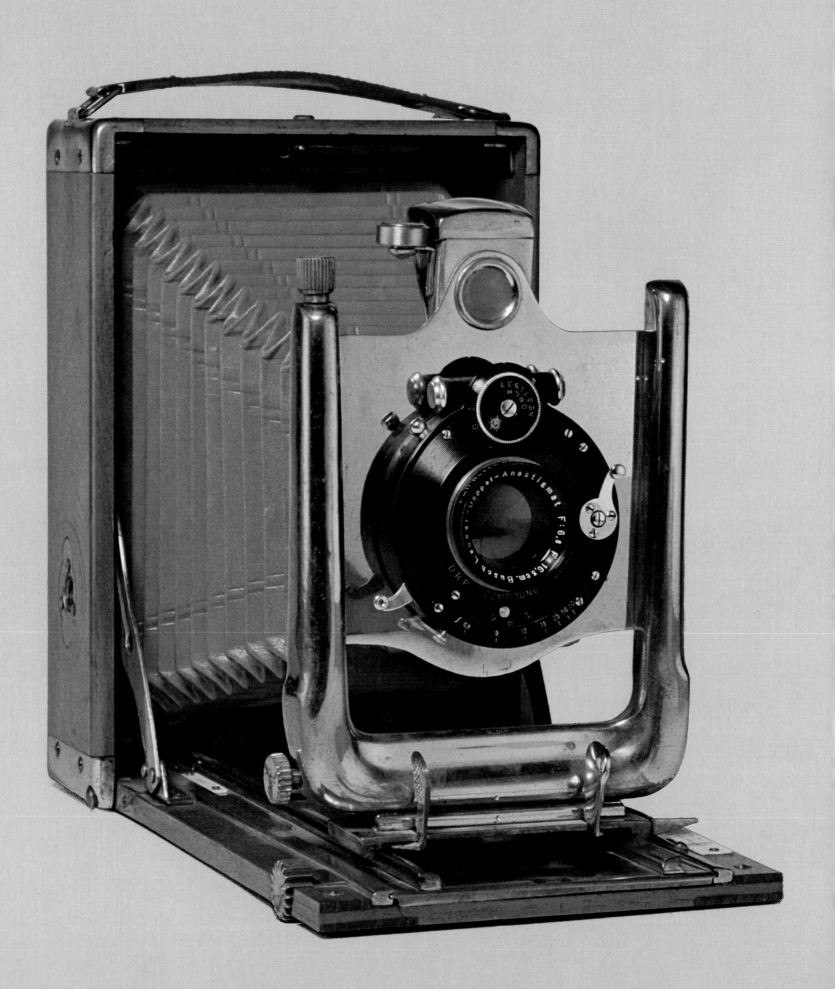

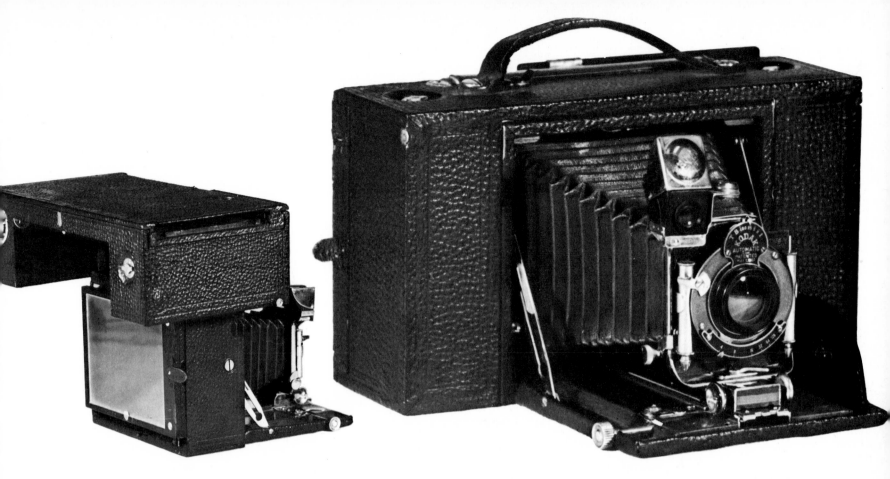

The **Phoenix** manufactured by W. Kenngott of Stuttgart is noticed in a 1924 catalogue called *Warenkunde des Photo und Kinohändlers*, although the fact that it has a Compound between-the-lens shutter, precursor of the same maker's Compur designed by Friedrich Deckel of Munich in 1912 suggests an earlier date. So do the brilliant finder with spirit level, rising and cross front for correcting vertical perspective when photographing tall buildings, and double extension. Maximum aperture of the universal 16.5 cm Busch Leukar lens is f/6.8 but the coloured bellows, brassbound woodwork and gilt metal put this camera in the luxury goods class.

Kodak's ingenious **Screen Focus model A No. 4** (5×4 in) combined the advantages of full-size focusing screen with those of daylight-loading film. A dark slide or shutter was inserted to cover the opening before raising the box (left).

E. Krauss, Paris, listed this **Takir** hand camera for 9×12 cm quarter-plate plates in 1902. The Zeiss Protar lens with which it is fitted was one of the first anastigmats, an unsymmetrical doublet comprising in effect the front component of a rapid rectilinear and the rear component of Ross's concentric lens, patented in 1888 and taking advantage of the new Jena glasses. This was a 'universal' lens, the components of which could be used separately or together. The Takir has double extension giving scope to the Protar both as a 135 mm f/8 or an f/12.5 of 224 mm focal length. Direct finder, rising, falling and cross movements. A focal-plane shutter is used, the winding-key of which may be seen, left. This camera may be regarded a fore-runner of the **Graflex**.

153

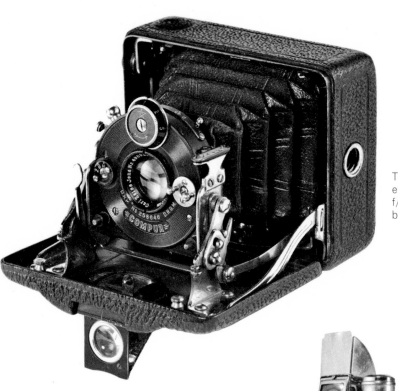

The **Atom** was made by Ica-Kamerawerke, Dresden, in 1913. It is a 4.5×6 cm self-erecting VP plate camera, i.e. it springs fully open on pressure of a button. A 65 mm f/6.3 Zeiss Tessar is housed in an early version of Compur shutter. Note folding brilliant viewfinder in the baseboard.

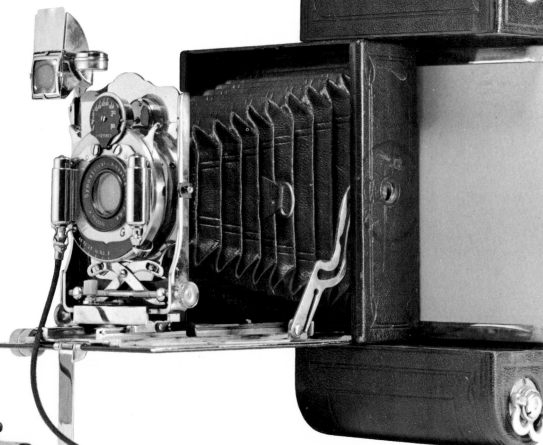

Saint-Etienne **Universelle**, 1908, a plate and rollfilm camera on the lines of a Screen Focus Kodak (see page 153). Roussel Symmetrical Anastigmat, 135 mm, f/6.8 in pneumatic shutter and built-in iris diaphragm, 1 sec. to 1/100.

1 A Speed Kodak, a camera taking 12 exposures on 6×9 cm 120 film which dates from 1909. With a 127 mm Bausch & Lomb 4.5 Tessar and Graflex focal-plane shutter giving 1/1000 of a second, it was aimed at the sporting public.

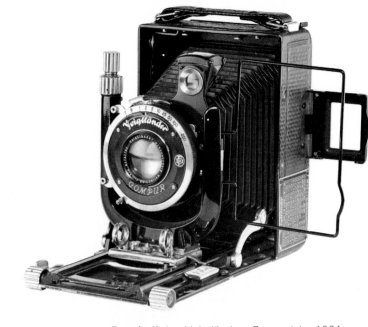

Bergheil by Voigtländer, Brunswick, 1934 example of a model introduced in 1925. Beautifully made and luxuriously covered in green Russian leather, this is a 6,5×9 cm (2⅜×3½in) plate camera which must often have been used with filmpack adaptor. Heliar f/4.5 105 mm lens in 1—1/250 Compur shutter, double extension, rising front, and it has both brilliant and frame finders.

Patent Etui-Kamera, so called because it folded almost as flat as a cigarette-case thanks to the double-strutting. *Photofreund* lists the model in 1924. Format 6.5×9 cm (2½×3¾in) plates, 105 mm Schneider Radionar f/6.3, Pronto shutter with speeds 1/25, 1/50, 1/100, T and B. Brilliant and wire frame finders.

Aluminium-bodied quarter-plate bellows plate camera, about 1920 by Kern, Aarau, Switzerland. Rising front, 120 mm f/4.5 Kern Anastigmat in Compur shutter, 1 to 1/250 sec.

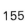

The original **Vest Pocket Kodak** of 1912 had ▷ undergone a sex-change by 1926 and lived in a 'vanity case'. On the left can be seen the stylus supplied with 'autographic' Kodaks in which, by lifting a flap, it was possible to write titles, etc. on the film itself. Eastman bought the rights of this invention from H. S. Caisman for half a million dollars. It was current from 1914-1934.

Zeiss-Ikon **Super-Ikonta 6/9** of 1934 for 8 exposures on 120 film. Zeiss Tessar 105 mm f/4.5, Compur shutter. This camera has a coupled range-finder of rotating wedge type, the signal-like arm of which stands out from the shutter. The knurled wheel was coupled to both lens mount and finder.

Kodak **Regent**, 1934. Built in the Kodak-Nagel factory at Stuttgart this is a typical German camera of the period taking eight on a 120 film, complete with f/4.5 Zeiss Tessar (more cheaply, a Schneider Xenar) and 1 to 1/400 sec. Compur Rapid shutter. It has also a coupled range-finder so that measuring the distance simultaneously focused the lens. The twin windows for the range-finder can be seen below the frame viewfinder.

By offering 16 exposures on a VP 127 film (3×4 cm [1³/₁₆×1⁹/₁₆in]) Dr Nagel, of Stuttgart, designer of the **Vollenda** (1932) was able to take advantage of the best miniature-camera lens of its day, the 50 mm Leitz Elmar f/3.5 as used in the Leica, while avoiding 35 mm film, which was less easy to find. Here it is mounted in a Compur shutter complete with delayed action device allowing the taker to appear in the picture. Optical direct finder.

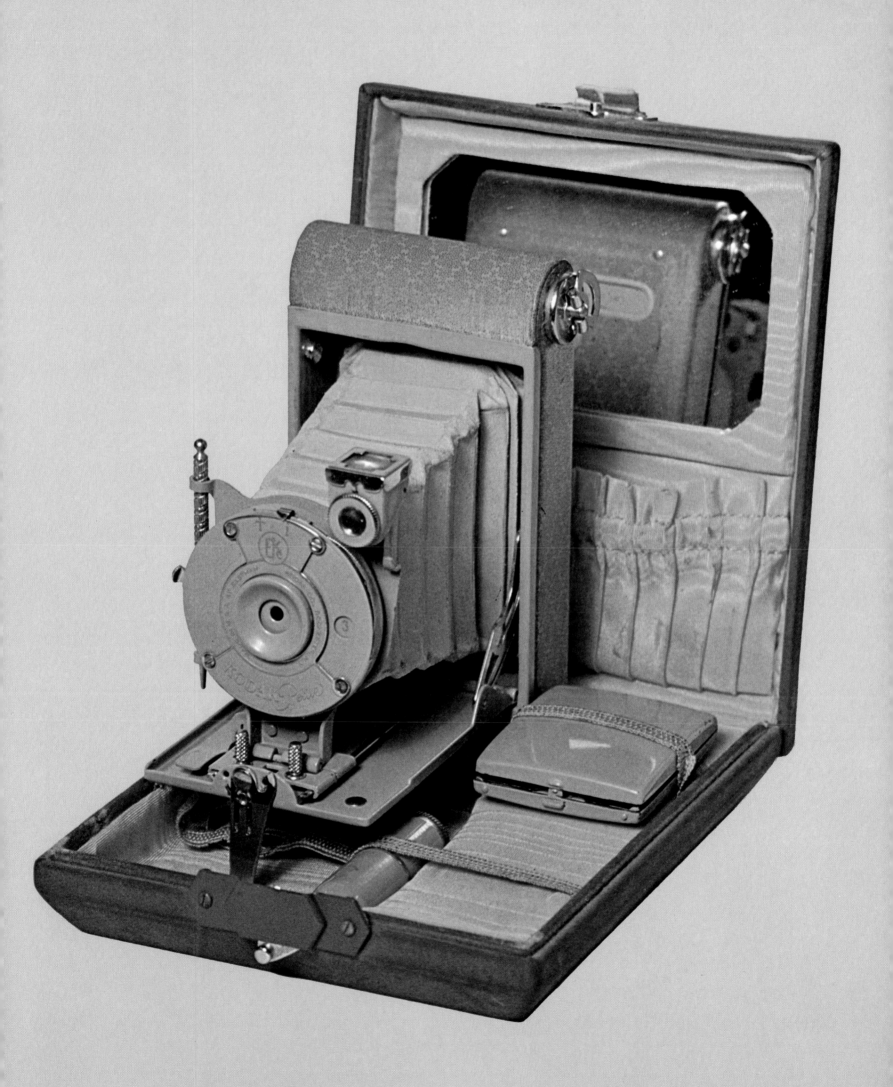

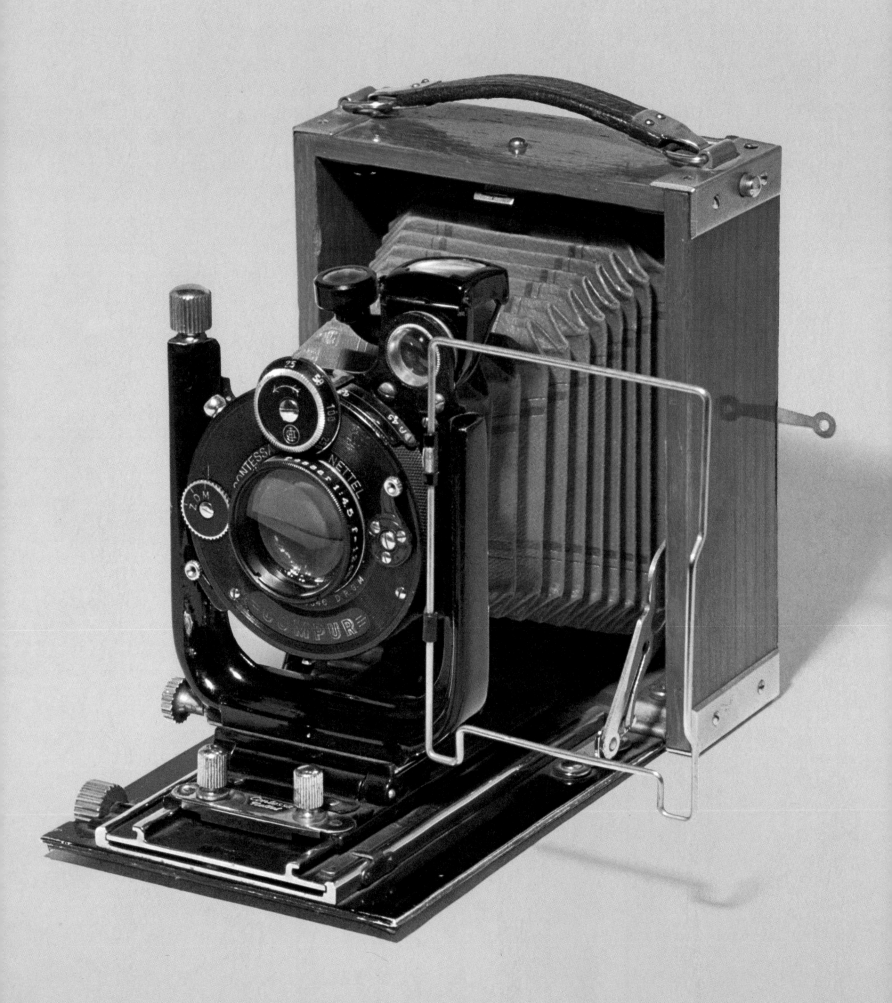

The **Super Ikonta 533/16** was listed by Zeiss in their 1937 catalogue and designed to take 12 pictures on 120 film. The highly covetable lens is an 80 mm Tessar f/2.8 in Compur Rapid shutter. As usual in good small cameras of the pre-war period it is fitted with coupled range-finding; it also has a built-in selenium-cell light-meter, the readings from which could be translated into aperture and shutter-speed. No automatic exposure-setting yet.

Voigtländer-**Prominent**, a 1932 model which took either 8 or—by insertion of a mask—16 views on an ordinary 120 film. Across the top lay a magnifying range-finder with coupled focusing (knurled button on right) and there was an optical exposure meter of extinction type. Compur shutter, 105 mm Heliar lens, f/4.5. A refinement was an orifice with light-trap to allow air into or out of the bellows as the camera was opened and shut.

◁ Contessa-Nettel **Tropen Adoro**, 1925. With body of teak specially made for the Tropics and very well finished, the Tropen took 6×9 cm (2⅜×3½in) plates and was quite 'fast', having 120 mm f/4.5 Zeiss Tessar and Compur shutter offering 1 sec. to 1/250.

The Voigtländer **Bessa** was a good quality 6×9 cm 120 camera listed in 1937. The coupled range-finder was neater than most, and the 105 mm f/3.5 Heliar lens and Compur Rapid shutter made it fast enough for most purposes. A filter, hinged to the lens mount, was a feature.

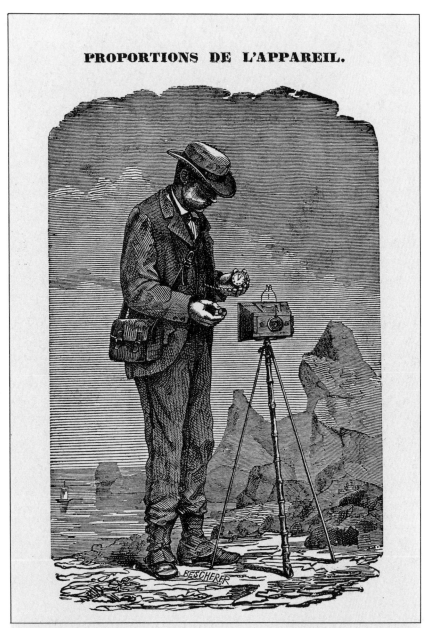

PROPORTIONS DE L'APPAREIL.

Ce trait noir indique la dimension des épreuves que l'on obtient avec le Scénographe.

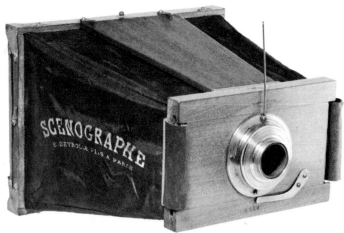

Vintage motorcars were not the only machines to be designed with a fabric body for lightness. E. Deyrolle Fils à Paris made their **Scenographe** largely of cloth. The walking-stick tripod is interesting: one leg packed inside the other and both then disappeared into the cane. The photographer is intent on his work, watch in one hand, lens cap in the other. Perhaps this is a portrait of the inventor, Dr Candèze, of Paris, who took out French patent No. 102784 on 26 March 1874 for this very portable instrument. It was versatile too because by sliding the lens panel sideways and inserting a division or 'septum' one could take stereoscopic views. Dry collodion or gelatine emulsion plates were used, 11×15 cm (4¼×5¾ in). Meniscus lens with washer stop.

160

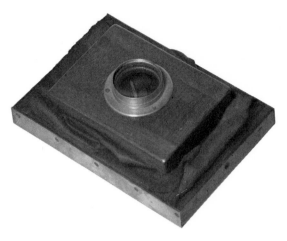

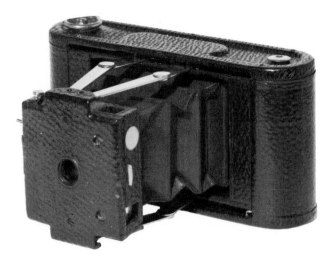

There is an element of burlesque about the **Photo-Gibus** which sprang open or shut like an opera-hat. When closed with the lens removed it was indeed flat. The finder is of later date.

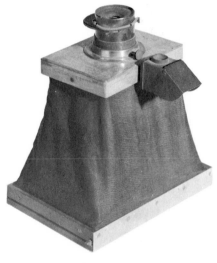

Folding Pocket Kodak No. 1. Early models, 1897-1900 were self-erecting strut cameras. The baseboard/lid came later, protecting the lens. This model was made by the Eastman Co. in 1898. It took 12 pictures, 2½×3¼in. The meniscus achromatic lens had a 3-piece diaphragm, and single-speed and time shutter.

Models à joues in which metal plates take the place of struts. This camera was patented by J. Fetter in 1900. It took 9×12 cm (3½×4¾in) plates. Verax anastigmat f/8, 150 mm lens, with iris and variable speed guillotine shutter.

Anschütz hand camera of 1895. This is a development of the tapered box stand camera of 1891 (page 134) and a forerunner of the famous f/4.5 Tessar Goerz-Anschütz press camera. This example has a Goerz double anastigmat Series III which, after 1904 was known as the Dagor. The upper picture with slide removed shows the signature 'Ottomar Anschütz, Lissa (Posen)' on the focal-plane shutter, which gave speeds up to 1/1000 of a second and was used by Anschütz for animal and bird photography. There are rising and cross-front movements for architectural work, and a focusing mount.

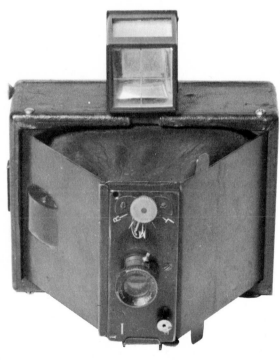

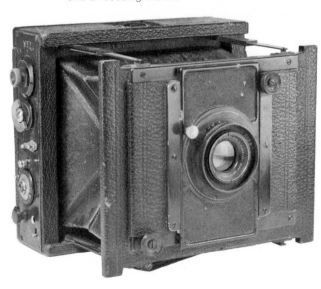

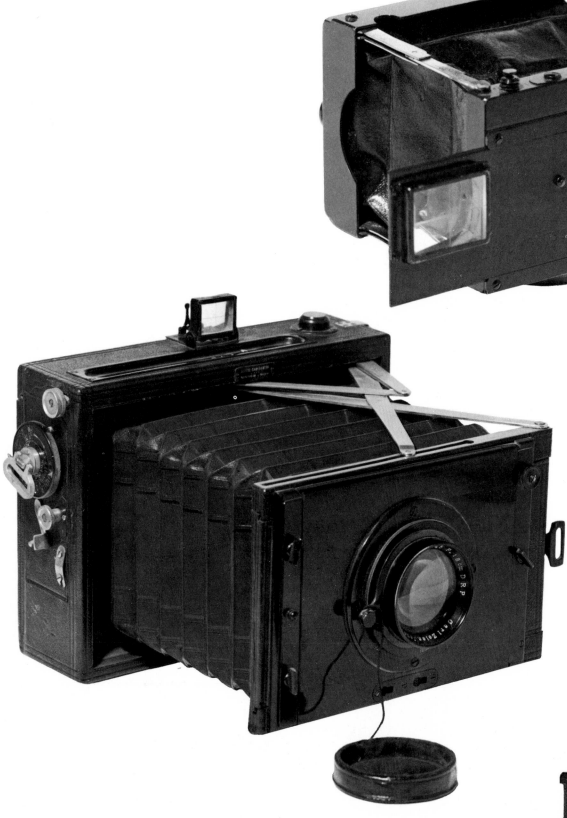

L. Gaumont, Paris, called this little folding plate camera (mentioned in *La Nature* 1903) **Bloc-Notes**, 'Notebook', as it would slip into a pocket. Format was the old VP plate size 4.5×6 cm (1¾×2¼ in). Fixed aperture Zeiss Protar 75 mm f/9; variable speed but uncalibrated drop shutter, cocked by drawing out the plate carrying the viewfinder.

Nettel-Deckrollo bellows strut camera by Nettel-Camerawerk, Sontheim, rather larger than quarter-plate (10×15 cm). The earliest examples date from 1904. Rising front, cross front, focusing mount, optical finder; the self-capping focal plane shutter offered a nominal 1/2800 of a second. The lens cap was used both for protection and time exposures. Zeiss Tessar f/4.5, 180 mm. *Deckrollo* is German for 'self-capping shutter' i.e. a blind which covers.

Patented on 19 December 1889 in Paris ▷ (No. 202706) this is the Dubroni **Photo-Sport**, Dubroni being an anagram of the French optician Bourdin. This 9×12 cm quarter-plate hand and stand camera had a 210 mm f/9 Planigraphe by Darlot with rotary sector shutter and rotating stop. The struts are stowed inside the cloth body, making quite a compact package.

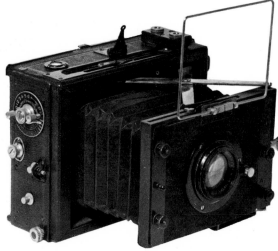

The **Klopsic**, cited in the *Bulletin de la Société Française de Photographie* 1903 is a French press camera resembling the Goerz-Anschütz taking 10×15 cm (4×6 in) plates. Instead of a Tessar it uses a 135 mm f/4.5 Flor lens by Berthiot. Focal-plane shutter from 1/2 sec. to 1/1200.

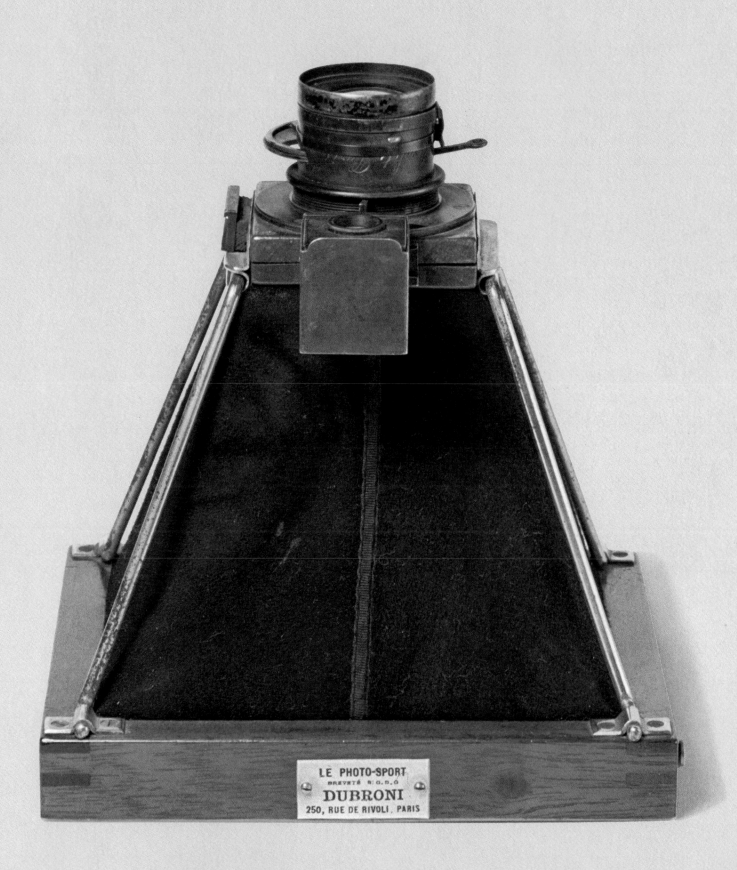

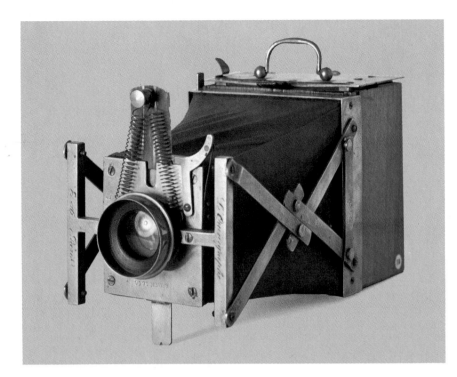

There is a charmingly engineering look about the **Omnigraph** patented by Hanau of Paris (no. 183257 of 2 May 1887). Having such sturdy struts it can well save weight on the bellows. This little quarter-plate was one of the earliest strut cameras. There are no stops but a blade shutter, worked by the springs, lurks between the elements of the R.R. lens.

Although unsigned this neat folding quarter-plate camera with wooden struts and changing-bag is almost certainly an early **Eclipse** by J.F. Shew & Co., of Newman Street, London. Shew sometimes fitted lenses by Darlot, and it may be no coincidence that cameras of this type were introduced to the French market by that Paris optician. The lens here is a 6 in Rapid Rectilinear f/9 with Waterhouse stops. Notches in the struts enable the lens-board to be set either for landscape work or groups. The **Eclipse** came out about 1888.

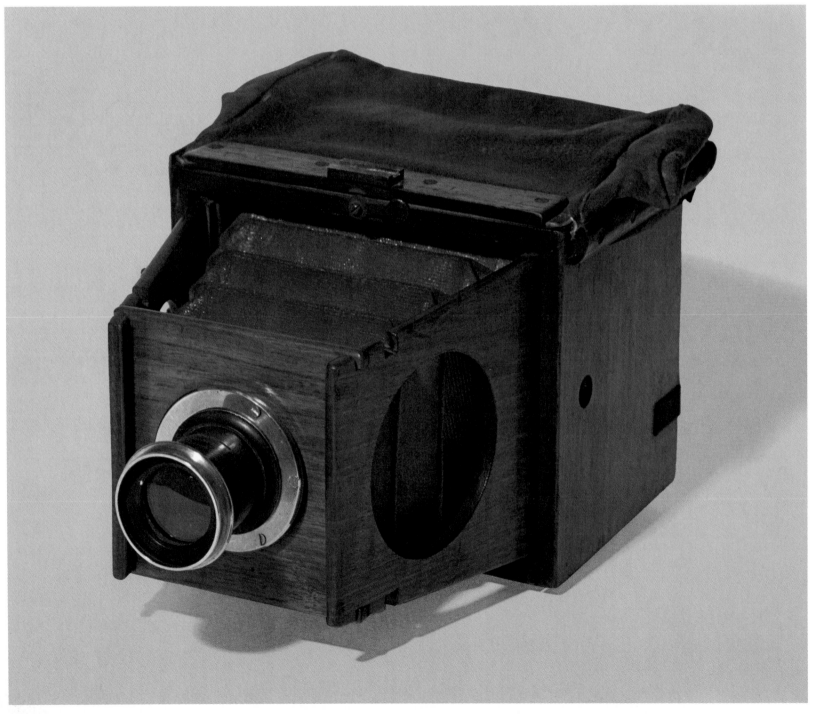

Nydia camera by Newman & Guardia (1900). A tapered-bellows folding camera with Wray f/8 rapid rectilinear lens and between-the-lens shutter of 'eyelid' type opening and closing to the centre. The changing-box, a development of the N & G changing-box for plates, holds 12 quarter-plate cut films in sheaths and has an exposure counter. The shutter gave speeds from 1/2 to 1/100 of a second.
(Science Museum, London)

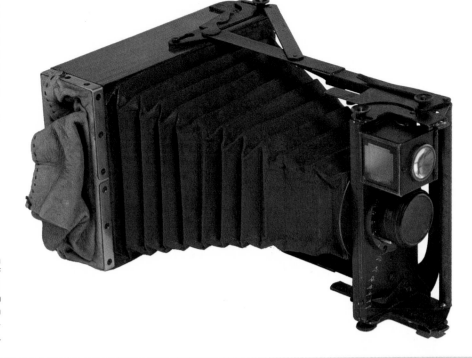

The Xit was the name given to this camera made partly of aluminium by Shew & Co. of London in 1898. It took 7,5×10 cm (3×4 in.) plates. The lens was a Dallmeyer f/6.135 mm focal length with diaphragm-iris and a Bausch & Lomb central shutter speeded from 1/2-1/100 sec. Focusing was by a helical screw.

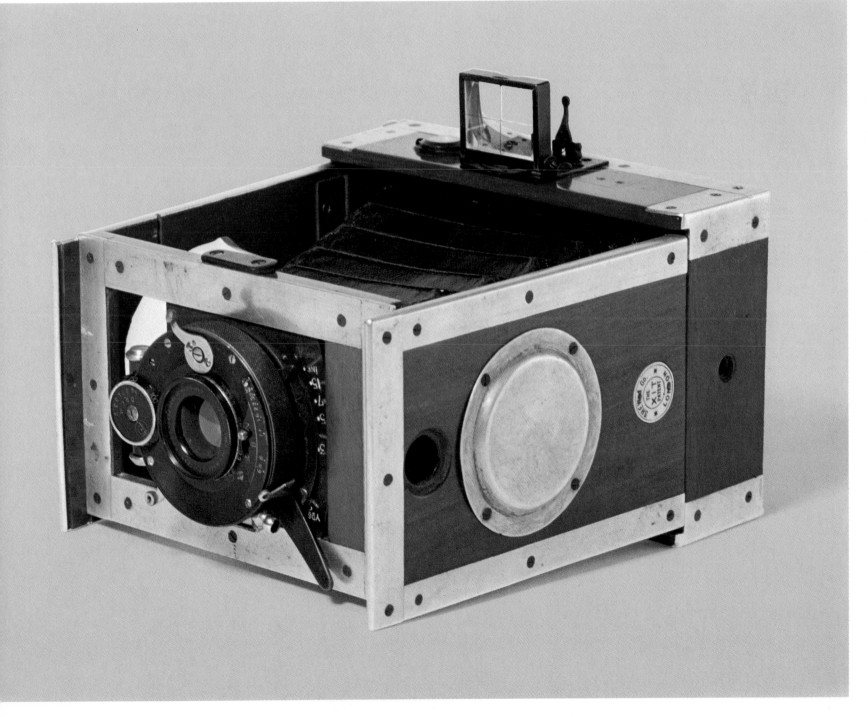

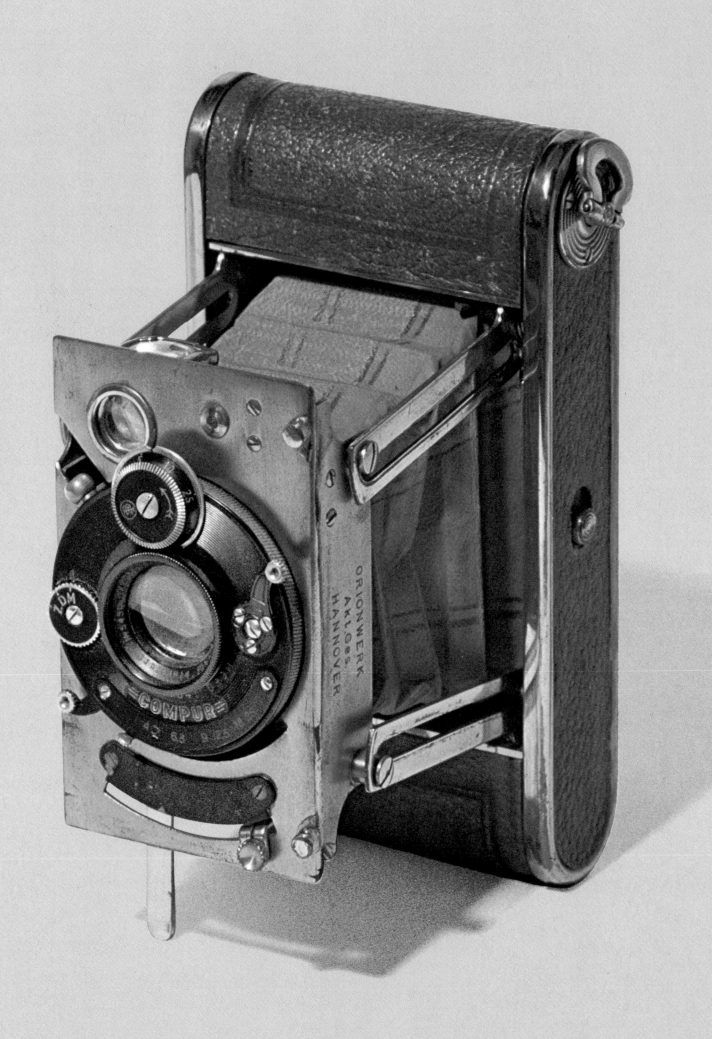

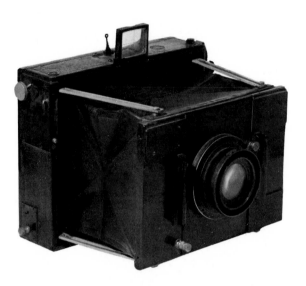

Simple strut camera by Ernemann A.G. Dresden, without model name. Focal-plane shutter, 180 mm f/4.8 Goerz double anastigmat Celor. Format 13×18 cm (5⅛×7⅛in).

◁This handsome Vest Pocket **Orion** rollfilm camera hailed from the Orion factory at Hanover and was made in 1920. The covering is morocco and all metal parts are gold-plated; but besides this it has an f/4.2 Plaubel Anticomar lens and 1 sec. to 1/300 dial-set Compur shutter fitted as standard.

A well-made VP folding camera by Ica A.G., Dresden, this is the **Ica Bébé**, with f/4.5 Tessar, no less, in shutter with speeds from 1 sec. to 1/250. Front panel racks out for focus.

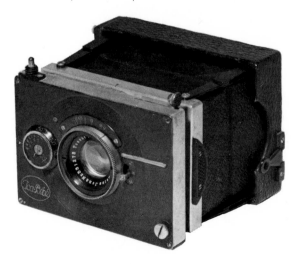

When launched in 1912 the **Vest Pocket Kodak**, or **V.P.K.** for short caused quite a stir. It meant what it said, as the camera stowed easily in a man's 'vest', i.e. waistcoat, pocket, being only an inch thick and less than 5 in long. It took eight 1⅝×2½in exposures on No. 127 daylight-loading film. The lazy-tongs made it quite rigid. Various models could be had, of which this is one of the more expensive, having an f/6.3 lens in 1/25, 1/50 sec., T and B shutter.

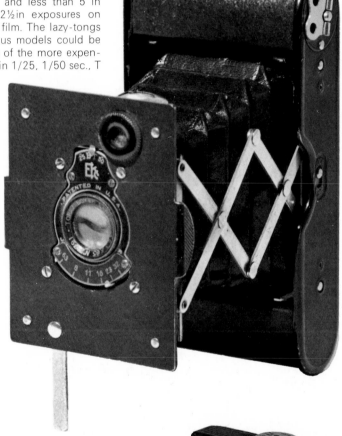

Tenax is a model name much used by Goerz. This VP plate camera is from their 1908 catalogue, a neat little instrument with 75 mm f/4.5 Goerz Dogmar in 1 sec. to 1/250 shutter. Shutter cocking on left. Dogmar lenses were used by the German Air Force during the First World War because of their flatness of field.

167

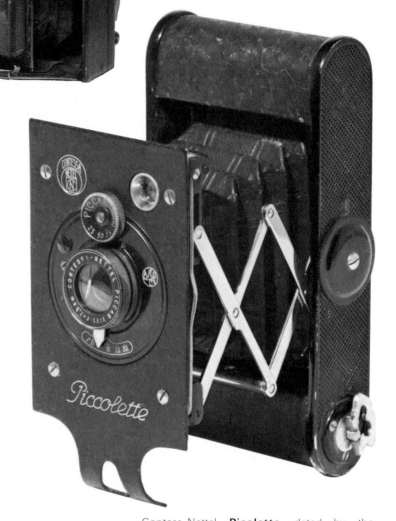

The Adams **Idento** folding quarter-plate camera, by Adams of Charing Cross Road, London. Described in the *British Journal Photographic Almanac* 1907. Ross Homocentric f/6.3 symmetrical four-element lens noted for its flat field and freedom from coma. Shutter speeds 1/2 to 1/100 of a second.

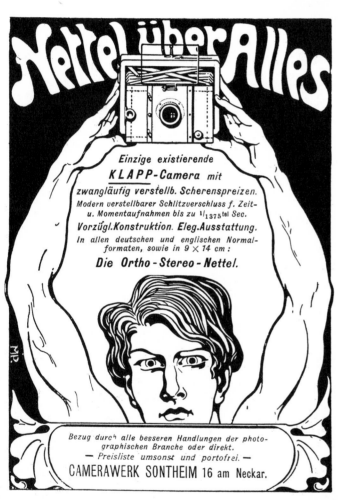

A somewhat chauvinist approach—understandable in wartime. A 1915 advertisement for the Nettel range of **Klapp** or strut-cameras.

Contess-Nettel **Picolette**, dated by the Munich Stadtmuseum as 1914. A VP plate camera with a strong German accent. Zeiss Tessar f/4.5 75 mm in 1—1/300 Compur shutter. The lens-panel/stand is strong and neat.

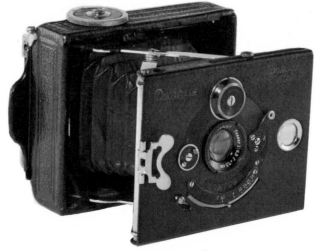

Contess-Nettel **Duchessa** VP plate camera (see *Photo pour Tous* catalogue, Geneva 1913). Zeiss Tessar f/6.3, 75 mm focal length in Compur 1—1/300 shutter.

A 100 mm (4 in) lens opening to f/2.9 puts this 6×9 cm (2⅜×3½ in) **Makina** miniature plate camera in the luxury pages of its makers' 1925 catalogue. A product of Plaubel & Co., Frankfurt, it has a 1–1/200 Compur shutter and three viewfinders: wire frame, optical with blue-glass eyepiece, and ground-glass screen. Many serious photographers preferred plates to rollfilm at this period; the camera was less bulky and exposures could be developed one at a time without waiting for the end of a spool.

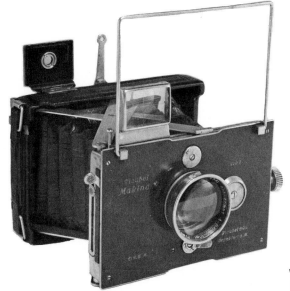

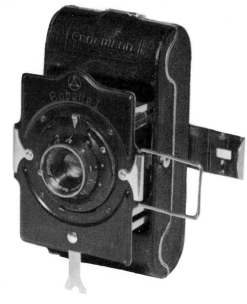

This chunky strut camera by Ernemann catalogued in 1925 offered Press camera advantages—plate back, 1/1000 sec. focal-plane shutter, direct finder, f/4.5 Ernotar 75 mm lens—with the portability of VP format, 4.5×6 cm (1¾×2⅜ in).

With its pivoted prop foot in position, this Ernemann **Bobette I** seems to stand midway between the Leitz Leica, its senior by a year having been launched commercially in 1924, and conventional VP cameras, because it takes neither 127 film like the latter nor 35 mm cine stock. Users had a choice of 12 or 24 exposures each 22×35 mm. The lens is a 50 mm f/4.5 Ernoplast in central 1/25–1/100 shutter.

The **Muro** was manufactured by the brothers Murer at Milan immediately after the First World War; it is listed in the *Photo-Hall* catalogue of July 1919 in 6.5×9 cm (2½×3½ in) format. Four years previously it had been noticed by the *British Journal Photographic Almanac* 1915 with Aldis anastigmat and 4.5×6 cm (1¾×2⅜ in) plates, the VP size. Fitted with the Murer 70 mm f/4.5 anastigmat seen here, focal-plane shutter and direct finder, this might be called a miniature Press camera. The sliding viewfinder doubles as lens-protector.

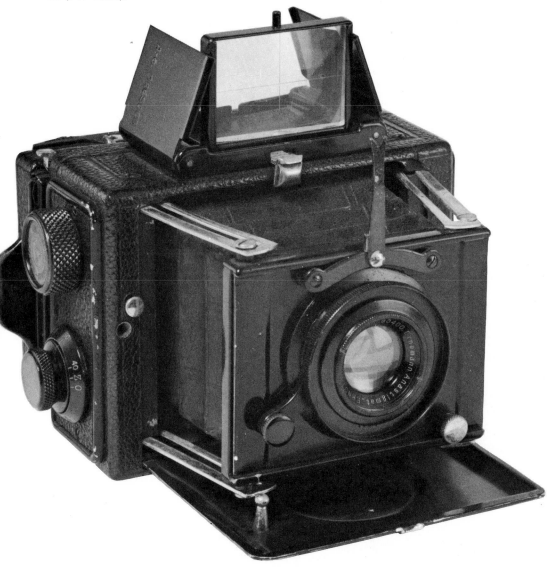

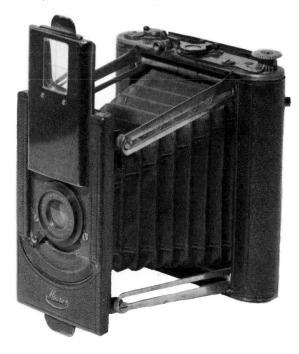

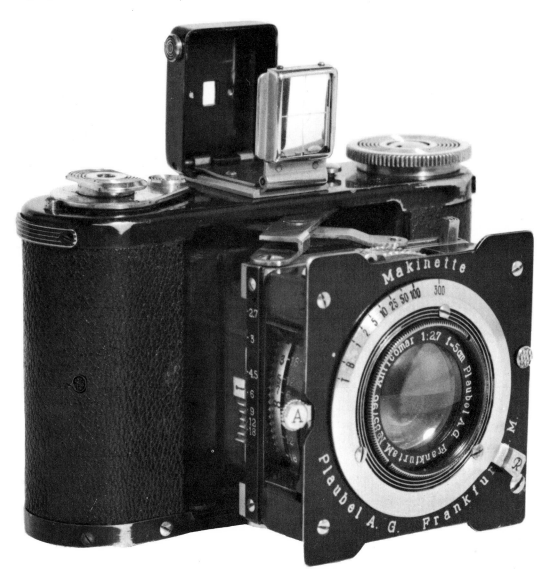

Here shown larger than life, the Plaubel **Makinette** was put out during the Depression (1929-31) as a competitor to the Leica, taking sixteen 3×4 cm (1¼×1⅝in) on a VP 127 film. The small picture and short focal length (50 mm, like the Leitz Elmar) allowed an aperture of f/2.7, continuing a Plaubel policy already noted on page 169.

From the same stable as the Plaubel **Makinette**, the **Makina** plate or filmpack camera of 1934 has a coupled range-finder and was sold with optional rollfilm adaptor or, of course, filmpack. Interchangeable lenses were available. Most examples have the f/2.9 Anticomar, but this one is fitted with a Plaubel-Reflex f/4.5 in Compur shutter.

Ernemann 10×15 cm (4×6in) focal-plane press plate camera catalogue by Zeiss Ikon in 1927. The big f/4.5 Zeiss Tessar must have made it quite expensive. The lens panel has a cross movement.

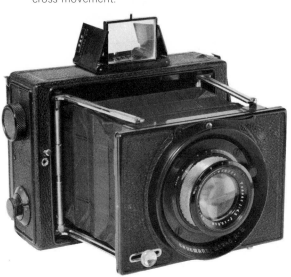

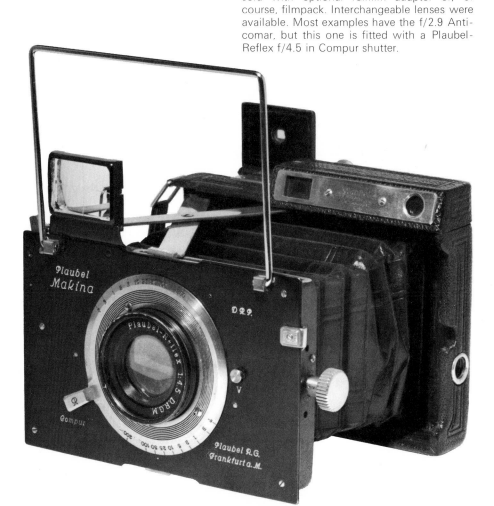

Foth-Derby miniature (16 on 127 film) by Foth GmbH, Berlin as noted by Dr Loher in 1931. Leica style optical finder, focal plane shutter giving 1/25–1/500. Foth f/3.5 50 mm anastigmat in focusing mount.

The **Ensign Midget** made by Houghtons of High Holborn was described in the *British Journal Photographic Almanac* for 1912, and remained popular with British amateurs long after the Great War. It took six exposures 3.7×5.7 cm (1½×2¼ in) on special film. This example has a 75 mm f/6.8 Zeiss Tessar and 3-speed T & B shutter.

Billed as the first camera to have the diaphragm controlled by a photo-electric cell, this is the **Kodak Six-20** of 1938, which had also a coupled range-finder. It had a 4 in Kodak anastigmat f/4.5 in Supermatic shutter 1–1/400. Six-20 film had the same 6×9 cm (2⅜×3½ in) format as 120 but the spool was different, having smaller-diameter ends and metal roller instead of wood. This allowed a slimmer spool and therefore slimmer cameras. It was at first a Kodak monopoly.

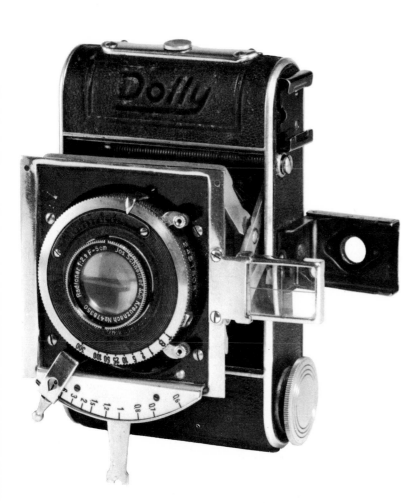

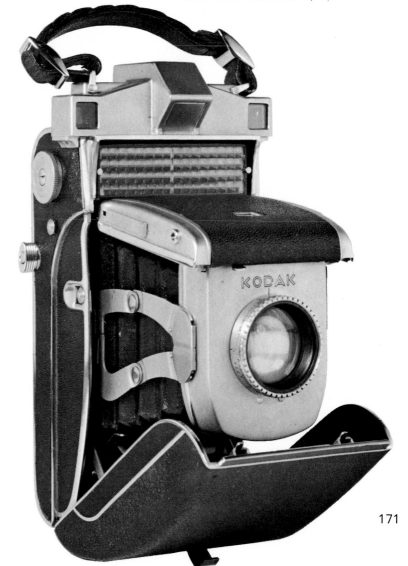

The **Certo Dolly**. Here is another '16 on' VP camera (127 film, 3×4 cm) (1¼×1⅜ in). It may be found in the Albrecht catalogue, Prague, in 1935 and was made by the Certo Werke for those who preferred ordinary rollfilm to 35 mm. The lens is an f/2.9 Schneider Radionar of the usual 50 mm focal length, in Compur shutter with focusing scale below.

171

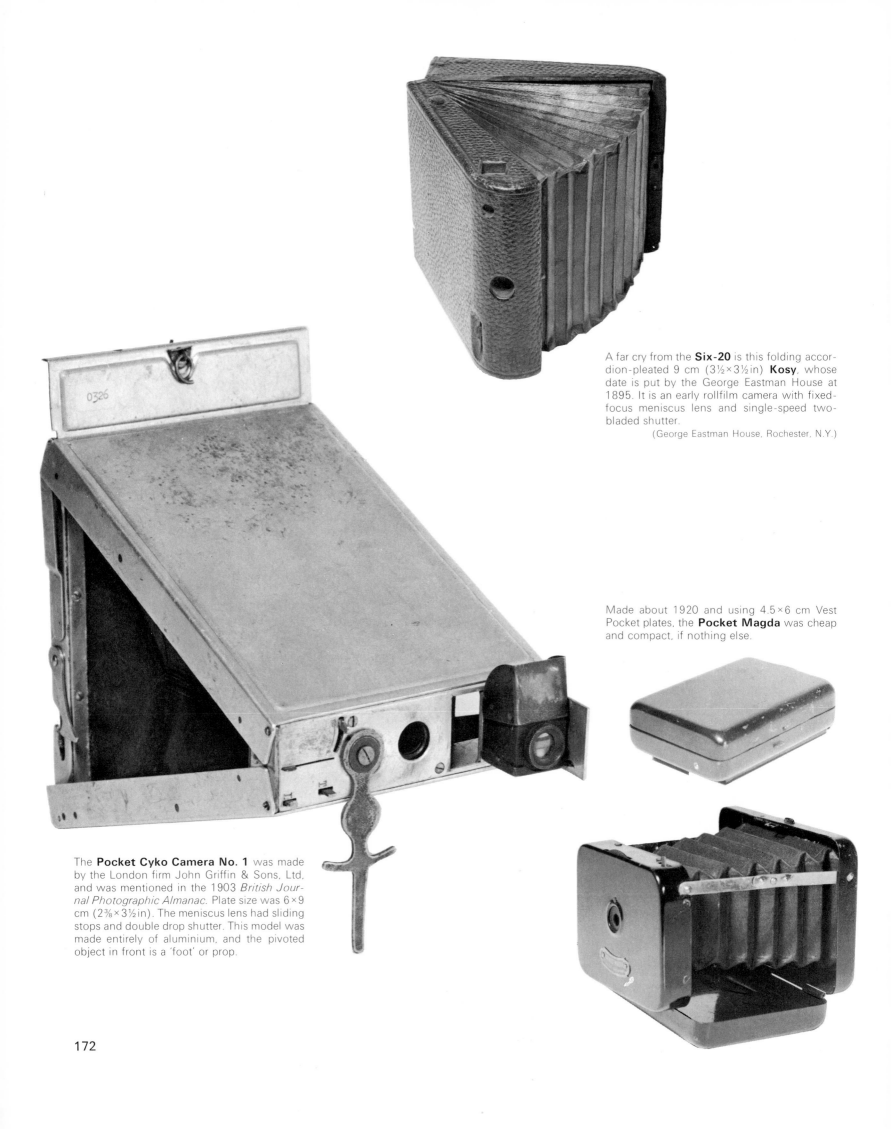

A far cry from the **Six-20** is this folding accordion-pleated 9 cm (3½×3½ in) **Kosy**, whose date is put by the George Eastman House at 1895. It is an early rollfilm camera with fixed-focus meniscus lens and single-speed two-bladed shutter.

(George Eastman House, Rochester, N.Y.)

Made about 1920 and using 4.5×6 cm Vest Pocket plates, the **Pocket Magda** was cheap and compact, if nothing else.

The **Pocket Cyko Camera No. 1** was made by the London firm John Griffin & Sons, Ltd, and was mentioned in the 1903 *British Journal Photographic Almanac*. Plate size was 6×9 cm (2⅜×3½ in). The meniscus lens had sliding stops and double drop shutter. This model was made entirely of aluminium, and the pivoted object in front is a 'foot' or prop.

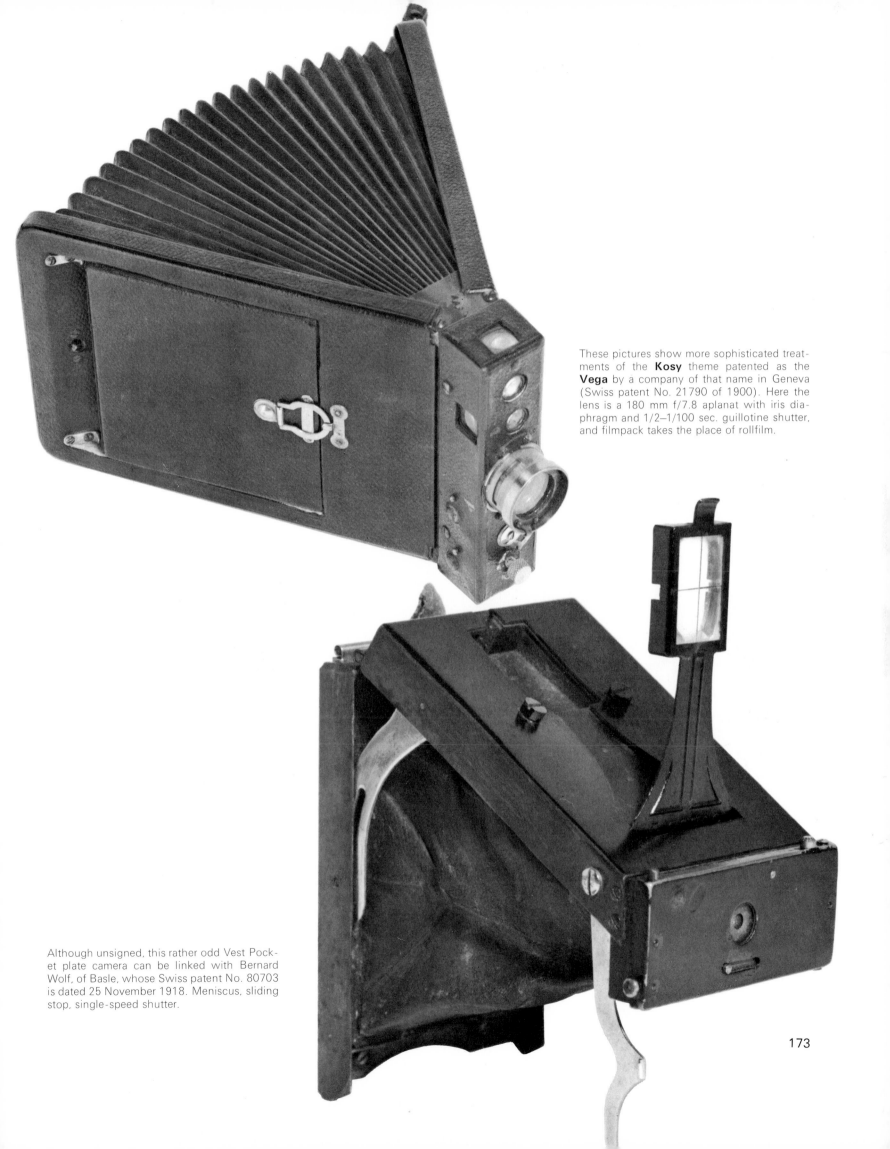

These pictures show more sophisticated treatments of the **Kosy** theme patented as the **Vega** by a company of that name in Geneva (Swiss patent No. 21790 of 1900). Here the lens is a 180 mm f/7.8 aplanat with iris diaphragm and 1/2–1/100 sec. guillotine shutter, and filmpack takes the place of rollfilm.

Although unsigned, this rather odd Vest Pocket plate camera can be linked with Bernard Wolf, of Basle, whose Swiss patent No. 80703 is dated 25 November 1918. Meniscus, sliding stop, single-speed shutter.

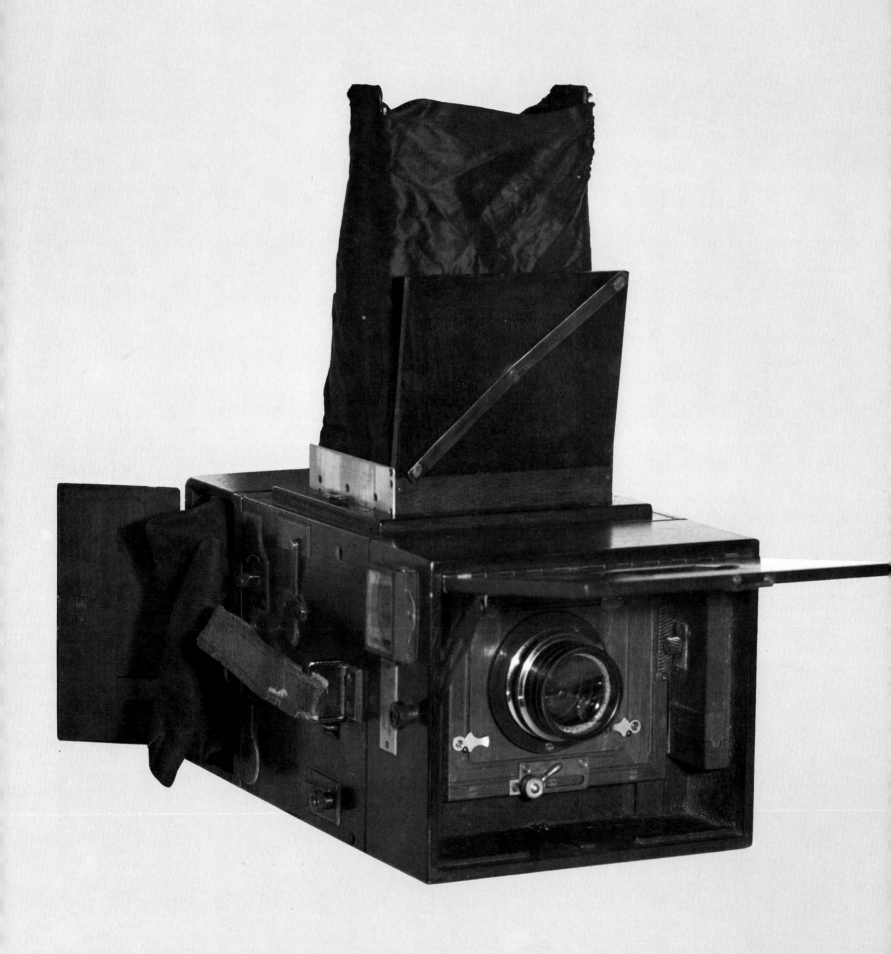

REFLEX CAMERAS

The principle of the *camera obscura* or 'darkened chamber' has been known at least since the eleventh century, when it was described by the Arab scholar Alhazen (AD 965-1038). A portable reflex one was described by the Nuremberg mathematician Johann Christoph Sturm in 1676. The idea was much used by artists including Canaletto. This is an early nineteenth century example. A desire to fix the images viewed in a *camera obscura* led Henry Fox Talbot, F.R.S., to invent the Calotype.

◁ Belgian quarter-plate changing-box reflex by Frennet, of Brussels. Focal-plane shutter. Now fitted with later 180 mm f/4.5. Zeiss Tessar.

THE SINGLE-LENS REFLEX

The introduction of relatively fast dry plates and the tremendous upsurge in the popularity of photography after 1880 produced a demand for handy cameras which, as one sportsman put it, could be used against moving targets. Ideally, focusing must be instantaneous, the subject must be visible up to the moment of exposure and the shutter must be rapid. All these requirements were to be found in the big Press reflexes that began to appear during the 1890s and held their popularity for forty years.

The principle of a reflex camera is simple. A moveable mirror at $45°$ is placed between the lens and the plate so that the picture coming in through the lens is thrown upon the underside of a ground-glass screen, the latter being shaded by a hood so that a focusing cloth can be dispensed with. At the moment of exposure the mirror is moved out of the way and the image falls instead on to the photographic plate. Safeguards are provided so that light will not reach the plate when it should not.

Early single-lens reflexes were big and heavy, often made larger by a changing-box, but they were provided with focal-plane shutters and therefore could 'stop' most moving subjects. From simple Thornton-Pickard and Anschutz designs the British trade adopted the Kershaw shutter and mirror assembly, with ingenious pneumatic damping against 'jolt'. Marion's Soho reflex gave its name to the type, examples being made by such firms as Adams, Dallmeyer, Thornton Pickard and Butcher. More compact were the folding designs of Goltz & Breutmann and the Americans Folmer & Schwing for Kodak and, later, Graflex.

During the 1930s the big SLRs lost ground to slenderer instruments like the Rolleiflex and Leica. The first modern single-lens reflex came with the 40×65 mm Exakta, by Ihagee, Dresden. Today the type is probably the most popular of all, revivified by eye-level viewing and what may be called the 'system' system instituted by Hasselblad, the camera chosen by NASA for taking pictures on the moon.

First Reflex Camera. First to apply the ancient *camera obscura* principle to a camera was an Englishman, Thomas Sutton (1819-1875), who obtained a patent on 20 August 1861. This diagram shows how the image was reflected upwards by a 45-degree mirror, which also acted as shutter.

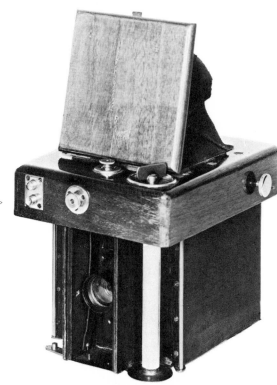

This luxury-model reflex camera was made ▷ about 1895 by Dr Hesekiel, of Berlin. It shows its class by being made of polished mahogany with nickle-plated fittings. It used a Goerz double anastigmat lens and 9×12 cm (3½×4¾ in) plates. The roller-blind shutter had only a single speed.

Probably the first commercial reflex camera was E.W. Smith's, patented simultaneously in England, France and the U.S.A. in 1884. The earliest used only plates but from 1886 Eastman roller slides and rollfilm could be used.

Reflex box camera by Schiffmacher (German ▷ patent No. 67428 of 28 November 1896), taking six 9×9 cm (3½in square) exposures on Eastman rollfilm. It had an f/8 100 mm aplanat lens, and was brought back by the action of cocking. (Deutsches Museum, Munich)

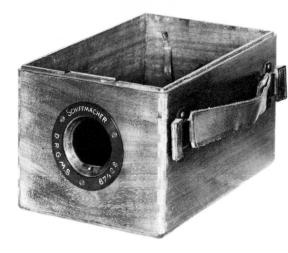

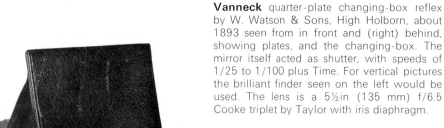

Vanneck quarter-plate changing-box reflex by W. Watson & Sons, High Holborn, about 1893 seen from in front and (right) behind, showing plates, and the changing-box. The mirror itself acted as shutter, with speeds of 1/25 to 1/100 plus Time. For vertical pictures the brilliant finder seen on the left would be used. The lens is a 5½in (135 mm) f/6.5 Cooke triplet by Taylor with iris diaphragm.

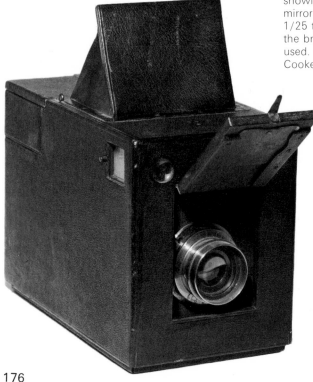

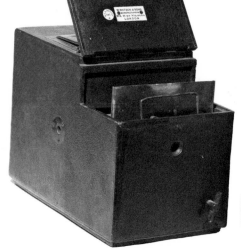

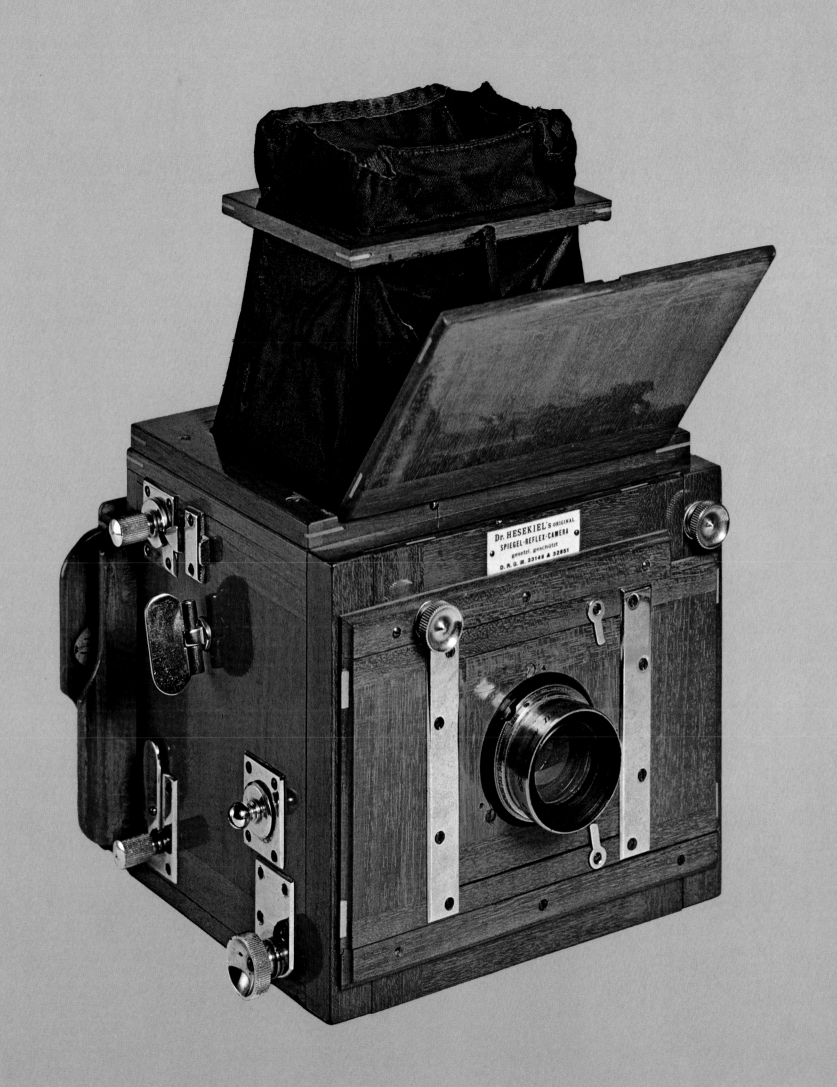

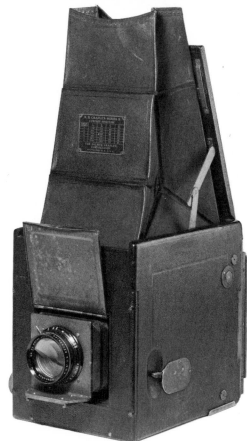

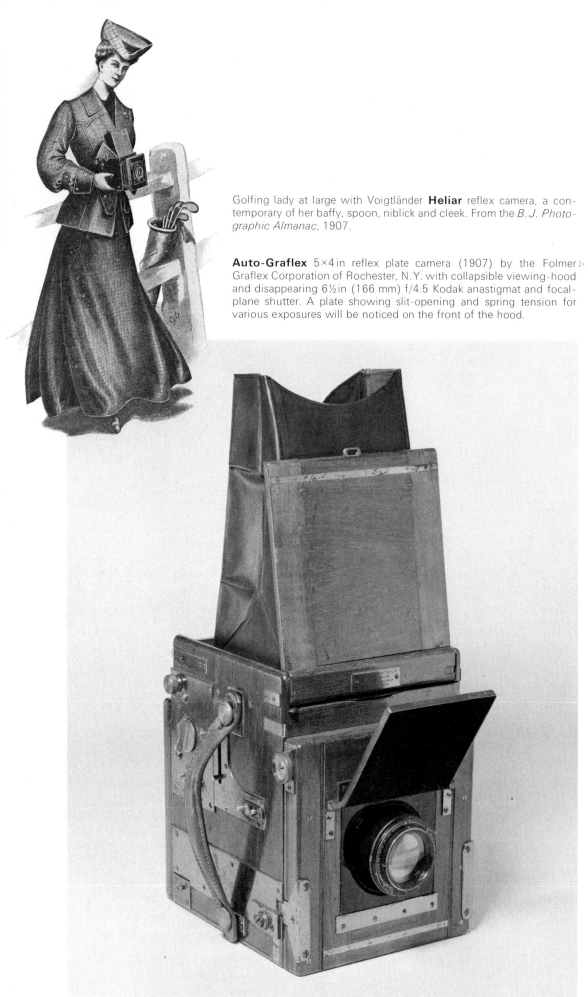

Golfing lady at large with Voigtländer **Heliar** reflex camera, a contemporary of her baffy, spoon, niblick and cleek. From the *B. J. Photographic Almanac*, 1907.

Auto-Graflex 5×4 in reflex plate camera (1907) by the Folmer ▷ Graflex Corporation of Rochester, N.Y. with collapsible viewing-hood and disappearing 6½ in (166 mm) f/4.5 Kodak anastigmat and focal-plane shutter. A plate showing slit-opening and spring tension for various exposures will be noticed on the front of the hood.

◁ This very handsome brassbound teak tropical model single-lens reflex bearing the name-plate of the London Stereoscopic Company is typical of what the English trade called a Soho, after Marions of Soho Square who almost certainly made this example. An ingenious feature was the Kershaw patent mirror, so hinged that it moved back as it rose, allowing the use of a short-focus lens such as this 6 in Voigtländer Heliar f/4.5. The mirror incorporated an air brake so that it worked completely without thud.

Rochester, in upper New York state, is very much a photographic town. Besides Kodak and Folmer-Graflex (see above) it housed the Rochester Optical Company, makers of this quarter-plate **Premograph** (1908) reflex. Bausch & Lomb lens, focal plane shutter from 1/2–1/1000 sec. (Kodak Museum, Harrow)
▽

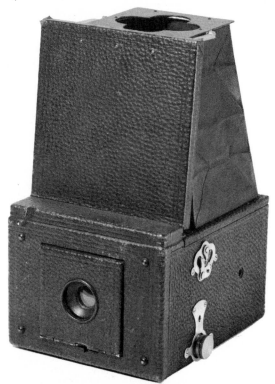

178

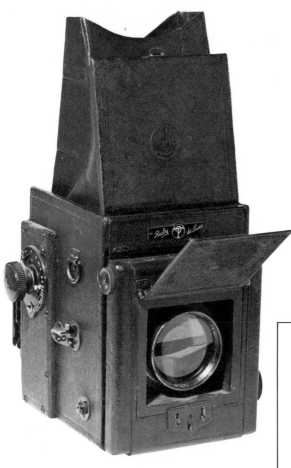

Great names are combined in this splendid English quarter-plate reflex reviewed in the *B. J. Photographic Almanac* 1912. It is a focal-plane Thornton-Pickard **Ruby de Luxe** and that vast lens is a 5½ in Cooke Series X Taylor & Hobson f/2.5. This lens, designed by Lee in 1926 was derived from the famous Cooke Triplet, but had the rear component split into two, thus increasing the aperture. The camera body is mahogany, leather covered. The front panel has rising and falling movements.

Very compact for a quarter-plate reflex is this **Mentor-Reflex** by Coltz & Breytmann, Dresden, mentioned in a 1910 catalogue from Wachtl, Prague. Apart from the folding arrangements which are self-explanatory, the specification includes rising and cross front, focal plane shutter 1/8–1/300, 150 mm f/4.5 Zeiss Tessar in focusing mount iris diaphragm.

Ica of Dresden were not alone in marketing cameras called **L'Artiste**. This single-lens reflex dates from about 1910 when focal plane shutters and the f/4.5 150 mm Tessar were very much in vogue. For photographing tall buildings in vertical format the lens panel has a sliding movement.

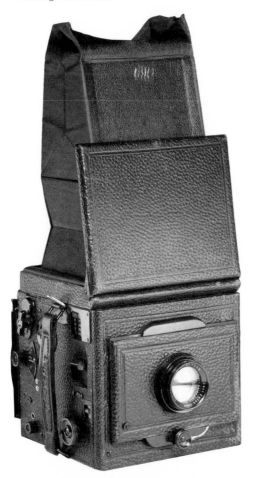

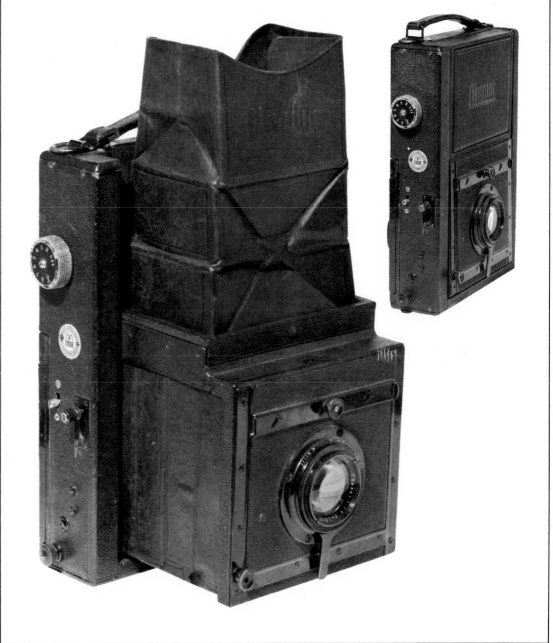

This one was aimed at the medium-priced market, the **Box Reflex** by Kamera Werkstätten, Dresden, giving either 8 or 16 exposures on a 120 rollfilm. Ennatar 105 mm f/4.5 with roller-blind shutter behind for 1/25, 1/50 and 1/100. Focusing mount.

Something else again, this single-lens 9×6 cm (3½×2⅜in) **N & G Folding Reflex** by Newman & Guardia, London, which came out in 1921 with rack focusing and lazy-tongs extension. Rising front, 1/8–1/800 focal-plane shutter and the famous f/4.5 Ross Xpress of 130 mm (5.25in) focal length.

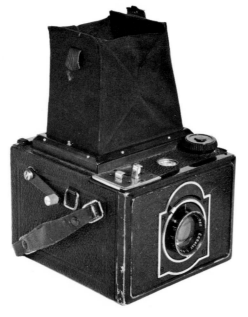

The writing embossed in the leather hood tells most of the story: **'Ensign Roll Film Reflex 2¼ 8 Anastigmat Model'**. Originally patented by Houghtons in 1922 (British patent No. 210531) this **Ensign**, the trademark of Houghton-Butcher is somewhat later. An inexpensive front-shutter reflex not much larger than an ordinary box camera and taking 8 2¼×3¼in exposures on the popular 120 film. Single-speed shutter, exposure being adjusted by stopping-down the f/7.7 Luxor.

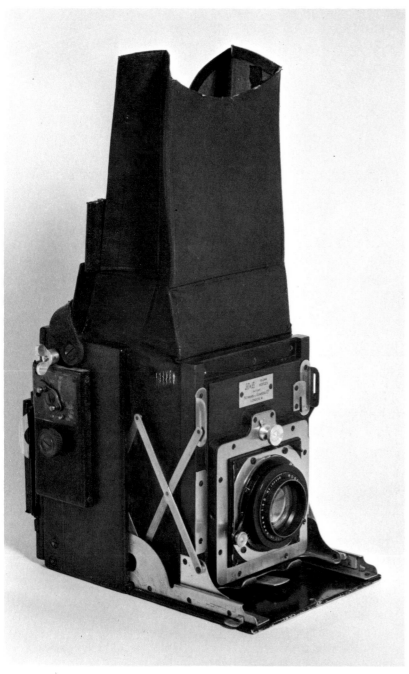

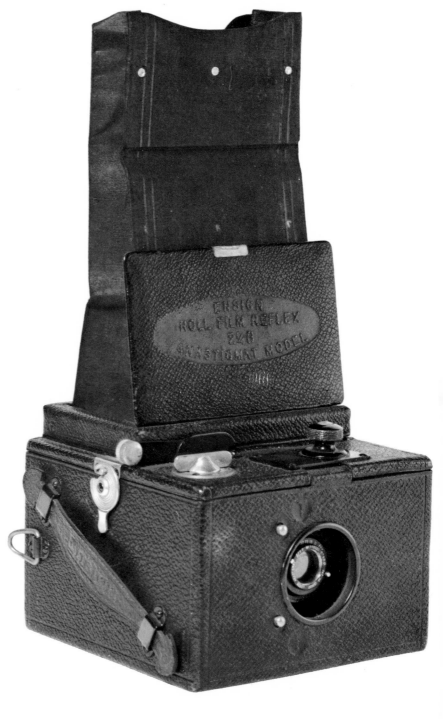

Before the coming of the modern eye-level miniatures one could hardly find a more compact single-lens reflex than this Ernemann A.G. **Ernoflex VP**, 4.5×6 cm (1¾×2⅜ in) plate camera, nor a faster one for action pictures, since the lens was a 75 mm f/3.5 Ernon and the shutter a focal-plane with speeds from 1/20 to 1/1000 sec. Note the rising front.

Ihagee Patent Klappreflex by Ihagee, Dresden. In this strange upside-down reflex, to be found in the Viennese *Walz Mitteilungen* for 1925, one looks *down* through the baseboard, which acts as a sun shade. Focal plane 1/15–1/1000 shutter, 125 mm (5 in) f/4.5 Goerz Dogmar with iris diaphragm and focusing mount. *Klapp* is photographic German for 'strut camera'. Format 6.5×9 cm (2½×3½ in) plates. Eight years later Ihagee were to pioneer miniature SLR cameras with the **Exacta**, first in VP then in 35 mm form.

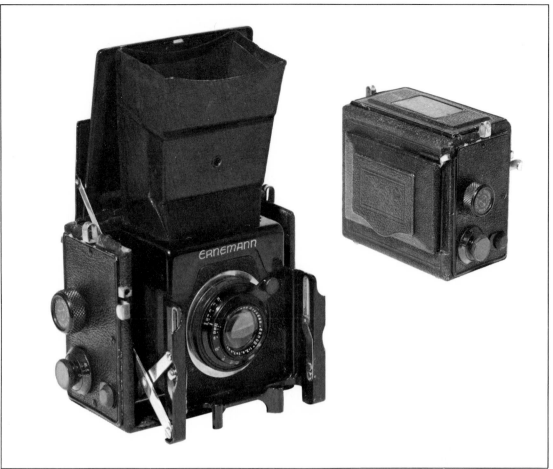

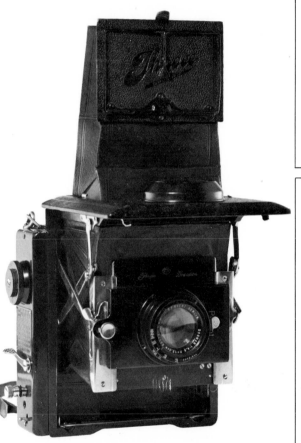

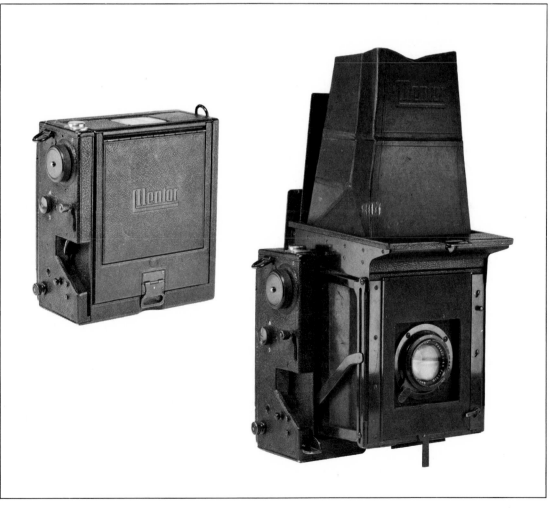

Mentor-Sport-Spiegel Reflex Camera was the description of this SLR used by its manufacturers, Goltz & Breutmann of Dresden: 'Mentor Sport Mirror', an ingeniously contrived and compact 9×12 cm (quarter-plate) plate camera catalogued in 1925 with 6 in Zeiss Tessar f/4.5 and 1/8–1/1300 sec. focal plane shutter. A combined mirror-tripping and shutter release was worked by the right thumb, unaided by a spring; so gravity was not in your favour when trying for pictures in a crowd. When the camera was held upside down above the head the mirror fell and covered the focusing screen.

Contemporary with the **Mentor Sport** was this version of the **Mentor** from the same stable, a vast 135 mm f/1.9 Rietzschel Pro-linear peeping out of its emplacement like an 18-inch gun. Format and shutter were as on page 181 but this one has a revolving back and additional wire-frame finder.

To realize how compact the **Ernoflex** was, one has only to glance at the hood, here open to view the VP 4.5×6 cm (1¾×2⅜ in) screen. A tiny plate or film-pack camera able to profit by the 105 mm f/1.8 Ernostar. Focal-plane with speeds from 1/20–1/1200 sec., and beautifully presented in black morocco.

The Contess-Nettel **Miroflex** 6×9 cm (2⅜×3½ in) listed in 1926 has a 150 mm Zeiss Tessar f/4.5 focal-plane shutter and rising front, but shows evidence of having been built down to a price.

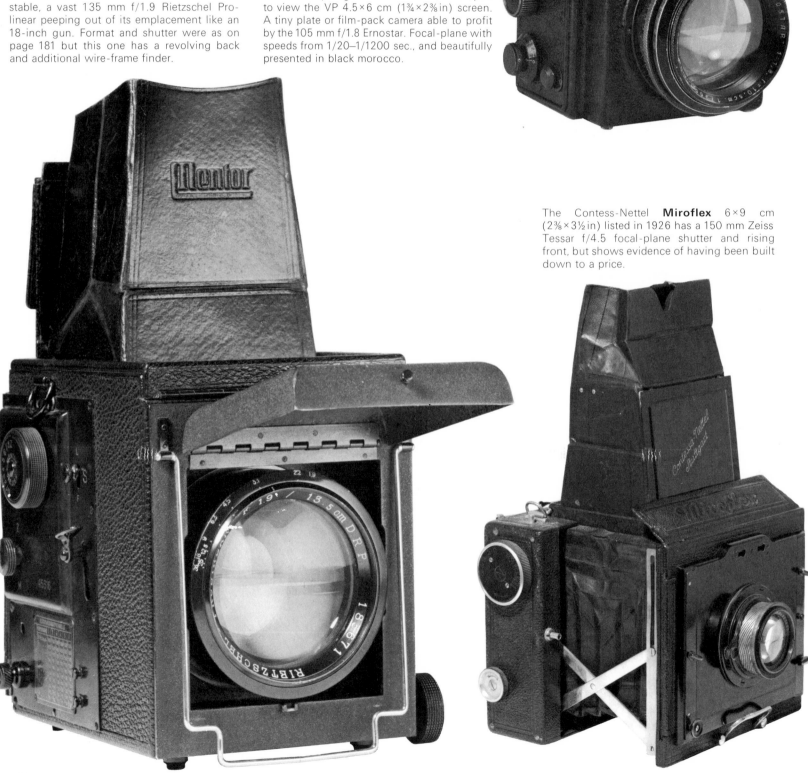

Front-Shutter Reflex. If you wanted a relatively inexpensive reflex in 1928 you could hardly expect a more compact 6.5×9 cm (2½×3½in) camera than this **Mentor Compur Reflex**, with f/4.5 Tessar in the new 'rim setting' Compur shutter on which speeds were selected by turning the knurled bezel. A plate camera without bellows, roll-holder or focal-plane shutter to add bulk, it was hardly larger in plan than its format. The Compur was ingeniously linked with the mirror so that the lens could be used for viewing whether the shutter was cocked or not. Mentioned in the 1928 *B.J. Photographic Almanac*.

An earlier front-shutter reflex than its neighbour (left) this **Mentor-Sport-Reflex** dates from 1925. It is better finished and the same size, although the 1/25–1/100 Pronto shutter lacks Compur slow speeds and the lens is an f/4.5 105 mm Meyer-Goerlitz Trioplan.

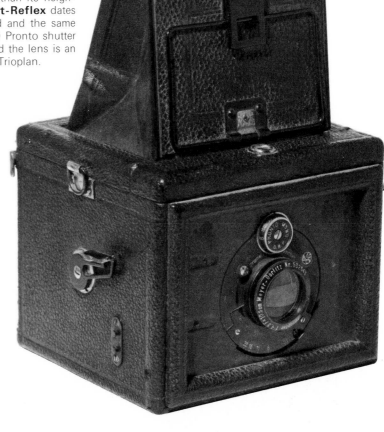

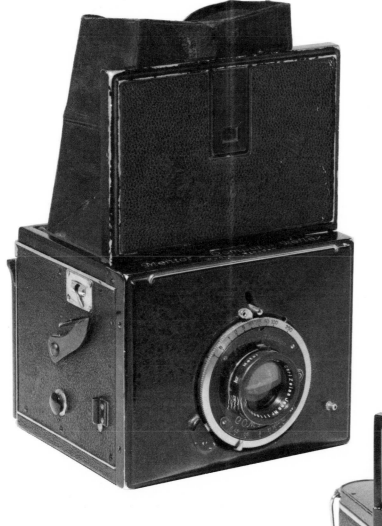

With the **Exakta** by Ihagee, Dresden we move out of the 'vintage' period into the realm of modern photography. Introduced in 1933 (Swiss patent No. 175376/176059) it stemmed not from the 'press reflex' plate camera but from the new strain of 35 mm focal-plane miniatures typified by the Leica and Contax and had much the same shape. This is an early model taking 8 normal size 4×6.5 cm (1⅝×2½in) on a VP 127 rollfilm; 35 mm models soon followed. Shutter speeds are from 1 to 1/1000 sec. and the lens is a 75 mm f/2.8 Zeiss Tessar. An unusual position was chosen for the shutter release: close beside the lens on the front panel. This meant that one squeezed the camera body instead of pressing a button, and so avoided jogging it.

A minor ambition of schoolboy photographers, ▷
the inexpensive **Pilot 6** came from Kamera
Werkstätten, Dresden in 1935 and used their
75 mm f/4.5 KW lens. Focal-plane shutter
1/20–1/200; twelve 6 cm (2⅜in) square pic-
tures on 120. Square format has obvious
advantages for a reflex, and the new relatively
fine-grain emulsion encouraged 'picture crop-
ping', the making of enlargements from part
only of the negative.

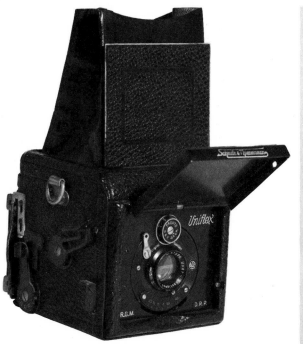

Schmidt & Thienemann, Dresden, offered the
Uniflex VP plate SLR with f/4.5 Unar in
Pronto 1–1/100 sec. front shutter and focus-
ing mount. The two side levers held the mirror
in viewing position.

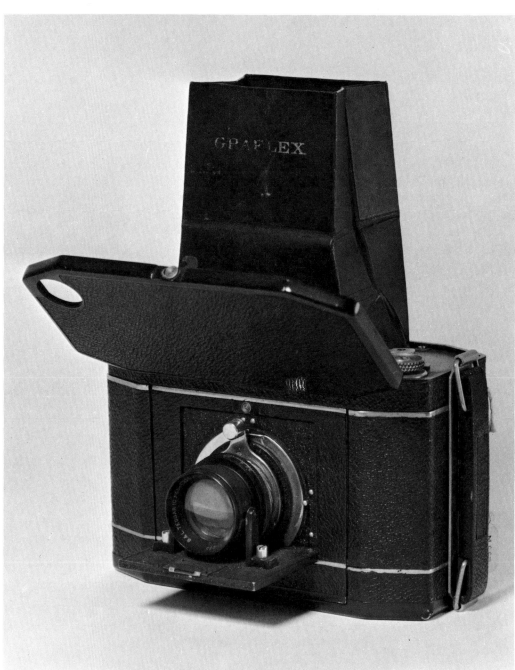

By 1932 when the **National Graflex** rollfilm
reflex was announced 'stylists' had been to
work putting away the knobs and levers.
Focal-plane shutter up to 1/1000 sec., f/3.5
Bausch & Lomb Tessar in focusing mount. A
rather odd 6×7 cm (2⅜×2¾in) format was
used giving 10 exposures on 120 film.

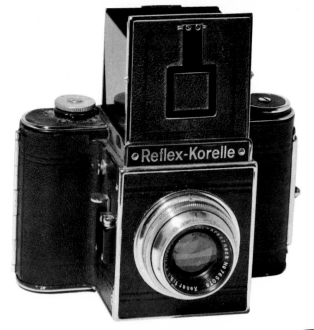

There is still a hint of the reflex press camera in the lines of the **Reflex-Korelle**, built by Robert Kochmann, which like the direct finder, may have endeared it to the older school. Specification similar to **Exakta** but listed in 1936 and with 75 mm f/3.5 Schneider-Kreuznach lens and 1/10–1/1000 speeds. This model had a mobile magnifier for sharp focusing. Several versions were made, and the camera reappeared after the war as the **Agiflex**.

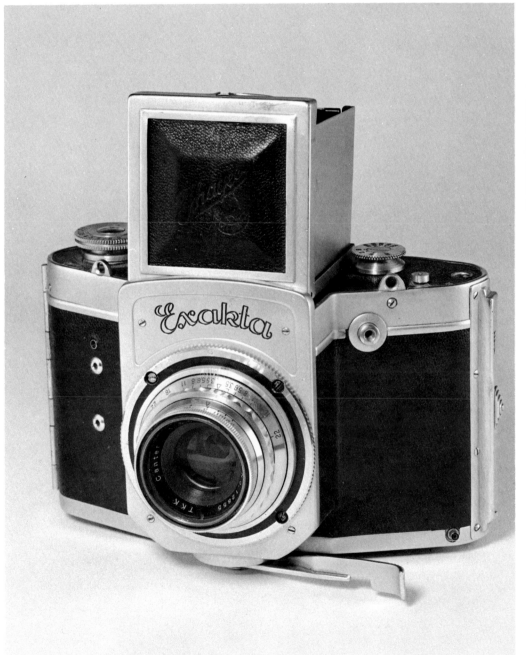

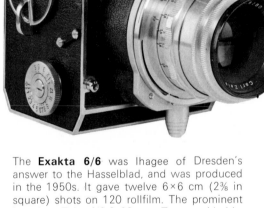

The **Exakta 6/6** was Ihagee of Dresden's answer to the Hasselblad, and was produced in the 1950s. It gave twelve 6×6 cm (2⅜ in square) shots on 120 rollfilm. The prominent lens is a Zeiss f/2.8 80 mm Tessar with iris. The blind shutter gave speeds from 12 sec. to 1/1000.

◁ This is an Ihagee **Exakta** in larger format, the **6/6** taking twelve 6×6 cm on 120 film and finished in satin chrome which by 1938 was replacing black stove-enamel. New low speeds (1 sec.–12 sec.) were a talking-point at least, and 1/1000 was available too. Simultaneous film-winding and shutter-setting; the release would not work unless the hood was open. A TK Canter 75 mm f/3.5 was fitted; the socket, left, was for a synchronised flash bulb.

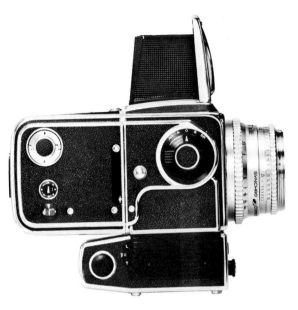

The **Hasselblad 500EL** was a development that came out in 1965. It uses a Zeiss Planar f/2.8 80 mm, with iris diaphragm, and has a Synchro Compur shutter with a 1 to 1/500 sec. range. This model has motor drive, which is contained in the compartment below the camera, and which advances the film automatically after each exposure. 120 rollfilm, 12 ex. 6×6 cm. The high quality of these cameras made them the choice for NASA's space programme.

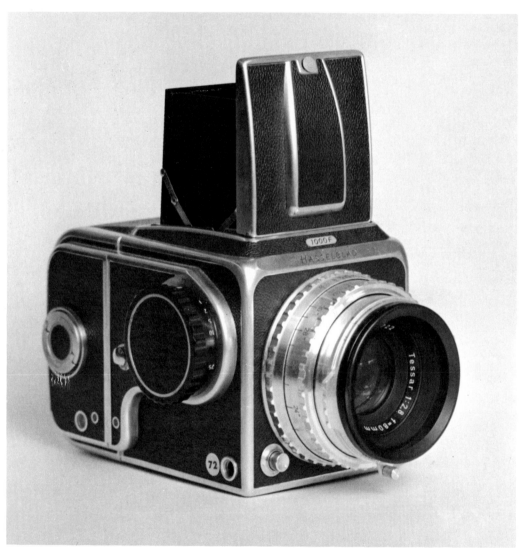

The Hasselblad 'system' includes several lenses in the Zeiss Planar and Sonnar series which come complete with their own diaphragm-control unit comprising a silicon meter and built-in battery-powered servo motor. This automatically chooses the correct stop in relation to film-speed, shutter setting and the prevailing light. It is especially useful when photographing by remote control.

The **Hasselblad 1000F** dates from 1948. Precision made in Victor Hasselblad's Göteborg works, it ushered in a new conception in high-quality 'system' cameras. The focal plane shutter was a metal blind, speeded from 1 sec. to 1/1000. Removable film magazine for 120 film, giving 12 6×6 cm exposures. The magazine could be removed in daylight, thanks to a light-tight shutter incorporated in it. Numerous accessories could be fitted. Zeiss Tessar f/2.8 80 mm with iris diaphragm.

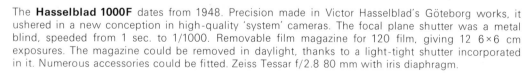

Introduced at the 1970 Photokina, the **Mamiya RB 67** is a reflex taking 6×7 cm (2⅜×2¾ in) on 120 or 220 rollfilm, though it can also be used for cut film. It is notable for having a moveable back, which can be turned to give either upright or landscape views. Each of the interchangeable lenses has its own central shutter, a Seiko 1-1/400 sec. The camera normally wears a Mamiya Dekor f/3.8 of 90 mm. The bellows allows the camera to be focussed at 8 in.

The **Asaki Pentax 6×7** is another camera for the same size format, and was launched at the 1968 Photokina. Ten shots on rollfilm, or twenty on 220. The usual lens is a f/2.4 105 mm Super-Takumar, with bayonet fitting for easy changing. Rapid return mirror, and an electronically controlled shutter with speeds from 1 sec. to 1/1000 sec.

Rolleiflex SLX. 'Modern Soho' might be shorthand for Rollei's latter-day waist-level single-lens reflex, which like earlier Rolleiflex cameras takes 6 cm square pictures on 120 size film. Sophisticated metering system (rechargeable selenium battery) governs aperture and 'system' includes magazine for 800 exposures with automatic advance. Extensive range of Carl Zeiss lenses from 30 mm to 500 mm, large array of accessories. Manufacture in West Germany and Singapore.

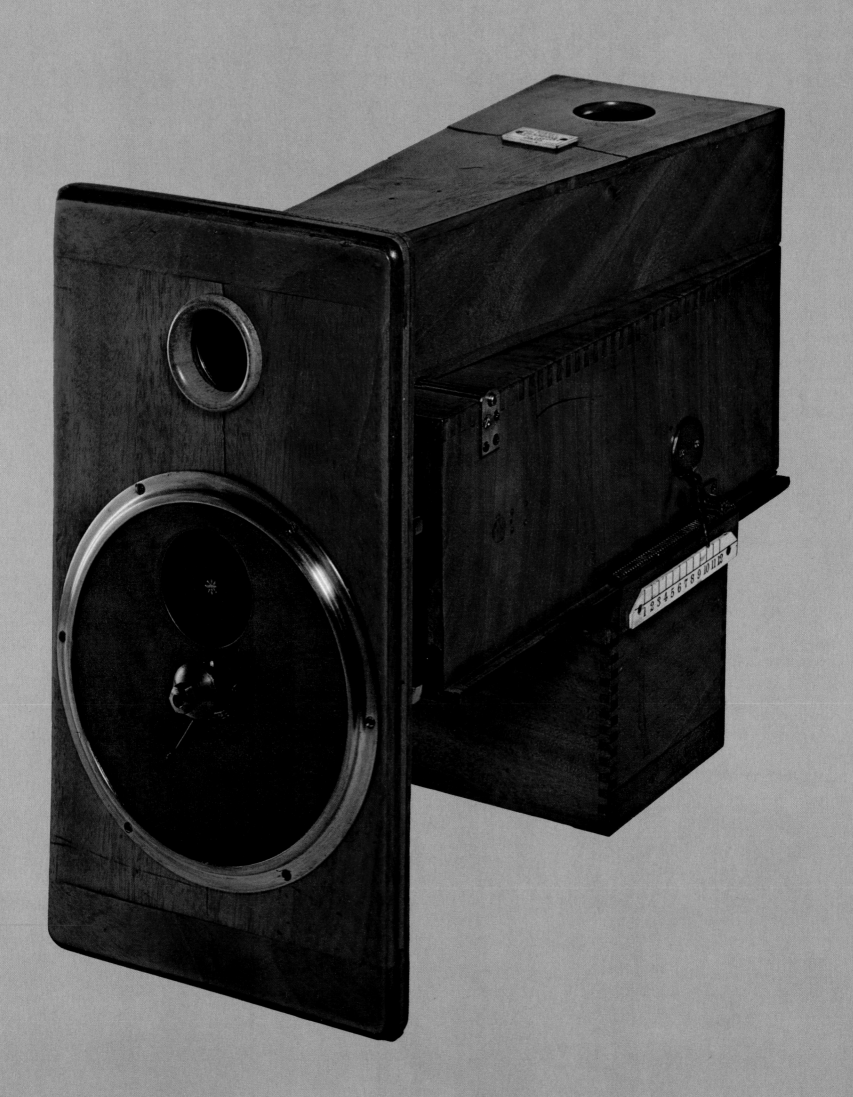

TWIN-LENS REFLEX

Reporter by Marion & Son, Soho Square, London. An early quarter-plate example (1872) of Twin Lens camera, a two-storey construction in which the lower lens was used for taking, the upper for viewing on a ground-glass screen. The lenses moved in unison by means of a rack and pinion. At the suggestion of V.C. Driffield (of H & D plate-speed fame) a mirror was sometimes incorporated so that the focused image could be viewed the right way up, making this a forerunner of the Twin Lens Reflex.

◁ Marion's **Academy** was built on the same lines as the Reporter seen above, being a double sliding-box camera in which the image from the upper lens could be viewed either through the back of the camera or through the top via a mirror. This example has a single-speed rotary shutter and is of quarter-plate size. The twelve-plate changing-box could be exchanged for another in daylight. When an exposure had been made the brass knob at the back was pulled and the exposed plate dropped through a light-tight slot. The box was then moved forward one notch and the camera turned upside-down to bring an unexposed plate into position. Dated 1883 in the Science Museum collection, this camera was made for gelatin/silver bromide plates.

By twin-lens reflex we mean a double-decker camera having two separate compartments, each with its own lens; one for viewing and focusing, the other for taking pictures. A 45° mirror in the upper story throws the image received through the viewing lens upon a ground-glass screen, and by bringing this image to sharpness the user focuses the camera since the lenses move in unison. The screen may be the same size as the picture format, it may be viewed through a magnifying lens or, as in the pre-war twin-lens Contaflex, the screen may be larger than the picture, in this case 50 × 75 mm instead of 24 × 36 mm.

The first twin-lens cameras were not reflex, merely double-deckers, like the Marion. They were used in portrait studios, on board ship and even, it is recorded, for aerial photography from balloons. The advantage, of course, was that the operator could watch his subject right up to the moment of exposure instead of having to break off while a screen was withdrawn and a dark slide substituted. A mirror was added at the suggestion of Vero C. Driffield, one of the pioneers of sensitometry, and the twin-lens reflex was born.

A drawback with early TLR cameras was parallax—the fact that the two lenses both looked straight to their front without converging. This was of no importance when photographing distant objects but for close-ups the viewing lens gave a picture that was quite untrue. Correction for parallax appeared about 1932, on the third model Rolleiflex, a mobile mask on the screen being connected with the focusing knob. The Rolleiflex, introduced in 1929 gave a new lease of life to the TLR, hitherto considered too bulky. It became a favourite instrument of professionals and serious amateurs and remained so until supplanted during the 1950s by the eye-level pentaprism single-lens reflexes. Even now it has staunch adherents, who prefer $2\frac{1}{4}$ square to 35 mm. Perhaps we should add that a square format was chosen for this most popular of twin-lens instruments because a reflex camera cannot conveniently be used on its side. Square pictures in themselves are not very attractive. Perhaps it was the Rollei format, more than anything else, that spread the fashion for "picture cropping" — the taking of enlargements from part only of a negative.

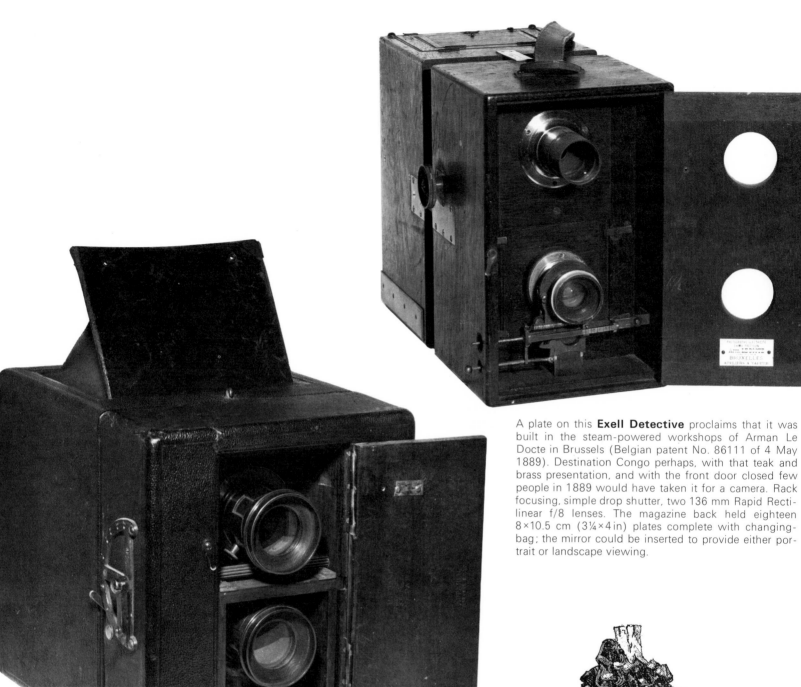

A plate on this **Exell Detective** proclaims that it was built in the steam-powered workshops of Arman Le Docte in Brussels (Belgian patent No. 86111 of 4 May 1889). Destination Congo perhaps, with that teak and brass presentation, and with the front door closed few people in 1889 would have taken it for a camera. Rack focusing, simple drop shutter, two 136 mm Rapid Rectilinear f/8 lenses. The magazine back held eighteen 8×10.5 cm (3¼×4 in) plates complete with changing-bag; the mirror could be inserted to provide either portrait or landscape viewing.

The **Cosmopolite** (French patent No. 181089 of 24 January 1887) was manufactured by E. Français, Paris. This quarter-plate camera has a pair of 150 mm (6 in) f/7 Rapid Rectilinear lenses with Waterhouse stops and rack and pinion focusing. To change the stop it was necessary first to remove the lens, but this was easy enough because the mount had a bayonet fitting.

The **Ross New Model Twin Lens Camera** was designed especially for lady photographers, being light and reasonably compact when the front was retracted and the double doors closed. A wide choice of Ross, Goerz and Zeiss lenses was offered.

190

Dr Krügener's **Simplex Magazin Camera** was patented in Switzerland on 30 January 1889 (No. 491). The drawing shows the reflex mirror and gravity-feed arrangements. The model shown has plain mahogany finish and holds two dozen 6×8 cm (2⅜×3¼in) plates; single stop, rotary sector shutter. The taking lens is a 90 mm f/9 Steinheil Antiplanet. A quarter-plate model was also listed, together with one giving 40 exposures on film.

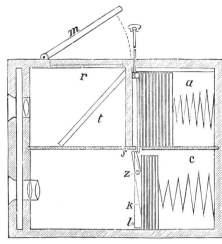

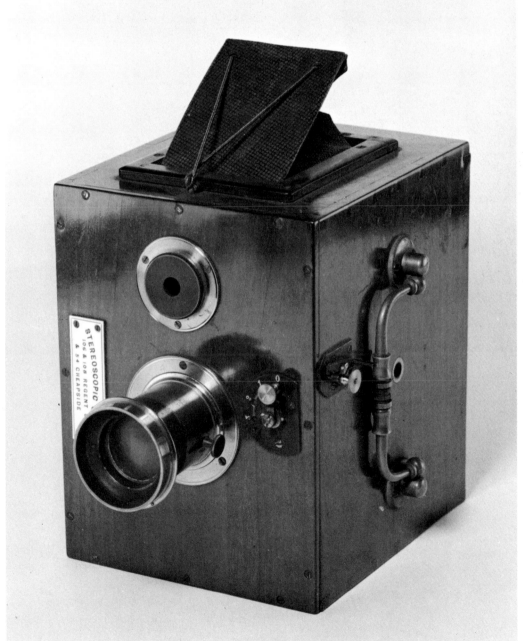

◁ The quarter-plate **Artist Camera** (1890) marketed by the Stereoscopic Company cannot be called a *Twin* Lens Reflex because here, as in the **Simplex** above, the viewing lens is small. The principal lens is a Rapid Rectilinear in bayonet mount. Rotary sector shutter.

Ross & Co., of 111 New Bond Street with factory at Clapham Common, spoke sometimes of their 'Divided' camera and sometimes of the Portable Twin Lens Camera. The model dated from 1891 and production continued after the appearance of the twin-door model (page 190). The taking lens is a Ross Rapid Symmetrical and the finish a Ross speciality: hand-sewn black hide instead of morocco.

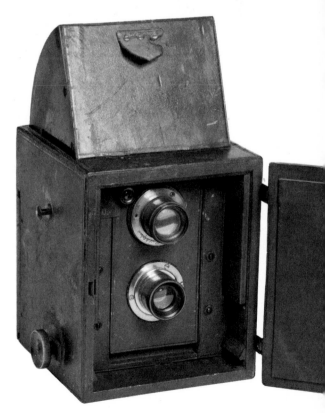

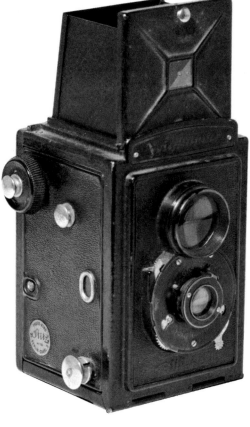

Twin-lens reflexes could be quite inexpensive, like this schoolboy Voigtländer. It took 120 rollfilm, giving 12 pictures. The taking lens is an f/7.7, 75 mm, with diaphragm stop and central shutter for 1/25 to 1/50 sec. The viewfinder comprised a mirror and a convex lens, which gave a very clear image.

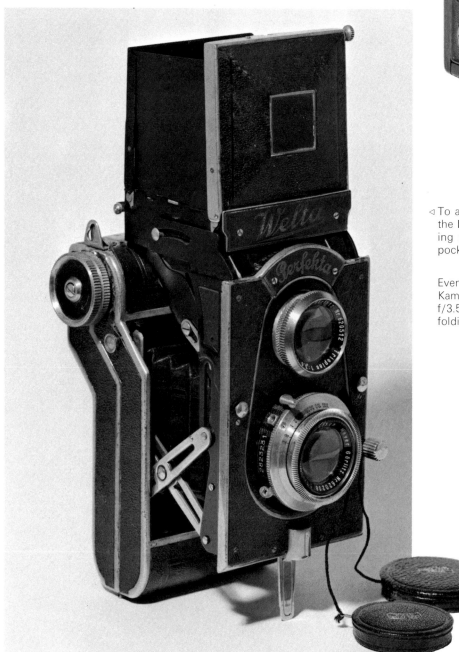

◁ To avoid the cubic bulkiness of an ordinary TLR, Welta designed the **Perfecta** with cranked back and ingenious hopper-like folding mirror. When shut it took little more room than a single-lens pocket camera.

Even more compact than the Welta was this **Pilot**, hailing from the Kamera Werkstätten of Guthe & Thorsch in Dresden. Fitted with f/3.5 Zeiss Tessar lens in Compur to 1/300 sec. shutter this 'flat folding' is much sought after by collectors. It took 120 rollfilm.

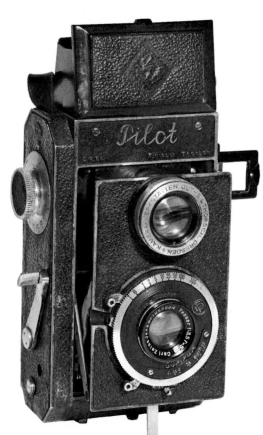

Zeiss Ikon A.G., Dresden were responsible for the **Ikoflex**, catalogued by Wachtl in 1934. It used 120 rollfilm to give twelve pictures. The Novar f/4.5 80 mm lens had a Zeiss Ikon 1/25-1/100 sec. everset shutter. The lateral lever needed to be moved twice to advance the film.

Prague Technical Museum dates the **Mento-rett**, made by Goltz & Brentmann, to 1935. As usual, it took 12 shots on 120 film, 2¼×2¼ in. The taking lens, in a helical mounting, is a f/3.5 75 mm Mentor-Special with iris diaphragm, and a blind shutter is fitted.

(Technical Museum, Prague)

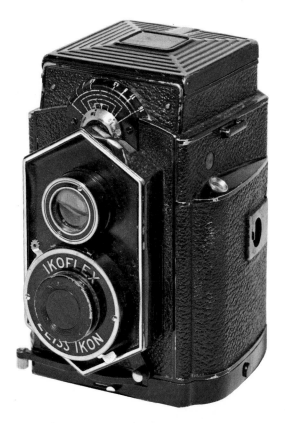

Voigtländer's **Superb** was an offering from the Brunswick firm recorded by the *Walz Mitteilungen* in 1933. It took 12 pictures on 120 rollfilm. The taking lens is a Skopar f/3.5 75 mm anastigmat, with an iris diaphragm and Compur shutter giving 1-1/250 sec. An unusual detail is that the exposure times are engraved in reverse on the lens mounting, and can be read easily from above by means of small mirror sight. The lever on the right of the picture is the horizontal film advance. Gearing coupled the two lenses, which moved in and out together. The correction for parallax was made by the viewfinder lens dipping for close-up work. Altogether, a well-thought out piece of equipment.

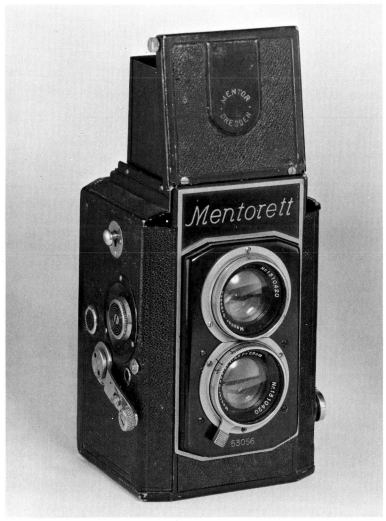

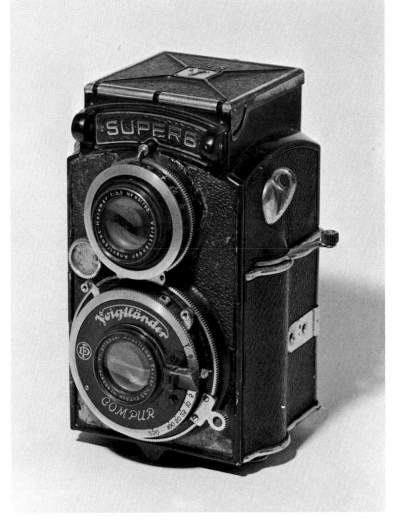

The **Bayerflex**, made by Waldemar Bayer at Freital, appeared in the 1936 Chotard catalogue, published in Paris. It wore two Laack Rathenow Pololyt f/3.5 75 lenses, with iris stop. The focal-plane shutter went from 1/25 to 1/500 sec. The arms and lever coupling the two lenses is obvious. This camera is one of the rare twin lens reflex models that has a horizontal film movement. The speed setting knob and shutter release can be seen on the left of the picture. Twelve shots on 120 rollfilm.

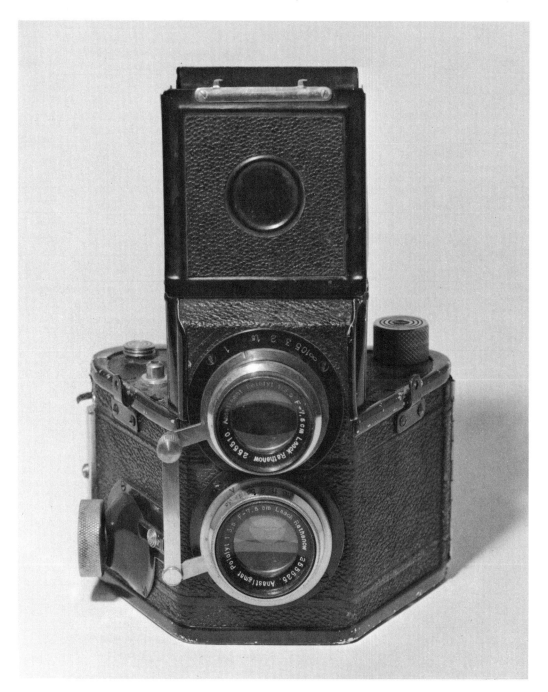

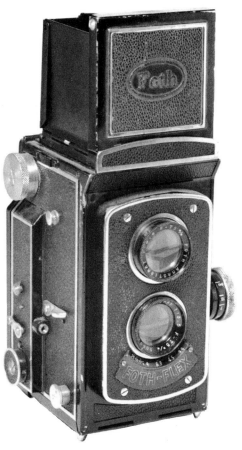

A catalogue published by the Prague Engineers' Club in 1935 gives details of the **Foth Flex**, made by Foth & Co., of Berlin. Twelve pictures on 120 rollfilm. The taking lens is a Foth anastigmatic, f/3.5 75 mm. Focal plane shutter. The raised protecting cover for this can be seen on the left of the illustration. It was speeded from 1/8 to 1/5000 sec. In focusing, only the lenses moved, not the front of the camera.

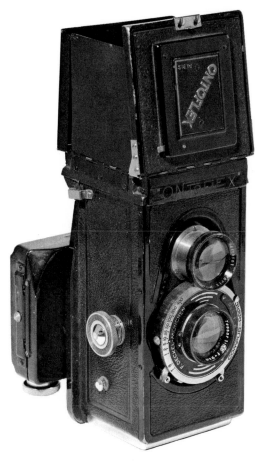

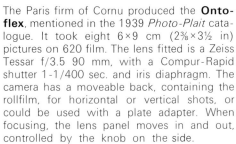

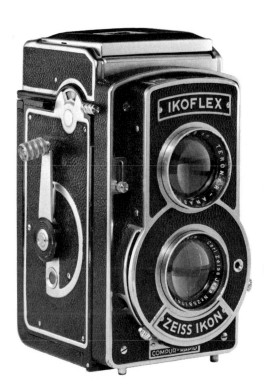

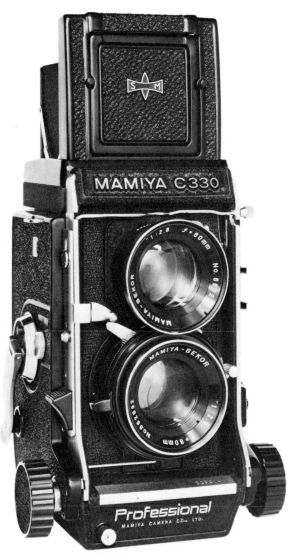

The Paris firm of Cornu produced the **Onto-flex**, mentioned in the 1939 *Photo-Plait* catalogue. It took eight 6×9 cm (2⅜×3½ in) pictures on 620 film. The lens fitted is a Zeiss Tessar f/3.5 90 mm, with a Compur-Rapid shutter 1-1/400 sec. and iris diaphragm. The camera has a moveable back, containing the rollfilm, for horizontal or vertical shots, or could be used with a plate adapter. When focusing, the lens panel moves in and out, controlled by the knob on the side.

Another, later, version of the Zeiss Ikon **Iko-flex**, which came out in 1939, and was noticed then by Dr Loher. This model again gave twelve pictures on 120 film. The taking lens is a Zeiss Tessar f/2.8 80 mm, iris diaphragm, and Compur-Rapid shutter speeded from 1-1/400 sec. Cocking and film transport are effected by pushing down the lever, and raising it. Parallax correction with the sports viewfinder.

The **Mamiya C330** is one of the most highly-developed TLR cameras. The range of 7 lenses and 6 screens, fully interchangeable, can be used. For long focus lenses, the lens-mounting panel has a bellows between it and the camera body. This brought about the disadvantage that automatic parallax correction, using a tilting viewing lens, could not be used. To overcome this, the viewfinder carried an engraved scale, calibrated to show what would be cut in a close-up picture. This scale also gave the exposure coefficient for macrophotography. A central shutter gave speeds from 1 to 1/500 sec. The first version the Mamiya **C**, appeared in 1957, while the **C330** was launched in 1969.

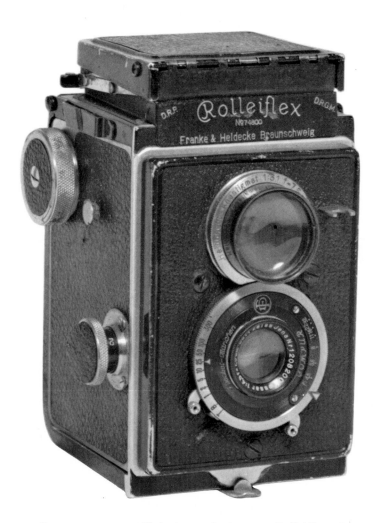

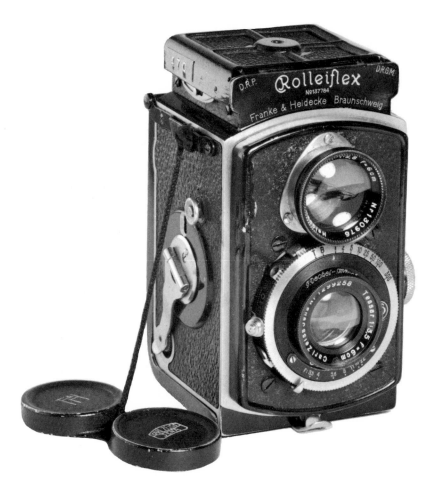

To many amateurs 'Twin lens reflex' means **Rolleiflex**, the trademark of Franke & Heidecke, Brunswick. This, the first model of all with f/4.5 Zeiss Tessar in Compur shutter, takes the obsolete No. 117 film, giving six pictures 6 cm (2¼in) square.

The 'small' **Rolleiflex**, in the same series as the standard, was put on the market in June 1931. Its size was reduced to 2¼×3×4¼ in. It took twelve views of 1⅝×1⅝ in on VP 127 film. It came with either a f/3.5 or f/2.8 Tessar.

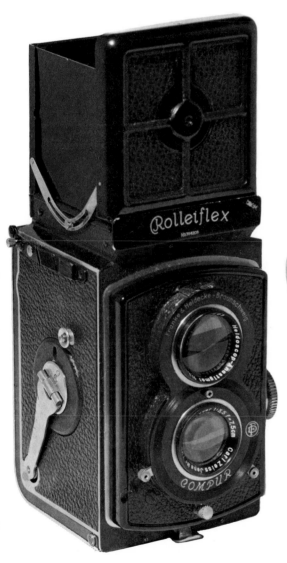

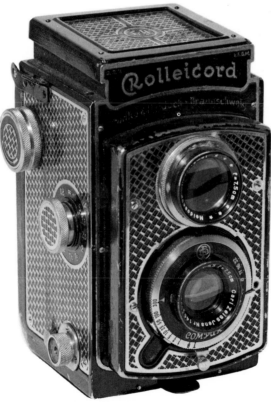

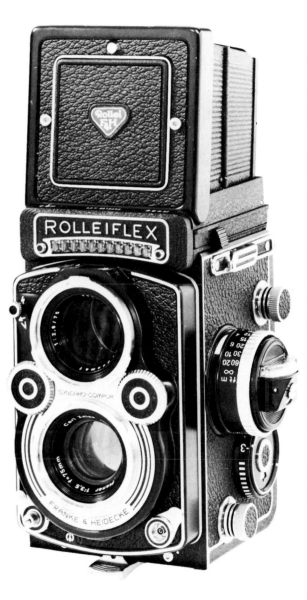

A later variant of the **Rolleiflex**, the Sport, which in 1932 replaced the earlier model. The cocking and shutter release were both made by the small lever situated below the taking lens, which was equipped with a Compur 1-1/300 sec. shutter. The earlier models in this series had a Tessar f/3.8 lens. Another modification was that speeds and openings could be read from above.

The **Rolleicord 1** came out in 1934, and was a cheaper version of the Rolleiflex. An early version, appearing in November 1933, had a Zeiss Triotar f/4.5, and was not able to take the plate-back, or the Rolleikin, for 35 mm rollfilm. The florid decoration earned this model the nickname "Louis XV" in France.

This model, the **Rolleiflex Automatic 3.5 E**, was put on the market at the end of 1956, and is one of the most highly-developed of this firm's range of cameras. It is equipped with a photo electric cell, with the needle and scale of the meter fitted into the focusing knob. It has lenses from Carl Zeiss or Schneider, the Planar and the Xenotar, both of f/3.5.

35 MM

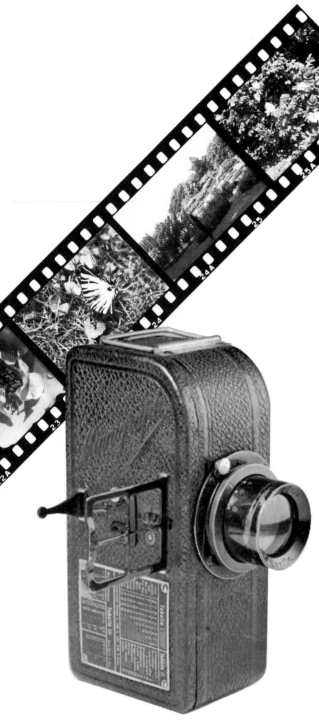

The **Minigraph** by Levy-Roth, Berlin, is an early example of camera designed to use perforated 35 mm motion picture filmstock. Enough film was carried for 50 exposures 18×24 mm, the size of one movie-camera 'frame', the long dimension lying across the film; i.e., half the Leica format. The **Minigraph** dates from 1915. It has a 54 mm f/3.5 anastigmat and direct viewfinder; the shutter is reset by winding on.

More 35 mm film is shot off daily by amateurs and professionals than any other size and almost every advance in camera technology during the past forty years has been pioneered on 35 mm cameras. Although, as the following pages show, perforated 'movie' film was tried soon after the introduction of motion pictures (Edison 1891, the Lumière brothers 1895) the slow soot-and-whitewash emulsion of those days was of no use for still pictures, and enlarging-techniques were pretty primitive. This is probably why Oscar Barnack's brilliant Leica design of 1913 (page 203) did not go into production until 1924, and even then was mistrusted by older photographers for another decade or so; it must be remembered that right up to the Second World War "miniature camera" included not only 35 mm and Vest Pocket but also 6 × 6 cm (2¼ × 2¼ in). Small negatives were vulnerable to dust and scratches, retouching was difficult and fine-grain developers a thing of the future. As against this the cheapness of film, especially if bought in bulk and loaded at home, and the convenience of having 36 shots on a reel endeared Leica photography to more and more people. It was invaluable for sporting subjects and child photographs.

At first Leitz was almost alone in the field. On the Leica Ic (1930) they introduced interchangeable lenses in screw mounts and an accessory range-finder was sold so that depth of field could be properly assessed. On Leica II (1932) the range-finder was coupled to the lens; slow speeds were added the following year, by which time Carl Zeiss, Jena, had introduced the Contax, a focal-plane 35 mm similar to the Leica but bigger and heavier. Contax III, introduced in time for 1936 Berlin Olympic Games, had a built-in selenium cell light-meter (page 213). The Leica was copied in Russia

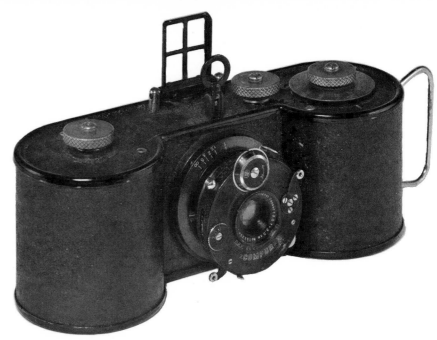

by Fed. Inexpensive 35 mm cameras appeared with between-the-lens shutter and bellows focusing. Robot provided rapid-fire clockwork film winding, Zeiss-Ikon even made the Contaflex a 35 mm twin-lens reflex with built-in light meter in 1935, most covetable camera of its time. What more could anyone want?

One answer, introduced soon after the war by an English company, Wray, Ltd, of Bronley, Kent, was an *eye-level* reflex. The Wrayflex SLR was short-lived because viewing was possible only with the shutter cocked, and the image was laterally reversed. Still it was a start. Then in 1948/9 came the Zeiss Contax S, probably the first SLR with a pentaprism finder. The modern 35 mm was finding its form.

Called **Phototank** from its shape, no doubt, this very French design was the work of Henri Bayle, manufactured by Victor Houssin in 1921. It is unusual in taking square pictures 24×24 on 35 mm filmstock; the focal-plane shutter is adjustable for tension and width of slit. Berthiot Stellar f/3.5, 50 mm.

However, the Second World War spelled the end of German supremacy. Leitz rebuilt, Zeiss, too, but the balance now shifted to Japan where the optical and electronic industries after a few years of zealous imitation showed a growing flare for design. Small compact 35 mm cameras like the original Leica are still to be had —from Rollei, for example—but the emphasis now is upon sophistication at the cost of additional weight. It would be churlish to complain. An expensive SLR 35 mm camera body today offers TTL (through-the-lens metering) by means of CdS (Cadmium disulphide) or Silicon Blue cell or LED (light-emitting diodes) and automatic exposure setting between 8 seconds and 1/2000. It will take lenses of f/1.2 aperture and every focal length from 16 mm to 1000 mm. Zoom lenses too. It has interchangeable backs, rapid fire and remote control. Fine-grain emulsions, developers and colour-film have kept pace with camera design. Purchase a 35 mm camera and you buy into a system, almost a way of life.

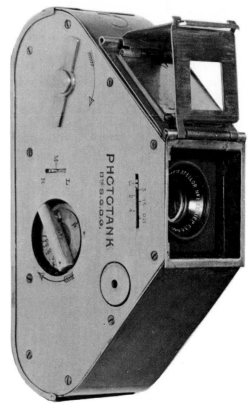

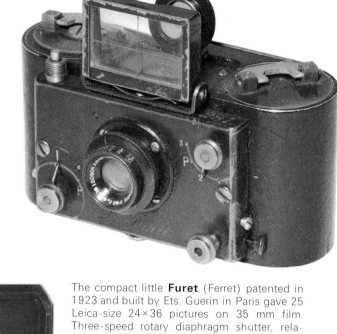

The compact little **Furet** (Ferret) patented in 1923 and built by Ets. Guerin in Paris gave 25 Leica-size 24×36 pictures on 35 mm film. Three-speed rotary diaphragm shutter, relatively wide-angle 40 mm f/4.5 Hermagis lens.

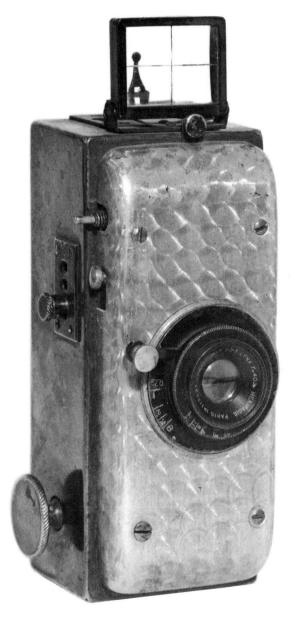

Because it held enough 35 mm film for 100 18×24 mm exposures this camera patented in 1924 and built by Mollier of Paris was called the **Cent Vues**. The interior shot shows the film-feed gears, the ample spool space and the 'crosswise' format. Hermagis Lynx 45 mm f/3.5.

The **Eka** built by E. Krauss, the Paris opticians well-known for their association with Carl Zeiss, can be dated to 1924. It carries a 50 mm f/3.5 Krauss Tessar lens in dial-set Compur shutter giving speeds up to 1/300 sec. The burly body contains enough film for 100 exposures and because unperforated stock is used the format is almost 35×45 mm.

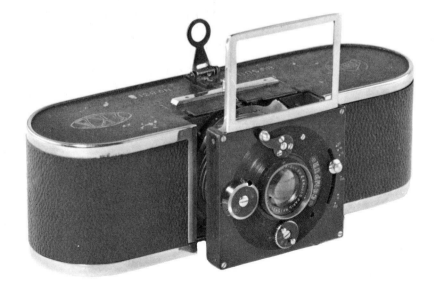

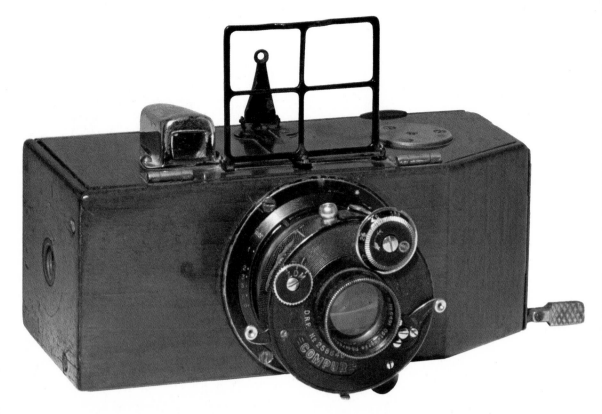

The wooden-bodied **Sico** took its name from the 1922 patentees Simons & Co., of Berne, and contained enough 35 mm film for 25 30×40 mm photos. It would accept either plain or perforated film, advanced by pulling the brass-tipped lever. The makers' 60 mm f/3.5 Sico lens was used in a focusing mount and dial-set 1 to 1/300 Compur shutter.

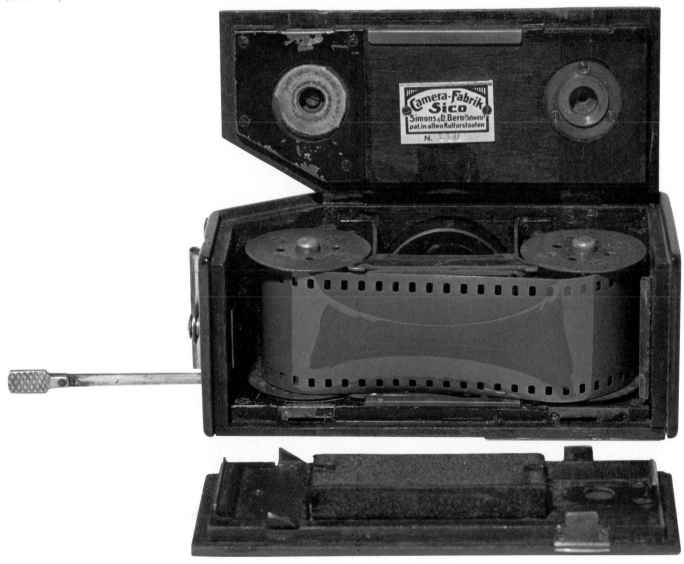

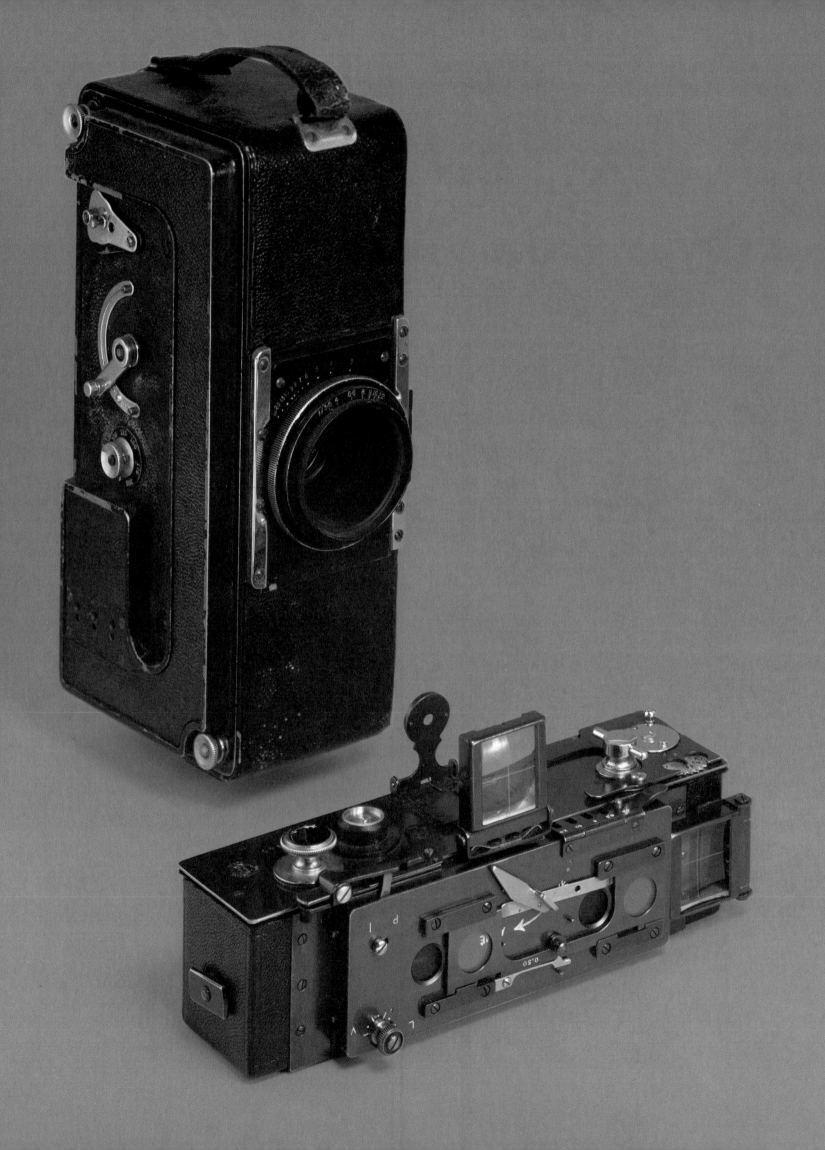

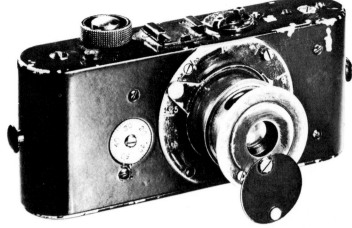

Oskar Barnack's 1913 prototype **Leica** (the name come from **LE**itz **CA**mera) was fairly fat, holding film enough for 50 shots. The swinging lens-cover was necessary because the focal-plane shutter was not yet self-capping. The lens even at this stage was retractable.

Oskar Barnack (1879-1936) in his lab. His Leica design has revolutionised photography.

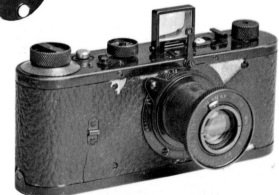

Pre-production prototype **Leica**. This camera, which bears the number 113, is the fourteenth in a series of experimental models made entirely by hand between 1923 and 1924, the numbering of which began with 100. The lens, a 50 mm f/3.5, is an Elmax anastigmat calculated by Prof. Max Berck, precursor of the famous f/3.5 Elmar of the same focal length. On this series shutter speeds are indicated in millimeters representing the width of the slit in the blind, not in seconds or fractions of a second.

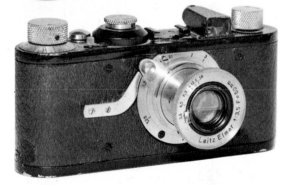

The first production version, the **Leica I model A**, of 1925. Elmar lens f/3.5, 50 mm, and focal plane shutter speeded from 1/5 to 1/500 sec.

◁ Just the thing for Doing Europe, the **Tourist Multiple** by Herbert & Hugesson of New York held enough perforated 35 mm film for 750 18×24 'half frame' negatives and had several ingenious features. The lens being recessed into the body had no need of a hood, and the lever used for setting the metal-diaphragm 1/40 to 1/200 sec. shutter advanced the film and operated an exposure-counter. 'Round the World without Reloading' said the advertisements, or something rather like it.

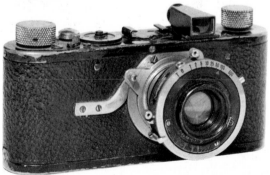

Compur Leica, model I b. Two series of Leicas were marketed with Compur instead of focal-plane shutter, at first with the dial-set Compur, later with the rim setting version seen here. Their only advantage was the provision of slow speeds (from 1 sec.-1/10) which did not appear on focal-plane models until the Leica III.

◁ Patented in 1913 and clearly showing its *photo-jumelle* ancestry, the **Homeos** hails from Jules Richard, the well-known Paris stereoscopic opticians. It was probably the first stereo camera to use perforated 35 mm film, taking 18×24 mm pictures in pairs. Viewfinders for upright and landscape subjects, 28 mm f/4.5 Krauss lenses with lever operated stops and external Chronomos 1/5 to 1/400 sec. shutter, removable for dusting the mechanism and cleaning the lenses. Fixed focus, as in almost all Jules Richard stereo cameras.

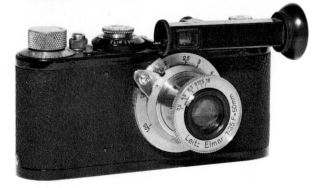

Leica I c of 1930. Series I Leicas were fitted towards the end of their span with screwed lens mounts. Note the absence of an L-piece on the body. This one carries a separate right-angle view-finder. The focal plane shutter goes from 1/20 to 1/500 sec.

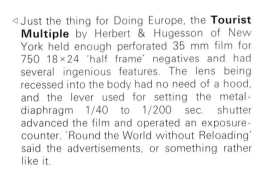

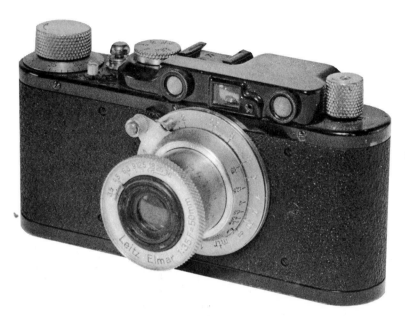

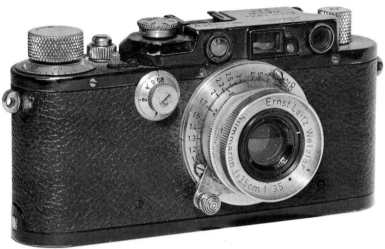

Leica II, 1932. Development of the Leica is now fully launched. A built-in range-finder is coupled to the lens, and lens mounts have a standardised screw thread to accept six assorted lenses besides the f/3.5 Elmar, including a 50 mm Hektor opening to f/2.5. Finish is still black enamel with nickel plating.

Slow speeds reached the focal-plane Leicas with the satin chrome finished **Leica III**, appearing in 1933; they gave 1 second, 1/2, 1/4 and 1/8 as well as the normal 1/20, and were selected by a plated button beside the lens. The lens here is an f/3.5 Summaron wide-angle of only 35 mm focal length.

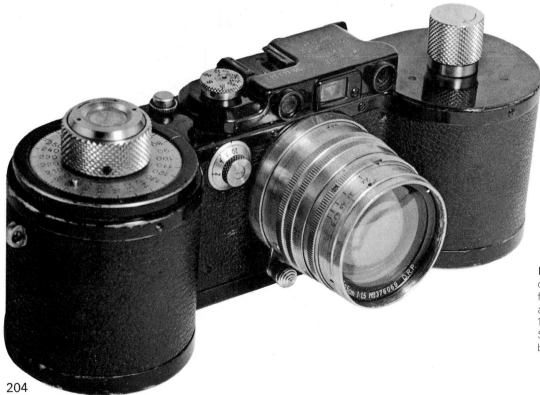

Leica 250, of 1936. This big double handful carries enough film for 250 exposures. Apart from the big body the specification was virtually IIIa, i.e. Leica III with the addition of a 1/1000 sec. speed. The large lens is a 50 mm Schneider Xenon opening to f/1.5 said to have been designed for taking movie 'stills'.

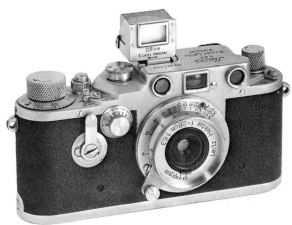

Leica III D. A short series of these was made during the Second World War. The III D was similar to a III C, which had been substantially re-designed internally and offered speeds starting from 1/30 instead of 1/20 as in Barnack's day; with the addition of a delayed-action 'self-portrait' device. The latter did not reappear until about 1950 on the III F.

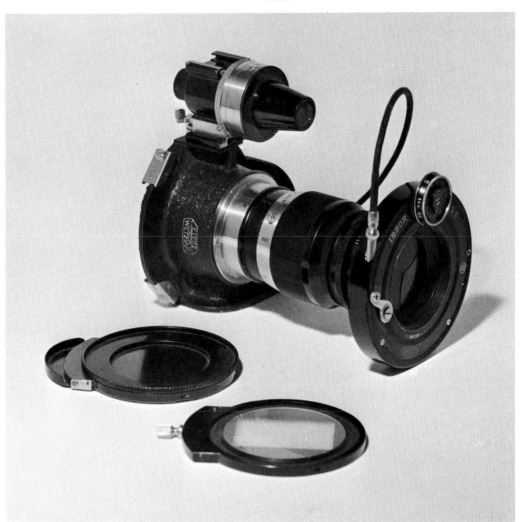

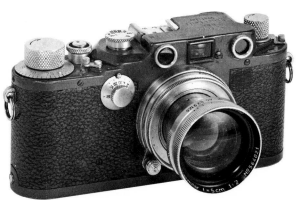

Luftwaffe Leica. This is a III C in blue-grey finish manufactured during the war for use by aircrew. The cameras bore a letter K after the serial number and on the shutter blind, signifying *Kugellager* (ball bearings). They were designed to operate in very low temperatures.

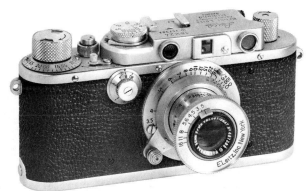

Half-frame Leica. Built in very small numbers by Leitz Canada Ltd, this model took 72 half-size exposures (18×24 mm) on an ordinary 36 exposure roll. The lens is a 50 mm Wollensack Velostigmat f/3.5 produced by E. Leitz Inc., New York. The small upright-format view-finder window gives it away.

△
Single-shot **Leica**: The body accepts any of a big range of lenses; it is here seen wearing an Elmar f/4 cm telephoto together with a multiple view-finder suited to this focal length. The front shutter is a 1 sec. to 1/100 sec. Ibsor with Antinous release. In the foreground, a dark slide and a ground-glass screen.

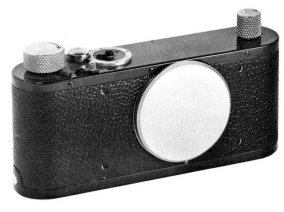

◁**Mifilca** Leica body specially designed for use with a microscope. There is no shutter, and film-winding is done by means of a ratchet, as on the Compur Leicas.

205

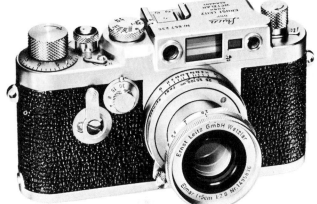

Leica III G, 1957, is the last of its type. It differs from the III F, which had flash-contacts and delayed action, in having an improved view-finder and correction for parallax when using lenses of 50 and 90 mm focal length. Shown is the 50 mm f/2.8 Elmar.

Leica I Luxus. From the word go all Leicas ▷ were exciting and covetable; but this one exceeded all, having its brightwork gold plated and the body covered in lizard skin. Legend has it that only 15 examples of the **Luxus** were made, but in fact they could be had to order. A metal L-piece on the front of a Leica body means that the camera was made before the introduction of interchangeable lenses.

The **Leicaflex SL** dates from 1968. Here we have a single-lens reflex Leica presenting the subject right way up at the photographer's eye level by means of a pentaprism. Exposures are measured through the lens by means of a built-in CdS exposure-meter. There is a tremendous range of Leitz lenses all the way from 21 mm to 800 mm focal length. The silent focal-plane shutter has speeds up to 1/2000 sec. SL stands for Selected Light, a reference to the sophisticated through-the-lens metering. Replaced in Autumn 1974 by Leicaflex SL2 in which meter sensitivity is four times as great and the lower scale is illuminated by separate battery.

In 1971 Leitz of Wetzlar completely rethought the **Leica**. The result was the **Leica M5**, a larger, heavier, very sophisticated 35 mm camera measuring 150×87×35 mm (approx. 6×3⅜×1⅜ in), the first range-finder camera to have through-the-lens metering, using a CdS cell and internal printed electronic circuits to govern cross-linked matching needles; thus the user chooses either the aperture or the shutter-speed he wants and has only to bring the second needle into line. Mechanically operated focal-plane shutter 1/2 to 1/1000 sec. A 'preview' lever on the front adjusts the suspended frame in an Albada viewfinder to correspond with the focal-length of the lens in use, from 35 to 135 mm. High quality was reflected in the price.

This is the **Leica CL**, the letters standing for 'compact Leica', which came out in 1973. By using a top-to-bottom focal-plane (1/2 to 1/1000) shutter instead of the classic horizontal type, designers at Wetzlar brought the overall dimensions down to 120×78×35 mm (roughly 4¾×3⅛×1⅜ in), delighting those who deplore weight and bulk. The **CL** has through-the-lens metering and a coupled range-finder with Albada view-finder showing the field of view for any lens of 40 mm, 50 mm or 90 mm focal length. All the Leica M series lenses may be used with the **CL**, together with two evolved specially, the f/2 40 mm Summicron and f/4 90 mm Elmar. Leica **CL** bodies are made in Japan by Minolta.

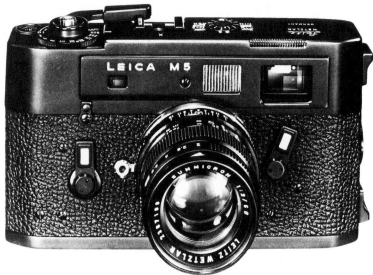

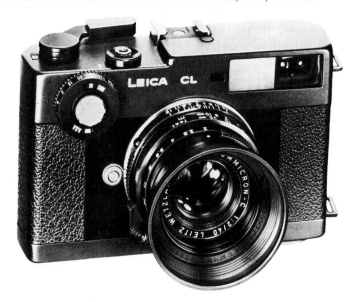

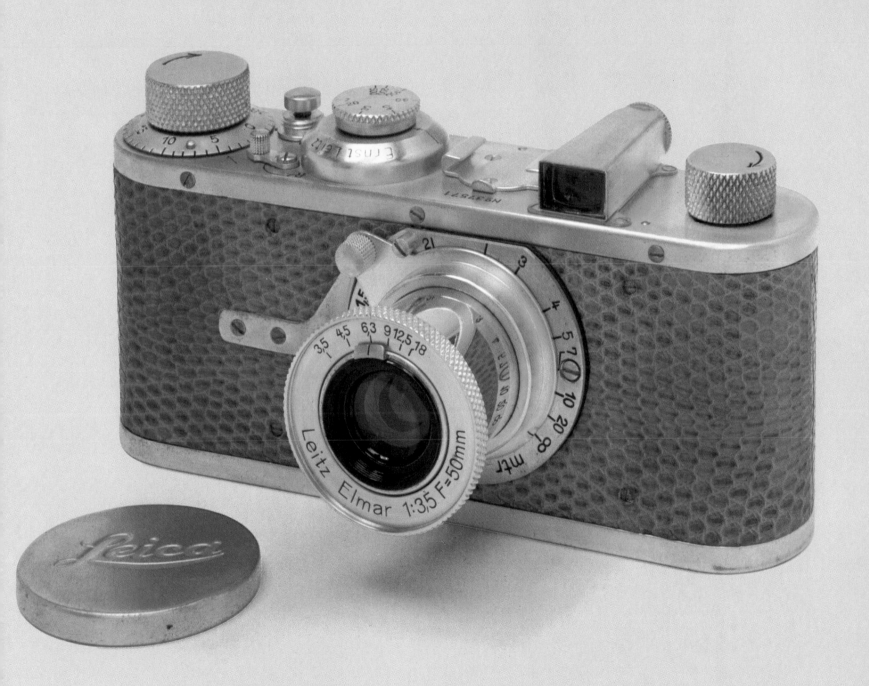

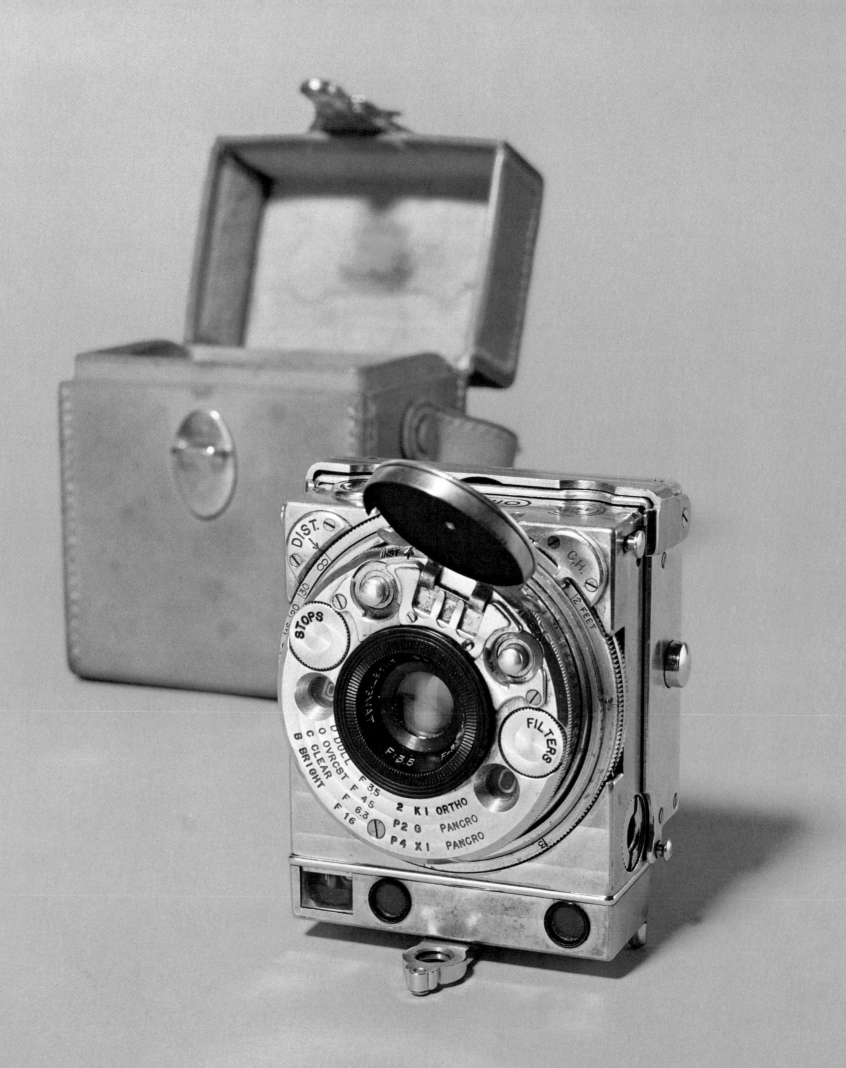

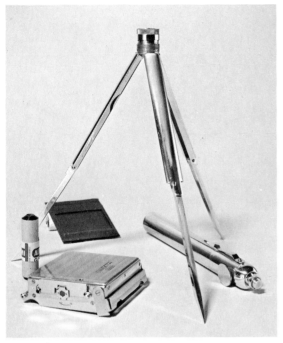

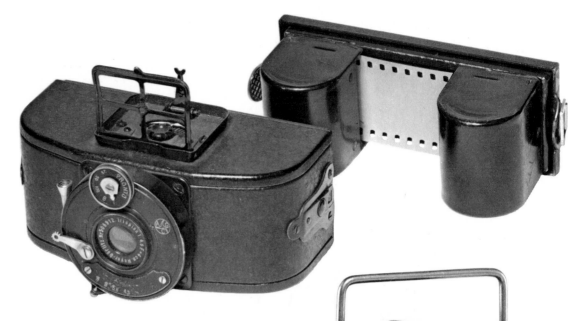

⊲ **Compass II**, a very rare camera indeed. Designed by that colourful character, Noel Pemberton-Billing—airman, Member of Parliament, publicist—for manufacture in Switzerland by the watch and instrument makers, Lecoultre, in 1937 the all-metal *Compass* measured 2¾×2⅛×1¼ inches and weighed 7¾ ounces. It was as full of works as a complicated watch. They included: coupled rangefinder, built-in lens hood and filters, extinction exposure-meter and stops indicators, normal and right-angle viewfinders, provision for landscape views (by overlapping two frames) and even a stereoscopic option by means of related tripod bushes. The Compass was designed as a plate camera with glass screen focusing, but a small roll-film pack was supplied for six 24×36 negatives. There was a magnifyer for use with the screen. Accessories included a folding tripod. Rotary shutter for speeds from 4½ sec. to 1/500, 35 mm f/3.5 Kern. **Compass I** cameras are very rare because the makers offered to exchange them free of charge in 1938 for the improved **Compass II** which differed slightly in layout.

Amourette is the name of this little love constructed by the Österreichische Telephon AG of Vienna. The ingenious detachable back holds sufficient film for 50 exposures; it also calls to mind certain 'instant' cartridge changing systems of the present day. Meyer Trioplan 40 mm f/4.5 on Pronto 1/25-1/100 between-the-lens shutter.

A latter-day jumelle with Leica overtones, the **Stereo Kern SS** came from Aarau, Switzerland, in 1932 and held enough perforated 35 mm film in special charger for 30 double views 20×20. Pair of 35 mm f/3.5 Kernons, shutter speeds from 1/25-1/300 sec., iris diaphragm, all controls grouped on top. No focusing as the short focal length made it unnecessary.

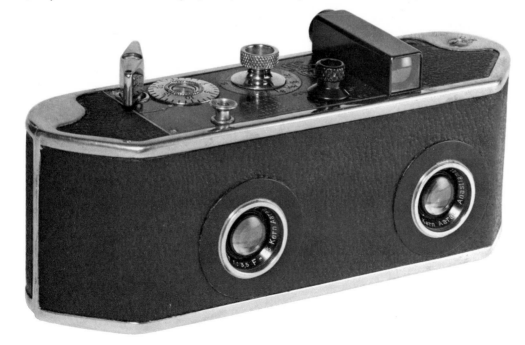

'Why make a note when you can take a photo?' might have been the motto when Agfa Ansco of Binghamton, N.Y. brought out the **Official Boy Scout Memo Camera**, one of the first box cameras to use 35 mm film. Film-advance by lever on the back, counter in aperture above the lens, a 35 mm f/6.3 Ilex-Ansco Cinemat with iris diaphragm and shutter speeded to 1/100 sec.

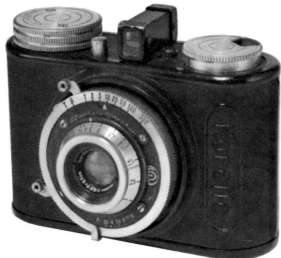

Very compact and workmanlike was the **Korelle**, built in Germany from 1933, and highly 'touristic' with a capacity for 72 half-frame views on 35 mm film. A 35 mm f/2.8 Tessar and 1 second to 1/300 rim set Compur shutter made it also quite fast.

The **Carmen** of about 1933 carries no maker's name and is of the crudest construction. It used Bantam 828 size non-perforated 35 mm roll film for 24×36 negatives. Meniscus lens, fixed focus, single speed. Supplied in France under the name **Pygmée**.

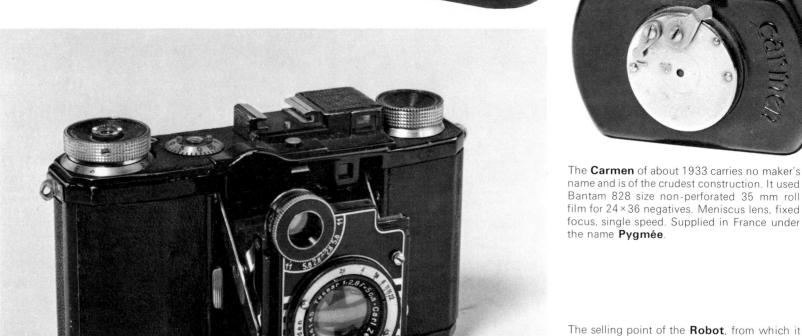

The selling point of the **Robot**, from which it took its name, was a clockwork motor to wind on and re-cock the shutter as soon as an exposure had been made. This was especially nice for recording photo finishes. Special chargers containing perforated 35 mm film provided 24 shots 24×24 mm. This one has an f/2.8 Tessar. Shutter speeds 1 sec. to 1/500.

About 1934 Zeiss Ikon AG brought out this interesting 35 mm called the **Super Nettel J**, whose family tree includes elements from both Contessa Nettel and Zeiss, who had amalgamated in 1926. It took ordinary 36-exposure cassettes and used a focal-plane shutter like that of the Contax; unlike the Contax it had bellows, and the lens lived under cover. Either a f/3.5 or an f/2.8 Tessar could be fitted, and the rotating wedge range-finder came from the Super Ikonta. Altogether a very superior instrument. This one has the larger Tessar.

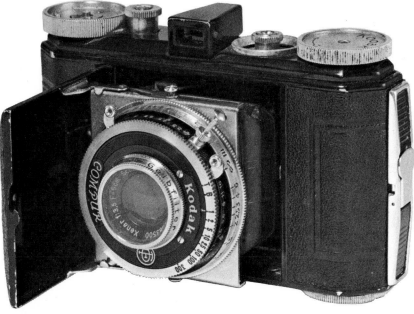

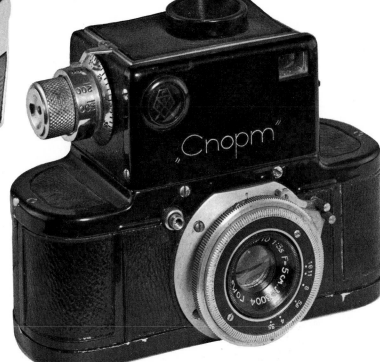

A medium priced bellows camera designed and made in the Kodak factory at Stuttgart, the **Retina I** appeared in 1934 and was intended to undercut Leica and Contax. The Retina used ordinary 36 exposure cassettes for 24×36 pictures. This example has a 50 mm f/3.5 Xenar and is wearing a yellow filter. Rim set Compur shutter.

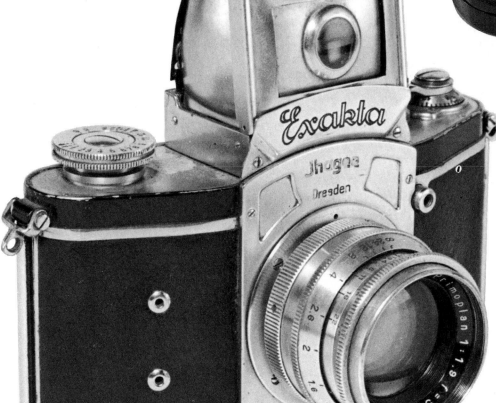

Cnopm says Sport in Russian characters. This chunky little 1935 camera from the USSR houses special feed and take-up spools containing enough 35 mm film for 50 exposures. Controls for the focal-plane (1/25-1/500 sec.) shutter, and an exposure-counter, are mounted on the view-finder housing, which incorporates a magnifying glass. The lens is a 50 mm Industar f/3.5 with iris.

Two important strains came together in the **Kine Exacta** brought out by Ihagee, Dresden, in 1936: single-lens reflex and 35 mm format. The 35 mm **Kine** followed close upon an earlier VP **Exacta** and may be regarded as an ancestor of the modern SLR although it was a top-viewing, not an eye-level, reflex. Note the alternative direct view-finder. A strong, well-made, but rather bulky instrument, with 12 sec. to 1/1000 focal-plane shutter and lenses which included the 58 mm f/1.9 Primoplan seen here.

211

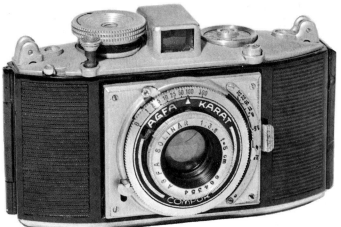

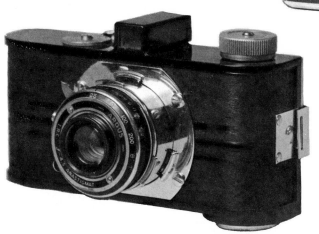

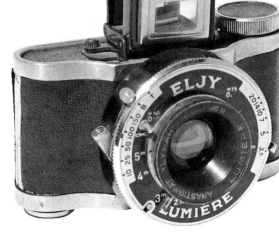

Agfa **Karat**, made at Leverkusen in 1938, the first model dating from the previous year. Competition was keen in the 35 mm field, especially in Germany. This medium-priced Agfa was aimed at the amateur who still liked bellows cameras, wanted something compact and objected to waiting for the end of a 36-exposure spool. The Karat gave twelve 24×36 mm in special cassettes. Solinar f/3.5 50 mm, Compur from 1 to 1/300 sec.

The **Argus**, made in 1936 by the International Research Co., took 36 pictures on easy-load film. The Argus f/6.3 50 mm lens had a central shutter, speeded from 1/25 to 1/100 sec, and iris diaphragm.

The **Verascope 40** of 1938 carried on a model name associated with its manufacturers Jules Richard of Paris since 1905. This one is a 35 mm application offering 40 stereo pairs 24×36 using special cassettes. A very nicely made camera with coupled range-finder, pair of 40 mm f/3.5 Flor lenses and shutter going to 1/250 sec. The film advance and re-winding knobs on this example have been extended for use in a special body for underwater photography.

The **Eljy**: a French miniature made by the pioneer firm of Lumière at Lyon in 1937 gave eight exposures 24×36 on 127 unperforated 35 mm film. Self-setting shutter 1/25 to 1/100 sec.

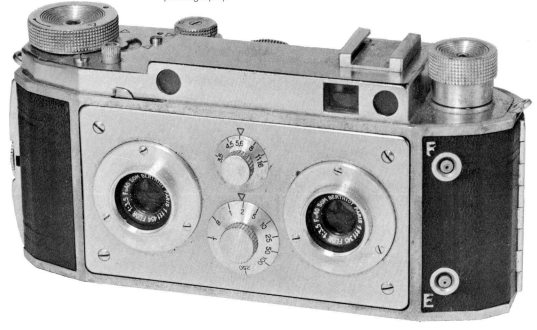

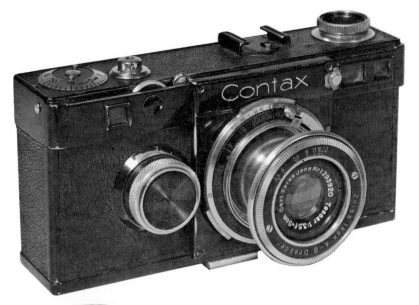

Zeiss Ikon were in no hurry to meet Leitz Leica competition; they waited until 1932 before bringing out the **Contax I**, by which time a good deal had been learned about fine-grain film and developers for 35 mm work. The **Contax** was heavier and bulkier than its slim contemporary the Leica **II** and there were many differences of approach: the lens mounts had bayonet instead of screw fitting, a wider-based coupled range-finder was fitted and the focal-plane shutter moved in the vertical plane, a very individual design built up from metal slats like a roll-top desk and provided with three crossing speeds. The knob on the front selected the shutter speed, cocked the shutter and wound on the film. The camera shown is wearing a 50 mm f/2 Zeiss Sonnar lens, one of four standard options. Speeds were from 1/25 to 1/1000 but later **Contax I**s had slow speeds down to 1/2 sec. Prices were slightly higher than comparable Leica models.

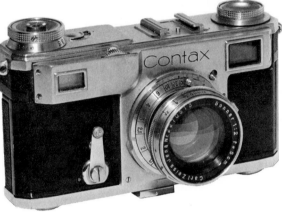

The **Contax II** had bevelled ends and was more convenient in use than the **I** because speed control and winding were controlled by a single knob on the top plate, with the shutter-release in its centre, and the same eyepiece was used for both view-finder and range-finder. The frame-counter was now under glass and a delay-action was included—the lever on the front. Bright and satin chrome finish replaced black enamel. Coupled lenses up to 180 mm focal length could be had, and even longer telephoto lenses in reflex mountings. The highest shutter speed was now 1/1250 sec.

Zeiss-Ikon **Contax III**. The **Contax III** ap-▷ peared during the same season as the **Contax II**, in time for the Olympic Games in Berlin. The two models were almost identical except that the **III** was furnished with a built-in selenium cell, seen here with lid raised, so that **III** users could dispense with a separate exposure meter. It was not of course connected to the camera mechanism, and its field was that of a 50 mm lens. Focusing on all three models was by means of the little knurled wheel above and to the right of the lens. The camera shown has an 85 mm f/2 Sonnar. Growing sophistication was reflected in Contax prices. **Contax I** models had ranged between £27.50 and £51.50; the **III** cost from £53 to £78.

The **Contax S** manufactured by Zeiss at Dresden since 1948 or 9 is historically important: it was probably the first eye-level reflex, using the 5-sided 'pentaprism' that revolutionised 35 mm photography. Other differences from earlier Contax models are a fabric rather than metal focal-plane shutter and a change from bayonet-fitting lenses to screw mounts.

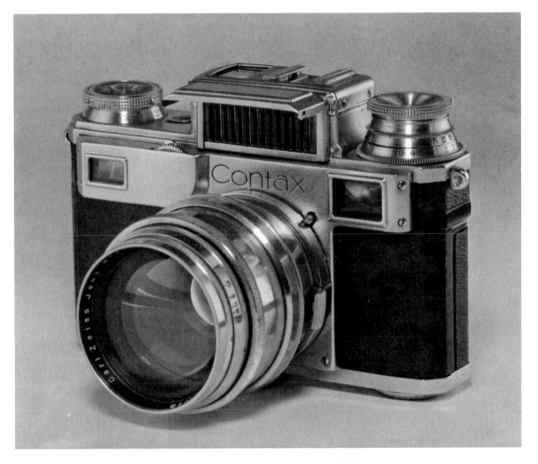

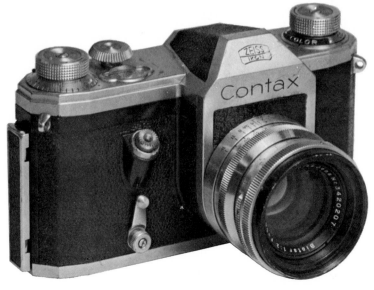

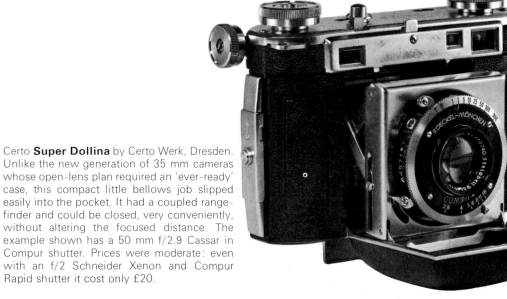

Certo **Super Dollina** by Certo Werk, Dresden. Unlike the new generation of 35 mm cameras whose open-lens plan required an 'ever-ready' case, this compact little bellows job slipped easily into the pocket. It had a coupled range-finder and could be closed, very conveniently, without altering the focused distance. The example shown has a 50 mm f/2.9 Cassar in Compur shutter. Prices were moderate: even with an f/2 Schneider Xenon and Compur Rapid shutter it cost only £20.

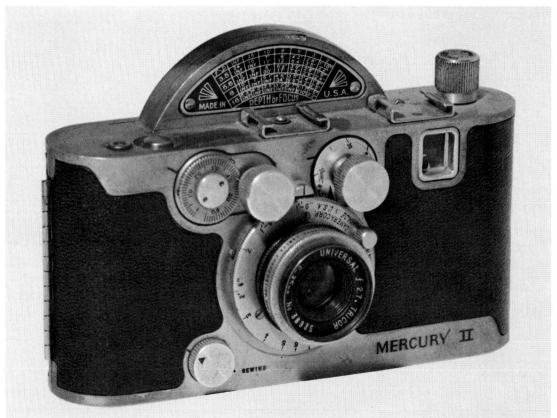

Billed as 'the smallest miniature in the world' this **Photavit** came from the Photavit Werk, Nuremberg, in 1938 and measured $2\frac{1}{4} \times 1\frac{1}{16} \times 3\frac{5}{8}$ in, taking fifty 24×24 mm shots on a 35 mm 36-exposure film. Radionar 37.5 mm f/3.5 lens in Prontor II shutter, 1 sec. to 1/200.

Dating from 1940 and made by the Universal Camera Corp. in the United States, the **Mercury** could hardly be called mainstream, since instead of a focal plane shutter a rotating disc was fitted (hence the bulge on top), giving speeds from 1/20 to 1/1000 sec. This would now be called a 'half-frame' camera since it takes 65 18×24 mm exposures on an ordinary 35 mm film. Universal Tricor f/2.7 50 mm lens in focusing mount without range-finder. The Model **II** is post-war.

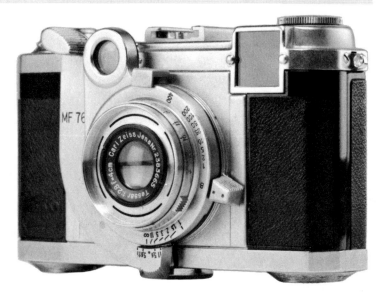

The Zeiss Ikon **Tenax** was an eminently pocketable little bellows 35 mm with coupled range-finder. Yet another reincarnation of the old Goerz model name.

Russian-made cameras by Fed, very reminiscent of a Leitz Leica, were on sale before the war. The 35 mm market has also been catered for by Zenit, makers of this inexpensive **Zenit 4**, a coupled rangefinder camera offering interchangeable lenses and a 1 sec. to 1/1000 focal-plane shutter. As in early Leicas, supplementary view-finders are needed for lenses of other than 50 mm focus.

Ducati half-frame camera from Ducati of Milan, about 1938, using 35 mm film in special cassettes to give 15 shots 18×24 mm. A charming miniature with coupled range-finder, focal-plane shutter, 1/20 to 1/500 sec. and 35 mm bayonet-fitting f/3.5 Victor lens.

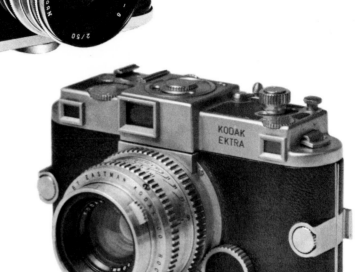

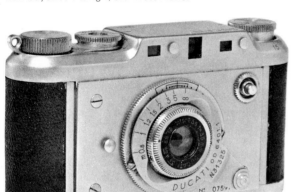

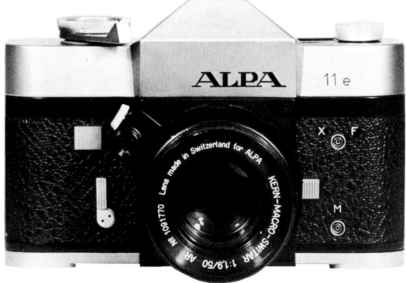

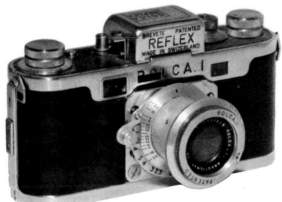

It is tempting to read influence from the Stuttgart works into the design of Kodak's **Ektra**, produced in America about 1940. This is the first high quality American 35 mm camera with interchangeable lenses. Optical finder, wide-base coupled range-finder, fabric focal-plane shutter from 1 sec. to 1/1000. Kodak Ektar f/3.5 50 mm lens in this example, its focusing mount geared to a knurled knob for the left forefinger. This camera could be used with a focusing screen; the back takes off for insertion of special cassettes, perhaps the germ of Kodak's present **Instamatic** principle.

Made by Pignons SA of Ballaigues, Switzerland, manufacturers of watch and clock parts, the **Bolca I Reflex** designed by Jacques Bolsky, of Bolex fame was the forerunner of the Alpa. The camera shown is an experimental model with uncalibrated focal plane-shutter; it is wearing a 50 mm Bol f/2.8 lens with bayonet fitting, one of an interchangeable range. Note: this is a dual-purpose instrument; it has a waist-level reflex mirror in addition to the coupled range-finder.

The **Alpa II**e is a recent addition to a series of cameras made in the Swiss watch-pinion factory of Pignons SA, Ballaigues, who brought out the Alpa **I** in 1942 and followed it in 1950 with model **II**, an eye-level reflex employing a pentaprism (then known as a 'roof prism'). The current Alpa is an SLR with stopped-down through-the-lens metering and illuminated signal arrows for the read-out. Focal-plane shutter from 1 sec. to 1/1000 and self-timer; Kern Macro-Switar f/1.9 lens of 50 mm specially designed for close-range work, focusing down to 28 cm (11 inches). Beautifully built for scientific use, and priced accordingly.

The **K1 Monobar** is a device offering all the movements and facilities of a technical camera, but in 24×36 mm format—in other words it is a 35 mm monorail. The lens here is a Zeiss Planar 80 mm f/2.8 in rim-setting Compur shutter. After focusing the ground-glass screen and magnifying eyepiece now in position would be replaced by a camera body. English made, and came out in the 1950s.

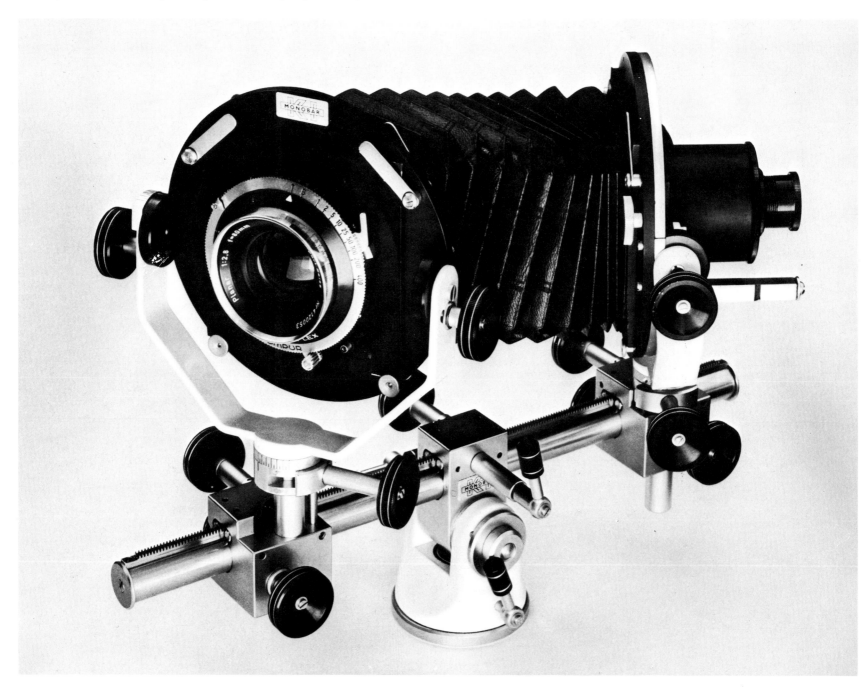

Rollei 35. A compact 35 mm full-frame camera with f/3.5 Zeiss Tessar, coupled CdS (Cadmium disulphide) exposure meter and shutter speeds from 1/2 to 1/500. Built-in 'hot shoe' flash. A well-made little instrument costing as much as the cheaper SLRs. It measures only 97×58 mm (3⅞×2¼in) and weighs 390 g (10¾oz).

Introduced in 1954, the Nikon **S2** from Nippon Kogaku is very reminiscent of the pre-war Zeiss **Contax II** in general outline, a 35 mm with coupled range-finder and interchangeable lenses, although the focal-plane shutter was fabric and speeded from 1 sec. to 1/1000. This was the first Nikon with lever shutter setting and rapid-rewinding crank. The lens here is a 50 mm Nikker f/1.4.

The **Asahiflex**, by the Asahi Optical Co., Tokyo, dates from 1952. Unlike the same makers' subsequent Pentax range, this is a waist-level reflex with alternative optical direct vision finder. It has a focal-plane shutter speeded from 1/25 to 1/500 sec., and 50 mm f/3.5 Takumar. The first automatic-return mirror appeared on this model in 1954.

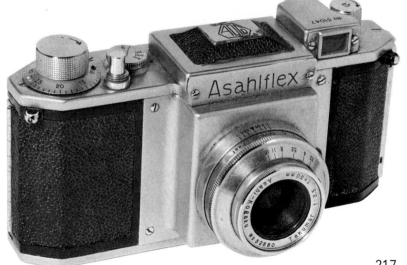

Proudly named by Commandant J.-Y. Cousteau after his research ship, the **Calypso** was the first camera to be produced in quantity with sealed body for underwater photography. It was built at first by Spirotechnique in Paris, then under licence by Nikon. It has a wide-angle 35 mm f/3 Berthiot Flor lens designed specially for close working and diaphragm shutter from 1/30 to 1/100 sec.

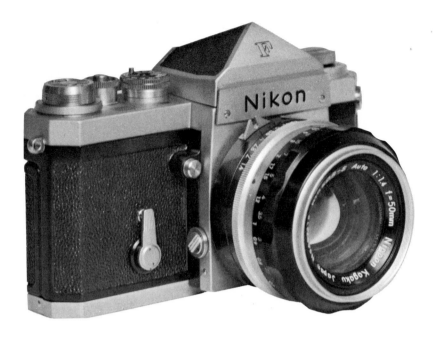

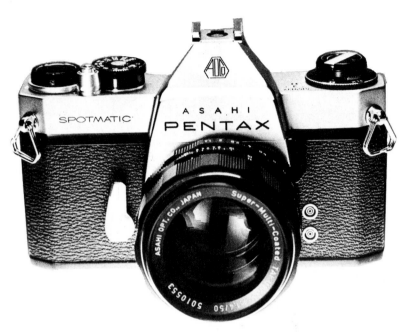

The Nikon **F** in its original form (seen here) was brought out by Nippon Kogaku, Tokyo, in 1959. It had no metering system, but a Photomic viewfinder could be attached, with its own photo-electric cell and window, and this cell was linked with the diaphragm and shutter. The **Nik-kormat Photomic TN** and **FTn**, appearing in 1968 and 1969 respectively, were given full-aperture TTL metering. Nikon offer a great variety of lenses and elaborate 'system' equipment used by amateurs and professional photographers throughout the world. Camera shown has the 50 mm Auto Nikkor f/1.4 and 1 sec. to 1/1000 focal-plane shutter.

Asahi Pentax Spotmatic II. The model name **Pentax** which has become so familiar all over the world calls attention to the 5-sided 'pentaprism' which brings reflex viewing to eye level. The **Spotmatic** is a single-lens reflex with stopped-down through the lens ('TTL') metering, with an 'auto' tab to switch the metering system on; it is typical in having delay-action 1 sec. to 1/1000 focal-plane shutter and viewing screen using the reverse side of a Fresnel condensing lens, the centre of the screen consisting of microprisms. Standard lenses for the **Sp II** are 50 mm Super Multi Coated Takumars of f/1.8 and f/1.4, with a score of alternatives from 16 mm wide-angle to 1000 mm telephoto, plus many proprietary ones using the popular Pentax/Praktika screw mountings. Variants are the **Sp F**, with full-aperture TTL metering and **ES II** (Electro Spotmatic II). The latter gives instant choice between stopped-down TTL metering and aperture-priority metering with electronic shutter-speeds from 8 sec. to 1/1000 plus manual control as a third option. There is a wide range of manufacturer's and proprietary screw-mounting lenses and accessories.

Also from Olympus, Tokyo, is this **Pen F**, a half-frame waist-level reflex with built-in-light-meter but without automatic control. A focal-plane shutter gives speeds from 1 sec. to 1/500 and interchangeable lenses add versatility. This one, an f/3.5 Auto-macro 38 mm is specially designed for copying and macrophotography; it will focus down to 6 cm—less than 1½ inches.

Olympus Pen, one of a series introduced during the late 1950s by the Olympus Optical Co., Ltd., Tokyo, taking 72 exposures on a standard 36-ex. 35 mm film. These 'half frame' cameras had fixed focus but made very sharp pictures thanks to the short focal length. The Pen has an f/3.0 of only 28 mm, mounted in an annular selenium cell which automatically adjusts the aperture between f/3.0 and f/22 according to the light and chooses a shutter speed of 1/40 or 1/100 sec. The only manual operation is adjusting a pointer to indicate the speed factor of the film in use. When light is inadequate, shutter is blocked.

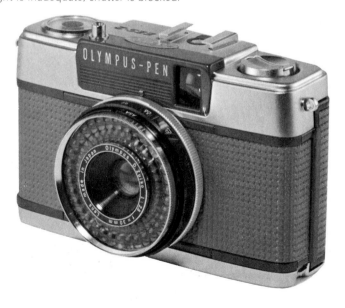

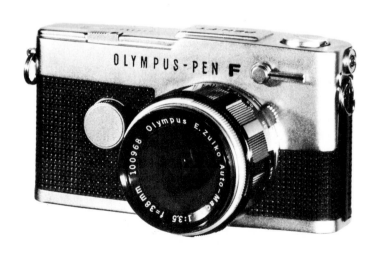

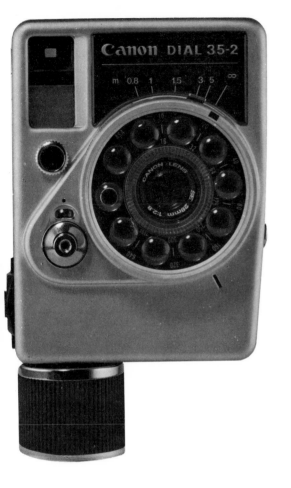

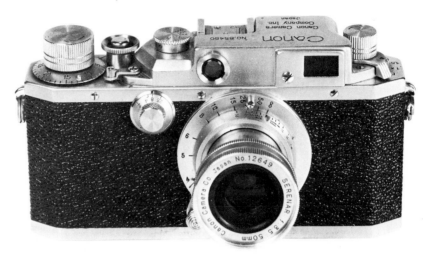

◁ Canon **Dial 35**. This 35 mm half-frame camera from Japan, like the pre-war **Robot**, has a clockwork motor for taking a quick succession of pictures—in this case up to 25 at the rate of 2 per second. The clockwork is in the grip, and also rewinds the film. The shutter gives a choice of four speeds, from 1/30 to 1/250 sec. and is coupled to a photo-electric cell which sets the diaphragm to suit the speed selected. Manual control is also provided. The viewfinder carries a scale of stops and picture-symbols to assist rapid focusing. There is a special device for centering the film during automatic shooting. A 28 mm f/2.8 Canon is fitted.

Showing strong pre-natal influence from Leitz, the Canon **IID** was an early 1952 Canon production: a classic 35 mm with 1 sec. to 1/1000 focal-plane shutter and coupled rangefinder. Even the lens is Leica-ish: a 50 mm f/3.5 Canon Serenar.

Introduced in 1970, the 35 mm SLR Canon **F-1** is a 'system' camera, one of the most sophisticated items in the comprehensive and often baffling list of this old-established Japanese maker. It has full-aperture TTL metering, with stopped-down metering option, and 1/2000 sec. focal plane shutter. This one has a 50 mm Canon f/1.4 but Canon make some 25 others, from 7.5 mm to 1200 mm, with their special breech-bayonet mount. Also available: motor drive, remote control, interchangeable screens, 250-exposure magazine...

Canon **UT de luxe**, dating from 1958, and fitted here with the big Canon 50 mm f/1.2.

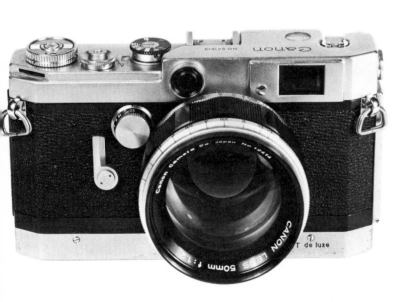

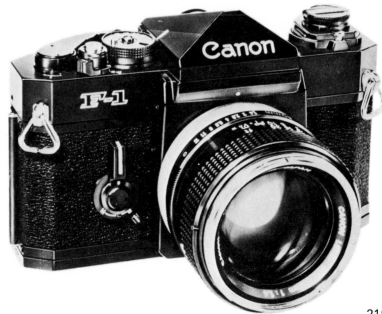

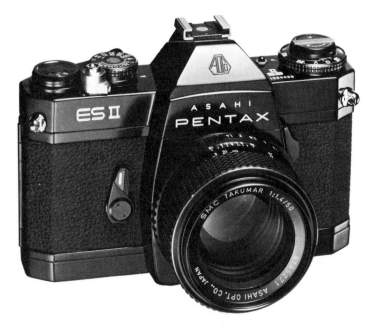

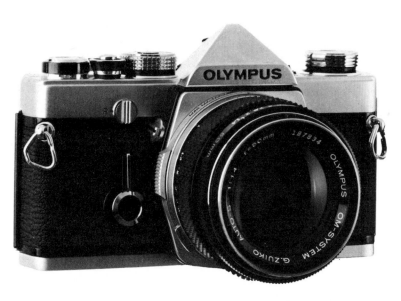

The Asahi Pentax **Electro Spotmatic ES II** is the most sophisticated camera in the Pentax SLR (single-lens reflex) range. It is an example of aperture-priority through-the-lens (TTL) metering: the user chooses a suitable aperture having regard to desired depth of field, and the camera matches it electronically with the appropriate shutter speed, all the way from 1/1000 down to .8 seconds. On Manual the range is 1/60 to 1/1000 with no metering; an additional control can be set to give double, 4 times, or half the metered exposure.

Small, light, handy and well made, the **Olympus OM-1** has full-aperture through-the-lens metering and screens may be changed through the lens mount. There is also a mirror lock. The finder gives a particularly bright, magnified, image, and innumerable accessories (including motor drive attachment shooting up to five frames a second) put it in the 'system' class. Highly praised optical performance, very competitive prices.

Replacing earlier stopped-down-metering models is the **Mamiya DSX 1000**, with full-aperture metering with matched-needle read-out for both average and spot (6%) readings. Shutter from 1 sec. to 1/1000. Good choice of lenses in standard (Pentax/Praktica) screw mounts.

Konica were early in the automatic field with their **Autoreflex** (1967). This **Konica Autoreflex T3** is a shutter-priority automatic: the user chooses a shutter speed and the camera sets the aperture accordingly. Manual over-ride is provided. Vertical-travel focal-plane shutter 1 sec. to 1/1000 with self-timer. Standard lenses f/1.7, f/1.4, f/1.2; priced in the middle range.

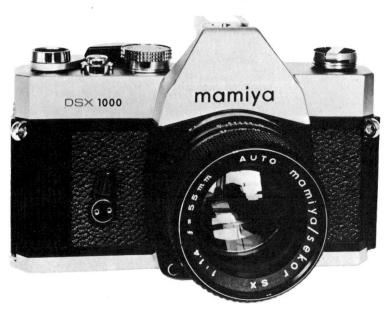

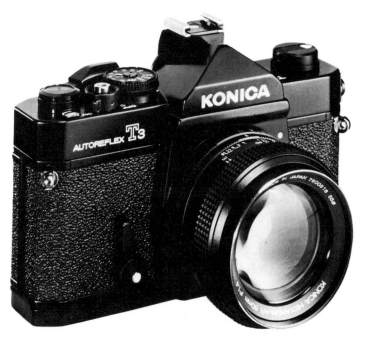

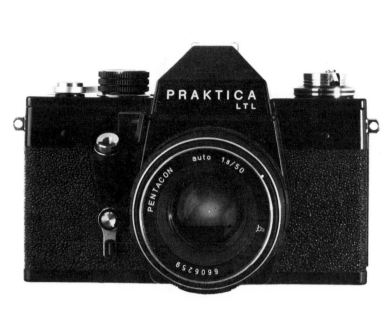

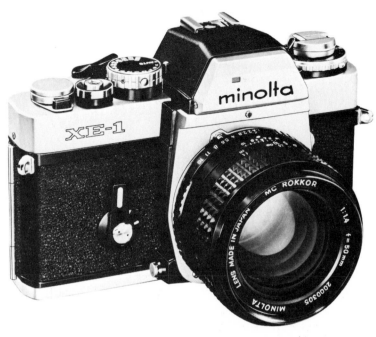

Made in East Germany, the **Praktica LTL** has proved a best-seller, since its prices heavily undercut those of comparable Japanese cameras such as the Asahi Pentax. The **LTL** is a typical single-lens reflex with stopped-down through-the-lens CdS metering, vertical metal-slat focal-plane shutter 1 sec. to 1/1000. 1/125 flash sync. and self-timer. Camera accepts all lenses of Pentax/Praktica screw-mounting type.

The **Minolta XE-1** from Japan is the latest and most sophisticated SLR in the Minolta range, which caters for the expensive end of the trade. It is an aperture-priority automatic with vertical focal-plane shutter operating electronically over a continuous speed band from 4 sec. to 1/1000. Manual operation is also possible and the camera forms part of a very comprehensive 'system' of additional equipment.

Nikon **F2**. During the late 1950s the engineers at Nippon Kogaku envisaged a complete Nikon 'system' of 35 mm photography, a comprehensive range of modular equipment designed for the Nikon camera body. The **F2** is the latest body in the series, offering a speed range extending from 10 sec. to 1/2000, with infinite variation between 1/80 and 1/2000. The hinged back is removeable and can be replaced by magazine backs holding from 250 to 800 exposures, complete with motor drive for automatic film advance and shutter setting, and repeating electronic flash. The body will accept 19 screens and 6 different finders, giving various options including full-aperture TTL metering and shutter-priority automatic. Nikon list some 50 lenses with flange bayonet mounting, some for specialist applications. Perhaps the most comprehensive 35 mm system.

This is the **Nikkormat EL**, an example of automatic SLR built on the aperture-priority system; in other words the user selects the aperture he wants and the camera adjusts the vertically moving focal-plane shutter electronically between 4 sec. and 1/1000 sec. An 'electronic memory' (a charge in capacitors) gathers exposure information during initial pressure on the release button and applies it when pressure is completed, determining the time interval between the operation of the first and second (closing) shutter blinds. The auto feature can be over-ridden, giving way to manual operation. Electronic flash synchronisation at 1/125. Standard lenses are f/2, f/1.4, f/1.2; about 50 other lenses including 30 from Nikon in Nikon bayonet mounts, from 6 mm to 1200 mm, and numerous accessories. The **Nikkormat** is considered in many respects the best camera in its class.

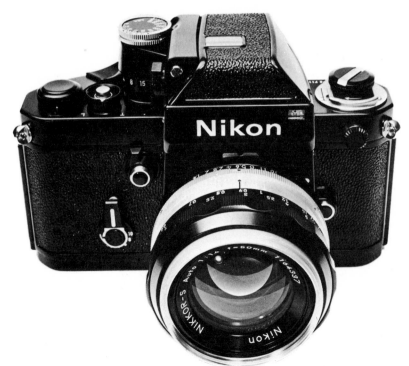

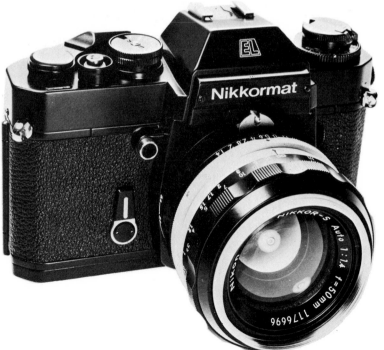

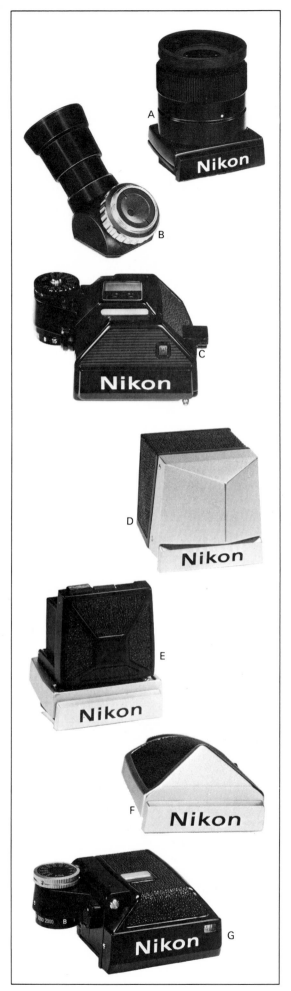

Automatic diaphragm, which fits the Nikon F2. When used in conjunction with the Photomic DP-2 viewfinder, it automatically controls the diaphragm opening.

Viewfinders for every occasion. A: Focusing finder with a magnification of 6. B: Right-angle finder. C: Photomic finder DP-2 for use with the automatic diaphragm. D: Action finder. E: Waist-level finder. F: Eye-level prism finder. G: Photomic finder DP-1 with light-meter incorporated. All these are for use on the Nikon F2.

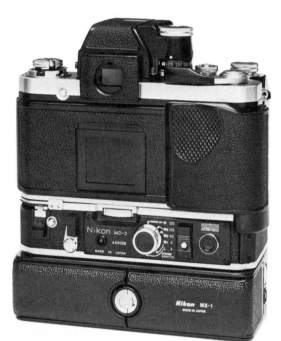

Motor drive is extremely useful for animal photography, sports and fashion shots. The photographer can use the viewfinder continuously, thus concentrating on his subject, while the motor cocks the shutter and moves on the film. It is indispensable for remote control systems, and for automatic time interval photography. The motor can also be used to rewind film, taking 7 sec. to rewind a 36 frame film. Exposure times range from 1 sec. to 1/2000 sec. and the film advance speed can reach 5 frames per sec. Three choices of power supply: 10 1.5 V batteries, 2 Nickel-cadmium rechargeable cells, or an AC/DC Converter.

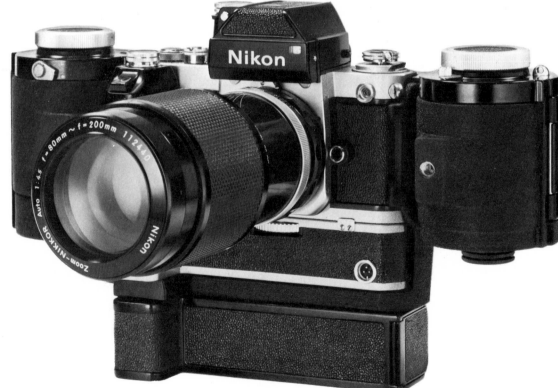

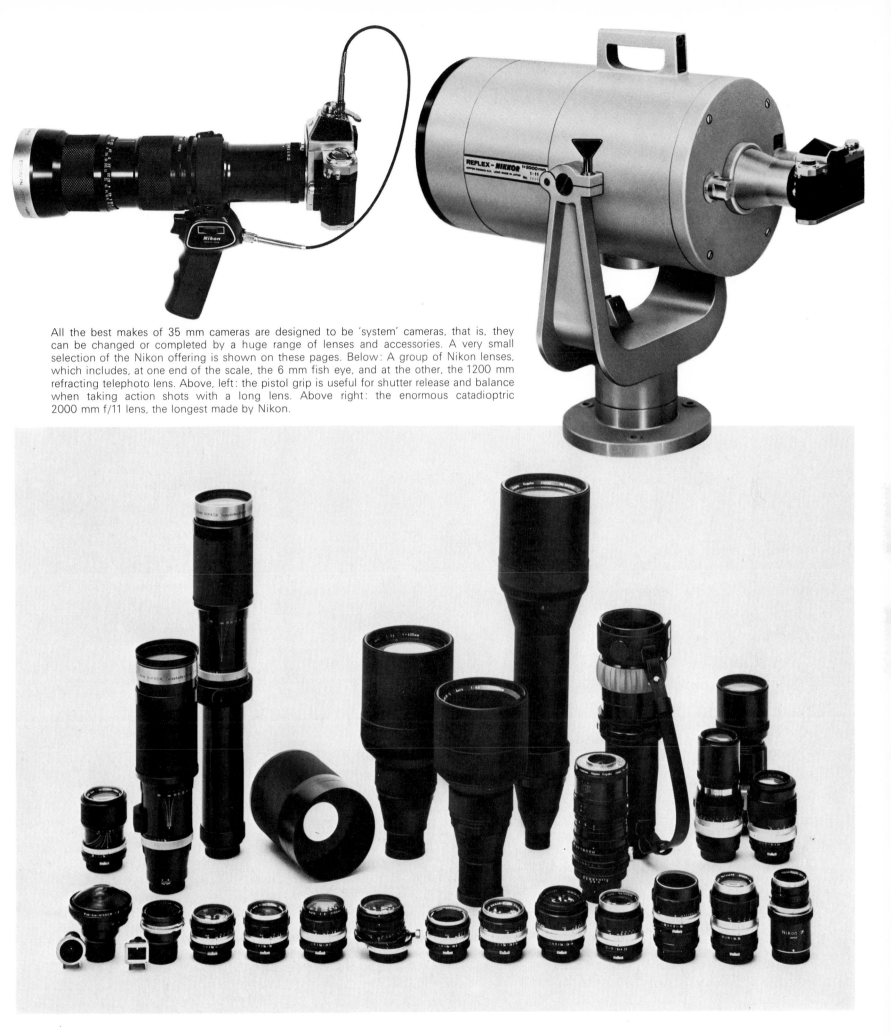

All the best makes of 35 mm cameras are designed to be 'system' cameras, that is, they can be changed or completed by a huge range of lenses and accessories. A very small selection of the Nikon offering is shown on these pages. Below: A group of Nikon lenses, which includes, at one end of the scale, the 6 mm fish eye, and at the other, the 1200 mm refracting telephoto lens. Above, left: the pistol grip is useful for shutter release and balance when taking action shots with a long lens. Above right: the enormous catadioptric 2000 mm f/11 lens, the longest made by Nikon.

STEREOSCOPIC CAMERAS

We see things three-dimensionally because we have two eyes. When we look at a solid object one eye collects information that is, if only fractionally, hidden from the other. The brain receives both pictures and synthesises them into one. A one-eyed man sees in 3D simply by shifting his head.

It was natural, once people began taking pictures that they should wish to see things 'in the round'. Stereoscopic cameras are therefore almost as old as photography itself; stereoscopic daguerreotypes and calotypes are not particularly rare, nor are the binocular viewers that went with them, which vary all the way from the crude to the sumptuous. The important thing is that the viewer lenses should have the same focal length as the lens or lenses used for taking the original photographs, otherwise the effect of solidity will be spoiled.

Stereoscopic pairs may be obtained in several ways. To begin with photographers used an ordinary single-lens camera mounted on a board marked with two positions, moving it between shots, a disadvantage being that the pair could never be strictly identical. Accordingly, Sir David Brewster, physicist friend of Henry Fox Talbot, suggested the use of two lenses in one camera with a division or 'septum' between. Handsome examples exist from the wetplate period (page 225). Certain makers, notably George Hare, of Pentonville Road and Calthorpe Street, Islington, preferred a single lens on a sliding panel so that with septum removed and the lens central, wide single views could be taken (page 230). On early cameras the septum was made on the sliding-box principle, one element having

Dallmeyer **Stereocamera**, London, about ▷ 1861, the year in which J.H. Dallmeyer launched his Triple Achromatic lens. The Dallmeyer Triplet marked a big advance in respect of flatness of field and correction for astigmatism, and enjoyed great popularity until superseded after 1869 by the Rapid Rectilinear. It covered a field of 50 degrees at an aperture of f/10. This handsome mahogany sliding-box camera, format 3¼×6½in, could be adapted for either wet collodion or dry collodion plates. The flap shutter mounted in front of the lenses opened upwards so that the sky received less exposure than the ground.

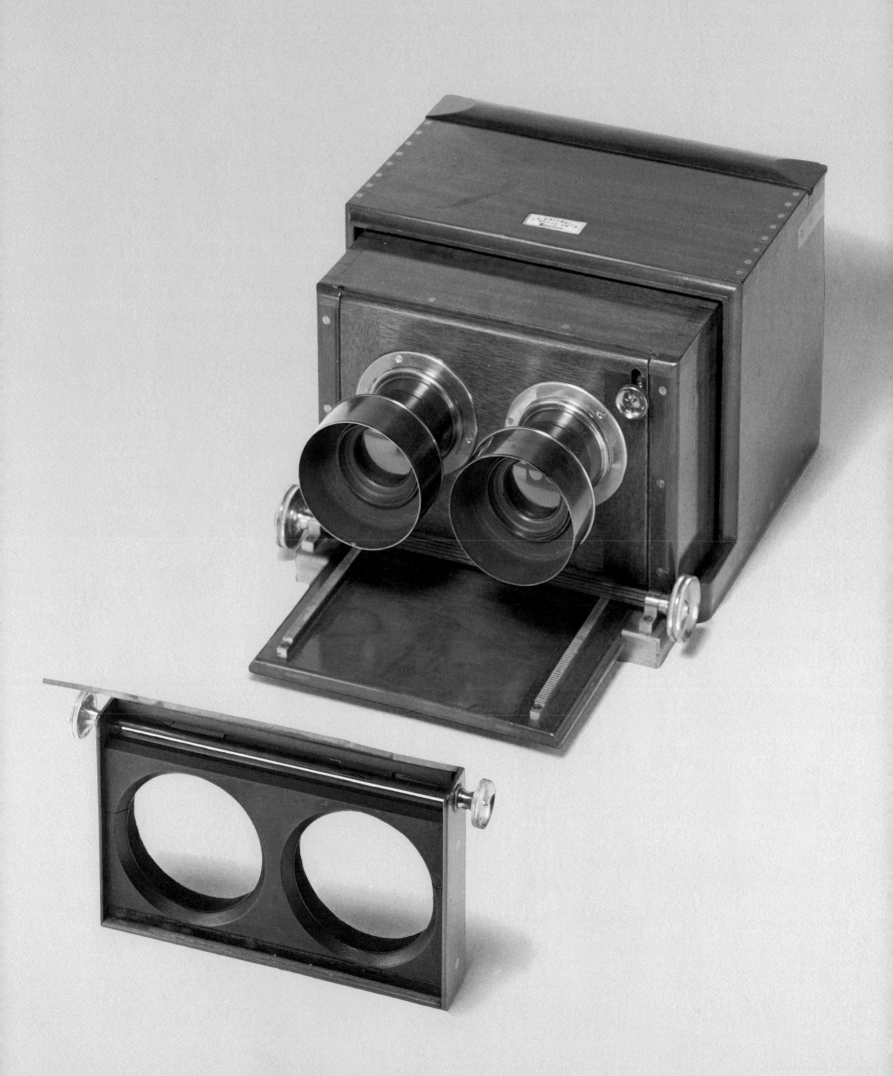

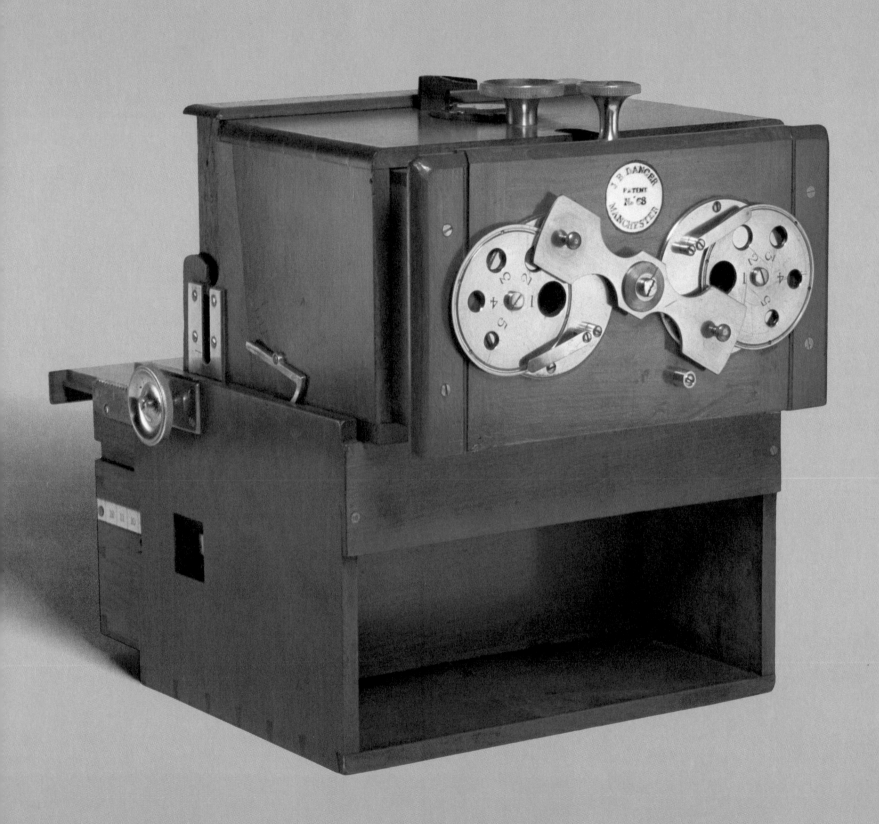

◁ J.B. Dancer's **Binocular Stereocamera** (1856). Covered by British Patent No. 2064 of 5 September 1856, this sliding-box-camera by Dancer of Manchester had several original features for, although designed for wet collodion it had also a changing-box for use with Taupenot's collodio-albumen dry plates and was thus one of the earliest 'magazine' cameras in which a supply of plates was carried inside the camera itself. Glass plates, held in wooden frames, were lifted from the lower box by means of a rod which screwed into the top of the frame. Prominent in this photograph are the see-saw shutter and wheel stops graduated from 1 to 5. The lens box was racked in or out for focusing. A water-level showed when the camera was horizontal.

(Science Museum, London)

This diagram shows a plate being lifted from changing-box to camera by means of a screwed rod. The inner element of the magazine was moved by turning the knurled brass knob. The number of the plate then showed in the square indicator window.

This all-brass **Chambre Automatique** stereo apparatus by Bertsch for double 6×6 cm views may be compared with the single instrument on p. 109; it is covered by French patent No. 45755 of 29 June 1860. Twin 110 mm f/16 achromatic doublets of fixed focus and no stops, hence the name 'automatique'. Coupled shutters. The frame finder is probably an addition.

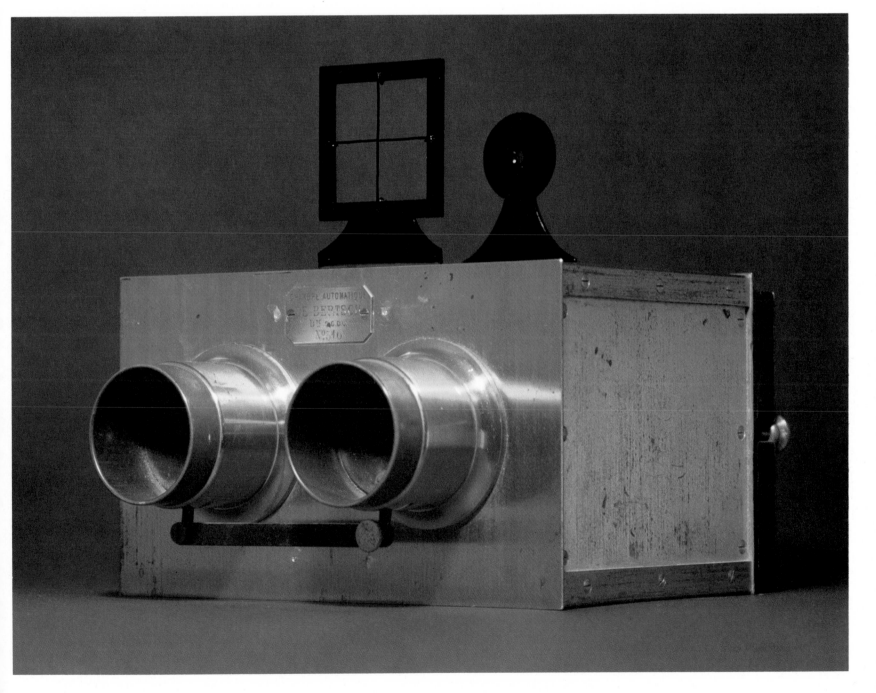

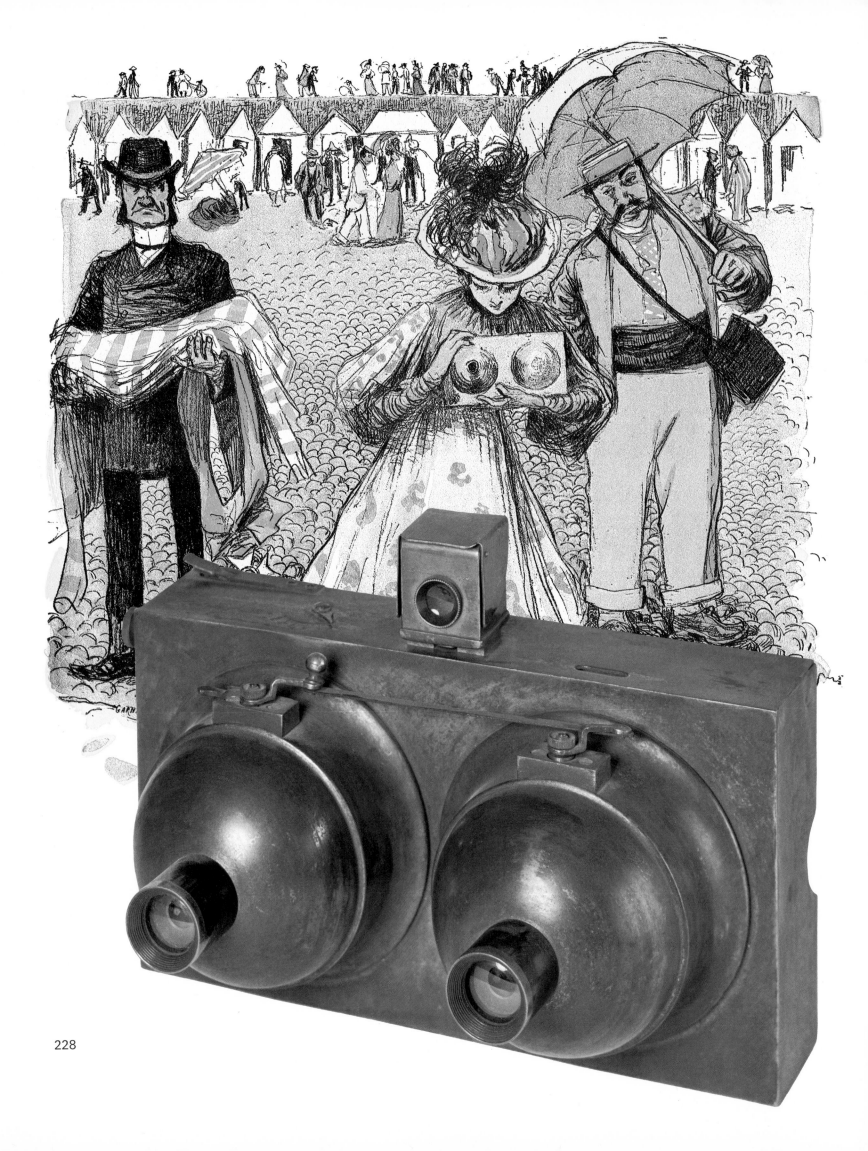

This sliding-box 12×24 cm (4¼×9½in) stereo camera was built about 1855 by Ninet of Paris, and has a pair of Petzval lenses by Derogy. Washer stops were used, so to change them it was necessary to unscrew the front of the lens.

Ottewill's Single Stereoscope c. 1857, now in the Science Museum, is a single-lens stereocamera for wet collodion plates. The camera slides in a curved groove, and is kept the same distance from the subject by pantograph arms, taking a stereo-pair of photographs on one plate. It has a Petzval lens; the double dark slide will be noted.

◁ The grandly named Napoleon Conti, of Paris, patented his **Photosphere** on 4 November 1888. His all-brass half-plate camera with oxidised silver finish was designed 'for officers and explorers', he said, although caricaturists may have thought differently. The dome behind each RR lens held a hemispherical bellows 'eyelid' shutter. They were coupled by a bar and cranks.

two partitions very close together, the other a wooden tongue which fitted between them, forming a perfect light-trap. Later, detachable roller blinds were used.

Almost every kind of ordinary camera has a stereoscopic counterpart. The *jumelle* form, being based on an opera-glass was a natural (page 236), but so too were the folding pocket camera, 'flat folding' Press cameras like the Goerz Anschütz (page 237) and the Bloc-Notes (236), even the Press reflex. Nor was the influence one-sided; the firm of Francke & Heidecke started by making stereo plate cameras (the Heidoscop), went on to the Rolleidoscop roll-film stereo camera and eventually developed the Rolleiflex twin-lens reflex range. The Rolleidoscop was provided with a third lens for reflex viewing; in other three-lens stereo instruments the central lens was used for wide landscape shots. Yet another approach to stereo photography was provided by Leitz. This was the Steroly beam-splitter which by fitting in front of the lens converted a Leica into a stereo half-frame camera. Anyone who has seen shots taken vertically downwards from the top of Rockefeller Center, New York, will know how effective this was. The slogan might be *In camera vertigo*.

In recent years, stereoscopic photography has fallen completely out of fashion. Its heyday was certainly the early 1900s, when virtually every camera manufacturer brought out at least one stereoscopic version of his current line. Stereo views were sold ready mounted for use in viewers, which could also be supplied from the same firms. One or two stereo cameras appeared in the 1950s, and the Russians brought out one in 1960, but the craze has ended, at any rate for the time being.

229

Stereoscopic 'tailboard' camera by George Hare, Ottewill's famous apprentice. The single lens (a Dallmeyer 100 mm f/11 Rapid Rectilinear) in sliding panel allowed a pair of stereoscopic views or, with the dividing 'septum' removed and the lens placed centrally, a single picture. This instrument has Berry of Liverpool's changing-box for twelve plates. To fold, the back and bellows are pushed forward against the front panel; the bottom board is then raised like the tailboard of a cart, protecting the ground-glass screen.

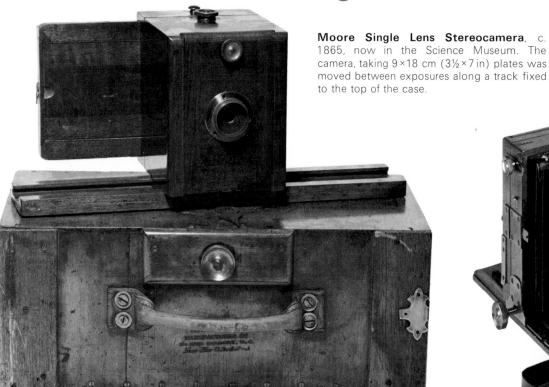

Moore Single Lens Stereocamera, c. 1865, now in the Science Museum. The camera, taking 9×18 cm (3½×7 in) plates was moved between exposures along a track fixed to the top of the case.

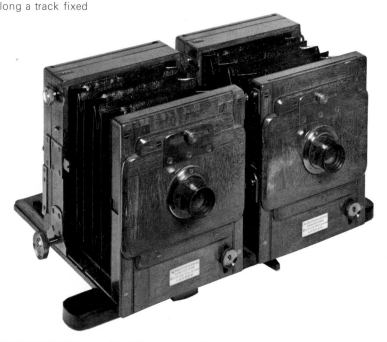

W. Watson, of High Holborn, about 1852 obtained stereoscopic effects by mounting a pair of tailboard bellows cameras on a suitably angled base. (Science Museum)

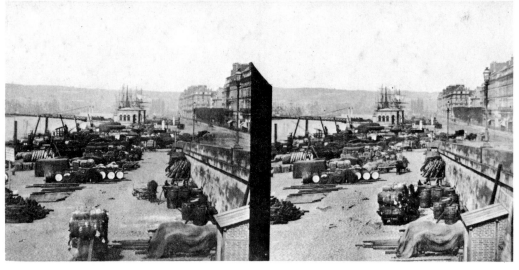

With a single-lens stereocamera some while must elapse between the two exposures. In this view of a harbour the dray in the foreground has moved several yards. The displacement of the lens may be judged by comparing the position of the little shed on the right, and the angle of the wall.

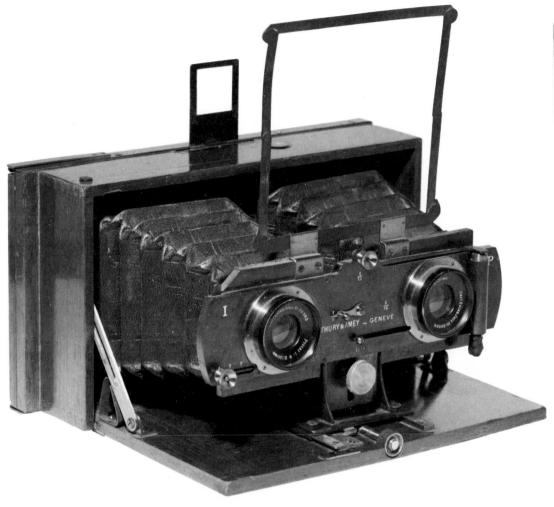

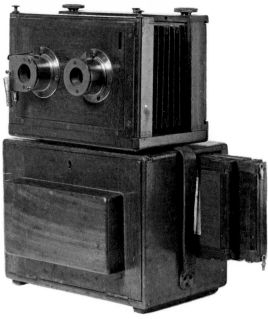

An early English-made stereocamera with square bellows and pair of Ross landscape lenses; it has drop shutters and Waterhouse stops, the tabs of which may be seen above the lens barrels. The stout carrying case held also six double dark slides.

This wooden folding stereo camera is considerably later, since the tapered bellows have chamfered rather than square corners, a feature which came in during the 1890's, and Zeiss Protar 120 mm f/9 lenses. The Protar, one of the first anastigmats, was designed by P. Rudolph in 1890. Thury and Amey between-the-lens shutters were among the best of their time.

This stereoscopic daguerreotype by an unknown photographer dates from about 1850; not only is it 3D but also hand coloured by a process developed in France, using miniature-painting technique, the pigments being fixed with transparent gum. Wonderfully realistic effects were obtained.

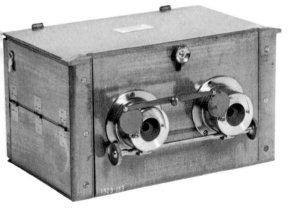

Meagher's Folding Stereoscopic Camera (c. 1860), now in the Science Museum, is a most ingenious instrument. With the rising-front lens panel removed the body folds into very little space. The Ross single landscape lenses are of about 5½ in focus (137 mm) and move simultaneously by rack and pinion. The linked shutters work by means of a connecting bar. The most popular size for stereo cameras was half-plate.

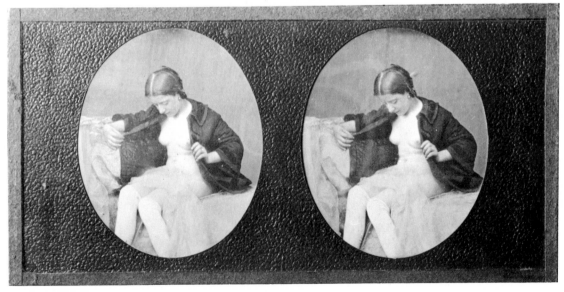

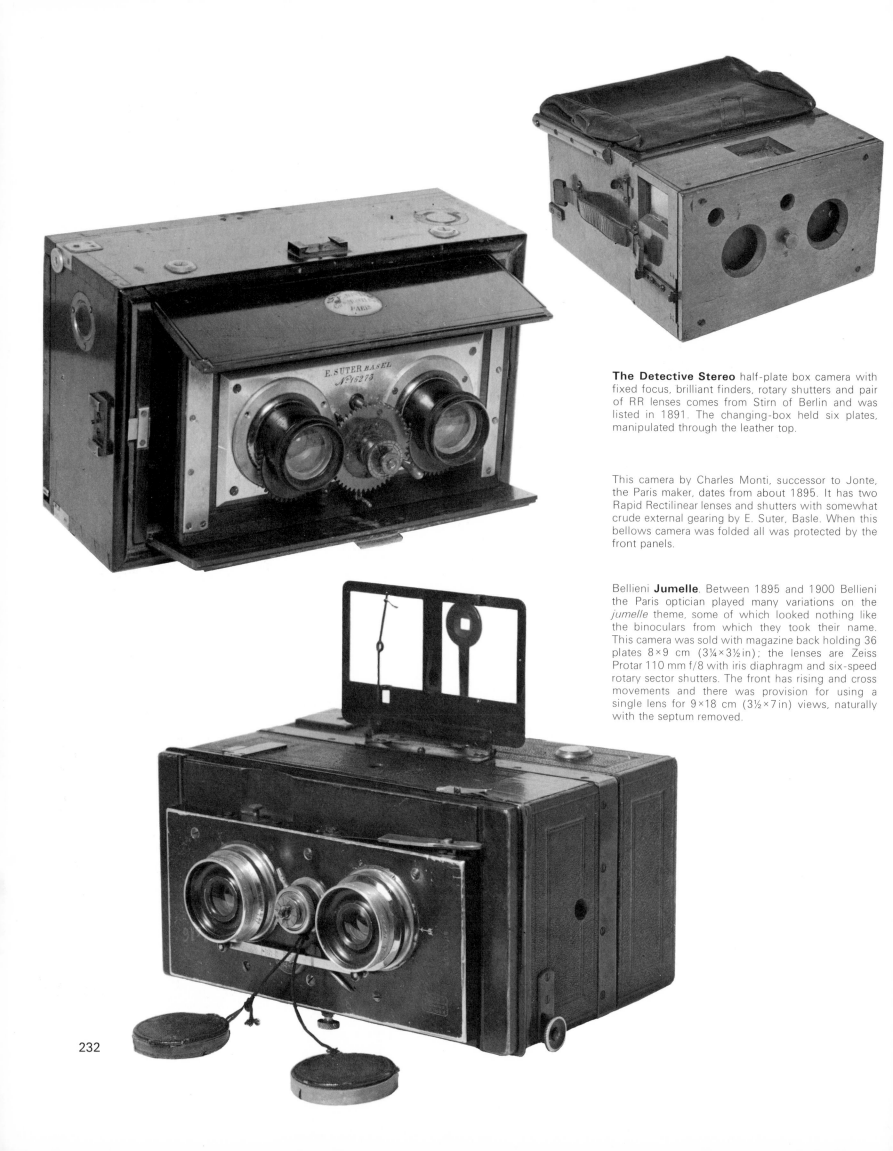

The Detective Stereo half-plate box camera with fixed focus, brilliant finders, rotary shutters and pair of RR lenses comes from Stirn of Berlin and was listed in 1891. The changing-box held six plates, manipulated through the leather top.

This camera by Charles Monti, successor to Jonte, the Paris maker, dates from about 1895. It has two Rapid Rectilinear lenses and shutters with somewhat crude external gearing by E. Suter, Basle. When this bellows camera was folded all was protected by the front panels.

Bellieni **Jumelle**. Between 1895 and 1900 Bellieni the Paris optician played many variations on the *jumelle* theme, some of which looked nothing like the binoculars from which they took their name. This camera was sold with magazine back holding 36 plates 8×9 cm (3¼×3½ in); the lenses are Zeiss Protar 110 mm f/8 with iris diaphragm and six-speed rotary sector shutters. The front has rising and cross movements and there was provision for using a single lens for 9×18 cm (3½×7 in) views, naturally with the septum removed.

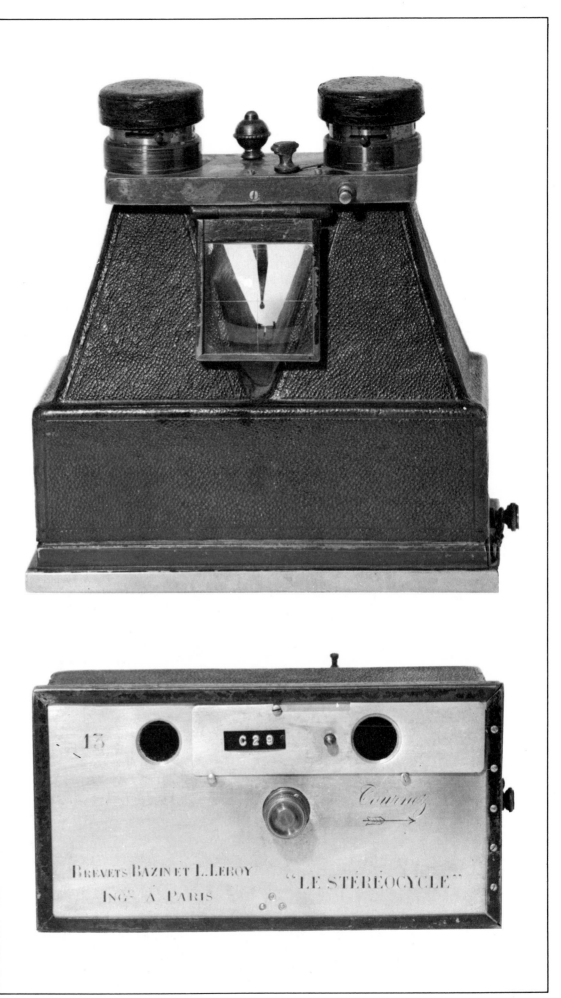

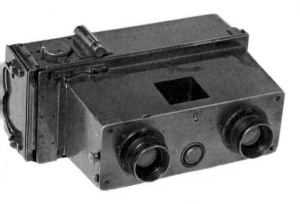

This miniature stereo camera by Jules Richard, Paris, is the **Verascope** described in *La Nature* during 1894. A magazine held six 45×107 mm plates (1¾×4¼ in) plates and the small format allowed the use of a very respectable lens, a fixed aperture 55 mm Rapid Rectilinear of f/6.3. Single-speed coupled shutters. This was the first miniature stereo, and it proved very popular.

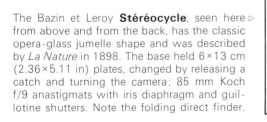

The Bazin et Leroy **Stéréocycle**, seen here ▷ from above and from the back, has the classic opera-glass jumelle shape and was described by *La Nature* in 1898. The base held 6×13 cm (2.36×5.11 in) plates, changed by releasing a catch and turning the camera; 85 mm Koch f/9 anastigmats with iris diaphragm and guillotine shutters. Note the folding direct finder.

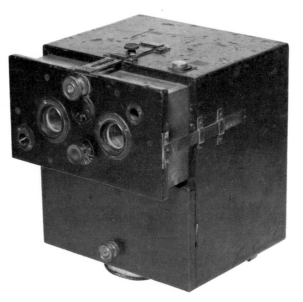

Manufactured by Suter, Basle on the Möller system, this sliding-box stereo is a duplex version of a similar and commoner Detective camera. It was listed by Wachtl, Vienna, in 1893. The integral changing-box held six 9×18 (3½×7 in) plates, changed by pulling a knob. Coupled rotary sector shutters, 90 mm f/10 Detective lenses with iris diaphragms.

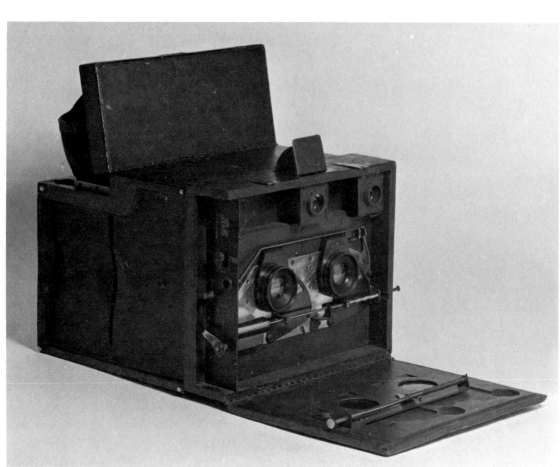

The **Stereo Palmos** folding plate camera by Ica AG, Dresden, was protected by German patent No. 124537, 8 January 1901 and used 9×12 cm plates (3½×4¾ in). It has a pair of f/6.3 90 mm Tessars, iris diaphragms and an early example of focal-plane shutter speeded from 1/7 to 1/1000 sec.

◁ This double quarter-plate Newman & Guardia detective stereo was listed in the *B.J. Photographic Almanac* 1898 and is shown here with the front down to expose the neat N & G pneumatic shutter mechanism which gave speeds from 1/2 sec. to 1/100. The lenses are Wray f/8 Rapid Rectilinear of 120 mm focal length; N & G changing-box for twelve plates.

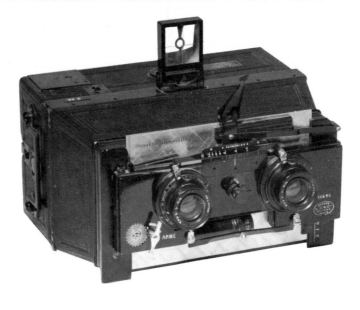

A **Stéréo-Spido** is noticed in the *Annuaire Général de la Photographie* for 1898. This instrument is later as it bears mention of a Grand Prix won in 1900. The format is 9×18 cm (3½×7 in) for use with either two or one of the 110 mm f/6.8 Goerz Dagors. Rising and cross-front movements, 6-speed Decaux pneumatic shutter.

234

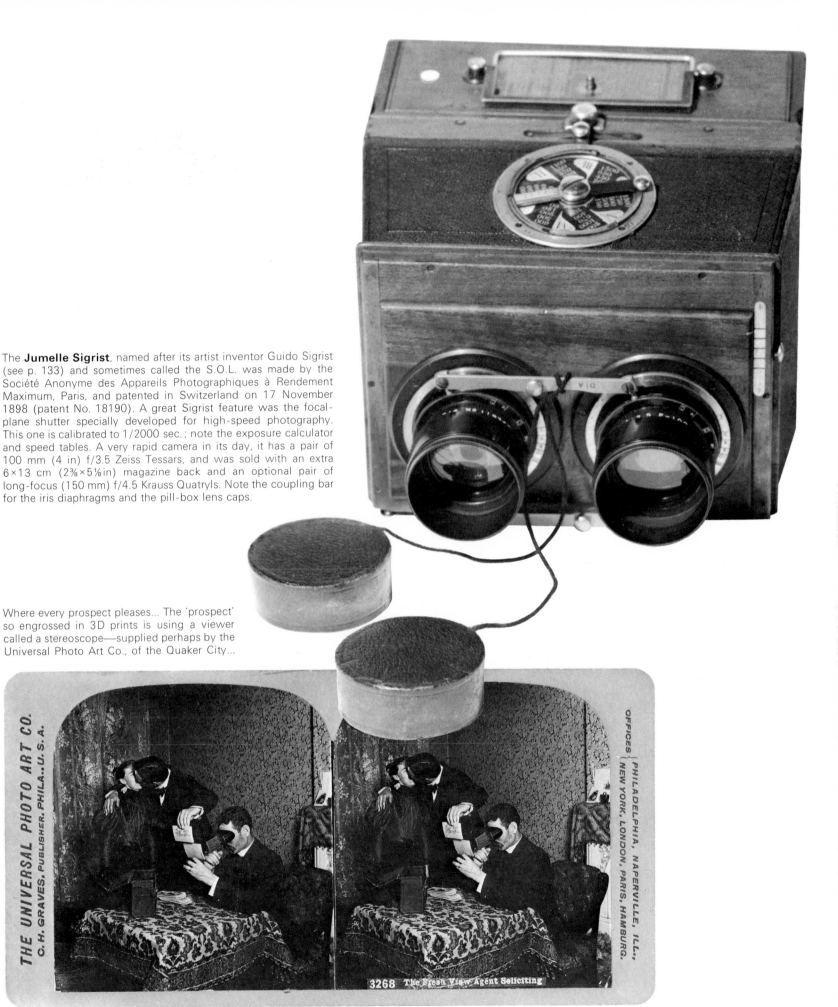

The **Jumelle Sigrist**, named after its artist inventor Guido Sigrist (see p. 133) and sometimes called the S.O.L. was made by the Société Anonyme des Appareils Photographiques à Rendement Maximum, Paris, and patented in Switzerland on 17 November 1898 (patent No. 18190). A great Sigrist feature was the focal-plane shutter specially developed for high-speed photography. This one is calibrated to 1/2000 sec.; note the exposure calculator and speed tables. A very rapid camera in its day, it has a pair of 100 mm (4 in) f/3.5 Zeiss Tessars, and was sold with an extra 6×13 cm (2⅜×5⅛in) magazine back and an optional pair of long-focus (150 mm) f/4.5 Krauss Quatryls. Note the coupling bar for the iris diaphragms and the pill-box lens caps.

Where every prospect pleases... The 'prospect' so engrossed in 3D prints is using a viewer called a stereoscope—supplied perhaps by the Universal Photo Art Co., of the Quaker City...

THE UNIVERSAL PHOTO ART CO.
C. H. GRAVES, PUBLISHER, PHILA., U. S. A.

OFFICES { PHILADELPHIA, NAPERVILLE, ILL., NEW YORK, LONDON, PARIS, HAMBURG.

3268 The Fresh View Agent Soliciting

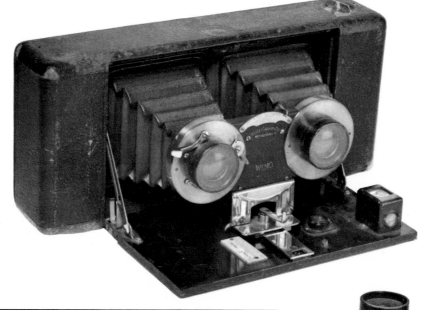

American stereo: This twin-bellows **Weno** by the Blair Camera Co., of Rochester, N.Y., is to be found in the *B.J. Photographic Almanac* 1903. It is unusual in taking two pieces of cut film 3¼×3¼ in, the lantern-slide size. Pair of 120 mm f/10 Rapid Rectilinear lenses in single-speed Bausch & Lomb shutter. Note the focusing scale and brilliant finder.

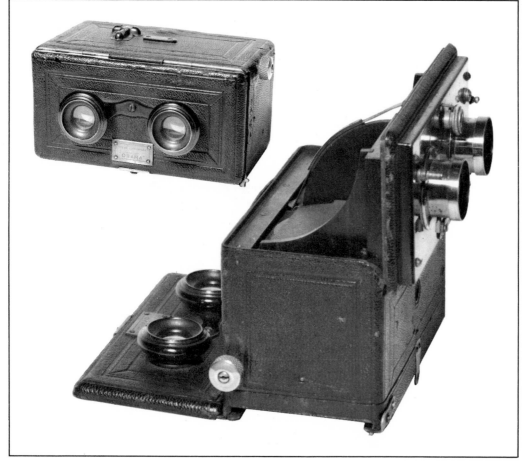

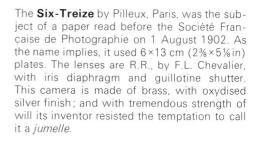

The **Six-Treize** by Pilleux, Paris, was the subject of a paper read before the Société Française de Photographie on 1 August 1902. As the name implies, it used 6×13 cm (2⅜×5⅛ in) plates. The lenses are R.R., by F.L. Chevalier, with iris diaphragm and guillotine shutter. This camera is made of brass, with oxydised silver finish; and with tremendous strength of will its inventor resisted the temptation to call it a *jumelle*.

◁ This **Stado Jumelle** from the Paris house of Rancoule was described in *La Nature* during 1903. A versatile little instrument, it took 6×13 cm (2⅜×5⅛ in) plates and could be used also as an opera glass, a stereoscope and a viewer for transparencies.

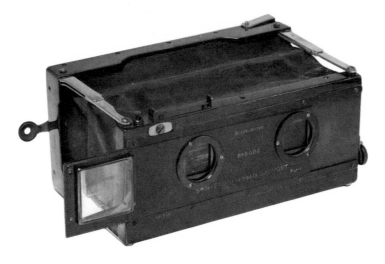

Compare this **Stereo Bloc-notes** with the *monoculaire* of the same type on p. 162. They have similar view-finder/shutter arrangements although the shutter here has six speeds. Listed in 1904, this particular photographic note-pad takes 45×107 mm plates (1¼×4¼ in) plates. Elgé f/5.5 60 mm anastigmats. Designed with metal front and back, a leather bag in place of bellows, and two pairs of struts, the camera was really pocketable.

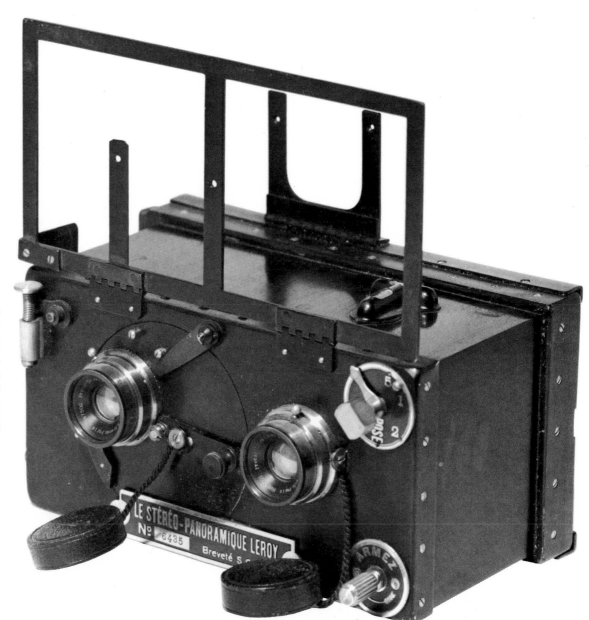

Here is another 'six-thirteen', this time made wholly of sheet metal: Leroy's **Stéréo-Panoramique** mentioned in the 1904 *Annuaire*. It has a pair of 82 mm f/9 Krauss Protars, one of which is carried eccentrically on a circular mount. By undoing a catch the mount may be turned to bring one lens to the middle; the same movement removes the septum which normally divides the plate into two stereo halves, and the camera can be used, in the inventor's word 'panoramically'.

Stereo Ango by Goerz. Fitted with 120 mm f/6.8 Dagors, iris diaphragm, direct optical finder and 1/5 to 1/1000 sec. focal-plane shutter, this 9×18 cm (3½×7 in) stereo is virtually a double Goerz Anschütz press camera. By adjusting the distance between the lenses, it was possible to vary the three-dimensional effect, and also to use a single lens placed centrally. The **Ango** is to be found in Fabre's *Traité de Photographie*, 1906.

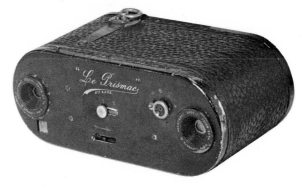

Here is a fairly early rollfilm stereo camera in 127 VP size: the **Prismac**, built by A. Devaux to the designs of Deloye, of Paris. The widely separated Kenngott anastigmats, were stopped down by a central knob. The feature of this camera was that the film was led round rollers to fold back on itself in the centre of the camera, at vertical right angles to the lenses. Prisms bent the image at right angles to the lenses, so that two images were exposed simultaneously on the film, which then was moved on two frames for the next picture.

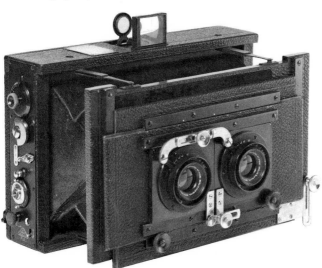

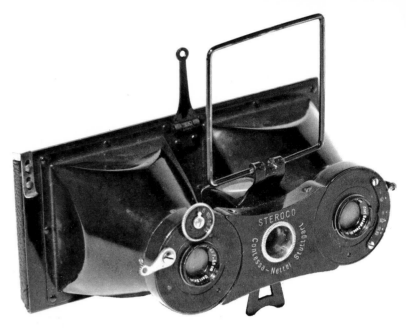

Contessa-Nettel of Stuttgart made this Vest Pocket plate **Steroco**, listed in 1920. It has 55 mm Zeiss f/6.3 Tessars in Stereo Ibsor 1/25-1/100 sec. shutter unit with central brilliant as well as frame finder; the binocular shape made its purpose perfectly plain.

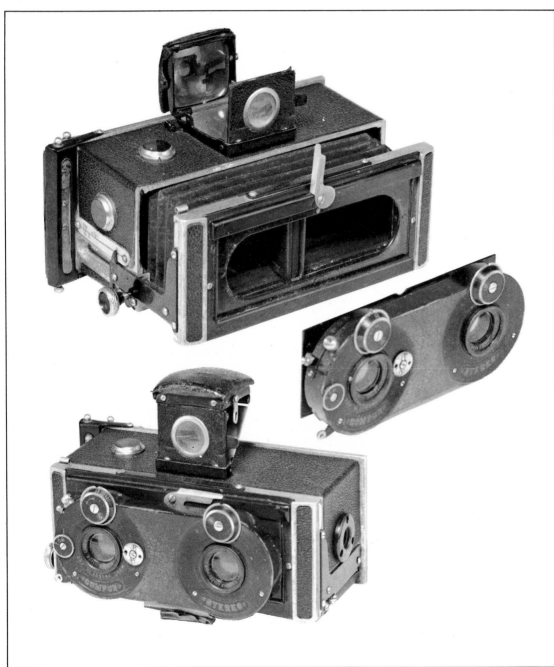

Dated by Dr Loher to 1906, the **Kosmo Clack** by Rietschel, Munich, was rather clever; it had rising and cross movements and could also be used 'panoramically' to give one long picture on the 47×107 mm (1¾×4¼ in) plate. The extending bellows are for when only the long-focus elements of the normally 65 mm f/4.5 Linear double anastigmats are in use. Compur Stereo shutters.

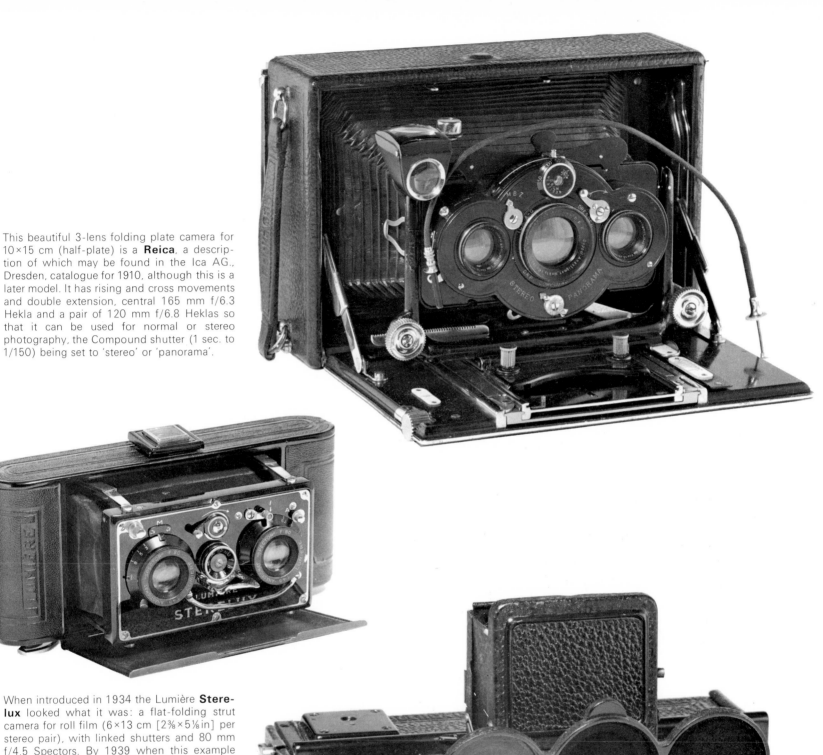

This beautiful 3-lens folding plate camera for 10×15 cm (half-plate) is a **Reica**, a description of which may be found in the Ica AG., Dresden, catalogue for 1910, although this is a later model. It has rising and cross movements and double extension, central 165 mm f/6.3 Hekla and a pair of 120 mm f/6.8 Heklas so that it can be used for normal or stereo photography, the Compound shutter (1 sec. to 1/150) being set to 'stereo' or 'panorama'.

When introduced in 1934 the Lumière **Stere-lux** looked what it was: a flat-folding strut camera for roll film (6×13 cm [2⅜×5⅛ in] per stereo pair), with linked shutters and 80 mm f/4.5 Spectors. By 1939 when this example was made a protective door had been added, disguising it as an ordinary rollfilm job.

Reflex stereo: the Franke & Heidecke **Hei-doscop**, ancester of the *Rolleidoscop* and *Rolleiflex* rollfilm ranges. Dr Heidecke had been interested in stereo work for many years before the founding of the F & H firm in 1920, when this plate camera appeared. The viewing lens, like the taking pair, is a Zeiss Tessar.

239

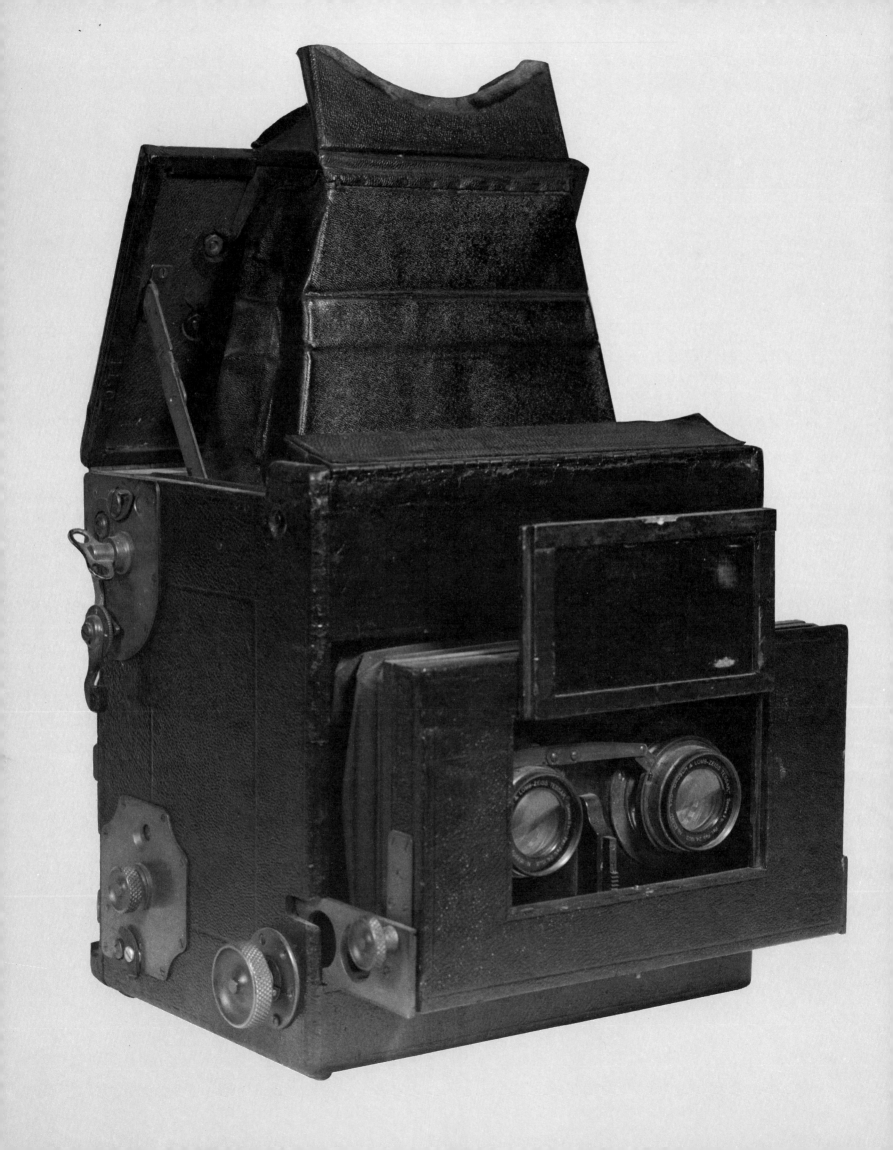

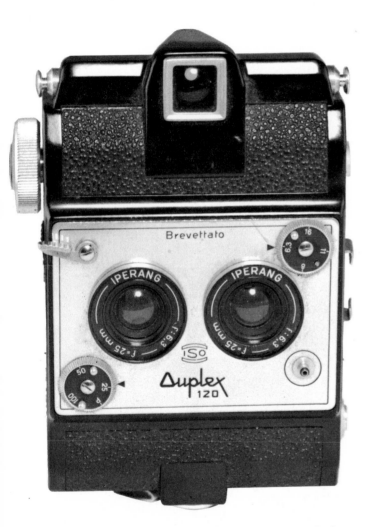

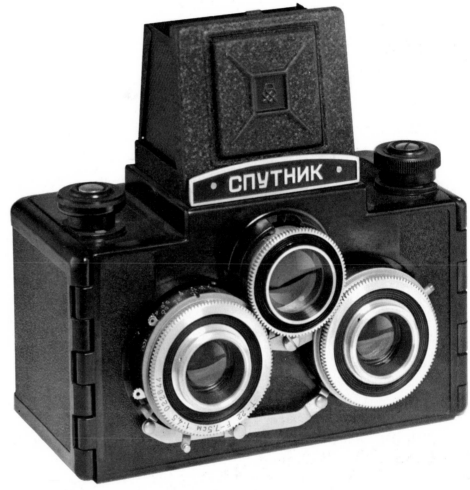

The **Iso Duplex 120**, c. 1950, used 120 rollfilm widthwise for pairs of images each 24×24 mm (just under 1 in). Lenses are Iperang 25 mm f/6.3, shutters from 1/25 to 1/100. A de luxe version was sold under the name **Klinax 3D**, with Isco Iriar 35 mm f/3.5 lenses.

◁ **Stereo Graflex** from the Eastman Kodak Co., Rochester, N.Y. in the familiar Kodak 13×18 cm (5×7 in) size, from about 1920. This is a double reflex, with two 6in Bausch & Lomb f/6.3 Tessars, iris diaphragms and 1/10 to 1/1000 sec. focal-plane shutter. This is one of the famous range of Graflex cameras brought out by Folmer & Schwing of New York and taken over by Kodak.

In 1960 it was almost a Soviet reflex to celebrate the first satellite; so this reflex from the USSR was named **Sputnik**. It used 120 roll film, but with the images lengthwise, each pair 6×13 cm (2⅜×5⅛in). Focusing is ingeniously simple, with the paired 75 mm f/4.5 lenses geared to the viewing lens. Shutter speeds from 1/10 to 1/100, mainly plastic construction. One of the few relatively recent stereo cameras.

(Technical Museum, Prague)

SPECIALISED EQUIPMENT

COLOUR SEPARATION CAMERAS

The idea of colour photography was first mooted, perhaps, by Tiphaigne de la Roche, whose anagramatically titled work *Giphantie* forecast it in 1760. Before that Sir Isaac Newton's work on the spectrum had laid down the lines of future research by such workers as Clerk Maxwell who demonstrated in 1851 that all the colours in nature could be matched by transmitting light through suitably chosen filters of the three primary colours. In France J.-C. Le Blon, an engraver not a photographer, and Louis Ducos du Hauron carried out useful three-colour research as did Charles Cros, working independently. Maxwell showed that if a multicoloured subject illuminated by white light was photographed three times through different filters each of which passed only one-third of the spectrum, and positives from the three negatives were placed in register and projected through similarly coloured filters, the result was a reasonably close approximation to the colours of the original. This is known as an "additive" process and by incorporating the colour filters into the emulsion in the form of minute grains of starch dyed to the primary colours and intimately mixed, the Lumière brothers arrived at the Autochrome process, invented in 1904 and marketed four years later. Made possible by the invention of panchromatic emulsions by H. W. Vogel in 1873, the Autochrome process was slow (about 1/25 sec. at f/1.9 in summer sunlight) but it pointed the way.

This chapter however is concerned not with processes but with apparatus for the preparation of three-colour separation negatives. If, researchers reasoned, three exposures could be taken through suitably coloured filters at one and the same time, much effort would be spared and the operator assured that the subject had not moved or altered. An American, F. E. Ives, developed an instrument in 1888 (patented 1890) called the Krömsköp for viewing

Dr Miethe's three-colour camera was manufactured by Bermpohl, Berlin, and described in 1903 by Dr G. Fritsch in *Drei-Farbenphotographie* ('Three-colour photography'). The secret lay in the special plate carrying chassis, which held three 7.5×8.5 cm (3×3¼ in) plates and also three filters. When each plate and its filter was exposed, the next dropped down by gravity, and thus the three colour separations were taken successively. The lens is a Goerz f/3.5 double anastigmat of 150 mm, and an iris diaphragm is fitted.

Abney's Colour Camera, 1905. Sir William de W. Abney inventor of this three-colour camera was no newcomer to the art; in the Science Museum which now houses this apparatus are waxed paper negatives 12×15 in taken by him in 1874 when he visited Egypt to observe the transit of Venus. Here three lenses are used, small and close together to minimise parallax, to make colour separation negatives. Rays from the centre lens reach the middle negative (green filter) direct; those from the left-hand and right-hand lenses are deflected by pairs of mirrors to 'red' and 'blue' negatives respectively, via supplementary lenses, the latter being necessary to bring all three images to exactly the same size. Colour filters were placed just in front of the plate.

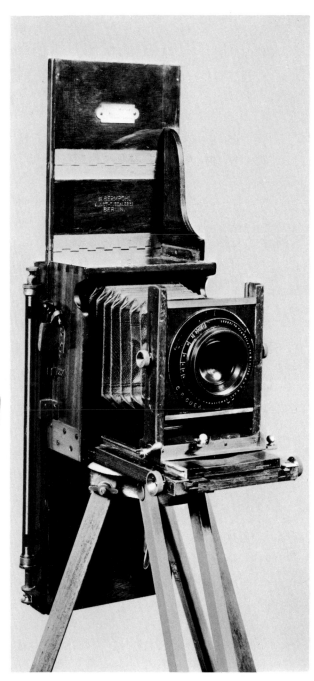

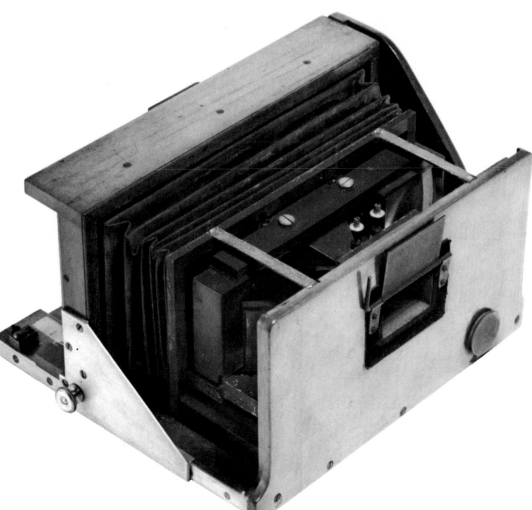

Three-colour process. This cross-sectional diagram shows the working of a colour-separation camera. The principle is that of a periscope. Light entering via the taking lens, top right, is reflected downwards by a 45° mirror to a set of three mirrors similarly angled. The middle pair, marked 21 and 22 on the diagram are semi-reflectors, allowing light to pass. Each of three compartments is provided with a coloured filter, red, blue or green, through which the image is received by the photographic plates, 31, 32, and 33.

colour-separation transparencies, a camera for taking three successive negatives, and a triple lantern projector.

One-shot three-colour cameras may be said to date from 1874 when Ducos invented the apparatus shown on page 246, although this was not built until 1897. It is what is called a beam-splitter, producing three simultaneous trichrome negatives by means of semi-reflectors. The Ducos Chromographoscope dates from 1897, the same inventor's Melanochromoscope from the French patent of 16 May, 1899 (page 245). During 1902 improvements to emulsions were carried out by Professor Miethe in Germany, which led to the construction of special cameras by the Berlin cabinet-maker Bermpohl, later constructor of commercial cameras and viewers on the Miethe principle. Bermpohl beam-splitters, beautifully built of mahogany are perhaps the best-known of all, and have been much used in the three-colour printing industry.

In England the principal three-colour process was that of Sanger-Shepherd. This too depended upon a beam-splitting camera (1902). Two semi-reflectors were placed at 45° to the light path; light reflected at the first mirror formed the red image, light from the second gave a blue image; light reflected from both combined to produced a green. Positives from the three separation negatives were bound up in register for viewing in a chromoscope or projecting upon a screen. Sir William Abney (1905) and E. T. Butler (1905) produced similar beam-splitting cameras, as did Eves, Vivex and in the USA, Barker-Devin, although Abney's employed three lenses, very small and placed close together. A three-colour repeating back was sometimes used on an ordinary camera by devotees of colour-photography. All such things were rendered unnecessary with the coming of the integral tripack — Kodachrome 1935, Agfacolor 1936.

The **Melanochromoscope** of Louis Ducos▷ du Hauron was patented by the inventor on 16 May 1899 (French patent No. 288870) and manufactured by him in partnership with L. Lesueur. The name combines the Greek roots meaning 'black' and 'colour' and the apparatus does in fact allow colour photographs to be produced by means of black-and-white negatives. The idea is an extension of the Ives Krömsköp process of 1892. Three colour separation negatives are produced by means of a simple lens and a beam-splitting arrangement of mirrors in the lower compartment (shown half open). The first two mirrors are semi-reflectors, the third fully silvered; light from these is reflected upwards through blue, yellow and red filters on to three sensitised plates in a dark slide (not shown). The device could also be used for viewing transparent positives in colour.

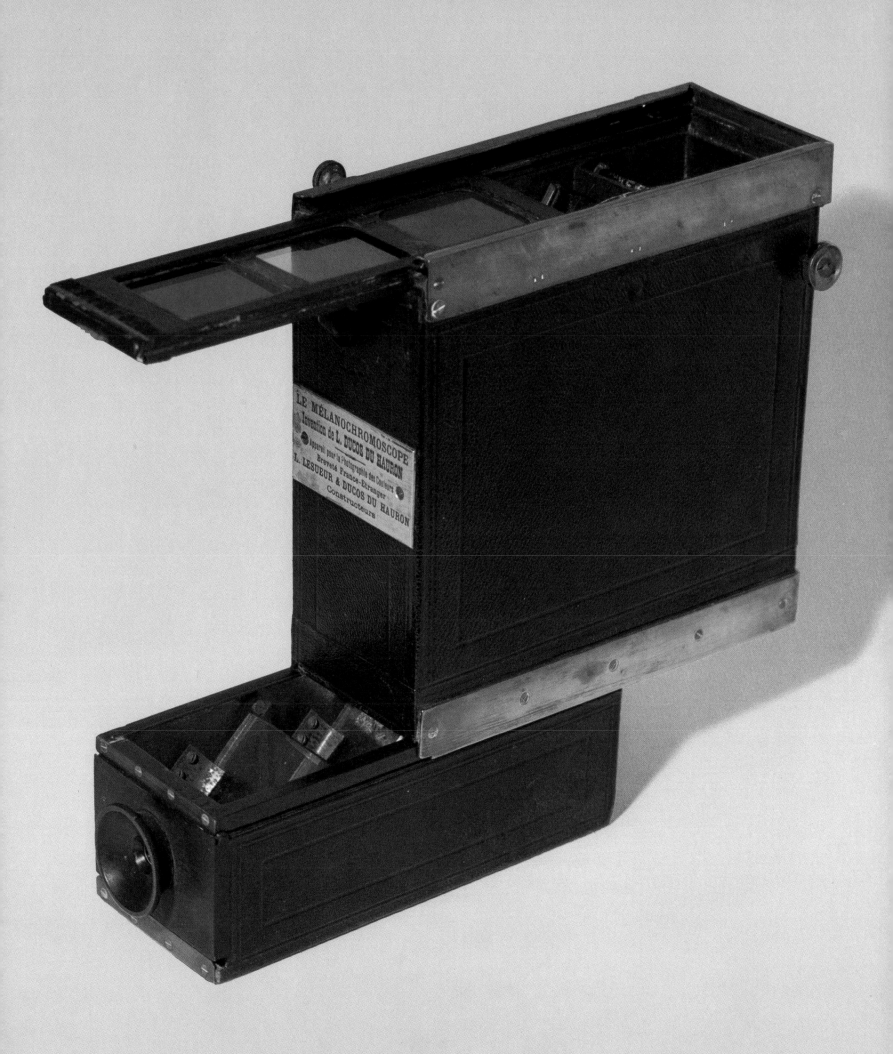

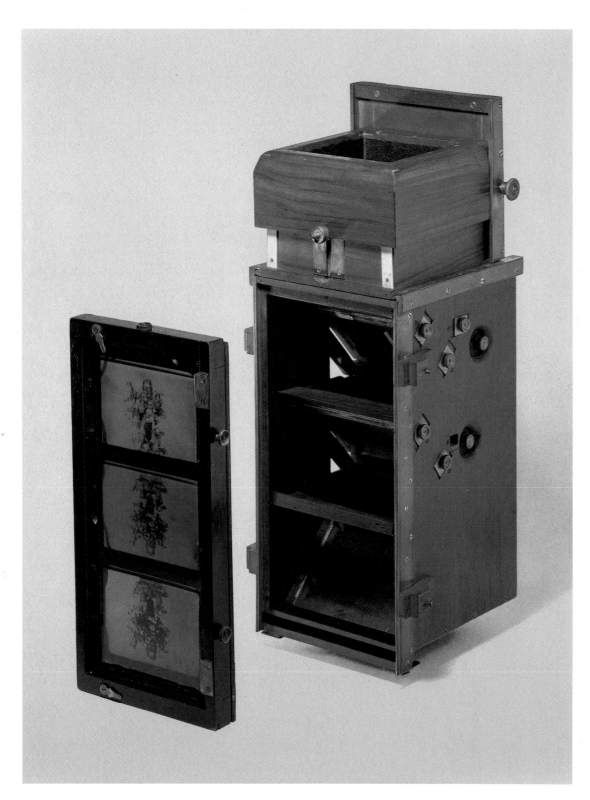

The **Chromographoscope** was patented by Louis Ducos du Hauron in 1874 but the first example was built in 1879, by Mackenstein, the Paris optician and camera maker. This device is a three-colour camera taking three separation negatives on a single plate, and may also be used as a viewer for colour transparencies. At the top is a prism so that images appear the right way up. As in the **Melanochromoscope** which followed (p. 245) a set of semi-reflecting and ordinary mirrors transmits the picture through trichrome filters to a photographic plate placed here a short distance behind them. To use the instrument as a viewer the prism was taken off and a magnifying eyepiece installed in its place.

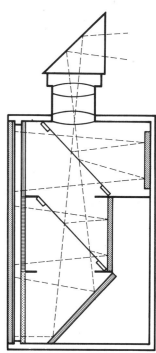

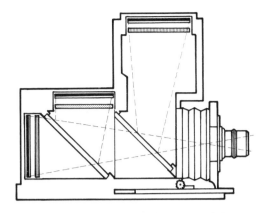

Invented by E.T. Butler, this colour-separation camera appeared in 1905. It used 3½×4¾ in plates. Manufactured for its inventor by Lancaster of London, it used their Trinar anastigmat lens, f/6.3 and 178 mm (7 in) focal length. Iris diaphragm, and Compound shutter speeded from 1 sec. to 1/150 sec. The way it functioned is clearly shown in the diaphragm, and it seems to be based on similar principles to Ives' **Krömsköp**, which came out in 1892. Two semi-transparent mirrors caused the image to pass through the three colour filters, situated at the back of the camera, and in the top. Focus was by rack and pinion, and the lens front was connected by bellows.

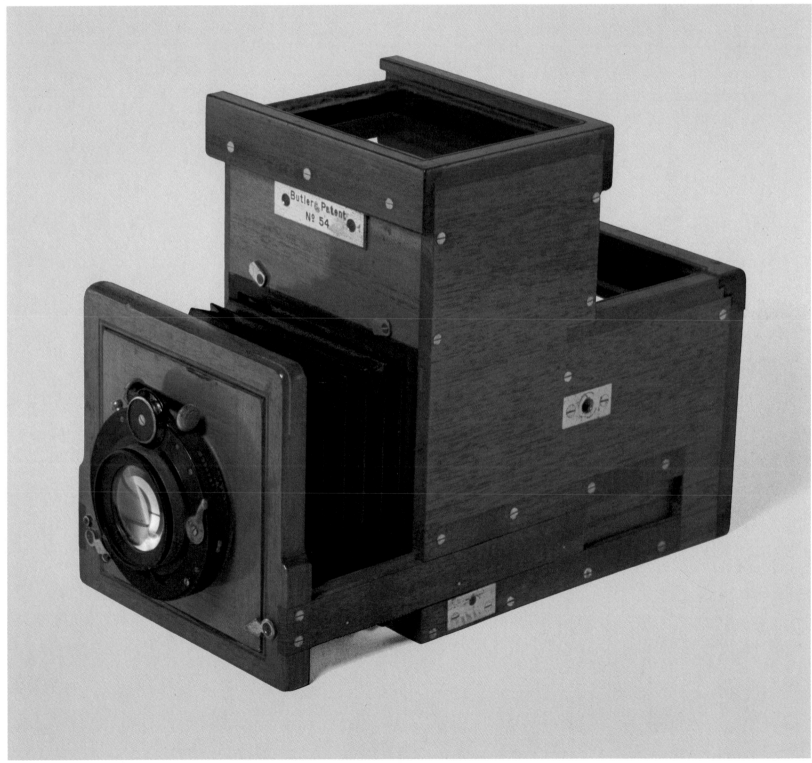

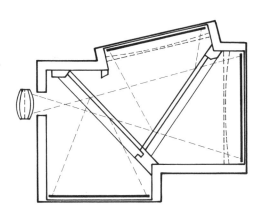

Three-colour quarter-plate beam-splitter camera by Bermpohl of Berlin about 1925, although evidently the work of a craftsman of the old school. The lens is a 210 mm f/4.5 double anastigmat by Hugo Meyer, with iris diaphragm and Compound shutter, the body a mixture of bellows and sliding box. A diagram above shows the arrangement of semi-transparent mirrors and the colour filter in front of each 9×12 cm (3½×4¾ in) plate.

Positive transparencies printed from separation negatives and dyed to the colours of the original filters, when placed in register and projected or held to the light reproduce the subject in full colour.

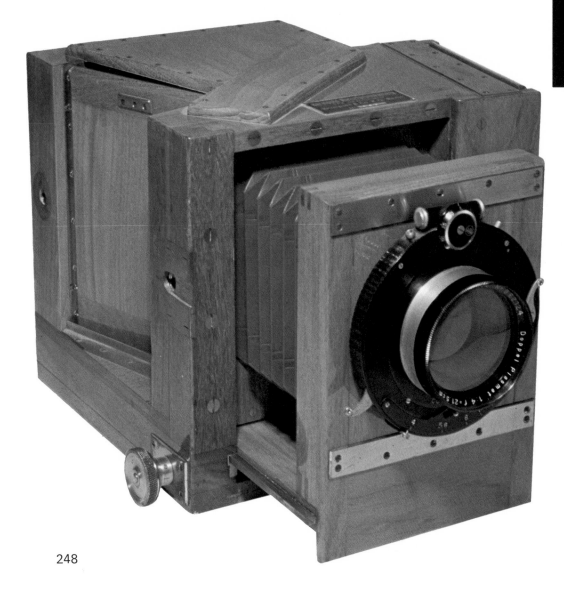

Prismatic **Jos-Pe** beam-splitter camera by Jos-Pe of Hamburg and Munich. VP size (4.5 × 6 cm) plates in bellows holders with appropriate colour filters to make colour separation negatives. Produced about 1925, this is a precision instrument fitted with the large-aperture lens made possible by miniature format: an f/2.5 10.5 cm Quinar anastigmat by the pioneer opticians Steinheil of Munich. Separation is made by prisms just behind the lens, which split the image into three.

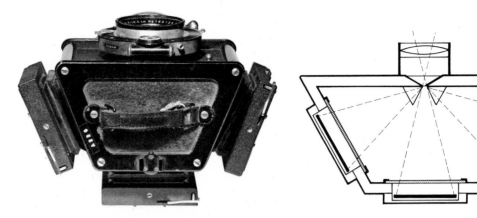

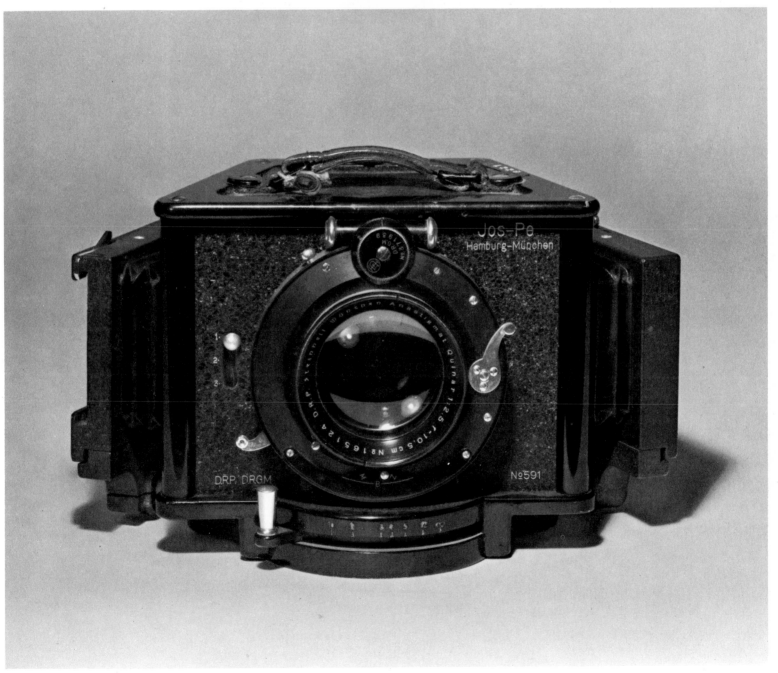

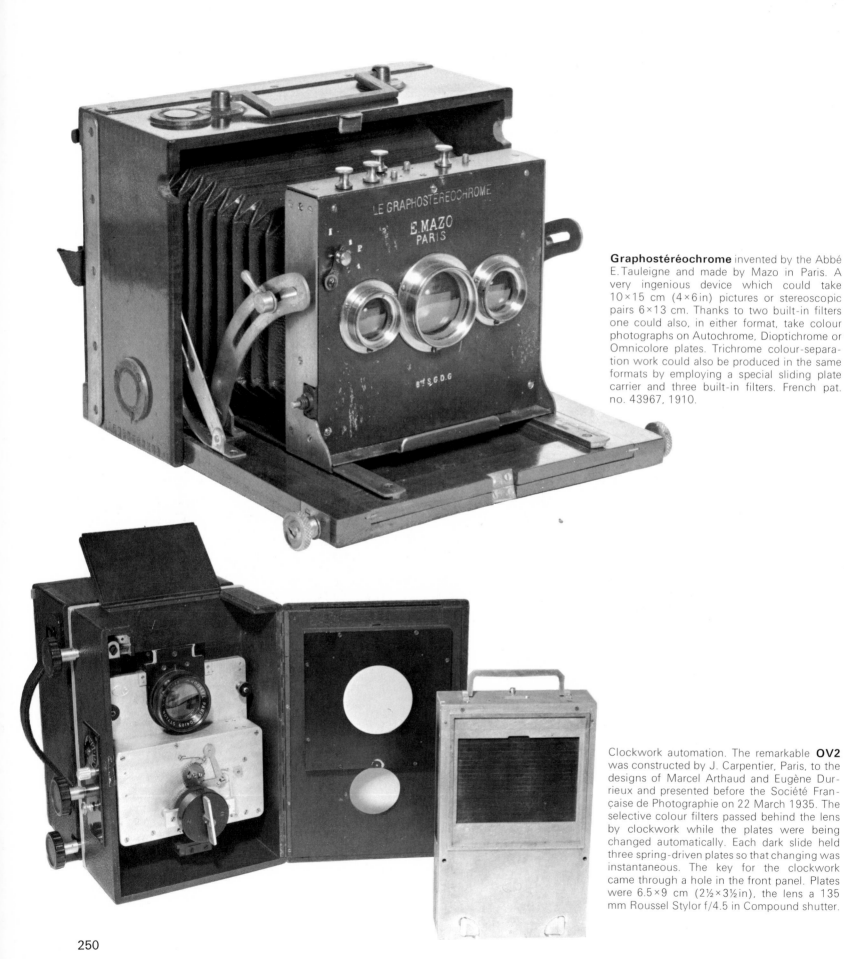

Graphostéréochrome invented by the Abbé E. Tauleigne and made by Mazo in Paris. A very ingenious device which could take 10×15 cm (4×6 in) pictures or stereoscopic pairs 6×13 cm. Thanks to two built-in filters one could also, in either format, take colour photographs on Autochrome, Dioptichrome or Omnicolore plates. Trichrome colour-separation work could also be produced in the same formats by employing a special sliding plate carrier and three built-in filters. French pat. no. 43967, 1910.

Clockwork automation. The remarkable **OV2** was constructed by J. Carpentier, Paris, to the designs of Marcel Arthaud and Eugène Durrieux and presented before the Société Française de Photographie on 22 March 1935. The selective colour filters passed behind the lens by clockwork while the plates were being changed automatically. Each dark slide held three spring-driven plates so that changing was instantaneous. The key for the clockwork came through a hole in the front panel. Plates were 6.5×9 cm (2½×3½ in), the lens a 135 mm Roussel Stylor f/4.5 in Compound shutter.

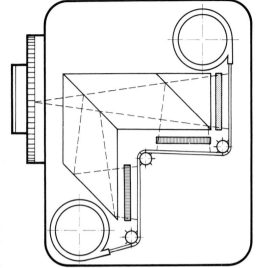

The **Spektaretta** was produced by Optikotechna, Prague. It is an elaborate development of the beam-splitter devices, using a rather complex prism instead of semi-transparent mirrors, as explained in the diagram above. The image is split into three, and each image is directed through a different filter on to the perforated 35 mm film, which is guided by rollers. Thus three frames are simultaneously exposed. The lens is a Spektar f/2.9, 70 mm, with a Compur shutter working from 1-1/250 sec. and iris diaphragm. Focusing was achieved through the species of telescope mounted on the far side of the camera, and framing checked through the viewfinder on the opposite side. In the foreground of the picture, the prism, the three colour filters, and the film cartridge are seen. The previous model was known as the **Coloretta**, and came out in 1939.

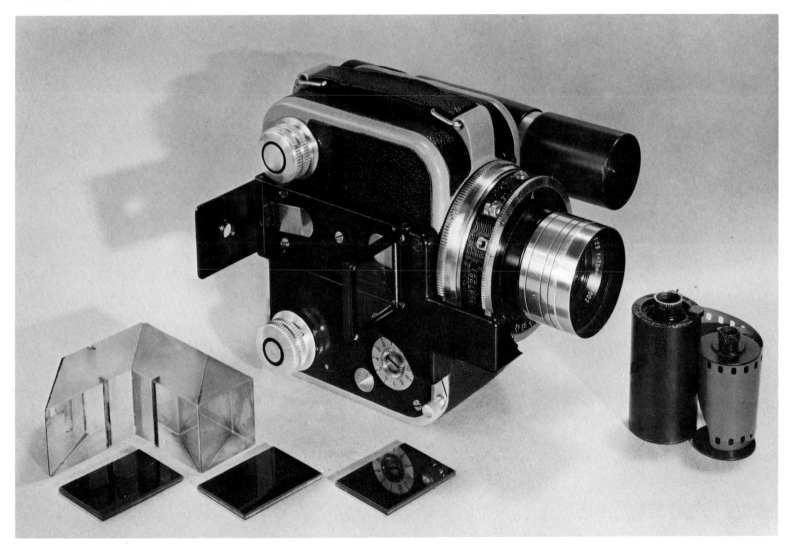

SELF-CONTAINED CAMERAS

The idea of a magic camera containing everything essential for the production of pictures must have occupied photographers' minds from the very beginning. Especially must this have been so in the complex days of daguerreotype and wet collodion, when two men and a boy, and preferably a vehicle as well, were hardly too much for an afternoon's expedition. One man who tackled the problem was the Parisian, Bourdin, who launched the Dubroni wet-plate outfit in 1864. There were several models but two pounds in English money purchased a small camera for pictures 45 mm square ($1\frac{3}{4} \times 1\frac{3}{4}$ in) neatly boxed with all necessary chemicals ranged round it in glass bottles.

A glass plate still wet with newly applied bromiodised collodion was put in through the hinged back. It was now in communication with an earthenware container forming the inside of the camera. Silver nitrate was introduced via a funnel or bulb-topped pipette and encouraged to flow over the plate, sensitising it. An exposure was made by uncapping the lens, and developer (pyrogallic and acetic acids from two of the bottles) was introduced in the same way, followed by a fixing solution. The plate was then ready to be washed, varnished and printed—or indeed framed against a black background as an Ambrotype.

Rather similar were the tintype fairground cameras which went on producing collodion negatives on black-lacquered sheet iron—hence the grander name Ferrotype for the process. Originally wet plates, later dry ones were used, exposed and passed directly into processing tanks inside or attached to the camera itself.

Dubroni wet plate outfit. Dating from 1864, the height of the wet-collodion process, this delightful Science Museum exhibit by Dubroni, Paris (whose anagrammatic surname was really Bourdin) is a camera and darkroom in one. This one has been sectioned to show how it worked. A glass plate 1¾ in square (45 mm) was coated with bromo-iodised collodion and placed in the camera. Silver nitrate solution was then introduced by means of the bulb and pipette (which entered through a light-tight flap to prevent fogging of the plate) and the camera tilted so that the sensitising solution flowed over the collodion plate. The pipette and solution were then withdrawn and an exposure made. Developing solution (pyrogallic and acetic acids) was then introduced in the same way. The photographer could watch the progress of development by placing his eye to the lens, with light from an orange window forming a false back to the camera. At other times, this window would be covered by a brass plate. The photograph was then washed, fixed, removed and varnished. This camera has an f/4 portrait lens allowing typical exposures of 2 to 5 seconds for landscapes in fine weather and 6 to 10 seconds for portraits out of doors. Patent No. 3175 of 1864. Note price of the whole outfit—£2.

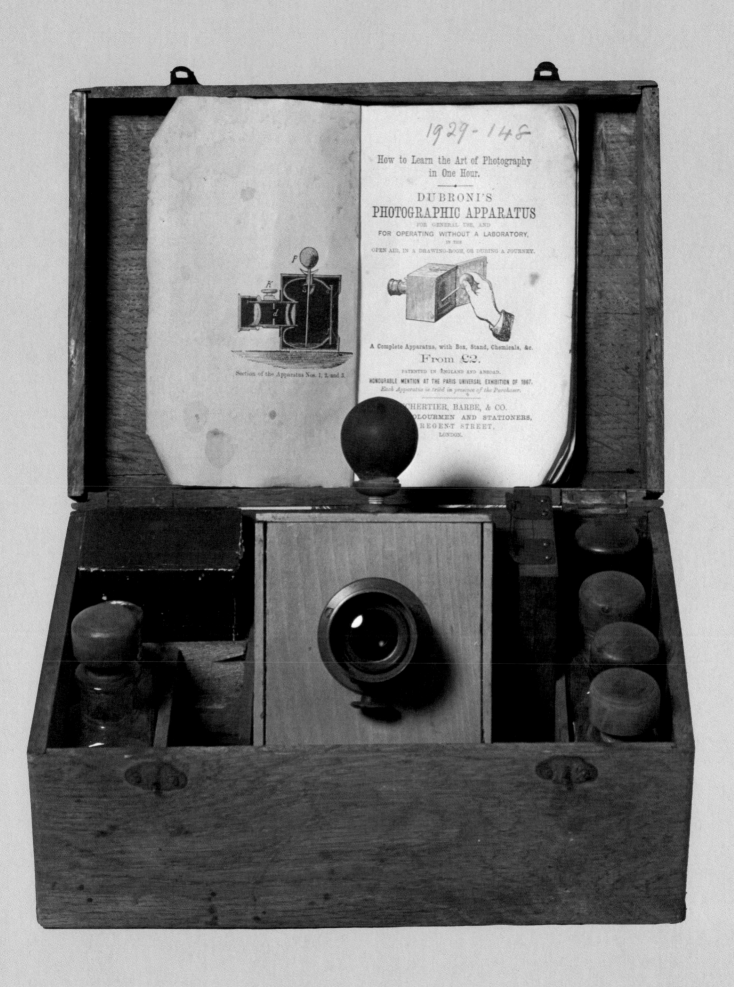

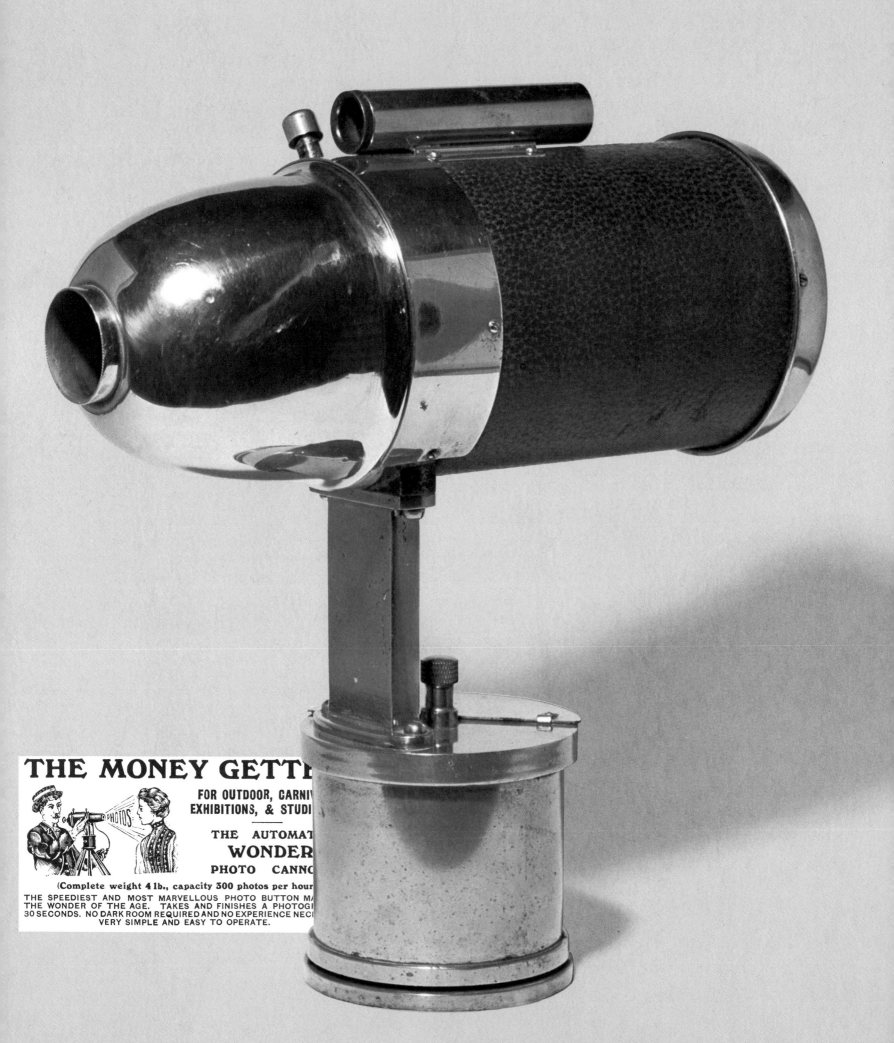

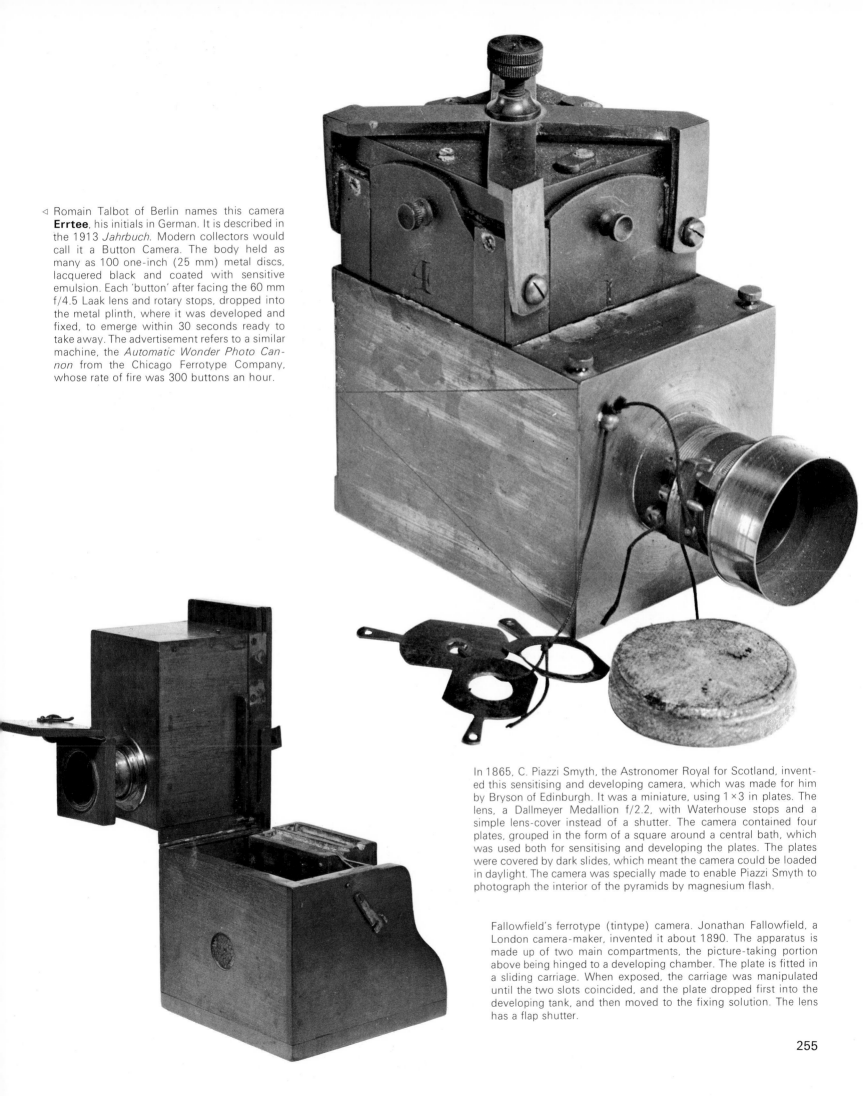

◁ Romain Talbot of Berlin names this camera **Errtee**, his initials in German. It is described in the 1913 *Jahrbuch*. Modern collectors would call it a Button Camera. The body held as many as 100 one-inch (25 mm) metal discs, lacquered black and coated with sensitive emulsion. Each 'button' after facing the 60 mm f/4.5 Laak lens and rotary stops, dropped into the metal plinth, where it was developed and fixed, to emerge within 30 seconds ready to take away. The advertisement refers to a similar machine, the *Automatic Wonder Photo Cannon* from the Chicago Ferrotype Company, whose rate of fire was 300 buttons an hour.

In 1865, C. Piazzi Smyth, the Astronomer Royal for Scotland, invented this sensitising and developing camera, which was made for him by Bryson of Edinburgh. It was a miniature, using 1×3 in plates. The lens, a Dallmeyer Medallion f/2.2, with Waterhouse stops and a simple lens-cover instead of a shutter. The camera contained four plates, grouped in the form of a square around a central bath, which was used both for sensitising and developing the plates. The plates were covered by dark slides, which meant the camera could be loaded in daylight. The camera was specially made to enable Piazzi Smyth to photograph the interior of the pyramids by magnesium flash.

Fallowfield's ferrotype (tintype) camera. Jonathan Fallowfield, a London camera-maker, invented it about 1890. The apparatus is made up of two main compartments, the picture-taking portion above being hinged to a developing chamber. The plate is fitted in a sliding carriage. When exposed, the carriage was manipulated until the two slots coincided, and the plate dropped first into the developing tank, and then moved to the fixing solution. The lens has a flap shutter.

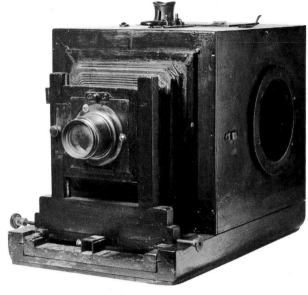

The **Hemerascope** was made for the company of that name by L. Gaumont in Paris to French patents granted on 14 August 1897. One could call it a combined quarter-plate (9×12 cm) camera and daylight developing-tank. The lens provided is a 136 mm f/8 Zeiss anastigmat. Having taken its photo the camera was placed back downwards in a bath of developer, as shown in the upper picture, which flowed over the plate through slots which may be seen in the illustrations while the operator watched through a spy-hole as the image formed. The camera was then transferred to a fixing-bath of hypo which entered in the same way. The **Hemerascope** is made entirely of vulcanite, bakelite or similar early plastic material. ▽

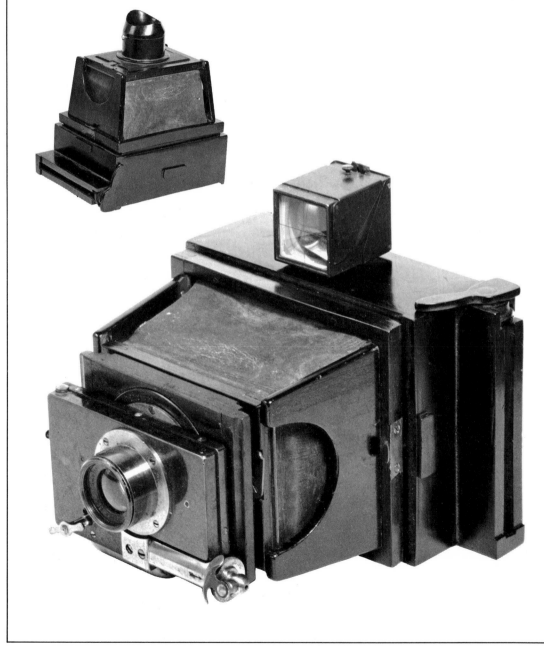

Postcard-size fairground camera. The photographer made his exposure on paper, developing it inside the camera, thrusting his hands through light-tight sleeves into the holes at the sides. The paper negative was used to obtain a paper positive; and so, within a few minutes the customer received an underfixed, underwashed portrait to take home.

Seaside Tintype camera for instant photographs. 'All the fun of the fair, roll up, roll up, roll up, ladies and gents, and get yer photo took while yer waits!' **L'Operateur** of Marco Mendoza came out in 1892 or thereabouts for taking tintype or, in grander language, Ferrotype photos. Using a simple flap shutter the photographer exposed his plate in the upper compartment. It was then ingeniously transferred, by hinging over the upper compartment, allowing the plate, still in the dark of course, to drop to the fixing and washing baths in the lower box. The negative was ready within minutes; it could be used to make prints or it could be lacquered black and framed as a collodion positive, 'the poor man's daguerreotype'. (Coll. Genard, Lyon)

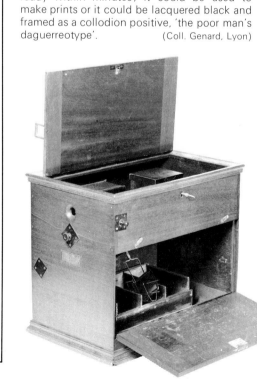

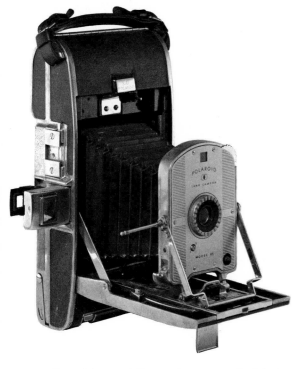

From fairground Button Cameras to Dr Edwin H. Land's instant success is a far cry although both in their way realised the photographer's dream: finished positives 'while you wait'. The **Model 95 Polaroid** dates from 1948, the first generation of modern 'instant' cameras.

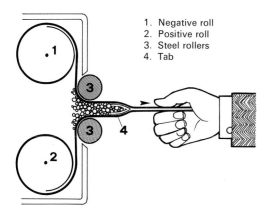

1. Negative roll
2. Positive roll
3. Steel rollers
4. Tab

The diagram shows the working of the **Model 95**. There are three elements: the negative film, a capsule containing developer and fixer, and a roll of positive paper. The exposure is made on the separate negative film. Afterwards, the photographer pulled a paper tab, which led the exposed negative, the positive paper, and a capsule of chemicals between two steel rollers, which crushed the capsule and spread the chemicals between the paper and the negative. Development took place automatically inside the camera, and after a few seconds, the developed and fixed positive emerged from the back of the camera.

POLAROID

Many minds have been applied to the problem of increasing the efficiency of the camera by making it completely self-contained, doing its own developing and printing internally. As has been seen earlier in the book, various processes have appeared, but most of them were unsatisfactory, at least for amateur use, in that they were so large as not to be portable, or entailed the immersion of the plate, still in the camera, in a bath of developer, and subsequently fixer, which meant that a supplementary chest of chemicals had to be carried about. An American, Dr Edwin Land, came up with the solution, by combining all the processes needed in a filmpack, which developed and printed pictures in the camera in 60 seconds. The explanation of the process will be found in the technical introduction, suffice it to say here that the necessary chemicals for contact printing from the negative are present on the film.

It is said that the first firm approached by Land to commercialize his invention saw no possibilities in it—a striking if rare example of business shortsightedness. Some 14 years later, some 14 million Americans alone had bought the camera, and the Polaroid Land Corporation was the second largest producer of photographic materials in the whole of the United States. The first process was for black and white prints, and was developed until perfect prints could be obtained from 10 to 20 seconds after the shutter release was pressed. In 1962, Land came up with an adaptation of his process which gave natural colour prints in 60 seconds. He went on to develop, in the latest models, a system whereby all the operations between pressing the shutter release, and the developing picture arriving in the hand, are entirely automatic and electric powered. Here at last was a system—compact, needing no technical knowledge to achieve perfect results, and above all, rapid. The fully automatic camera had arrived.

257

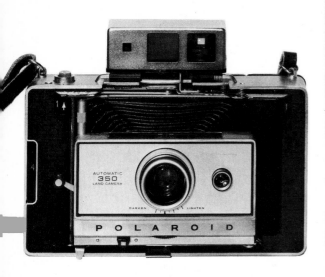

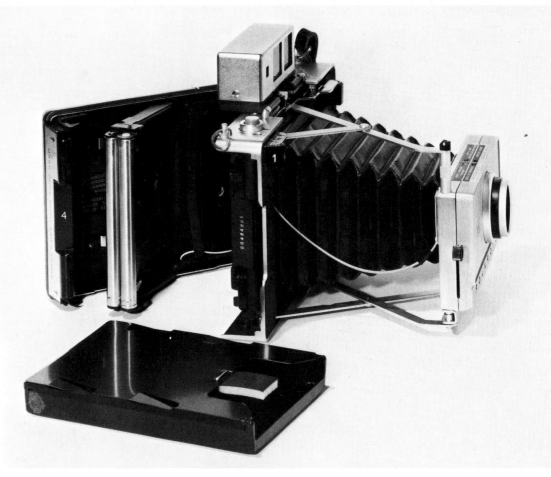

The **Polaroid Automatic 350** is a coupled-rangefinder bellows camera taking 8-exposure filmpacks (3⅜×4⅛in) colour or black and white. Shutter speed is governed electronically once the camera has been programmed for film-speed, interior/exterior or flash. After exposure the film is drawn out and a warning sounds when development is complete. Two different supplementary lenses are supplied for close-range work.

The image 'seen' by the lens is reflected down from the fixed mirror on to the Fresnel lens of the pivoting mirror, which reflects it back on to the fixed mirror and from thence, by way of the aspheric mirror, into the eyepiece of the viewfinder. As the shutter button is pressed the electric motor raises the pivoting mirror against the fixed mirror, thus uncovering the film. After exposure has been made the motor lowers the mirror back into place and actuates the drive mechanism by which the picture is passed between rollers which crush and spread the necessary chemicals, and 1.5 seconds later ejects the developing colour print into the user's hands.

1. Lens and shutter 2. View-finder 3. Aspheric viewing mirror 4. Fixed mirror 5. Pivoting mirror provided with Fresnel lens on its upper surface 6. Film pack containing battery 7. Rollers, and pod containing chemicals for development etc. 8. Slot from which pictures emerge 9. Drive for expulsion of picture 10. Motor.

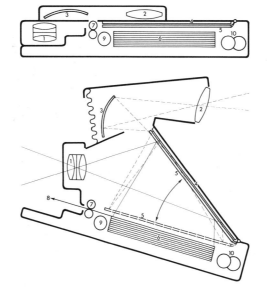

Polaroid SX-70. Instant colour photographs emerge from a slot in front of the camera less than two seconds after the shutter release is pressed, and develop before your eyes into hard, dry, glossy flat prints 8×8 cm (3⅛×3⅛in). They are the latest invention from Dr Edwin H. Land's Polaroid Land Corporation, of Cambridge, Massachusetts. Unlike earlier Polaroid pictures they generate no waste paper to peel off and throw away. The SX-70 is a single-lens reflex using 10-exposure film packs. Each pack contains a special wafer-thin electric battery which powers the motor that moves the reflex mirror, ejects prints as they are exposed, and fires a flash unit when one is fitted. Out of doors a light-meter governs the shutter speed, this meter being disconnected when a flash array is in place. When flash photographs are wanted, the shutter speed is regulated by the focusing distance set, the speed being slowest for a longer distance and speeding up for objects nearer the lens. The SX-70 camera closed measures 2.5×10×18 cm (1×4×7in) and weighs 24 ounces (670g). It focuses down to 10.2in with the standard lens; to 5in with close-up attachment, allowing copying natural size.

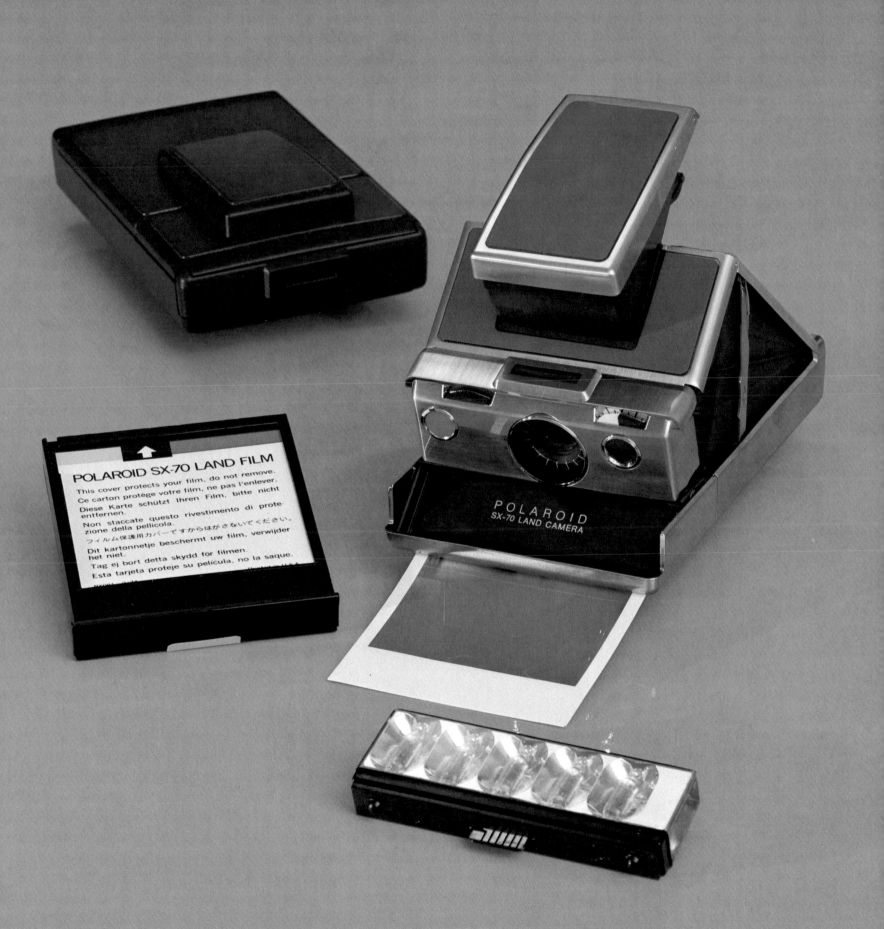

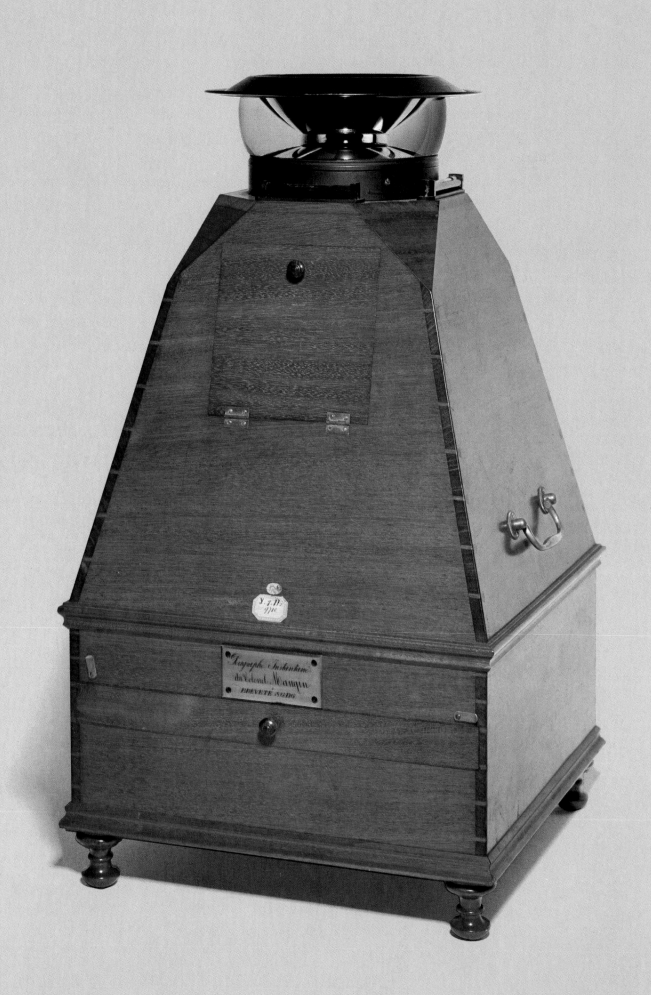

PANORAMIC CAMERAS

These are designed for taking panoramic landscapes or groups, i.e. photographs embracing an unusually wide field. The idea seems first to have occurred to Frédéric Martens, who realised its possibilities for topographical survey work almost from the beginning. In 1845, he mounted a daguerreotype camera on the roof of the Louvre and obtained 150° views over the Seine on cylindrically curved plates measuring 12×38 cm ($4\frac{3}{4} \times 15$ in). Martens employed a stationary camera with pivoted lens driven by clockwork; a mask pierced with a vertical slit travelled behind the lens to prevent fogging. This camera was later adapted to take paper negatives.

A different approach was that of Ross and Sutton in 1859, who built a camera for the latter's Panoramic Water Lens, a fluid-filled object covering a field of 120° at f/12. As this very early "extra wide-angle" was not corrected for field curvature, Ross, like Martens, was forced to employ curved plates.

About 1890, when rollfilm had simplified operations, a third method appeared. Cameras were mounted upon a turntable so as to sweep the whole horizon, and driven by clockwork with an air-brake to hold speed constant. As the camera rotated the film carrier moved at the same speed but in the opposite direction so that the portion to be exposed was always opposite the lens. Exposures were determined by camera speed and choice of diaphragm.

Modern panoramic cameras are mainly 35 mm, with wide-angle or pivoting lens. A simple alternative is a tripod with panoramic head.

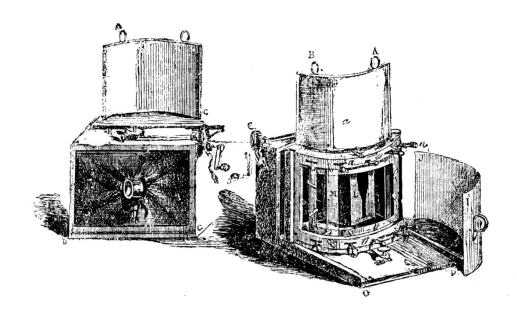

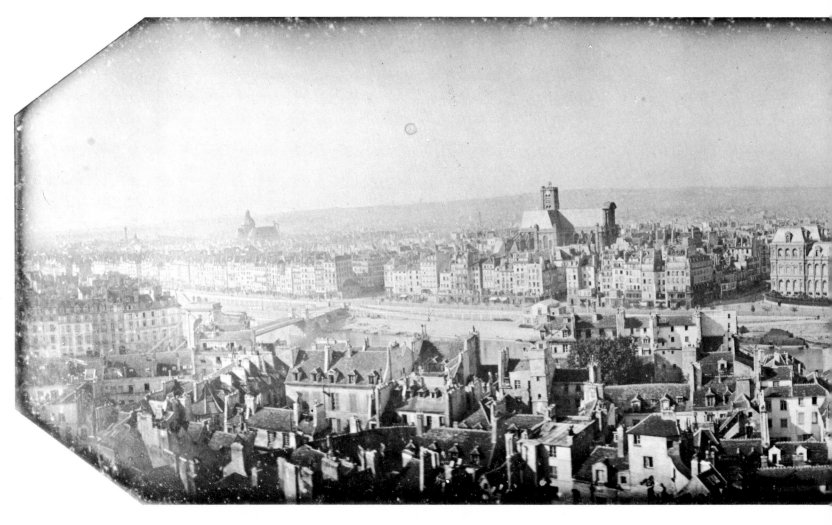

A panoramic camera invented by Frédéric Martens was described in *Mélanges photographiques* by Charles Chevalier, 1844. It was able to sweep an angle of some 150° and used specially curved daguerreotype plates. The drawings above show the handle and gear trains that swung the lens. The camera was modified later by the inventor's nephew, L. Schuller, to take pictures on flat glass plates covered with collodion. The photograph below is a daguerreotype of Paris taken with this camera, reproduced actual size. The view is transposed left to right.

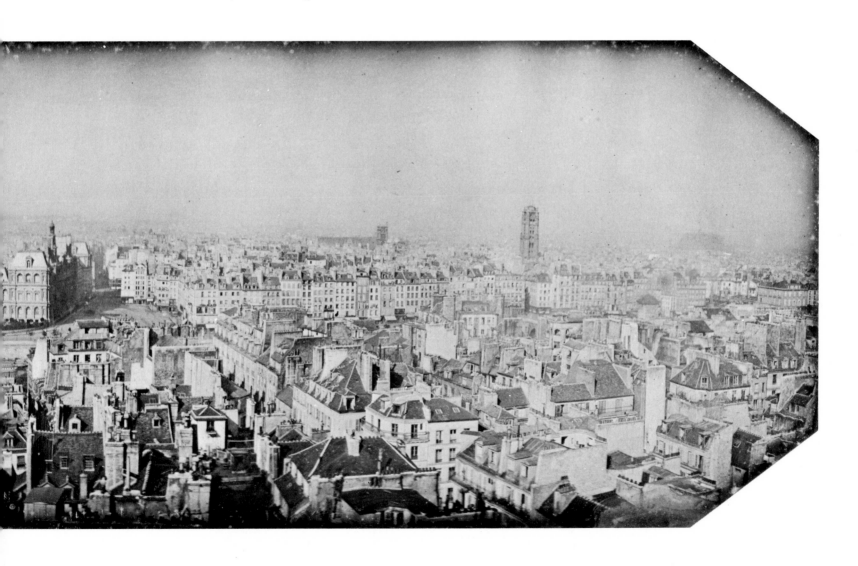

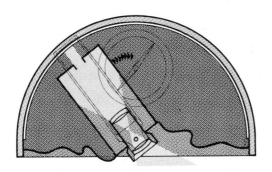

The **Cylindrographe**, invented by Lt. Colonel Moëssoral, was granted French patent No. 162 815 of 17 June 1889, and worked on much the same principle as the Martens camera on page 263. The lens, a rectilinear f/8 (approx.) of 150 mm, was pivoted in front, and moved across the concave film carrier at the rear of the apparatus. A flexible curtain ensured that light did not enter from the front, and a special system of light excluding surfaces enabled the lens etc. to be stopped where required. To aid the photographer select the portion of the view he required, a viewer mounted on top turned with the lens. To underline its topographical uses, the top was also fitted with a compass. The complete film size was 12×42 cm (4¾×16 in). The whole camera was resplendent in varnished walnut and german silver.

Every inch a High Victorian scientific instrument: Johnson & Harrison's **Phantoscopic Camera** ((British Patent No. 2459 5 September 1862) for 19×31 cm (7½×12 in) wet collodion plates. It is fitted with Grubb aplanatic single lens. The camera rests upon a brass turntable and is turned by clockwork so as to cover a field of 110°. Exposure time depends upon the speed of rotation, and this in turn is controlled by a 'fly' such as clockmakers use which acts as air-brake and governor. A sliding mount maintains the plate in correct relation to the lens.

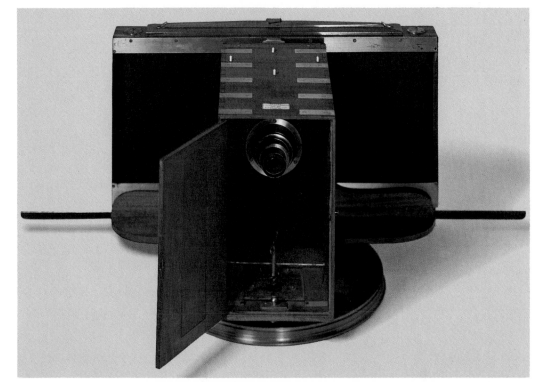

Ross Panoramic Camera fitted with Thomas Sutton's Panoramic Water Lens (British Patent No. 2193, 1859) which covered a field of 120° and worked at f/12. The lens, consisting of a hollow glass sphere, was filled with liquid and fitted with a central stop. As the lens was not corrected for field curvature, curved plates and plate-holder, had to be used interchangeably with the focusing screen here. A Sutton **Panoramic** set a world's record for camera prices at auction in 1974 when one was sold at Christie's in London for £11,000.

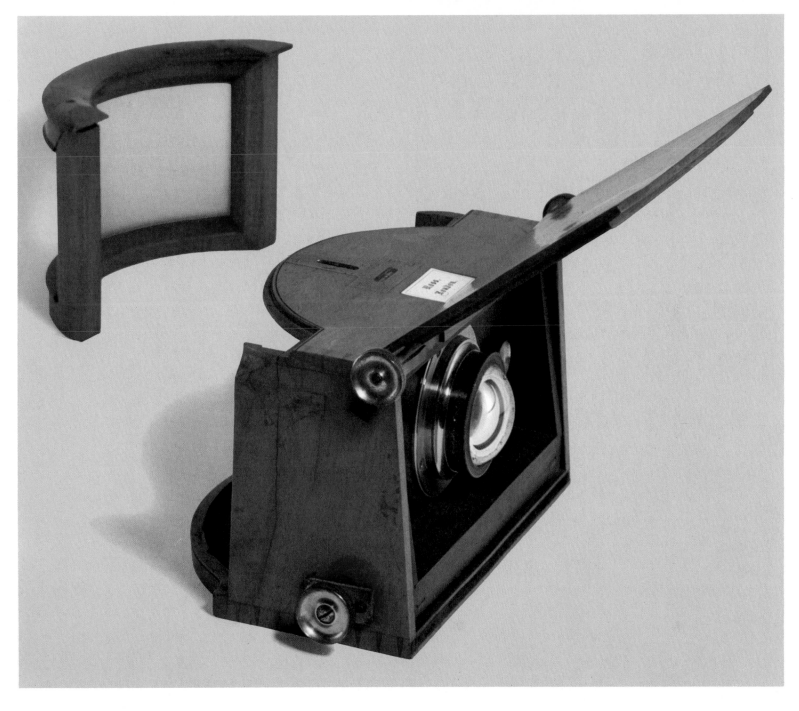

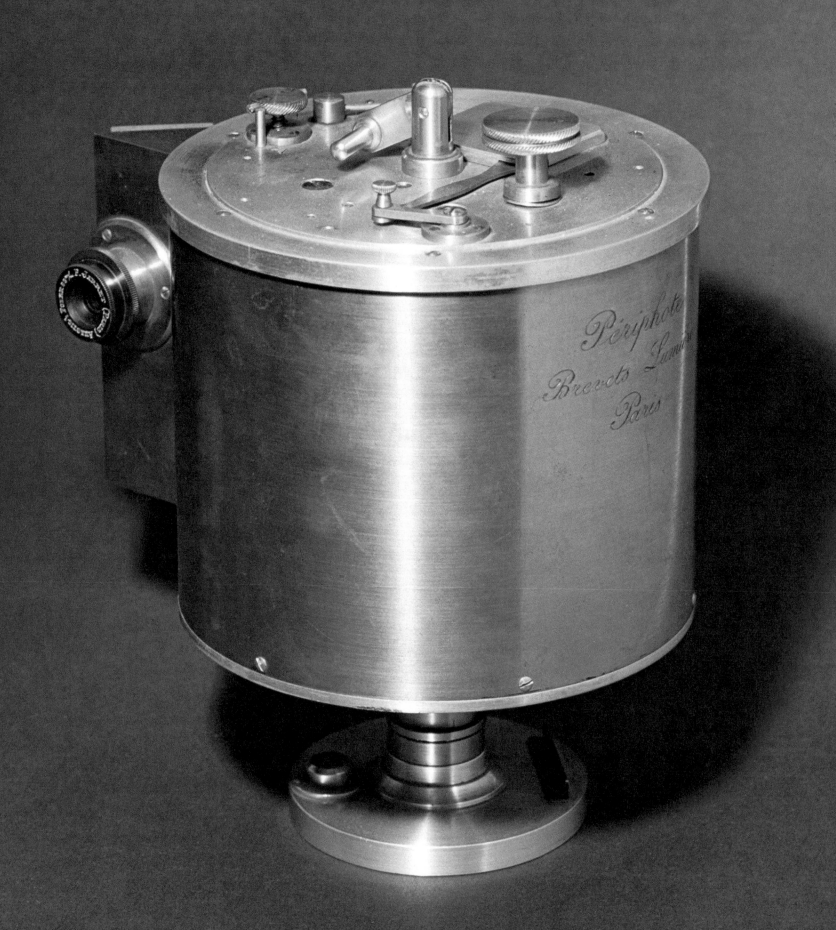

The Lumière Brothers' **Périphote**, which was the subject of Swiss patent No. 23746 of 1 March 1901. It gave six pictures 7×38 cm (2¾×15 in) on special film. An anastigmat f/5.6 55 mm Jarrett lens was fitted. This panoramic camera worked by clockwork, the film was held stationary in the centre of the camera, while the lens rotated around the drum. Sweeps could be either 360° or limited to 180°. The inventors also came up with a special projector for the pictures taken by the Périphote. The camera shown here was made of nickel-plated brass and aluminium.

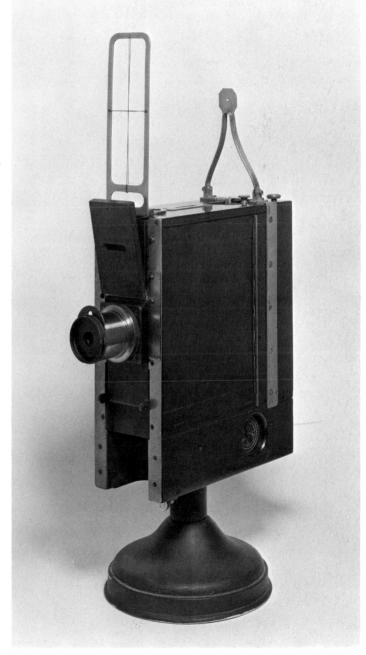

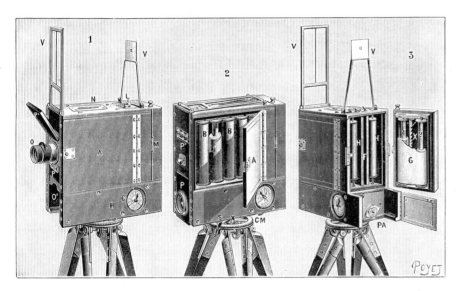

The **Cyclographe** was patented by M. Damoizeau, of Paris, on 11 March 1893, No. 228 548. Some variations were made. It used rollfilm, either 9 or 13 cm (3½ or 5 in) wide, by 80 cm (32 in) long. A clockwork motor turned the whole camera on its base, while the film was fed past the lens at the same speed in the opposite direction. It was also possible to stop the camera and film where desired. The lens was an achromatic meniscus, f/11 135 mm, with rotary stops. The engraving above shows the various rollers for the film transport.

The **Wonder Panoramic Camera** was invented by the American, J. R. Connon, and enabled a 360° panoramic photograph to be taken. An American patent was taken out in 1889 by C. P. Stirn, but it was R. Stirn who manufactured it in Berlin. The wooden body was fastened to a disc, which turned when the operator pulled down a string fixed underneath. A regulator and brake enabled the speed to be selected, and kept it constant. Eastman transparent film, 3 in wide unrolled at a speed governed by the rotation. Catches on the base enabled the rotation to be limited to 90°, 180° or 270°. For a complete circuit, a film length of 17⅞ in was used. The film was sold with the camera, and was of sufficient length to give five complete pictures. A device made a nick in the film after each exposure, facilitating cutting in the darkroom.

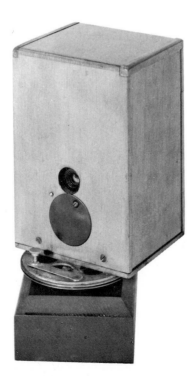

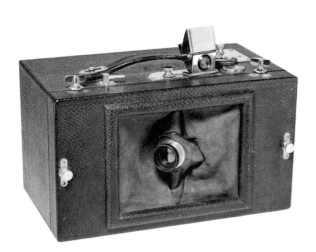

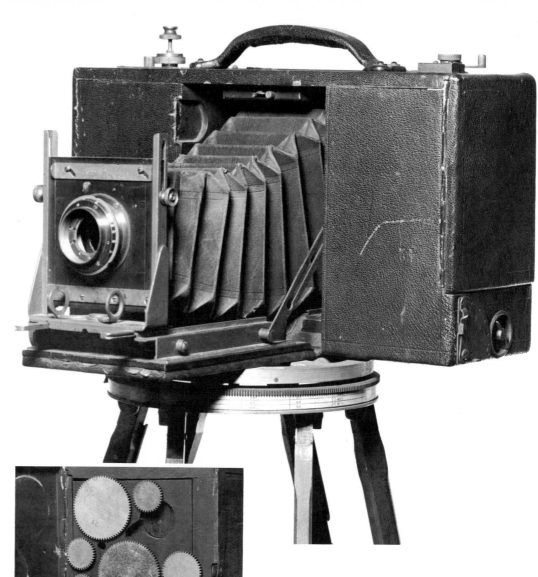

Al Vista panoramic rollfilm camera by the Multiscope & Film Corp. of Burlington, USA. The model was described in the *British Journal Photographic Almanac* for 1900 and came in five sizes, this being the 4 in × 12 in (10×30 cm). The 6 in (150 mm) R.R. lens turned through almost 180° by clockwork. Three 'fly' governors of different sizes were supplied, offering different speeds of rotation.

In the Kodak **Cirkut**, whose turntable mounting allowed the complete horizon to be photographed, rotation at speed was governed not by air-brakes but by gearing. The lower picture shows some of the cog-wheels the operator could choose from. The film travelled across the back of the camera in a reverse direction.

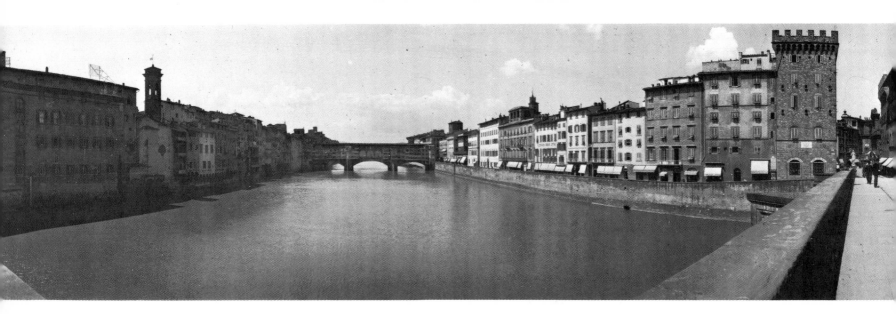

A panoramic view of Florence taken by the **Périphote**.

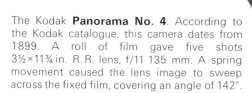

The Kodak **Panorama No. 4**. According to the Kodak catalogue, this camera dates from 1899. A roll of film gave five shots 3½×11¾ in. R.R. lens, f/11 135 mm. A spring movement caused the lens image to sweep across the fixed film, covering an angle of 142°.

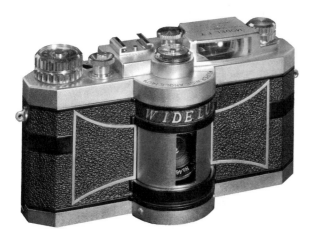

Made in Japan, the **Widelux** uses 35 mm film, giving 11 pictures 24×58 on a 20-ex. film or 21 on the ordinary 36-ex. film. The lens, a 26 mm wide-angle f/2.8 in three-speed shutter, covers a field of 140° horizontally and 55° vertically, virtually the same as that of the human eye.

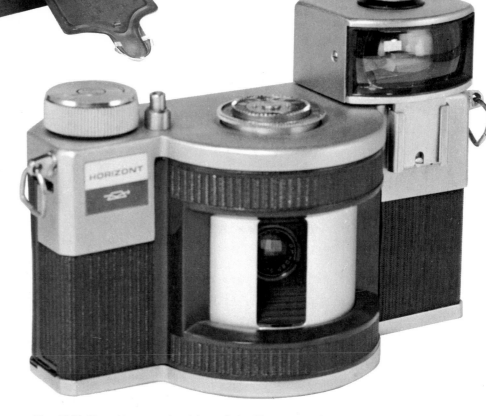

The 1966 Photokina saw the debut of the **Horizont**, of Russian manufacture. It is loaded with standard cartridges of 35 mm film, giving an image 24×58 mm. The mobile lens is a f/2.8, and has three speeds 1/30, 1/60, and 1/125 sec. The lens can move through 120° horizontally, 45° vertically, and the viewfinder is a wide-angle galilean type.

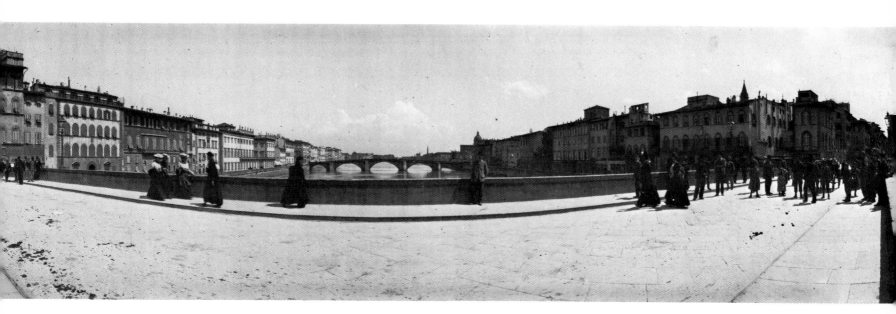

MULTIPLE LENS CAMERAS

The idea of a multi-lens camera taking a number of photographs simultaneously on one plate may have started with Sir David Brewster's twin-lens stereoscopic camera; it certainly saved trouble for sitter and photographer alike. In this chapter, we shall also consider cameras built on the "repeating back" principle suggested by the daguerreotypist A. F. J. Claudet in 1851, in which the dark slide could be moved vertically and horizontally to allow successive poses on the same plate. The two systems were sometimes combined, as for example by Hermagis, of Paris, during the *carte de visite* boom, whose 1860 four-lens camera had a sliding double dark slide so that two exposures gave eight *cartes*. Similar cameras took microscopic pictures for setting in jewelry, souvenirs, penholders, watchkeys to be viewed through a Stanhope lens. During the 1860s there was a craze, too, for albums, brooches, buttons and lockets containing prints or collodion positives. These were taken by special cameras, having 9, 12 or more lenses and often a single shutter to ensure equal exposure.

In 1867, a very odd device was proposed by one Rawson and described in the *Philadelphia Photographer*. A frame containing a number of little mirrors was set up so that each looking-glass held a reflection of the sitter. These reflections were photographed with an ordinary sliding-box wet-plate camera. The number and size of the images were varied by moving the camera closer or further away, the result being a quantity of small pictures on the same plate.

This unnamed studio camera took 12 'button' or postage-stamp portraits on one plate. A roller-blind 'mousetrap' shutter (seen here with Antinous release) uncovered all 12 lenses at once.

The **Lancaster Postage Stamp Camera** of 1896 was a sort of mass-production device for 'While-U-Wait' photographers. It had six f/8 Rapid Rectilinear lenses taking six identical ¾ in 'Gem' size (19 mm square) pictures on a single quarter plate Ferrotype dry plate. Rack-and-pinion focusing allowed it to be used for copying, and an Eclipse flap shutter was used.

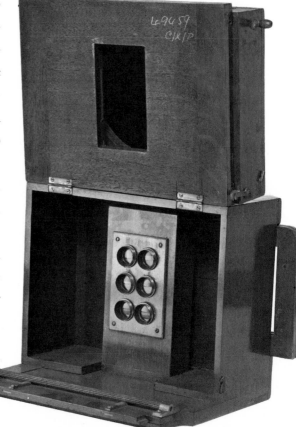

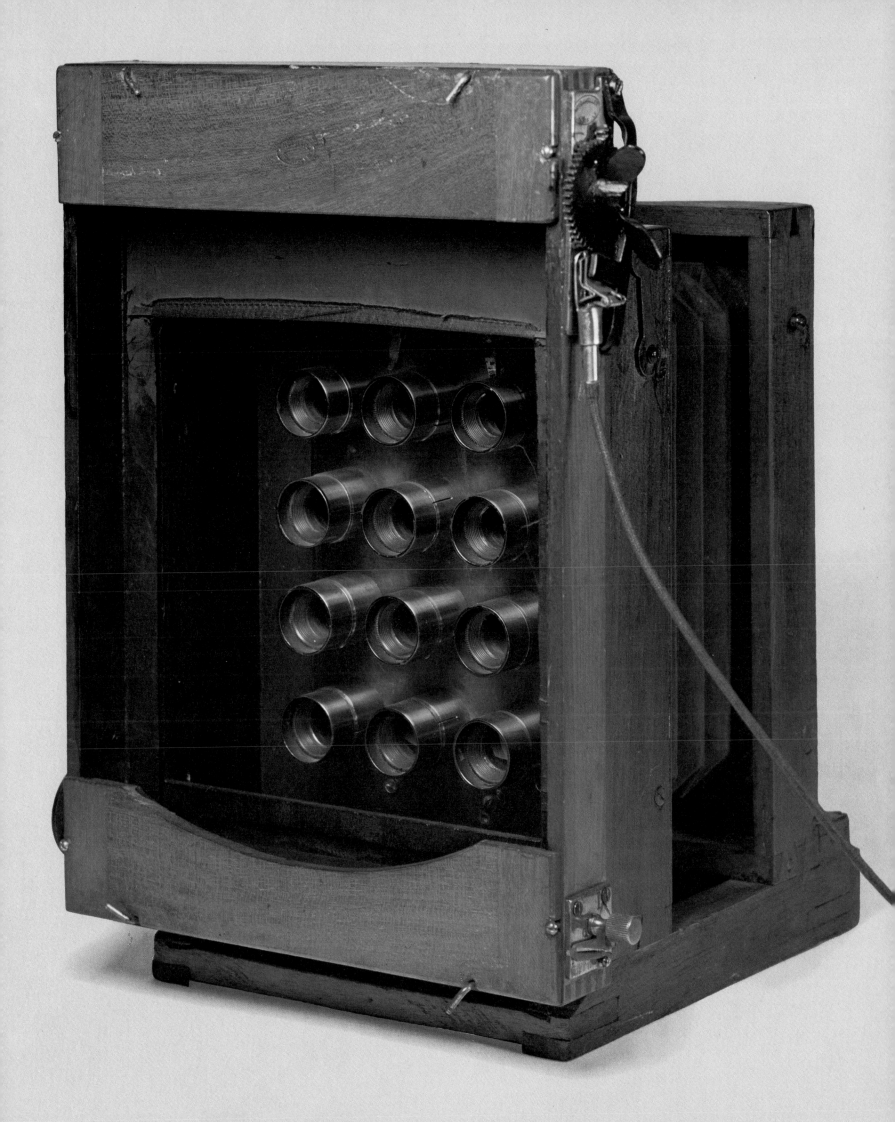

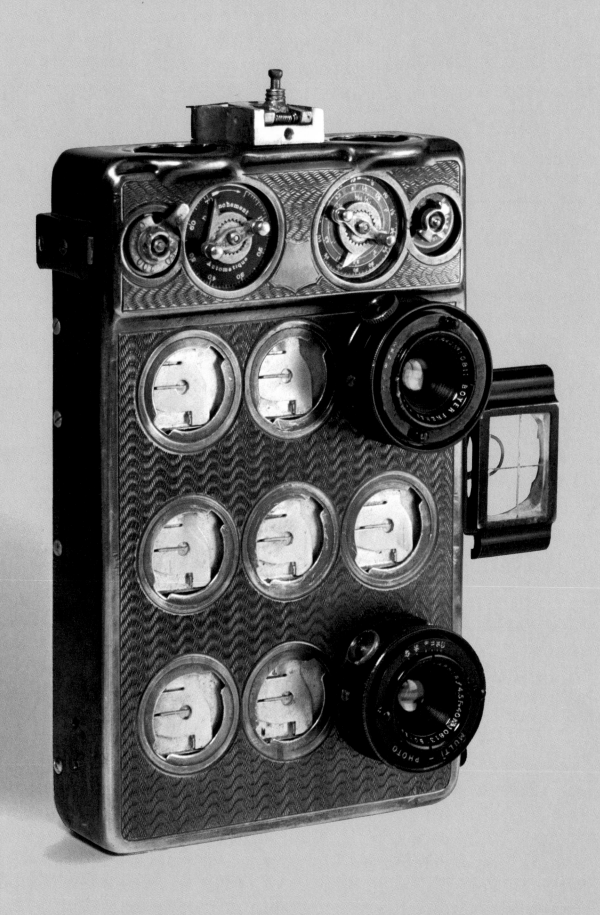

◁ Far more sophisticated was this all-metal **Multi-Photo** made by a Lyons company of that name and listed in their first catalogue in 1924. Here it has two 40 mm f/4.5 Boyer Saphir lenses with bayonet fitting and iris diaphragm. Focal-plane shutter, delay action, optical direct finder. Three stereoscopic views and three ordinary ones could be taken, or 9 ordinary views on one postcard-size plate. The engine-turned brass body could be plated in nickel, silver or gold as the customer wished.

This 12-lens wooden Multiplying Camera took 12 3 cm (1⅛ in) square pictures on a quarter plate, or, with one of the flaps closed, six on one-half of the plate, allowing a change of pose. The sliding front acted as shutter.

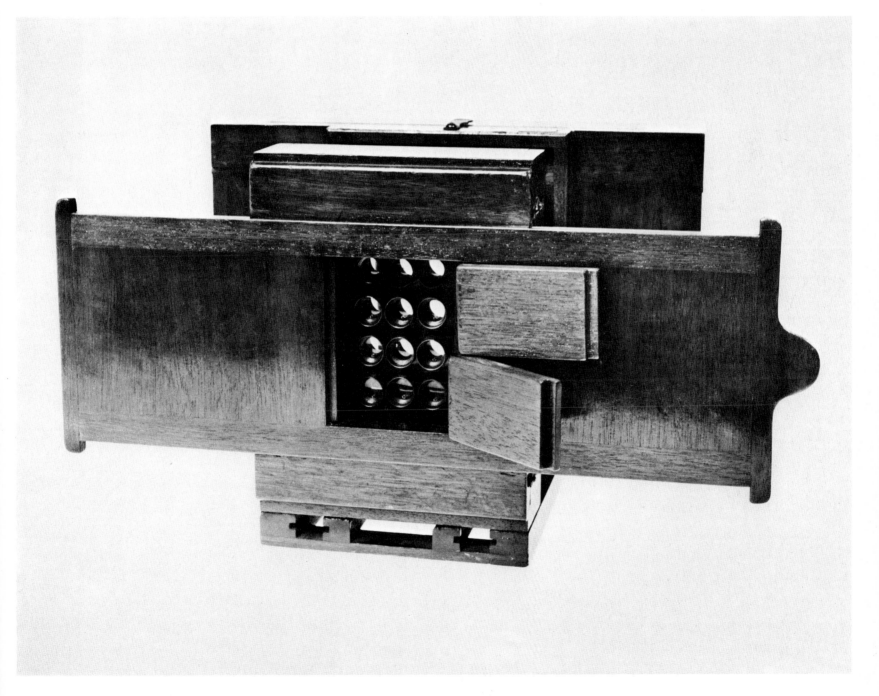

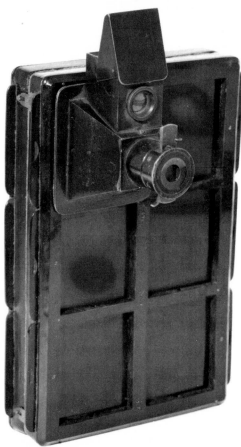

The **Carnet Photo-Rapide** was the subject of French patent No. 190025 granted to Charles Le Roy of Paris on 17 April 1888, an ingenious combination of book-form double dark slide and repeating back. It allowed 12 different 4×4.5 cm (approx. 1⅜×1⅞ in) photographs in succession on a single plate contained in a double dark slide opening like a book, hence the name **carnet**. To take a picture the camera body complete with lens, shutter and view-finder was placed in position, the appropriate dark-slide withdrawn and an exposure made. The lens is a 50 mm achromatic doublet of f/9 with simple blade shutter between the elements; fixed focus, and it is fitted with brilliant finder.

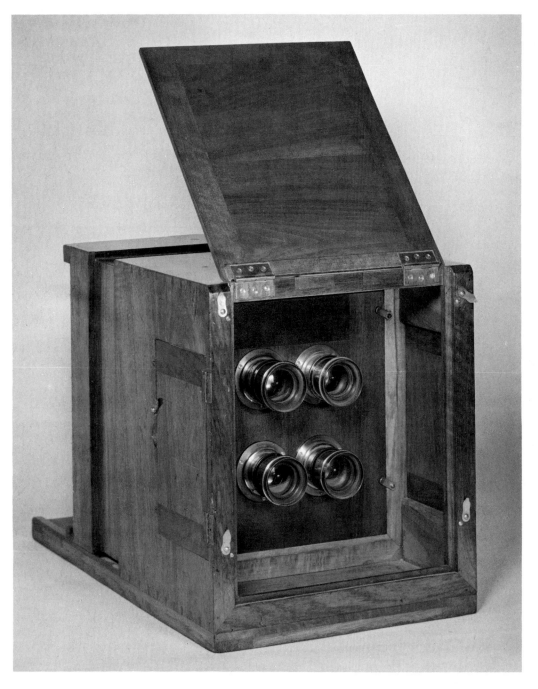

The eight studies on the opposite page are ▷ positives printed from a plate exposed in a multiplying camera of Le Roy type. Note that they are not repetitions, but eight separate poses; taken one at a time.

Four lenses and internal masking enabled this unsigned Multiplying Camera to take four passport-size photographs at once. With a sliding dark slide similarly masked, eight pictures could be made on the same plate. An attribution to Disdéri, 1854, is inconclusive.

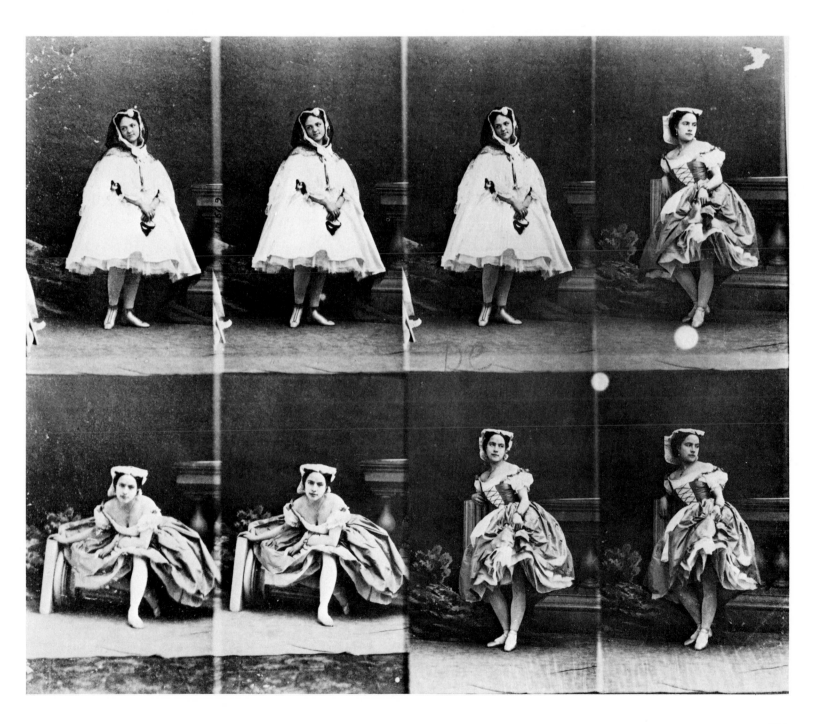

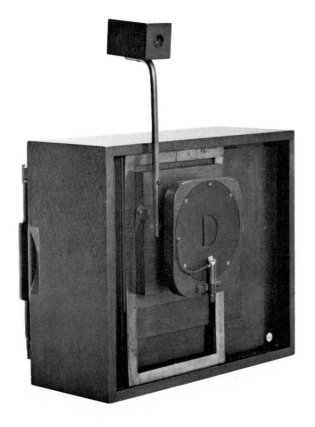

This camera by Simon Wing, of Boston, Mass., was patented on 17 June 1862 (U.S. patent No. 35635). It could take 15 pictures on a 13×18 cm (7×5 in) plate thanks to an ingenious lens panel able to slide both vertically and sideways; and as the finder is attached to this panel, it always gives a correct view of the subject. Petzval portrait lens made by Darlot, Paris; fixed aperture, sector shutter.

W. Butcher & Son, High Holborn, brought out this 15-exposure quarter plate camera in 1907 and called it **Royal Mail** because each picture fitted the portrait space on a postage stamp; special printing-masks came with the camera.

Postcard showing four 'postage-stamp' photos; family snapshots as a change from presidents and kings.

TELEPHOTOGRAPHY

There are several ways of "bringing things closer". One method would be a long-focus lens in a camera with long extension; another is the telephoto lens, which means a short, compact lens possessing the optical qualities of a long one.

The first use of such a lens in photography would seem to date from 1851, when an Italian, Professor Porro, took long-range photos of the Pantheon and also recorded an eclipse of the sun, obtaining an image 83 mm in diameter. By adjusting the focal length of his "Stenallatic" lens (and also its back focus) he obtained various magnifications.

Little more was done for the next 40 years. Then Steinheil, of Munich, in 1890 delivered a telephoto lens to the German navy and the following year T.R. Dallmeyer put his own version on the English market. The Dallmeyer "Naturalist" camera followed.

An ingenious device was constructed by Lorillon, who favored the long-focus method; and also interesting is the Telephot Vega (page 278), for although the optical system is Galilean an overlong extension is avoided by, as it were, folding the light-path into three by means of mirrors. Modern "Catadioptric" or mirror telephoto lenses also employ reflectors but these are built into the lens barrel.

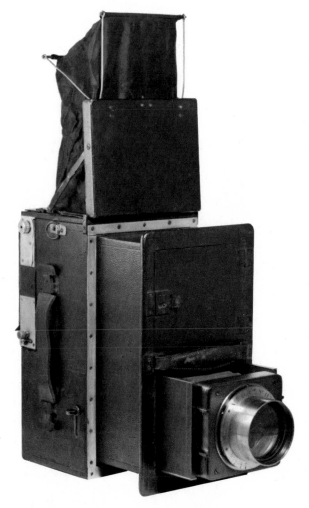

This **Vega** reflex by the company of that name in Geneva was patented on 1 October 1902, No. 25278, in the names of MM Dufour, Vautier and Schaer who designed it specially for telephotography: the Vega f/9.6 lens has a focal length of 600 mm (24 inches). Iris diaphragm, Thornton-Pickard shutter.

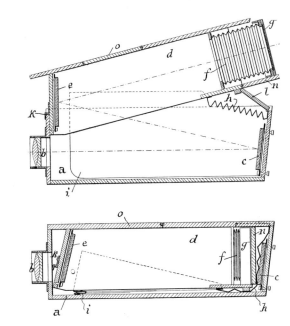

The **Téléphot-Véga** was invented by Auguste Vautier, and manufactured by the Genevan firm of Véga, under Swiss patent No. 21304 of 14 March 1901. It took plates of 18×24 cm (7⅛×9½ in). The lens, a gigantic f/10 of 1350 mm, no name, was devised and manufactured specially by Schaer. Such an enormous focal length implied a camera body of great length, but the inventor got round the problem by halving the length, installing a mirror opposite the lens in the upper half. This kept the dimensions within bounds, especially as the upper portion was made to collapse into the lower for transport, as is shown in the diagram. Roller-blind shutter, and iris diaphragm.

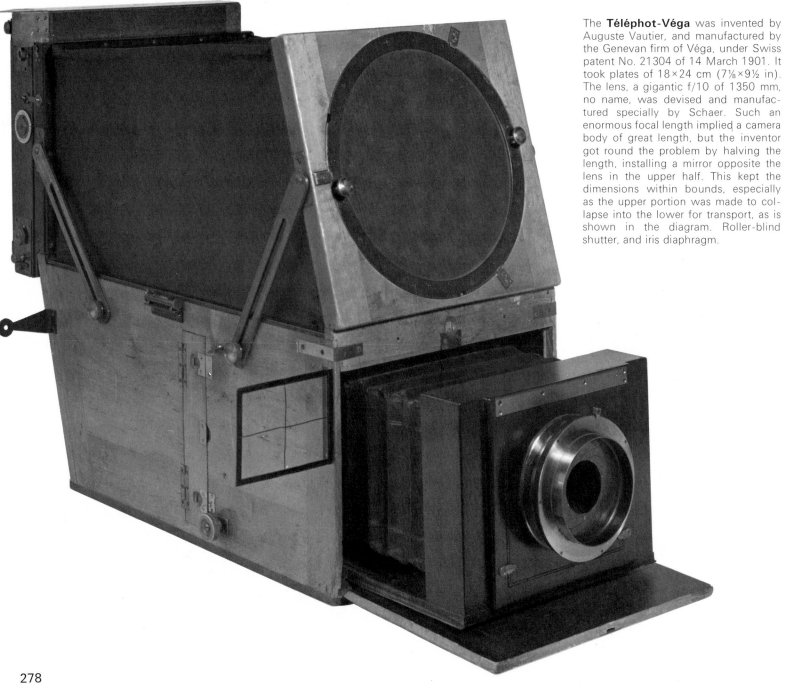

The **Téléphot-Véga Stéréoscopique** was designed by Auguste Vauthier and manufactured by the Société Véga at Geneva around 1905. Pairs of photos 7.5×7.5 cm (3in) were produced on plates measuring 8×16 cm; the lenses were f/12.8 of 700 mm (27½in) focal length, with iris diaphragm and focal-plane shutter. This was the stereoscopic version of the Téléphot (p. 277). A lens of normal focal length could also be used, and thanks to the presence of the mirror the image appeared right way round.

The Graflex Corporation of Rochester, NY brought out their 5×4 in **Naturalist-Graflex** in 1909, according to the Kodak Museum at Harrow. Lenses up to 25 inches focal length could be used, employing two mirrors in the strange caterpillar-like body. Reflex cameras have obvious advantages for wild-life photos.

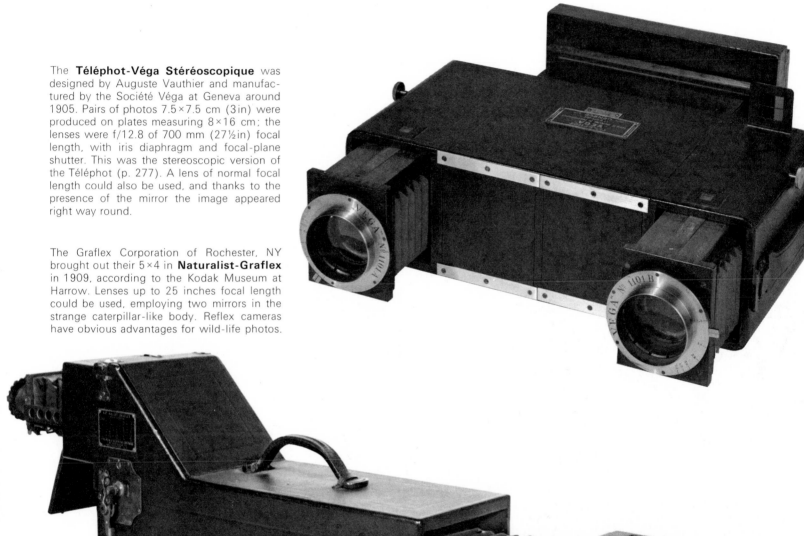

CAMERAS FOR SPECIAL TASKS

At first, photography was used simply to make a record of a landscape or a person, and was used as an adjunct to painting, which it profoundly influenced. Later, however, enquiring minds turned to photography as an aid to scientific and industrial research.

Amongst one of the most spectacular and interesting of technical applications was aerial photography, which arrived quite early. One of the first aerial photographs was made by a camera specially built into the nose of a rocket, which was patented in 1903 and later tested by the German army. This was a relatively sophisticated device, featuring such details as gyroscopic stabilisation and a parachute for the camera's safe return to earth. Rather cruder was the miniature camera strapped to a carrier pigeon. However, both devices needed a remote control, as once they were in the air, it was impossible to touch them. Once a reliable system had been worked out, aerial photography was in business.

There were, and are, many customers for it, quite apart from the military. Archaeology, agricultural and mineral research, land surveying, all owe a lot to the techniques developed initially for aerial reconnaissance and surveillance in war. Naturally enough, the two World Wars brought a host of new developments and applications. Progress has been continuous since the pigeon-borne devices of pre-1914 vintage. Modern aerial cameras are very expensive, and out of the public's reach.

However, pre-1939 aerial cameras can be found and are often featured in collections. This fate might soon overtake modern scientific cameras, such is the progress that has been made using laser beams, etc., and the special demands made by the exploration of space, especially by automated satellites. Indeed, it is doubtful if the term "camera" can properly be applied to such devices. Often, the image formed is such that it can only be made out by a computer. Photography has become an abstract art form!

In the 1880s, an ingenious Frenchman made an early attempt at producing a practical method of aerial photography. Possibly influenced by Benjamin Franklin, he decided to attach his camera to a kite. Naturally, there were difficulties to overcome, and his description of his researches in *La Nature* is a masterpiece of unconscious humour. But he did succeed in taking at least one successful picture of a small town in France, and the diagram above shows the methods he used to attach his camera to the kite string to obtain either vertical or oblique shots.

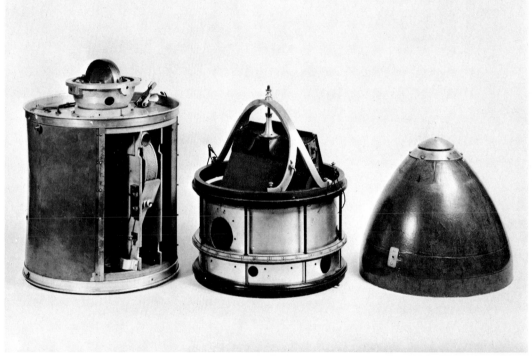

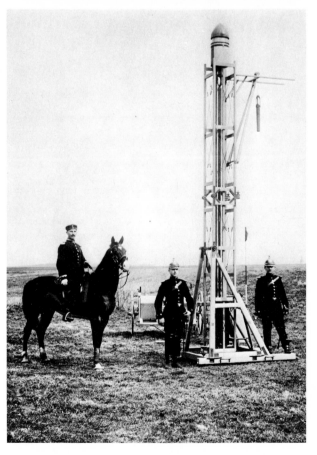

Alfred Maul's **Photo-Rocket**, patented 1903 and 1905. Above, left: the rocket and its platform folded for transport. Above, right, details of the rocket-head, showing (left) the gyroscopic stabilisor, centre, the camera mounting and release mechanism for the focal-plane shutter, and right, the nose cone which returned by parachute. In the lefthand picture below the count-down has begun; on the right an aerial photograph taken by one of Maul's rockets. (Deutsches Museum, Munich).

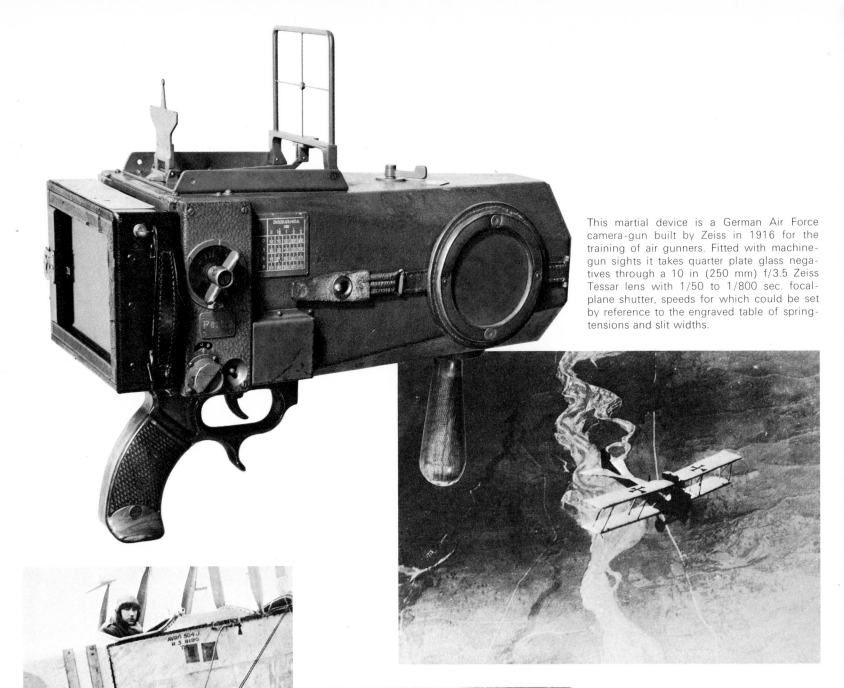

This martial device is a German Air Force camera-gun built by Zeiss in 1916 for the training of air gunners. Fitted with machine-gun sights it takes quarter plate glass negatives through a 10 in (250 mm) f/3.5 Zeiss Tessar lens with 1/50 to 1/800 sec. focal-plane shutter, speeds for which could be set by reference to the engraved table of spring-tensions and slit widths.

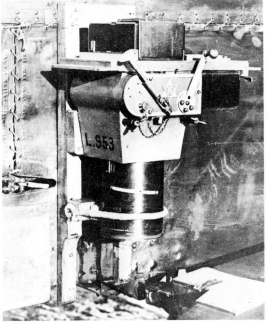

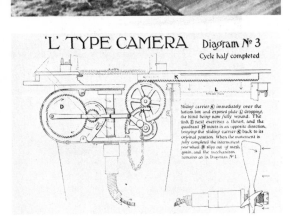

Aerial photography as practised in the canvas and glue days of flying. Far left: an L type camera, made by Williamson of Willesden, mounted on an Avro 504 towards the end of the First World War. Plate changing was effected by gears, driven by the small propellor mounted in the slipstream, which drove wormgear to a rack which slid the plates into place from a magazine containing 18 plates. The focal plane shutter was worked by the plunger on the rear of the camera. The lens could be either 8 in or 10 in for normal use, and the pilot was ordered to fly at 6,000 ft. There were, however, a whole series of lenses of up to 20 in focal length, and a prism could be fitted to most of them to convert the normal vertical view to an oblique shot. Far left below: Diagram of the plate-changing mechanism. It should be noted that it took 300 revolutions of the propellor to complete the cycle. Left: The same camera fitted to a BE2C. Here the mounting is within easy reach of the observer in the rear cockpit, and so the plates are changed by hand, using the lever in front of the shutter release plunger.

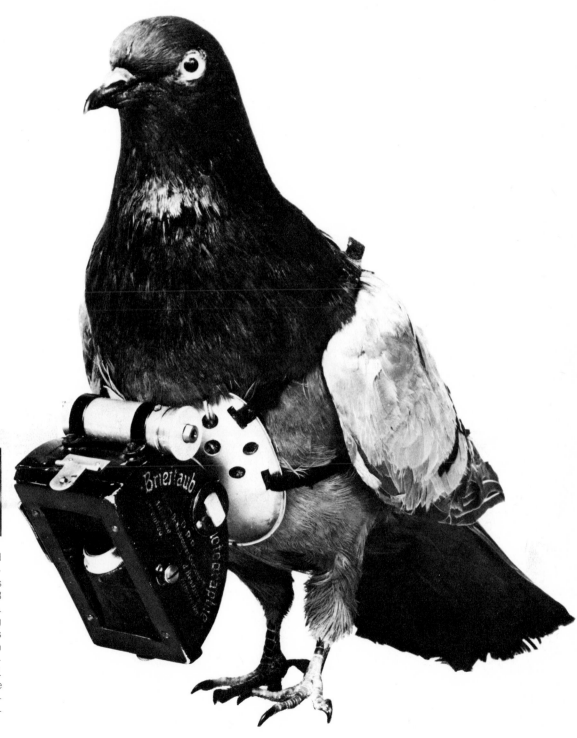

Doppel-Sport is one name given to this odd manifestation of photographic pigeon-fancying. The device was invented by Dr Julius Neubronner, of Kronberg, tested during 1908 at Spandau and marketed from 1912 onwards. The lens was arranged to swivel thus covering a wide field of view; the film carrier was therefore curved. A pneumatic delayed action shutter-release enabled the moment of exposure to be set before the pigeon took off. Format was 3×8 cm (say 1³/₁₆×3⅛ in). The photograph above taken in 1907 by Dr Neubronner's device, shows the castle of Kronberg—and the wingtips of the pigeon.

The **Linhof Electric 70** uses perforated 70 mm film, a 30-metre roll of which gives 400 exposures 56×72 mm (2¼×2⅞ in). Interchangeable backs are available for sizes 120 and 220 film, and there is a wide range of lenses from 55 mm to 180 mm focus each in 1/500 sec. Compur shutter. A motor-drive with remote control powered by 24-volt battery sets the shutter and advances the film.

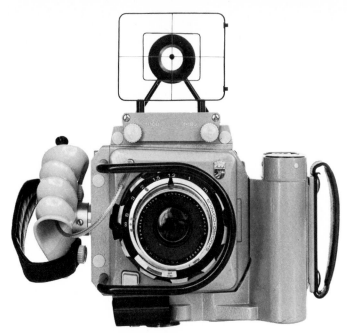

KEY TO DIAGRAM: 1. Exposure calculator 2. Control box. 3. Film magazine. 4. Suspension unit. 5. Lens mounting. 6. Electronic circuitry.

Wild RC10 aerial survey camera, made in Switzerland by Wild. The diagrams show the highly sophisticated gadgetry. The camera takes pictures 9 in by 9 in (23×23 cm), fed from a magazine holding up to 150 metres of film. It will accept a wide range of lenses, including one having an aperture of f/5.6 and focal length of 3½ in (88 mm) whose field of coverage is 120°. The suspension system permits either automatic or manual operation of the camera, and the control-box can be coupled to the aircraft's own instruments, e.g., an artificial horizon; the box governs all the camera's functions: shutter release (manual or automatic), electric control of speed and aperture settings, film advance and so on. The exposure-meter comprises two elements: a sensor and a calculator. The sensor is mounted outside the aircraft and measures the light by means of a photo-electric cell, the special characteristics of which are low sensitivity to the blue end of the spectrum, (reducing the effects of atmospheric haze) and maximum sensitivity to infra-red. This sensor is connected with a calculator which works out the exposure according to the camera settings, film speed and filters being used, over a continuous speed range, which is infinitely variable up to 1/1000 sec. This automatic control may be overridden. The electronic control box contains a series of interchangeable printed circuits, and through this unit pass all connections between the **RC10** camera and its controls, automatic or manual.

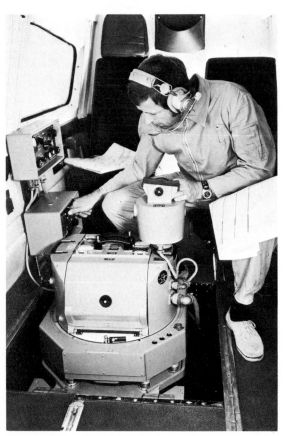

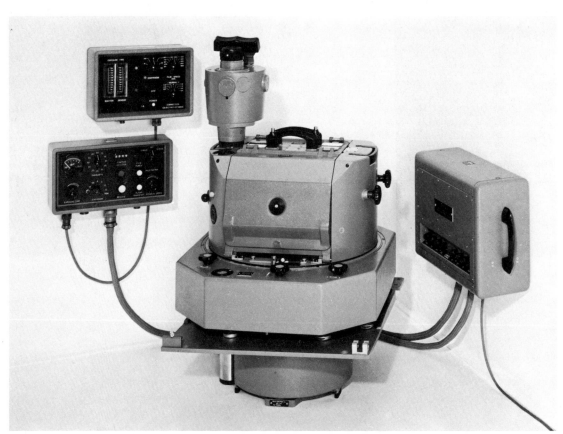

The name Victor Hasselblad, the Swedish maker, will always be associated with the remarkable American space missions carried out since 1962. On the early flights a standard camera was used by Walter M. Schirra, the Hasselblad 500c. During the Apollo 8 mission the astronauts were armed with an instrument developed specially in conjunction with NASA, the Hasselblad Electric 500 EL. This has no reflex viewing, but a simple direct-vision finder, simple to use when looking through the window of a space helmet. As the astronauts would be wearing gauntlets special controls were designed for focusing, shutter speeds, diaphragm setting and release. These cameras did not use 120 or 220 rollfilm; instead a supply of special backs for 70 mm perforated film giving 200 exposures in black and white or 160 in colour—the difference being due to the different thickness of the stock. As for optical equipment, they had the normal 80 mm f/2.8 Zeiss Planar, plus a Zeiss telephoto lens, the 250 mm Sonnar, opening to f/5.6.

Photographic Credits

All the illustrations appearing in this book are
by Michel Auer or Edita SA,
except where otherwise mentioned in the captions.

Acknowledgements

It is impossible to thank by name all those who have contributed to
this book. However, the author, the translator, and the publishers
would like to thank all Museums, Corporations and private collectors
who have rendered them invaluable aid, particularly Jacques Rouiller,
Marcel Bovis, Edward Holmes, of Christie's, Derek Grossmark and
Malcolm Taylor of the Hove Camera Company, Tony Kowal of
Vintage Cameras, Ltd, and Howard Ricketts.

This book is published under the direction of Ami Guichard
Editorial responsibility and supervision by Tim Chilvers
Produced under the direction of Charles Riesen
Layout and design by Max Thommen

Printed by Imprimeries Réunies SA, Lausanne
Bound by Maurice Busenhart, Lausanne

Printed in Switzerland